Talking Prices

PRINCETON STUDIES IN CULTURAL SOCIOLOGY

Paul J. DiMaggio, Michèle Lamont, Robert J. Wuthnow, Viviana A. Zelizer

A list of titles in the series appears at the back of the book

Talking Prices

Symbolic Meanings of Prices on
the Market for Contemporary Art

Olav Velthuis

PRINCETON UNIVERSITY PRESS

PRINCETON AND OXFORD

Copyright © 2005 by Princeton University Press
Published by Princeton University Press, 41 William Street, Princeton, New Jersey 08540
In the United Kingdom: Princeton University Press, 3 Market Place, Woodstock,
Oxfordshire OX20 1SY
All Rights Reserved

Fourth printing, and first paperback printing, 2007
Paperback ISBN-13: 978-0-691-13403-1

The Library of Congress has cataloged the cloth edition of this book as follows

Velthuis, Olav, 1972–
 Talking prices : symbolic meanings of prices on the market for contemporary art /
Olav Velthuis.
 p. cm.—(Princeton studies in cultural sociology)
 Revision of the author's thesis (Ph. D.—Erasmus University, Rotterdam).
 Includes bibliographical references and index.
 ISBN 0-691-12166-4 (cl. : alk. paper)
 1. Art, Modern—20th century—Prices—New York (State)—New York. 2. Art,
Modern—20th century—Prices—Netherlands—Amsterdam. 3. Pricing—Social
aspects—New York (State)—New York. 4. Pricing—Social aspects—Netherlands—
Amsterdam. 5. Art dealers—Psychology. I. Title. II. Series.

 N6490.V375 2005
 381'.457—dc22 2004051062

British Library Cataloging-in-Publication Data is available

This book has been composed in Sabon

Printed on acid-free paper. ∞

press.princeton.edu

Printed in the United States of America

10 9 8 7 6 5 4

Broer did not want to be an accountant. Later, when he was writing art criticism, people blamed him for using the words "indescribable" and "priceless" so often. "Those two words may be bad style," he would defend himself, "but they are good aesthetics. I used to have a father who was haggling perpetually. I hated his ceaseless thrift. The same hatred I now feel for the smooth operators who have words for anything. As a boy, I used to long for things that cannot be converted into whatever you like, that cannot be melted into air by money or words, things that are inviolable, insoluble, and now I have found them, in the world of art. To me 'beautiful' is synonymous with 'genuine.' And if I nowadays come across something that is nothing other than itself, that is real, I honor it by saying 'indescribable' or 'priceless'; thus, so to speak, I keep my mouth shut."

—Frans Kellendonk, *Mystiek Lichaam*

Contents

List of Tables and Graphs

Acknowledgments

THIS BOOK WAS ORIGINALLY WRITTEN as a dissertation at Erasmus University, Rotterdam. Back then Arjo Klamer was my Ph.D. supervisor; by now he is a dear friend. Arjo was a great inspiration throughout. Even if we disagreed at times on the interpretation of the findings that I am about to present, he helped me in bringing out my own views as eloquently as possible. I am more than grateful to Viviana Zelizer, who not only gave valuable comments, but also welcomed me in Princeton, where I wrote part of the book. Thanks to Neil De Marchi for the many enjoyable and helpful discussions about art markets, for being a warm host during a visit in Durham, North Carolina, and for detailed criticism of the first draft of the book. Jack Amariglio came into the process late, but he was all the more supportive.

Most chapters were presented at the weekly cultural economics seminar (Erasmus University, Department of History and Arts), run by Arjo Klamer. The seminar provided a warm and critical setting for testing preliminary versions of the ideas I present in this book. My stay in Princeton served as the operating base for my empirical research in New York. Professors and graduate students at the Sociology Department of Princeton University provided an inspiring environment during the two semesters I spent there. Ruth Towse, Charles Smith, Deirdre McCloskey, Donald Light, Michael Hütter, Karin Knorr Cetina, Alex Preda, Paul DiMaggio, Harrison White, Anna Mignosa, Alexandra Kalev, Jeroen Thijs, Julia Noordegraaf, Liesbeth Noordegraaf-Eelens, Krista Connerly, Rick Dolphijn, Josh Guetzkow, and P. W. Zuidhof read parts of the book, shared their insights with me, and gave valuable advice. Thanks to Bregje van Eeekelen for suggesting the title. Merijn Rengers and Hans Abbing, who were finishing dissertations on similar topics at almost exactly the same time, were generous in their advice, critical in their comments, and warm in their friendship. Alessandra Arcuri read the book from A to Z, gave helpful comments, and provided lots of other support. Marcel Cobussen did not provide any assistance, but it was wonderful to share an office space with him while working on this book. If I dedicated this book to anybody, it would have been to my parents, who died before I started off.

Research for this book was made possible by a Travel Grant and a Talent Stipend from the Netherlands Organization for Scientific Research (NWO) and by a grant of the Trust Foundation of Erasmus University,

Rotterdam. Their financial support is gratefully acknowledged. Thanks to Hanna Schouwink, Nanne Dekking, Krista Connerly, and Jan Willem Poels for providing some outstanding introductions to art dealers in New York. The IVA Tilburg (Research File Artists 1990–99), the Dutch Ministry of Education, Culture and Science, and the Mondrian Foundation are gratefully acknowledged for providing quantitative data on prices. Tom Bradshaw at the National Endowment for the Arts (Washington, DC) kindly and quickly provided unpublished data on the American art market. Alexandra Kalev provided valuable help in finding court materials for one of the chapters.

A revised version of chapter 4 was published with Merijn Rengers as "Determinants of Prices for Contemporary Art in Amsterdam Art Galleries 1992–1998" in the *Journal of Cultural Economics*, 2002 26 (2), pp. 1–28; an abridged version of chapter 7 was published as "Symbolic Meanings of Prices: Constructing the Value of Contemporary Art in Amsterdam and New York Galleries" in *Theory and Society,* 2003, pp. 181–215. Materials from both articles are used with kind permission of Kluwer Academic Publishers. Chapter 3 has been published before as "Promoters and Parasites: An Alternative Explanation for Price Dispersion on the Art Market," in Gianfranco Mossetto and Marilena Vecco (eds.), *Economics of Art Auctions* (Milano: Franco Angelli, 2003, pp. 130–50).

Talking Prices

Introduction

IN THE MIDDLE of one of the interviews which I conducted for this study, I decided to give up, desperate as I felt about the respondent's reluctance to respond to my questionnaire. The art dealer, whose gallery annex print-making studio was located in the geographical periphery of the New York art market, refused to discuss what I was trying to understand: how art dealers set prices for contemporary works of art. This dealer had explained casually that the prints made in his studio were priced at roughly two-thirds the price of a work on canvas, and that revenues of sales were split on an equal basis between him and the artist. Apart from that, however, he did not elaborate on pricing strategies, the dos and don'ts of price changes, or the rationale of the vast price differences between different works that prevail on the market for contemporary art.

His unwillingness to answer my questions was not informed by anxiety to disclose business secrets, but by a sheer disinterest in prices; at least that was what he tried to convey when my tape recorder was running. The art dealer claimed that he did not want to be a factory, a marketplace, or a banker; he and the artists he worked with would not, as he put it, "demean themselves to what is called commerce." Instead, this friendly but stubborn man characterized his own enterprise as a family. He elaborated on the egalitarian basis of his gallery and on the moral responsibility he felt towards the arts community; he repeatedly spoke about the gallery as a "mutually enabling environment," and claimed that his own role was to be "co-involved" with artists intellectually. Acquainted with many of America's best known painters, he emphasized how his relationship with them was based on "equality, harmony, and partnership." Regarding collectors, the dealer said that he only sold art to people who expect to "grow from it spiritually"; the fact that hardly any work he sold in the past had subsequently appeared at auction proved that collectors of the gallery "purchase [art] for the right reasons." This apparently pleased him, since he maintained that art loses its "emotional value" and degrades into "capital" once it appears at auction. The dealer did not leave any opportunity unused to make clear that this was to be avoided at all times. The "boom" of the art market in the 1980s, when prices for art rose steeply and works of art became popular as investment objects, had therefore done lasting damage to the art world, according to him.

After I had turned off the tape recorder, the dealer offered me a glass of white wine, and took me to his living space behind the gallery. He showed

me his own, private art collection, which consisted of works by modern masters I had only seen in museums before. Then, as he described the background of his collection, and how he had put it together passionately throughout the years, his wording changed dramatically. The same dealer who had so carefully avoided invoking mundane interests before, turned out to remember precisely how much he had paid for the works in his collection in the past, and was also up to date about their present price level. Moreover, he eagerly and proudly emphasized that the current market value of his collection surpassed the past acquisition prices dramatically.

It seemed that my respondent stood the world on its head: in his commercial role as a dealer, when I expected him to be concerned about prices and profits, he refused to talk numbers. Instead, the metaphor he used to characterize his business was a "family" and a "community" rather than a marketplace—reflecting on his own enterprise in terms of commerce, marketing, or business strategies seemed out of the question. In his living space, however, the same dealer apparently felt inclined to discuss the value of his precious collection in bare economic terms. Since I expected that explicit monetary measurement is avoided in the private sphere, especially regarding goods with a strong symbolic value like art, this attracted my attention as much as his earlier avoidance of prices did.

Other dealers whom I interviewed for this book claimed likewise that they had not entered the art business to make a profit, but because they loved art, or because they wanted to help artists make a living from their work. References to commerce, such as price tags or cash registers, were conspicuously absent from their business spaces. They said that they would never allow their artistic priorities to be compromised by commercial objectives and that they did not let financial matters interfere with the way they conducted relationships with artists and collectors. At the same time, however, when they were casually describing their daily lifeworld, including social interactions, prices surfaced prominently in their discourse.

The Cultural Constitution of Economic Life

To make sense of the way art dealers talk about their business, we need to go beyond conventional understandings of markets. According to one of those understandings, instigated by mainstream, neoclassical economists, but also endorsed frequently in the media, markets are about individuals who pursue their self-interest ruthlessly and who exchange goods without regard for others. Within this understanding, the dealer's discourse can be safely ignored, since economic life is ultimately structured by some underlying universal principle such as the "laws of supply and

demand," the "price mechanism," or the "invisible hand of the market." Cultural economists who study the art market have emphasized time and again that the buyers, sellers, and distributors on the art market are, like their counterparts on other markets, rational individuals who permanently strive to maximize their profits (see, e.g., Frey 2000; Grampp 1989). For such an economic analysis, the empirical evidence which interviews generate is fragmented, unsystematic, and anecdotal. Neoclassical economists prefer to look at outcomes like actual market prices, which directly reveal the behavior and preferences of economic agents.

According to another understanding, which has been put forward by economic sociologists since the mid-1980s, markets should be understood in network terms. Increasingly dissatisfied with the "undersocialized" perspective of neoclassical economics, these sociologists have argued that market exchange is invariably embedded in social networks. The emphasis that the art dealer put on his intimate social ties attests to the existence of such networks in the art market; these networks, the argument goes, can be formalized and have a decisive and measurable effect on the dealer's survival in the art market, on prices, on profit rates, or on some other indicator of success (Giuffre 1999). Within a third understanding, markets are the antithesis of social and cultural life. This view of markets, which can be found in social science as well as the humanities, and counts classical thinkers such as Karl Marx and Georg Simmel among its ranks, stresses the contaminating or corrosive effects that the market has on social and cultural life. When it comes to art, the market alienates artists from their work, their labor, and their public, while failing to recognize artistic values; moreover, through the price mechanism, which supposedly reduces all qualities to quantities, the market commensurates what is considered to be incommensurable.

The alternative understanding that I propose in this book is that markets are, apart from anything else, cultural constellations. Like any other type of social interaction, market exchange is highly ritualized; it involves a wide variety of symbols that transfer rich meanings between people who exchange goods with each other. These people are connected through ties of different sorts, whose emergence, maintenance, and possible decay involve complex social processes. What I argue, in short, is that just as culture infuses other social settings that sociologists and anthropologists have studied, it infuses market settings. This infusion is of such a degree, that it may be virtually impossible to separate market and culture analytically (DiMaggio 1994, p. 41).

Within the understanding of markets that I propose, even prices, which have long been considered to be devoid of any meaning at all, can be thought of as cultural entities. Indeed, the New York art dealer's sudden change of discourse when he showed me his private collection, from

denying to emphasizing them, makes sense once it is recognized that prices have symbolic meanings apart from just economic ones. Referring to the difference between the original acquisition price and the present market value of the works of art he owns, the dealer in question expressed noneconomic values and sketched his capabilities as a collector of art. During the interview, he had referred to similar price differences of works by one of his artists as follows: "When I first worked with Sam Francis in the 1970s, his reputation had slipped away a bit, and we could not give the works away for $8,000 or $9,000. However, not so long ago his work was traded on the market for $195,000. . . . It's interesting, it's a story. The figures describe a story that is not about the money." What I infer from these comments as well as those made by other dealers is that the price mechanism is not just an allocative but also a symbolic system: impersonal and businesslike as prices may seem, they are the numbers artists, collectors, and dealers live by (cf. Friedland and Alford, 1991, p. 247).

In advocating the role of culture in economic life, I do not mean to subscribe to a "culturalist" point of view, in which culture is the only or the prime explanatory concept (see Hannerz 1992). Neither do I think of culture as a stable, coherent set of values that decisively sets one group of people apart from another. Instead, building on recent strands in cultural sociology, I will show how culture simultaneously restrains and enables action on the art market (see DiMaggio 1997). Culture is *restraining* in economic life insofar as cultural values codetermine which types of goods can be exchanged, which social and cultural contexts are legitimate for conducting this exchange, and which business practices this exchange should be accompanied by. For instance, when it comes to the architecture of galleries, an avant-garde art dealer can hardly afford to deviate from the austere, white, spartanly furnished spaces that have dominated Western art markets for at least half a century. Doing so would, in most cases, seriously compromise his legitimacy within the art world. To give another example: when it comes to setting prices, ostentatious price decreases need to be avoided because such decreases harm the status of dealers and reputation of artists significantly in the eyes of their peers.

At the same time, culture is *enabling,* since it provides economic actors with the tools to shape markets, social relationships, and contexts of commodification, in legitimate and meaningful formats. I will refer to these tools in terms of a repertoire or a menu of possibilities (see DiMaggio 1997, p. 267). For instance, within the restriction of the so-called white cube, dealers can construct and fortify their identity by means of details inside of the space, by its location, or by the transparency of the gallery architecture. And when it comes to decreasing prices, dealers have an emergency repertoire at their disposal to carry these through less ostentatiously but more legitimately.

Avant-garde gallery in Chelsea, New York. Photo: author.

The conception of culture in economic life that I endorse differs from the toolkit notion of culture which was developed by Ann Swidler in the 1980s, and has become increasingly popular in recent years. According to Swidler, culture can be thought of as a toolkit which individuals can fall back on in order to find strategies of action of their own liking.[1] Instead, the account of culture that I provide is a relational account, according to which artists, collectors, and dealers mutually construct the landscapes of meanings they inhabit. The term I use for these landscapes of meaning in economic life is "circuits of commerce." Randall Collins originally proposed the term "Zelizer Circuits" to denote the dense exchange patterns studied by the economic sociologist Viviana Zelizer. Zelizer herself subsequently coined the phrase "circuits of commerce" to illuminate that exchange is invariably accompanied by "conversation, interchange, intercourse, and mutual shaping" and gives rise to "different understandings, practices, information, obligations, rights, symbols, and media of exchange."[2] Social ties are not uniform within these circuits, but are instead subject to differentiation. People may, for instance, mark the manifold exchange relationships they engage in, whether relatively intimate or relatively impersonal, by means of special names, the use of particular media of exchange, or the giving of appropriate gifts. The transfer of goods and

services within circuits is in other words not restricted to either market or gift exchange, but often involves a combination of both.

Rather than being solely motivated by utility maximization, members of these circuits may be inspired by concerns of status, care, love, pride or power. In daily economic life, they not only need to collect information and make decisions on its basis, they also need to make sense of the behavior of the partners they engage in trade relationships with. This behavior may not be universally rational, but it does make sense within the circuits that economic actors inhabit. On the one hand, then, the notion of circuits serves as an alternative to the reductive notion of exchange that prevails in neoclassical economics; on the other hand, it suggests that there is more to markets than social structure.

Organization of the Book

This book is not about colorful biographical details of artists, dealers, and collectors, about "the powers behind the scenes," about chivalrous and mischievous behavior of dealers, about amorous relationships with dramatic endings, or other juicy stories that the art world has come to be associated with in the popular press. The aim of the book is to understand how contemporary art is marketed in western societies around the turn of the twenty-first century, and how art dealers determine prices for contemporary works of art. In the first chapter, I show that by reducing all values to price, or by radically separating the categories of price and value, dominant strands within economics and the humanities have failed to understand how dealers operate in two worlds simultaneously. Their disciplinary separation notwithstanding, the worlds of art and economy need to be negotiated in the daily practice of the art dealer. In order to do so, art dealers rely on an intricate business repertoire. For instance, a sharp distinction is made between the front room of the gallery, where artworks are exhibited and references to commerce are suppressed, and the back room, which can be seen as the commercial nerve center of the gallery. In order to separate art from commerce, dealers also make a sharp distinction between "right" and "wrong" acquisition motives on the part of collectors, and between an active and a passive marketing scheme. They furthermore try to control the biography of artworks in order to prevent these works from coming into contact with money again. By doing so, the "disentanglement," as Michel Callon has called it, of the artwork from its producer, remains incomplete on the art market (Callon 1998).

In chapter 2 I elaborate on the social fabric of the market. The art market is characterized by a dense network of intimate, long-term relation-

ships between artists, collectors, and their intermediaries. As the dealer suggested at the beginning of this introduction, at times these relationships are framed like or grafted onto family ties and hardly look like the anonymous interaction assumed in neoclassical economic theory. I show how dealers, collectors, and artists maintain these relationships by marking, defining, and framing exchange; by doing so they actively manage the meanings of the transactions they engage in. A *quid pro quo* exchange between a dealer and an artist may, for instance, be framed both as a hostile act and as an act of care. Also, whereas some scholars are keen on making a sharp distinction between an (ideal) gift economy and a (corrosive) market economy I argue that this distinction is untenable, for circuits within the art market are characterized by economic transactions that are not *quid pro quo*, but involve mutual gift giving and delayed payments.

In chapter 3, I discuss the way this dense network of social relationships interacts with the price mechanism that is used on the art market. Since dealers want to have control over the future biography of the artwork, it is not always in their interest to sell art to the highest bidder. They prefer to sell new artworks by means of fixed prices, rather than by means of an auction mechanism, and sharply distinguish their own gallery prices from the hostile, parasitic prices established at auction. Apart from the fact that the auction mechanism results in price volatility, which can harm trust in the value of an artwork, the structural positions of both parties in the market differ. Whereas auction houses do not work with artists on a long-term basis, dealers see themselves as patrons who seek to establish a firm market for their artists. In order to prevent artworks from appearing at auction, dealers erect moral and sometimes even quasi-legal boundaries between the gallery and the auction circuit. As a result, an auction price may not be fully fungible with a gallery price. The art market, furthermore, gives rise to definitional struggles between dealers and auction houses, in which the dealer wants to suppress the commodity character of an artwork and sees these efforts obstructed by the auction house.

If not by means of an auction mechanism, how do art dealers arrive at the prices they post in their galleries? The book does not propose a new, grand theory of value, but those who are looking for the definite answer to the enigma of high prices for artworks, which has long aroused the curiosity of both academic and lay observers of the art market, will find bits and pieces of that answer in chapters 4 and 5. The crucial issue here is that feeble constructions of value, and a permanent awareness that these constructions may collapse, hide behind the impressive gallery spaces and the charismatic personalities of their owners. Therefore, dealers work hard to establish a sense of structure when deciding about

prices. In chapter 4 I explore this structure by means of a statistical model, which estimates the price of a contemporary work of art in terms of characteristics of the artist (e.g., age, reputation, sex), of the work of art (technique, size), and of the gallery (e.g., affiliation, age). Building on institutional currents in sociology, I explain these statistical regularities in chapter 5 with the help of what I call "pricing scripts." A script is a set of rules which enables dealers to set prices systematically. These rules circumvent the subjective, disputable issue of quality, and focus on measurable entities such as the size of the artwork or the age of its maker. Scripts not only structure the market by establishing a common pricing framework for different artists, but also create consistency within an artist's career, since they contain rules for different events that occur in the course of this career.

In chapter 6 my account of this scripted decision-making process is enriched by showing that the concept of price itself, unproblematic as it is in economic theory, turns out to be fluid, underspecified, and subject to (re-)definition in the discourse and practice of art dealers. As dealers distinguish different types of prices and attach moral significance to these, prices not only differ along quantitative but also along qualitative lines: they embed prices in different narratives of the market such as an honorable, a superstar, and a prudent narrative. In making these distinctions between different narratives, dealers identify themselves with some business practices and distance themselves from others. Also, they cancel out the commensurating effect of the price mechanism to some extent by means of these distinctions.

Making distinctions between different types of prices is not the only signifying act in markets. In chapter 7, I show how dealers convey social and cultural meanings to their colleagues, artists, and collectors through price levels, price changes, and price differences. High prices for art may not make sense in absolute terms, but they do make sense when seen within the context of other prices for art. Also, for the lack of a better alternative, prices are "read" as an indicator of artistic value by collectors. Moreover, my ethnographic material suggests that prices are not just about works of art, but also about the people who produce and consume them. Prices serve as a ranking device when it comes to artists. Although dealers may be able to use this ranking device to their advantage, for instance when high prices go to symbolize the extraordinary talent of an artist, meanings of prices may also turn the art market into a symbolic minefield: not all participants of the market, not the entire art community, and certainly not the entire society the art world is embedded in, interpret prices in the same way; outside of the art world people may see high prices for art not as a symbol of genius, but as a symbol of fraud. A price that is understood as cautious or modest in one circuit may be

interpreted as a sign of arrogance in another one. Also, some artists see prices as a source of self-esteem, which induces them to demand prices that are hardly "real" in the eyes of dealers. In short, meanings of prices are always multiple meanings. Neoclassical economists are likely to dismiss the relevance of such meanings when studying prices. Nevertheless, I will incidentally make claims that the stories which prices tell and the meanings which they convey have repercussions for economic outcomes as well. For instance, paying attention to meanings of prices will enable me to account for some anomalies of the price mechanism, such as the existence of a strong taboo on price decreases and the golden rule of pricing according to size rather than quality.

THE HOLLOW CORE AT THE HEART OF ECONOMICS

Although the reader will notice that my perspective on the art market is largely grounded in empirical data, it builds on recent strands in sociology and older strands in anthropology, as well as heterodox strands within the discipline of economics, which advocate the constructive role of culture in economic life.

In spite of the fact that markets are one of the central institutions of our society, the question of how they function has been largely ignored by neoclassical economics, as several economic sociologists have claimed. Richard Swedberg, for instance, has argued that since the end of the nineteenth century, economic theory of the market has been thinned to the abstract concept of the price mechanism that mainly served analytical interests of a highly mathematical kind (Swedberg 1994, p. 259). In a review of recent literature, John Lie notes likewise that economists have used the concept of the market as an ontologically indeterminate abstraction: it is the "hollow core at the heart of economics," as Lie puts it (Lie 1997, p. 342). The reason is that neoclassical economists have long analyzed markets as autonomous, de-contextualized mechanisms, which are devoid of an institutional grounding and are not disturbed by any social or cultural interference. The problem is not just that these markets do not exist in reality, but also that economic actors would most certainly feel at a loss in them (Castells 1996, p. 172).

Economic anthropologists like Marshall Sahlins, Mary Douglas, Arjun Appadurai, and Stephen Gudeman have countered the neoclassical economic notion of universal, acultural markets by arguing that economic value relies on cultural beliefs as much as on material practices, that consumption is at once determinant and expressive of identity, that economic goods can be seen as having a life or biography of their own, or that love and care may manifest themselves in economic activities as unlikely as

shopping. Economic sociologists have likewise argued that we should pay attention to the different ways in which economic life is socially constructed, and to the role that culture plays in the design of economic institutions.[3]

This book builds in particular on the work of economic sociologist Viviana Zelizer. A recurring theme in Zelizer's work, which deals with, among others, the marketing of life insurance in the nineteenth century, the use of money within domestic settings, and the changing economic valuation of children, is how actors transgress the boundaries between the marketable and the non-marketable, between the sacred and the profane, or between legitimate and illegitimate exchange. By actively modifying the morals of markets, economic actors manage to establish legitimacy for transactions in contested goods. They succeed in supplying seemingly homogeneous economic entities such as money with a human dimension. Also, Zelizer shows that a commercial setting does not keep economic actors from building up meaningful, intimate social relations.[4]

Apart from advocating the role of culture in the everyday functioning of markets, the main contribution of this book is a sociological analysis of prices. Although some sociologists, starting with Max Weber, have paid attention to the price mechanism, a full-fledged sociological alternative to the neoclassical perspective of prices is lacking. Some sociologists even contrast socially embedded action with the "atomized market governed by the price system," implying that price formation is essentially a nonsocial activity (Uzzi 1997, p. 49). Weber, however, saw "money prices" (*Economy and Society*) as the expression of the market struggle between relatively autonomous economic units. They were "the product of conflicts of interest and of compromises" and resulted from "power constellations" (Weber 1922 [1978], p. 108). Recently, a number of economic sociologists have also started analyzing prices in terms of the social structure of the market that produced them. They show that prices do not "mysteriously emerge from 'the market,'" as Harrison White has phrased it, but are instead social formations or social constructions, and form part of the established rules of the game that producers tacitly obey (White and Eccles 1987, p. 985; White 1981; White 2002). The uniform pricing schemes which came about in the late nineteenth-century electricity sector, for instance, reflected intra-industry political struggles, power configurations, and social networks rather than economic pressures propelling towards increased efficiency. Thus a suboptimal rate system for electricity came into being, which was subsequently locked in for the century to follow (Yakubovich et al. 2001); also, in a by now classical article, Wayne Baker has shown how volatility of stock prices depends on the social structure of the market and the size of networks in which traders operate. Whereas mainstream economists postulate that markets with

larger numbers of buyers and sellers show less price volatility, Baker shows that the opposite holds on the financial markets he studied. His explanation is that small groups of market actors are able to keep each other's market behavior in check, thus setting boundaries to price volatility (Baker 1984).[5]

Privileging the role of social structure, these studies have left cultural aspects of markets by and large unexamined. In particular, they do not recognize that prices are embedded in webs of meaning rather than just in social networks. Conversely, in cultural sociology, a wide range of vehicles of meaning have been recognized, including beliefs, ritual practices, art forms, and ceremonies, as well as informal cultural practices such as language, gossip, stories, and rituals of daily life; the symbolic content of economic entities such as prices, however, has hardly ever been considered. In that respect, this book contributes to opening up a new field for cultural analysis.

Contemporary Art Galleries in Amsterdam and New York

The empirical focus of this book is on dealers that are active on the primary art market in Amsterdam and New York, and who show contemporary art on a regular basis in commercial exhibition spaces. The primary art market is the market for the first-time sale of contemporary art. I have excluded dealers on the secondary or resale market for art from my analysis as well as other actors on the primary market such as artists who sell their work directly out of their studio, intermediaries who operate via the internet, through furniture stores, on the sidewalks of busy, touristy streets, at Friday afternoon company gatherings or at Sunday afternoon society parties in chic private houses, or with the help of young, good-looking salesmen who go from door-to-door with a portfolio of images. According to previous research on the Dutch art market, 56 percent of all sales are made through galleries, 30 percent directly from the artist's studio, and 14 percent through other intermediaries (Brouwer and Meulenbeek 2000).

Although art has been produced for a dealer-mediated market from at least the sixteenth century onwards, the history of art galleries as we find them in New York, Amsterdam, or other art cities in the Western world dates back to nineteenth-century Paris. Art galleries developed out of shops for artist's supplies, out of print shops, as well as out of premodern dealerships that were often affiliated with the French salons.[6] The defining characteristic of the modern art dealer as he arose in the nineteenth century is that he shifted the attention from selling individual canvases to selecting a limited number of artists and actively promoting their careers.

In order to do so, art dealers heavily relied on, and in many cases even actively tried to entice, critical appraisal for the artist's oeuvre. Thus, in their classical book in the sociology of art, *Canvases and Careers,* Harrison and Cynthia White have named the system that governs the modern art market the "dealer-critic" system (White and White 1965). Up to this day, art dealers are not only concerned with making sales, but also with stimulating critical attention for the artist's work by having critics write about "their" artists, and persuading curators to include them in future museum shows and other noncommercial exhibitions. This means that while dealers, collectors, and artists are the main parties engaged in economic exchange on the art market, the value of the goods that they exchange would not be realized without a political economy of taste, constituted by a variety of noncommercial institutions. Arguably, if compared to the past, the dominant role of the critic in this economy has been replaced by the curator who either works for a museum or is independently in charge of highly regarded exhibitions like the Documenta in Kassel (Germany) or the Venice Biennial. Apart from curators and critics, private collectors have allegedly come to influence the rise and fall of artistic careers.

Paris has long remained the geographical center of the art market since its inception in the nineteenth century; illustrious dealers like Paul Durand-Ruel, Daniel-Henry Kahnweiler, Léonce and Paul Rosenberg, and Ambroise Vollard had their seat there. After the Second World War, however, when dealers and artists left Europe, and the art that commanded most attention was produced by American abstract expressionist artists, New York took over (Guilbaut 1983). The city managed to hold on to this position for more than four decades, and although some have argued that the international art market lacks a clearly identifiable center since the early 1990s, New York probably still outranks any other city when it comes to the number of galleries, collectors, and artists. The city hosts many of the largest art dealers in the world, as well as the headquarters of the world's three main auction houses, Sotheby's, Christie's, and Phillips, de Pury & Luxembourg. Nonresident collectors fly into the city in order to buy new works for their collections, while foreign artists seek to be represented by a New York art gallery.

Although Amsterdam is, like New York, the national center of the art market, its position on the international art market is peripheral at best. The Dutch art market is, to a much lesser extent than neighboring countries like Germany, Belgium, or the United Kingdom, part of the international art market; this means that the collectors that Amsterdam dealers sell to are by and large restricted to the Netherlands. In international art fairs that have come to play a crucial role in the global art market, like Art Cologne, Art Basel, or the New York Armory Show, only few Dutch

dealers tend to take part. Also, since foreign artists with an international reputation are usually selling their work for prices that are significantly above the customary level on the Dutch market, their work is hardly being exhibited in and sold by commercial Dutch galleries. Conversely, when a small number of artists like Rineke Dijkstra left their Dutch dealers for an English or American representative after making a breakthrough on the international art scene, this was widely deplored and considered to be a sign of the sorry state of the Dutch market.

No clear-cut explanation has been provided for this apparent weakness. Some have argued that the government is to blame; because of the stranglehold it supposedly has on the Dutch art world due to its extensive subsidy schemes, it would prevent private initiative from flourishing (Simons 1997). Others have argued that the Netherlands lacks a well-developed culture of art collecting, which may be due to a combination of socioeconomic circumstances such as the relatively equal distribution of income, or to cultural factors such as the originally Protestant taboo on ostentatious display of wealth (see Gubbels and Voolstra 1998).

Reliable and comparable figures on the Amsterdam and New York art market are hardly available. Table I.1 does give an overview, however, of

Booth of 303 Gallery at The Armory Show 2004, an annual fair for contemporary art in New York. Courtesy The Armory Show, Inc.

TABLE I.1
Key data on the American and Dutch art market

	Netherlands		USA	
(a) Number of dealers	500–600	(3.1–3.7)*	5,698	(2.0)*
(b) Annual turnover per dealer ($ thousand)	80–240		497	
(c) Size of dealer market ($ million)	40–144	(2.5–8.0)**	2,834	(10.1)**
(d) Number of artists	11,500	(0.7)***	191,160	(0.7)***
(e) Size of auction market ($ million)	26	(1.6)**	1,298	(4.6)**
(f) Share of global auction market	0.97%		49.14%	
(g) Average auction price ($)	6,189		71,035	
(h) Government expenditure ($ million)	714	(46)**	1,530	(6)**

Notes *per 100,000 inhabitants.

**per capita.

***per 1,000 inhabitants.

(a) Dutch figures for intermediaries on primary market only; American figures include secondary market dealers. Low Dutch figure: CBS (Central Bureau of Statistics), *Hedendaagse Kunstbemiddeling 1996*, Heerlen: CBS (1998). High Dutch figure: press release Dutch Gallery Association (NVG), 2000; see Gubbels and Janssen 2001.

(b) Low Dutch figure: CBS. High figure: average of 141 galleries who participate in a subsidy arrangement to stimulate the art market, 1999; see Gubbels and Janssen 2001. Note that the average $1.8 million/gallery for the New York City metropolitan area (including New Jersey) is much higher than for the rest of the country.

(c) Low Dutch figure: CBS. High Dutch figure: estimate based on maximum number of galleries and maximum average turnover. In the NYC metropolitan area, total sales of all dealers was $853 million.

(d) Dutch figure for 1998 (Brouwer 2000); American figure for 1990, including craft artists (see Alper et al. 1996).

(e) http://www.art-sales-index.com, auction season 2000/2001; figures do not include photographs and prints under $3,000, paintings, watercolors, drawings under $400, and sculpture under $2,000; net of premium to be paid by buyer to auction house and tax.

(f) For size of the global market, see http://www.art-sales-index.com, auction season 2000/2001.

(g) As (e) above.

(h) *International Data on Government Spending on the Arts. Research Division, Note #74*, Washington: National Endowment for the Arts, 2000; the figures include direct subsidies to the arts on a national and local level in 1994 (Netherlands) and 1995 (U.S.).

the national art markets that Amsterdam and New York are embedded in. The table shows that the average turnover of American galleries is at least twice as high as the average turnover of their Dutch counterparts. Depending on the definition used, the size of the American gallery market is up to 70 times as large as the Dutch market, whereas the American auction market is 50 times as large as in the Netherlands. Another striking difference regards the involvement of the government in the art world, which is, in relative terms, much larger in the Netherlands than in the United States. The per capita number of artists is roughly the same in both countries, however.

Whereas New York galleries are in some cases large, profitable enterprises, employing over 25 people, the majority of galleries in Amsterdam do not even provide a living wage to their owners (see Gubbels and Janssen 2001). In spite of this, the density of galleries is higher in Amsterdam than in New York (see table I.1). Depending on the definition of a gallery and on the source that is used, the number of galleries in New York lies between 470 and 1,294, and in Amsterdam between 121 and 288.[7] The most widely used gallery guides of New York and Amsterdam list 536 and 165 galleries respectively. Based on the latter figures, the number of galleries per 100,000 inhabitants is 6.7 in New York, as against 22.5 in Amsterdam.[8] Discussing the ecology of the art market, the economist Richard Caves notes that the art market may be relatively overcrowded because art dealers have other objectives than just maximizing profits (Caves 2000, p. 44): whereas firms with a similarly low profit level would have folded shop in other sectors of the economy, galleries stay in business. Given the higher density of art galleries in Amsterdam, this seems to hold to a greater degree there than it does in New York.

The Structure of Art Galleries

When it comes to the primary art market's structure, one may argue that there is really only one market, since all dealers are, in the end, competing for the scarce resources of a group of people who are willing and able to spend money on art. At the same time, however, one may hold that each gallery is a monopolist that, with a relatively stable set of artists on the supply side and collectors on the demand side of the market, hardly faces competition from its colleauges.

Presently, the primary art market in both Amsterdam and New York is a free market with relatively low start-up costs and no barriers of entry like licenses or diplomas. The backgrounds of gallery owners can hardly be generalized. Before opening an art gallery, owners of a gallery may have been businesspeople, art historians, artists, art consultants, or art

collectors (cf. Gubbels 1999); in New York in particular, many of them have worked as a director, dealer, or assistant for another gallery. Systematic data are not available, but the average lifespan of galleries seems limited. According to one estimate of a well-known art dealer in the mid-1980s, 75 percent of all contemporary art galleries do not survive more than five years (Caves 2000, p. 44).

Although both in New York and in Amsterdam dealer associations exist, there is no formal regulation by governmental institutions or self-regulation by trade organizations (Gubbels 1999, p. 61). Art dealers in the Netherlands and the United States represent on average between 10 and 20 artists (a few large galleries, which have extensive financial resources as well as personnel, may represent up to 50 artists, as well as the estates of artists who have deceased); they schedule exhibitions for "their" artists on an annual or biennial basis which last six weeks on average. Before, during, and after the exhibition, the dealer tries to sell these works, which happens mostly on a consignment basis: when a sale is made, the dealer receives a commission which in most cases amounts to 40 or 50 percent of the selling price. Some of the works that are not sold during the exhibition may be kept in the gallery's inventory, but unsold works usually remain the artist's property. Some artists have a preemptor or primary gallery, who represents them exclusively and arranges all business affairs for them; if other galleries want to sell work by these artists, they get the works from the primary gallery; when those galleries make a sale, they not only need to pay a percentage of the price to the artist, but also to the primary gallery. Other artists do not allow a single gallery to promote their work exclusively, and work with several galleries simultaneously under comparable conditions.

As an organizational form, the art gallery hardly resembles the modern, bureaucratic organization. When Max Weber discussed different types of authority in his magnum opus *Economy and Society*, he distinguished traditional and charismatic authority from the rational-legal type that came to dominate modern organizations (Weber 1922 [1978], pp. 241–45; see also Biggart 1989). The art market seems to conform to the charismatic type, that is, the authority exerted by such people as revolutionaries, heroes, or spiritual leaders. The daily operations of art galleries are centered around the founder and owner of the gallery, whose name the enterprise usually bears: although she may be assisted by directors in the case of a large gallery, the key business activities, such as developing social networks crucial for the marketing of art, selecting the artists which the gallery represents, or setting the prices for the works for sale, are solely her responsibility. Only in a few larger galleries are employees of the gallery, rather than the owner himself, involved in making sales (cf. Szántó 1996). Depending on the size of the gallery, other

tasks are executed by different employees such as an art handler, a book-keeper, an archivist, and people responsible for contacts with the press, with artists, and with clients respectively.

In running their galleries, these charismatic dealers present themselves as visionaries of the artistic field, who "are playing for history," as one of my informants put it. They say that they do not have an interest in selling what is economically viable in the present, but in what is of artistic importance in the future. In other words, dealers engage in a seemingly irrational form of commerce, which rejects a straightforward capitalist logic, but instead endorses the more profound goals of the aesthetic and the artistic. The charisma of an art dealer is not self-acclaimed, but is acknowledged and enhanced by the diverse followings the dealer has: by artists whose ultimate goal it is to be represented by her; by gallery visitors who, facing the abundance of shows they can visit, choose to return to her gallery repeatedly; and by collectors who rely on her taste and who frequently, if not exclusively, buy their art at her gallery. As Lucy Mitchell-Innes, former head of Sotheby's New York contemporary art department, characterized the dealer-collector relationship at the Pace Gallery, founded by Arnold Glimcher: "Buying from Pace is rather like membership in a club. Glimcher has this group of subscribers who are committed to his aesthetic, and they buy works by each of his stable of artists."[9] As a result of this pivotal role played by the founder of the gallery, the long-term continuity of art galleries is problematic, which accords with Weber's characterization of charismatic authority: once the founder of the gallery retires or dies, the gallery often withers away. Rather than succeeding their employer, assistants or directors of the gallery tend to start a new gallery of their own. It is telling that the New York–based Wildenstein Gallery, one of the few galleries that have been in business for more than a century, albeit on the secondary rather than the primary art market, is a family dynasty.

When it comes to types of dealers, economists and sociologists have come up with different, albeit overlapping, distinctions between traditional and entrepreneurial dealers (Moulin 1967 [1987]), between dealers that are motivated by symbolic and those that are motivated by monetary rewards (Bystryn 1978), between dealers that sell popular and those that sell high art (Fitz Gibbon 1987), or between explorer and commercial galleries (Santagata 1995).[10]

To date, the French sociologist Pierre Bourdieu has proposed the most sophisticated taxonomy of what he calls the economy of symbolic goods. This taxonomy consists of two different types of hierarchies. First of all, there is the opposition between "large-scale" production directed at catering to the preexisting demands of a larger audience, and small-scale production meant for an audience that mainly consists of fellow artists,

experts, critics, and a limited number of other insiders; on different occasions Bourdieu has referred to this opposition as an opposition between the commercial and the noncommercial, between traditional and avant-garde, or between bourgeois and intellectual art, between the "immediate, temporary success of best-sellers" and the "deferred, lasting success of 'classics'" (Bourdieu 1993, p. 82; Bourdieu 1992 [1996]). The second hierarchy concerns the circuit of small-scale, avant-garde production, in particular, and involves a young as yet unrecognized fraction, and a consecrated, well-to-do fraction of the cultural field, whose work has already been incorporated in the canon. This difference in degree of consecration, Bourdieu writes, "separates *artistic generations,* defined by the interval . . . between styles and lifestyles that are opposed to each other—as 'new' and 'old,' original and 'outmoded'" (Bourdieu 1992 [1996], p. 122).

In this book I will by and large adopt Bourdieu's taxonomy. The terms that I will use to denote the two opposed circuits within the art market are "avant-garde" and "traditional." Note that such terms are to a great extent misnomers, since the empirical basis of these terms is disputable at best: from an artistic perspective, it may in many cases be difficult to classify the artworks for sale in different types of galleries without insider's knowledge, especially once these artworks are lifted out of their gallery context. And when it comes to the economic dimension of the taxonomy, Bourdieu has rightly argued that the opposition between avant-garde and traditional or commercial does not concern economic success (profitability, price levels, turnover) per se; instead, the opposition coincides with economic success in the short run (in the case of traditional galleries) versus economic success in the long run (in the case of avant-garde galleries). What distinguishes both circuits, then, is not, or not only, the quality of the art or the economic success of the gallery, but the type of business repertoire that each endorses. This business repertoire manifests itself materially and symbolically in the way art is marketed, business is conducted, and prices are set. Surely each circuit may nowadays be too large for all its respective members (artists, dealers, and collectors) to actually engage in a day-to-day conversation with each other; nevertheless, they do share the same business culture, visit the same or similar shows, are interested in each other's gossip and rumors and read the same arts magazines.

This shared culture notwithstanding, the avant-garde circuit harbors a wide variety of galleries, from small, idealistic enterprises which try to help beginning artists show their work, to large, global corporations with offices around the world; within the traditional circuit, some dealers represent the expensive and painstakingly realist work of artists who have a waiting list of collectors willing to buy their work, while others offer a wide variety of low-priced works made by artists without a reputation whatsoever, for sale.

METHODOLOGY

With respect to empirical data, the analysis of markets and prices in this book largely follows Clifford Geertz's well-known dictum in *The Interpretation of Cultures* that "[i]t is with the kind of material produced by long-term, mainly (though not exclusively) qualitative, highly participative, and almost obsessively fine-comb field study in confined contexts that the mega-concepts with which contemporary social science is afflicted—legitimacy, modernization, integration, conflict, charisma, structure, . . . meaning—can be given the sort of sensible actuality that makes it possible to think not only realistically and concretely *about* them, but, what is more important, creatively and imaginatively *with* them" (Geertz 1973 [1993], p. 23; italics in original).

My field study included 18 semi-structured, in-depth interviews with art dealers in Amsterdam, and 19 interviews with art dealers in New York, which I conducted between April 1998 and March 2001. In both cities, the same questionnaire was used (see appendix A). The interviews lasted 45 minutes to an hour on average. I started with two pilot interviews in the Netherlands to test and improve the questionnaire.[11]

The selection of galleries was made on the basis of three criteria. First, diversity in terms of age and location of the galleries was maximized. Second, I made sure that "traditional" as well as "avant-garde" galleries were included; however, the sample is biased toward the second category (for a description of the sample, see appendix B). Third, the selection of galleries is partially based on a snowball method: interviews with some dealers were made on the basis of recommendations by gallery owners I had interviewed before (Arber 1993, pp. 73–74); I knew from previous research that access to prestigious dealers in particular can only be gained through these recommendations (Warchol 1992; Plattner 1996; cf. Abolafia 1998).[12] Apart from interviews, I conducted many informal conversations with dealers, artists, and collectors at openings, parties, professional meetings, art fairs, or public debates; during innumerable gallery visits, and especially during longer visits to dealers who provided me access to their archives, data were gathered by means of participant observation. My fieldwork has been supplemented with written material from eclectic sources such as reviews in art magazines; interviews with artists, collectors, or gallery owners published in books and magazines; biographies of art dealers; guidebooks to the art market for artists; and court materials.[13]

In some cases, I managed to triangulate my findings with the help of quantitative data. These data were derived from an arrangement of the Dutch government to provide individuals who buy visual art at a large

selection of galleries in the Netherlands with an interest-free loan (see Rengers and Velthuis 2002). The database contains data on prices of approximately 16,000 artworks, sold in the Netherlands between 1992 and 1998, and many potential determinants on the level of artworks, artists, and galleries. Comparable data for the American situation are lacking, but nonsystematic observations of prices in New York galleries strongly suggest that the average price level is higher in New York. Nevertheless, the patterns of marketing and pricing art that emerged from my interviews in both cities are striking in their similarity. Therefore, this book lacks an elaborate comparative dimension; the emphasis of this study will be on similarities rather than differences between the cities. However, different pricing patterns that result from local institutional factors, such as the influence of governmental subsidization schemes in Amsterdam or the strength of the auction market in New York, will be elaborated upon.

The type of knowledge about markets and pricing that I derive from my ethnographic material is less abstract, less rigorous, and more difficult to generalize than economists generally prefer. Nevertheless, I contend that it provides a richer understanding of the actual practices of dealers, of the way the art market functions, and the role prices play in this market. The book finishes with a conclusion in which I speculate about the extent to which my findings can be generalized to other markets. The art market may seem erratic when it comes to its prices, thin when it comes to the number of buyers and sellers that are active, almost irrelevant when it comes to its size as a percentage of GDP, and hardly part of the capitalist economy when it comes to its business practices. Still, the landscapes of meanings that make themselves manifest in the art market on a magnified scale are hardly exceptional. Those who have paid detailed attention to other markets have invariably run into similar meanings before.

The Architecture of the Art Market

INTRODUCTION

From the inception of the modern art market in the first half of the nineteenth century, art dealers have defined their own identity as disinterested promoters and patrons rather than merchants and marketeers of art. At a time when retail markets developed and department stores arose in most Western European metropolises, art dealers steered away from commerce and consumerism. They were quick in refashioning their stores "ideologically," as one historian writes, from "the equivalent of book dealers and antiquarians into rivals of museums" (Jensen 1994, p. 15). Moreover, art dealers have been wary of being identified with the economic elite that formed their clientele, and instead established close relationships with artists, critics, academics, and intellectuals (Green 1987, p. 66).

In a similar vein, contemporary art dealers maintain that they aspire to distribute art for history, not for the market. At seminars and expert meetings that I attended, they spoke of their galleries as a "place for experimentation," a "vehicle for ideas," and a "mild biotope" in which art can flourish. Rather than providing a "showcase for commodities," they aimed at engaging in a "privileged dialogue with the artist." In an empirical study, German art dealers told researchers that personal and artistic rather than economic criteria are decisive when it comes to the selection of artists that the gallery represents. In interviews they call themselves "amateurs," in the French sense of art lovers, who want to share their love for art with others; the function of their galleries would be to "provide people who understand art, who appreciate and follow art, with the opportunity to see it," as New York art dealer Barbara Gladstone put it in one of these interviews (Coppet and Jones 2002, pp. 115, 309). And on their websites, they write that they see it as their responsibility to "work for the long term development of each artist's career, acting as a liaison to international galleries and museums as well as placing works in collections; to create an historical archive for each artist; and to act as an accessible public space in which the exhibitions become an exemplary gesture of the power of subjectivity to the audience at large." That art galleries are also supposed to sell art can only be read between the lines, if at all.[1]

In writing this book, I ran into many other instances of this noncommercial self-representation among dealers in contemporary art. Gallery spaces I entered for interviews with the owner or director were pristine, white spaces, equipped like museums rather than retail stores. The works they were exhibiting, most often part of a solo show, surely were for sale, but I often failed to detect any initiatives to make those sales happen. In Amsterdam it was sometimes difficult to find gallery spaces, either because they were located away from crowded areas or shopping streets, or because they could hardly be identified from the outside as galleries. It should therefore not come as a surprise that people say they hesitate to enter a gallery space because of the psychological threshold that is being imposed upon them.[2]

I was warned by fellow researchers, friends with a background in the art world, and dealers in pilot interviews that my respondents would not be willing to discuss the business end of their operations. In this respect my background as an art historian proved to be an advantage. Before starting an interview I would usually ask questions about the current exhibition or about the artists which the gallery represented; I also signaled to my informants that I was aware of the position of the gallery and its artists in the contemporary art world. My impression was that after I had shown that my interests exceeded business matters, most dealers felt more at ease to discuss their commercial practices. Even then, however, my respondents hardly unfolded strategies explicitly directed at maximizing profits, catering to the demands of the market, or finding niches that had not been exploited before. Instead they emphasized that they were attached to "art rather than money," and that they would have chosen a different profession if they had wanted to become rich. Treating art commercially has no "cachet" or "savoir vivre," they said. With respect to their program, the dominant answer was that they continuously tried to "stay away from the trend"; they were only able to sell artworks they could appreciate themselves. One dealer described himself and his colleagues as "a bunch of dreamers."

These anti-commercial self-representations do not mean, however, that gallery owners discard commercial interests. As Nancy Troy writes about the illustrious art dealer Daniel-Henry Kahnweiler, who played a pivotal role in the marketing of cubist art at the beginning of the twentieth century: "In order to sell works of art by vanguard artists to the clients to whom they might reasonably be expected to appeal, [Kahnweiler] had to eschew the range of commercial practices associated with establishments appealing to much larger markets. If salons, like department stores, attracted enormous audiences to their vast and often highly orchestrated displays of disparate objects, if they issued extensive catalogues and generated highly visible accounts in newspapers and popular journals, the

private dealer maintained distinctiveness of his products by not advertising and by suggesting the elite character and intellectual self-sufficiency of the works of art he displayed" (Troy 1996, p. 122).

The contemporary art dealers I interviewed likewise manage to transform goods which lack any direct utilitarian value into some of the most highly priced commodities of modern retail markets: invariably, they sold artworks for four-, five-, six-, and sometimes even seven-digit prices. Especially given the fact that many of these works are hardly meaningful, intelligible, or valuable to people outside of the art world, such accomplishments seem striking. It would be foolish, then, to take the art dealers' anti-commercial self-representations at face value. Instead, it could be argued that these self-representations enhance the very pursuit of these interests. The solemn, austere gallery spaces, for instance, with their scarce references to commerce, transport people into a radically different environment, where utilitarian notions of value are temporarily suspended, and, when it comes to prices, different laws are at work.

ONE MARKET, TWO LOGICS

To understand in further detail the way art dealers operate and the way they represent these operations, we need to recognize that they are part of two different social worlds simultaneously. On the one hand, the art dealer's world is a *capitalist* world. Like any other commercial enterprise, a gallery needs to find items that it deems marketable, to attract potential customers, and to make sales in order to keep its doors open. Also, in case the dealer depends on the income of others to run the gallery's operation, if it has bank loans or private investors (so-called "backers"), it will need to hold itself accountable to these parties. In order to do so, the dealer needs to negotiate with the artist about contractual issues; he needs to determine a price for the works he offers for sale; and, if a collector is interested, he may need to bargain harshly over this price before the work is eventually sold. Afterwards, the dealer will try to keep track of the artwork, not only regarding its whereabouts, but also with respect to its future economic value. In order to do so, he pays attention to what appears at auction, the pre-sale estimates that the work has, and the final price it is sold for.[3]

At the same time, however, dealers are *cultural* institutions which serve as gatekeepers to the art world (Crane 1976); they elect and select artists from the many who seek to be represented, and promote new, innovative values that may go against the grain. Dealers mount exhibitions which contain works that have never been shown to the public before, and which are frequented above all by people who do not have the means to buy

them. With their manifold relations to the cultural field, required for the promotion of the artists they represent, they are the central nodes, or, as one art historian put it, the "crucible" of the art world (Fitzgerald 1995, p. 4). Disregarding the economic value of a new work, buyers may admire its artistic merits, critics may write about it in the press, curators will consider including it in an exhibition, and other scholarly attention will be devoted to the work.

In sociological and anthropological literature, the phenomenon that individuals or organizations are part of two worlds simultaneously has been discussed in different contexts and for varying purposes in terms of regimes of value, institutional spheres, spheres of justice, regimes of justification, or institutional logics.[4] Each regime, sphere, or logic would be characterized by its own conventions and routines, its own rituals and symbols, and its own shared understandings of what is appropriate, legitimate, or normal behavior (cf. Biggart and Guillén 1999). Understood in these terms, the art market is a site where human action is informed by two contradictory or conflicting logics: a logic of art, and a logic of capitalist markets. The logic of the first is understood to be a qualitative logic; it centers around the uncompromising creation of symbolic, imaginative, or meaningful goods, whose value cannot be measured, let alone in the monetary metric of the market. The logic of capitalist markets, by contrast, would be a quantitative logic that centers around commodification and commensuration of human activity.[5]

When it comes to the way these contradictory logics interact, different academic models can be distinguished. Building on the work of Viviana Zelizer, I characterize two alternative models in particular, "Hostile Worlds" and "Nothing But," before presenting a third, empirically grounded alternative (Zelizer 2000a). "Hostile Worlds" models of art and the market, which can be found in the humanities as well as the social sciences, and which count conservative as well as critical scholars among their adherents, highlight the detrimental effects of the confrontation between the logic of the arts and the logic of capitalist markets. The Marxist art historian Arnold Hauser, for instance, argued that market exchange would alienate the artist from his own labor, his art, as well as his public. It would harm the intimate, emotional relationship an artist has with the art he makes, as well as with the audience that looks at it: "People get used to buying what they find in stock at the art dealer's and begin to regard the work of art as just as impersonal a commodity as any other. For his part, the artist (. . .) again becomes accustomed to working for unknown, impersonal customers, of whom he knows nothing," except for the kind of art they desire (Hauser 1951, p. 469).[6] If Hauser was predominantly writing about the inception of the art market in seventeenth-century Holland, his comments have been reiterated by scholars as well

as artists for the art market of our own days. The American painter Mark Rothko, for instance, likened selling artworks on the market to selling his own children. Ian Burn, artist spokesman of the critical movement *Art and Language,* argued likewise that by selling his work on the market, the artist alienates herself not only from her own labor power, but also from the products which her labor results in: "once my work of art enters the art market, it takes on a power independent of me and this strikes me as a form of estrangement from what I have produced, an alienation from my own experiences" (Burn 1975 [1996], p. 910).

Other cultural experts have referred to Marx's notion of commodification in order to argue that economic value on the one hand and aesthetic, artistic, or critical value on the other cannot be reconciled. Whereas artworks are unique, incommensurable objects, market exchange and monetary measurement reduce their unique value to mere numbers. As a catalogue text of the prestigious Biennial Exhibition at the Whitney Museum in New York put it in the late 1980s: "[c]apitalism has overtaken contemporary art, quantifying and reducing it to the status of a commodity. Ours is a system adrift in mortgaged goods and obsessed with accumulation" (Armstrong, et al. 1989, p. 10). Art critic Robert Hughes summarized the "Hostile Worlds" perspective even more vividly when he wrote about the development of the postwar art market and the "alienatingly" high prices it generated: "What strip-mining is to nature, the art market has become to culture" (Hughes 1990, p. 20).

Another corrosive effect of the market, according to "Hostile Worlds" adherents, is that it would turn art into a fetish, that is, into a "god to be worshipped, sought after, and possessed" (Wood 1996, p. 263). Critical thinkers such as Theodor Adorno, Max Horkheimer, and Peter Bürger argued that art's audience in bourgeois society would not respond to artistic, critical, or emancipatory values, but to factors extrinsic to art, such as the signature and the name of the maker. And when the art collector's acquisition motives are inspected more closely, speculative sentiments and status considerations would prevail over aesthetic concerns: in their attempt to become part of an "imaginary commonwealth of connoisseurs," buyers would be primarily interested in the "sign value" of contemporary art. In that respect, the logic of the art market would hardly differ from the logic of branding as it emerged in late twentieth-century retail markets.[7]

Within this "Hostile Worlds" discourse, art dealers seem to personify the contaminating force of the market. They are portrayed as money-grubbers who take advantage of artists that are desperate to exhibit their work. In taking a big cut of all sales, dealers act as the modern heirs of nineteenth-century capitalists, exploiting artists who barely manage to survive in the first place. As the stereotype of art dealers is summed up in

a handbook on art and law: "Dealers are seen as quick to promise and slow to pay, untrustworthy, insensitive to artists' feelings, and with a tendency to use their power to bully. The stereotype depicts the dealer as avaricious and inclined to arrest an artist's growth by forcing the artist to repaint the things that sell and to take no chances" (Merryman and Elsen 1998, p. 620). Moreover, art dealers would willingly tap into the fetishist desires of collectors by offering them a lifestyle for sale rather than just an artwork, including access to art parties, dinners, and studio visits.

The second model of art and economy is a "Nothing But" model. In this model, the dual logic of the art market can, in the end, be reduced to a single one. One of the strongholds of this model has long been and continues to be the so-called neoclassical school within economics. For neoclassical economists, the art market is no different than any other market.[8] No doubt the most outspoken proponent of the "Nothing But" model is William Grampp, who argues in his book *Pricing the Priceless* that "works of art are economic goods, that their value can be measured by the market, that the sellers and buyers of art—the people who create and benefit from it—are people who try to get as much as they can from what they have" (Grampp 1989, p. 8).[9] He continues to argue that "[e]conomic value, strictly speaking, is the general form of all value, including that which is aesthetic and that which is not aesthetic but is value of another kind. . . . To say that aesthetic value is 'consistent' with economic value is to say no more than that the particular comes within the general, or that aesthetic value is a form of economic value just as every other form of value is" (Grampp 1989, pp. 20–21). Aesthetic or artistic value is, in other words, "Nothing But" a particular form of economic value.

The assumption of this reductive model of the market is that artists produce artworks in order to gain from it, like anybody else, whether in monetary or in psychic terms; collectors buy these artworks, since they expect to derive utility from consuming them, or because of the investment potential of artworks. The art world benefits from the market, since it allocates the scarce resources of artists (i.e., talent) and collectors (i.e., purchasing power) efficiently by means of the price mechanism. In this construct, art dealers are essentially middlemen. Their role is limited to matching supply and demand, reducing search costs for both buyers and sellers of art, and providing both parties with information relevant to a potential exchange. In doing so, the way dealers talk, dress, present themselves, or furnish their gallery spaces can safely be ignored, according to neoclassical economists. It does not add to our understanding of how the art market functions.

In an entirely different and substantially milder form, we find a "Nothing But" model in Pierre Bourdieu's influential sociological theory of the

economy of symbolic goods. At first glance, Bourdieu seems to acknowledge that there are two different logics at play in this economy. He argues that the functioning of the art market is defined by a "denegation" of commercial interest: actors in this market avoid talking about money or involving commercial interests.[10] This denegation is at the heart of what he calls the "habitus," that is, a set of predispositions and beliefs, which informs behavior of actors within the field. The denegation of the economy lends itself to two readings, one of which reduces it to disavowal and disinterestedness, the other to what is disavowed and self-interest. Both readings, however, fail to do justice to what Bourdieu calls the "essential duality and duplicity" of the field. In other words, the denegation of the economy can be interpreted neither naively as "a complete repudiation of economic interest" nor cynically in terms of a "a simple ideological mask" which covers up economic interests (Bourdieu 1993, p. 75).

Bourdieu's own interpretation of the denegation or disavowal of this economy is that works of art (and, for that matter, literary books or theater productions) are at the same time a commodity and a symbolic object (Bourdieu 1993, p. 113). By denying the economy, by believing that they enter the field for the sake of art, not for the sake of money, art dealers accumulate symbolic capital. In other words, art dealers establish a reputation or a recognized name, which enables them to "consecrate" objects or persons, and install those with both artistic and economic value. In consecrating these artworks and artists, other "cultural bankers" like art critics and art historians collaborate with the dealer (Bourdieu 1993, p. 78).

At this point, economistic tendencies enter into Bourdieu's thinking: economic interests ultimately seem to drive the economy of symbolic goods. In this respect, his persistent use of the economic metaphor of capital is telling. The reasoning is that the accumulation of symbolic capital in the short run, characterized by a disavowal of the economy, is a sound economic strategy in the long run: a higher reputation for a dealer may lead to more sales or higher prices. Thus Bourdieu suggests that actors in the field of cultural production are primarily socioeconomic maximizers, motivated, if only unconsciously, by an interest in some form of capital. If the capital is of a noneconomic form such as symbolic, social, or cultural capital, it can be transformed, in the long run and against costs, into economic capital (see Bourdieu 1983; Portes 1998, p. 4). Indeed, noneconomic forms of capital function most effectively insofar as they conceal the fact that economic capital is at their root (Bourdieu 1983, p. 252). Bourdieu even defines symbolic capital as "a kind of 'economic' capital denied but recognized, and hence legitimate" (Bourdieu 1992 [1996], p. 142).

This economistic tendency in Bourdieu's thinking is particularly explicit when he argues that dealers "form a protective screen between

the artist and the market," but at the same time provoke, "by their very existence, cruel unmaskings of the truth of artistic practices." The "truth" of these practices is as follows: artists are "deeply self-interested, calculating, obsessed with money and ready to do anything to succeed." The unmasked practices of dealers are no more comfortable: their interest in aesthetics is fundamentally guided by "their eye for an (economically) profitable investment" (Bourdieu 1993, p. 79). With such claims, Bourdieu moves in the direction of a "Nothing But" type of analysis: he suggests that the denegation of the economy is no more than a layer of cultural camouflage which conceals some type of interest. As Michèle Lamont puts it in her study of the American and French upper middle class, *Money, Morals, and Manners:* "Bourdieu shares with rational choice theorists the view that social actors are by definition socioeconomic maximizers who participate in a world of economic exchange in which they act to maximize material and symbolic payoffs" (Lamont 1992, p. 185).[11]

THE SACRED AND THE PROFANE

The upshot of the "Nothing But" approach to the art market is that the moment you take its cultural camouflage away, the art market is an ordinary market, where rational, self-interested, utility-maximizing individuals respond to economic incentives. Diametrically opposed to this approach, "Hostile Worlds" adherents regard the market for art with suspicion; they question the integrity of art dealers, and fear the detrimental effects of commodification. No matter how large the differences between "Nothing But" and "Hostile Worlds" perspectives are, they share a profound neglect of the role of culture in economic life. If the premise of the "Hostile Worlds" model is that commodification is a contaminating process, and the premise of the "Nothing But" model is that commodification is a neutral process that does not warrant any special attention whatsoever, my empirical research suggests that the crucial question is not *if* artworks are commodified, but instead *how* commodification takes place. In the remainder of the chapter I show that commodification is a culturally complex and symbolically charged process. In order to understand this process, I supplement Bourdieu's structural analysis of the field of cultural production with an interpretative account. The usefulness of macro-sociological concepts such as logics, spheres, or domains turns out to be limited in this account, the reason being that there is no such thing as a stable, well-defined sphere or domain where exchange is molded according to a universal, capitalist logic. Instead, economic exchange is always socially and culturally situated; art dealers need be sensitive not only to commercial opportunities and economic incentives, but also to

legitimacy structures, social imperatives, and patterns of meaning. In particular, their business repertoire is structured along a series of Durkheimian oppositions, between the sacred and the profane, between art and commerce, between the marketable and the non-marketable. As Durkheim argued in *The Elementary Forms of Religious Life,* these dealers attempt to preserve the sacred character of contemporary art by separating it from the commercial aspects of their trade. It is this separation, as Durkheim writes, that "constitutes the essence of their sacred character" (Durkheim 1914 [1964], pp. 335–36).[12]

On the art market, this separation of the sacred and the profane can be found at different levels. First of all, it manifests itself in the clear-cut separation between avant-garde and commercial galleries, which also figures prominently in Bourdieu's theory of the cultural field. Secondly, this separation can not only be found in a radical opposition *between* avant-garde and commercial galleries, but also *within* the daily operations of avant-garde art galleries themselves. By making an architectural distinction between the front room and the back room of their galleries, by separating their (noncommercial) primary from their (commercial) secondary market activities, and by deploying two opposed sets of selling techniques, art dealers enact the Durkheimian separation of the sacred and the profane, albeit, paradoxically, within a market setting.[13]

THE FRONT ROOM

Both in Amsterdam and in New York, avant-garde art galleries are located away from shopping districts, tourist hotspots, or other high-traffic areas. In other words, when it comes to location, a separation is established between the art market and the wider economy. In Amsterdam, and, to a much greater extent, in New York, art galleries have nevertheless clustered in streets, neighborhoods, or even in particular buildings. In New York, the postwar movements of these clusters can be traced in time. As if the New York art market were a glacier that slowly moves through the city and leaves its sediments wherever it withdraws, galleries are now spread in different parts of Manhattan. On West 57th Street, where the market for contemporary art was centered in the 1950s and 1960s, and in SoHo, where the art market moved from the mid-1970s onwards, few avant-garde galleries can still be found; nowadays, most of them are located in Chelsea (some less commercial and, in Bourdieu terms, less consecrated art galleries have been founded since the late 1990s in the neighborhood of Williamsburg, Brooklyn, where many artists live and work). At the time when galleries started moving there, both Chelsea and SoHo were by and large industrial neighborhoods;

although both neighborhoods have gentrified ever since, neither of them hosted many other retail stores, bars, or restaurants at the time that the first galleries started moving there.[14]

These collective migrations of art galleries are in the first place propelled by the prices of real estate: when dealers could no longer afford the galleries they were renting or when they wanted to expand their exhibition spaces, they were pulled towards new, virgin territories because of the low rents or real estate prices they were offered there. These migrations were not only significant from an economic perspective, however. Some galleries claimed to be moving out of SoHo exactly because of the increased popularity of the neighborhood, and because of the influx of fashion stores and luxury boutiques that they did not want to be associated with. Leaving aside the motives that are involved, economic or symbolic, the location of a gallery or the timing of its relocation is in itself a source of prestige within the arts community. Art dealer Paula Cooper, for instance, has often been credited with being one of the first movers to SoHo in the 1970s, as well as to Chelsea in the 1990s; these moves speak of an adventurous, independent attitude that is appreciated by peers, artists, and other members of the arts community. Likewise, dealers that have resisted the collective migrations of their peers and have remained in areas long after other galleries have moved on to another district have been praised for their stubbornness and their willingness to resist the trend.

The threshold that dealers effectively create by means of their physical location in the city is reinforced by the architecture of the avant-garde gallery: almost invariable, a shop window is absent, while it is impossible in many cases to view the inside of the gallery from the outside because of the use of opaque frosted glass windows or because of thin curtains behind the windows. Neon signs or signboards that most other retail stores have are absent, while some galleries only display their name in small letters next to the entrance door. For smaller galleries, this entrance door gives access to the main exhibition space, while visitors to larger galleries may need to pass through a small hall or corridor before accessing the exhibition. Much like in the classical, nineteenth-century design of art museums, this passage serves to disconnect the world of art from everyday life.

Inside, the most intricate symbolic attempt to separate art from commerce is a Goffmanian separation of the front and the back of the gallery (Goffman 1956 [1990]). The front of the gallery contains, depending on its size, one or more exhibition spaces. These spaces have concrete or wooden floors (carpets are hardly ever used), white walls without ornamentation, no furnishing, and neon or bright halogen lights, whose fixtures

Avant-garde galleries in SoHo, New York, are replaced by design stores.
Photo: author.

resemble those of construction sites. The minimal decoration, absence of
furniture, and lighting of the gallery space create an atmosphere that
reinforces the autonomy of the artwork on display, and keeps commerce
at bay (Moulin 1967 [1987], p. 154; Troy 1996, p. 113). The uniformity
of this basic structure of the gallery space is striking. It cannot only be
found in art capitals like Amsterdam and New York, but also in avant-
garde galleries located in small towns throughout the Western world.
Their architecture is one of the many examples of the market's isomor-
phism, as institutional sociologists have come to refer to it (DiMaggio
and Powell 1983). The minimalist, austere architectural language links
avant-garde gallery spaces on the one hand to the noncommercial world
of museums and on the other hand to the commercial world of luxury
commodities. Indeed, one of the well-known architects of gallery spaces,
Richard Gluckman of the architectural firm Gluckman Mayner Archi-
tects, who designed the gallery spaces of renowned New York art dealers
like Paula Cooper, Mary Boone, Luhring Augustine, Andrea Rosen, and
Larry Gagosian, has also designed retail spaces of well-known luxury

boutiques such as Helmut Lang, Yves Saint Laurent, Gianni Versace, and Katayone Adeli, as well as museum spaces for the Andy Warhol Museum in Pittsburgh, the Dia Foundation in New York, and the Georgia O'Keeffe Museum in Santa Fe.[15]

Inside the front room, price tags next to individual artworks and a cash register or a device for electronic payment are conspicuously absent. When a work has been sold, it is not removed from the exhibition (which would result in awkward situations in the not uncommon case that all works of art are sold before the exhibition even opens), but a small sticker may be put on a price list of the works that are exhibited. Although these lists are frequently lying on the desk located in the back or on the side of the exhibition space, the absence of price tags was the subject of a legal dispute in the late 1980s. In 1988 New York City decided to enforce the "truth-in-pricing" law for art galleries, which they had been exempted from since the early seventies. According to Consumer Affairs commissioner Angelo Aponte, people are entitled to buy art "without being subject to the vagaries of mystery, theater and snobbery." As a consequence of the decision, all galleries had to "conspicuously display" prices "by means of a stamp, tag or label attached to the item or by a sign at the point of display." Protests against the decision were fierce in the art world; conservative art critic Hilton Kramer argued in *The New York Times* that this law would turn galleries into ordinary retail stores. Adding fuel to "financial voyeurism," the law would make money and the "consciousness of money" even more important in the art world than it already was. Galleries themselves protested by arguing that their function was not only to sell art but also to show it; their exhibitions are open to the public without a fee. Because price would get in the way of the visitor's enjoyment of the exhibition, many art dealers refused to obey the "truth-in-pricing" law. Nineteen violators ended up paying $200 fines. Ronald Feldman, owner of an established SoHo gallery, faced a $4,000 fine when he refused to pay these fines in principle out of disagreement with the law.[16] In the end, however, the government dropped the issue, so that at the end of the century, when I was conducting my research, prices of expensive artworks in particular were only available on request; in some cases, assistants would not even be willing to mention prices on request, saying that the works "had not been priced yet."

In spite of this isomorphism, dealers have different opportunities to construct an identity of their own, and distinguish themselves from their peers. For instance, depending on the gallery's financial budget and the image it wishes to convey to the outside world, dealers may either remove or deliberately leave traces of the rough, industrial function the space most likely had in the past. Also, they can make a statement by opting for transparant glass in the front, which allows street traffic a glimpse into

the gallery space. Galleries like the successful Mary Boone Gallery in New York furthermore make a point of clearly displaying price lists even for the most expensive shows they host.

THE BACK ROOM

White cubes, as the austere gallery spaces have come to be referred to, have provoked a wide range of reactions. On the one hand, Charles Simpson argues in a sociological study of the SoHo art world that these types of spaces "try to make art viewing an unintimidating secular experience. . . . The public is encouraged to look around unchallenged and without ostentatious supervision" (Simpson 1981, pp. 16, 17–18). At least, Simpson writes, these galleries provide a neutral background for contemporary art. On the other hand, the artist Brian O'Doherty wrote in an essay entitled *Inside the White Cube* that the gallery space is directed at making works of art look expensive, difficult, and exclusive: "here we have a social, financial, and intellectually snobbery which models (. . .) our system of limited production, our modes of assigning value, our social habits at large. Never was a space, designed to accommodate the prejudices and enhance the self-image of the upper middle classes, so efficiently codified" (O'Doherty 1976 [1999], p. 76).

For my own purposes, it is besides the point to give a normative judgment of these spaces, whether critical or affirmative. Instead, it is important to register how the meaning of the white cube is constructed in opposition to the back room of the gallery: if the front, most visible and museum-like part of the gallery suppresses any references to the commercial function of the gallery, the back room, by contrast, is constructed as a commercial space; in other words, art and commerce are juxtaposed physically in the architecture of the modern gallery. In some cases, the back is sealed off from the front room hermetically, suggesting that the exhibition space is all there is to the gallery. Other gallery owners allow the public at least a partial view of the back space through open doors or glass windows. In small galleries, especially those located in Amsterdam, the back space may be limited to a single room or even a niche of the gallery space, where a small number of artworks are stored and a desk space is located for the owner of the gallery and her assistant. In the largest New York galleries such as the Marlborough Gallery or the PaceWildenstein Gallery located in corporate buildings on 57th Street, the back of the gallery consists of several corridors of spaces with distinct functions. These spaces may include the following: offices for the directors or dealers and, in some cases, for their personal assistants; a private viewing room, furnished with comfortable seats, where potential buyers

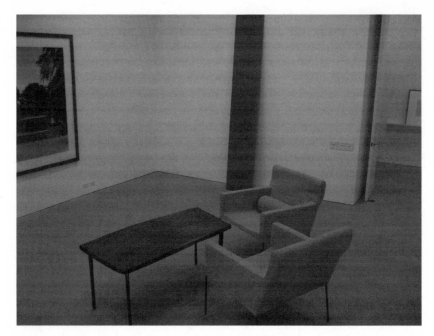

Private viewing room, courtesy David Zwirner Gallery, New York. Photo: author.

can look in full comfort at a small number of works they are interested in; a stock room, where (part of) the inventory of the gallery is stored—the everyday territory of the art handler, who is responsible for the shipping and installation of artworks. A general office room may have a large table where staff meetings take place, and where deals may be negotiated and arranged between the dealer and a collector, away from the works of art.

In general, the back room makes visible the permanent information streams which galleries both tap into and contribute to. Information about the whereabouts of the artworks that have been sold by the gallery in the past is stored in archives (after these works have been provided with a unique identification number), as well as price lists of past shows. Any information related to the careers of the artists that the gallery represents (books, newspaper clippings, magazine articles, catalogue texts, press releases) is kept track of meticulously, and is stored on floor-to-ceiling shelves, in computer databases, or in paper archives. If the gallery is involved in secondary market activities, auction catalogues and annual price guides published by art price information firms such as ADEC are standing on the shelves. Apart from computers, telephones, a fax, and a

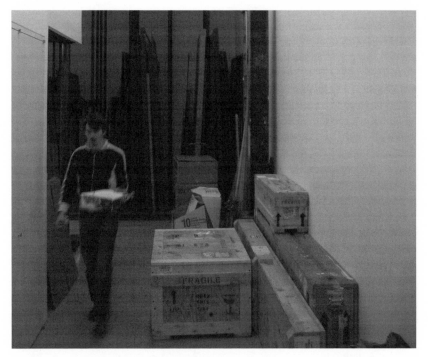

Stock room, courtesy David Zwirner Gallery, New York. Photo: author.

copier are the most essential "tools of the trade" that the directors and gallery assistants make use of. The back room may not only make the information architecture of the market visible, but also the gift economy that the art market is embedded in: multiple copies of monographs, gallery catalogues, and catalogues raisonnés of individual artists are stored in the back room, which the gallery may sporadically give as presents to collectors.[17]

Two different types of activities are conducted in the back spaces: primary market operations related to works which the gallery exhibits in the front room, and secondary market operations. On the primary market, new works of a limited number of living artists that the gallery represents are sold, while the secondary market involves the profitable trade in high-priced artworks made by a variety of established, often deceased artists that have, in most cases, never been represented by the gallery. In most cases, these secondary market sales happen on a commission basis (meaning that a collector who wants to sell a work pays a commission to the dealer); sometimes, however, the dealer buys these works himself, and subsequently tries to resell them. Because of a lack of financial means, because supply and demand for works in this price bracket is limited, or

Office space, courtesy Ronald Feldman Fine Arts, New York.
Photo: Emily Poole.

simply because local market conventions prevent them from doing so, few Amsterdam galleries engage in secondary market trading. In New York, however, during interviews I heard estimates of the percentage of total art sales transacted on the secondary market ranging from 25 to 60 percent (see Velthuis 2001). Nevertheless, as I noticed during my interviews, most dealers feel reluctant to talk about this part of their business, and conduct these activities out of sight of visitors in the front room. The reason is that the trading on the secondary market is as stigmatized as it is profitable: it makes the gallery resemble commercial establishments rather than cultural exhibition spaces. In other words, the secondary market violates the dealer's self-assigned role of promoter of artists and patron of art, which I will elaborate on in later chapters. One dealer (US17) said that "you are not really cutting edge if you would touch something that is established. (. . .) You want to be perceived really . . . pure. And you are only pure if you do primary. If you do secondary you are not pure." Since secondary market activities are stigmatized, dealers who run their gallery successfully without having recourse to the secondary market tend to take a pride in this. Conversely, the reputation of a dealer may be harmed when too much time and energy is devoted to

such commerce. Larry Gagosian, for instance, a New York dealer who is known for his aggressive secondary market activities, was accused by his colleagues of "degrading the business" and "bringing the habits of a souk rug seller to a refined trade." In the media Gagosian defended himself against such allegations by saying: "Is it written somewhere that only Sotheby's and Christie's should profit from the resale of art, and that everyone else should be some kind of saint?"[18] The point is, of course, that such legitimacy structures of the art world are neither formalized nor written down, but are effective nevertheless. Even a director at one of the world's largest dealerships told me that "interestingly enough it is not something we pay too much attention to. We are mostly interested in primary dealing, meaning from the studio. (. . .) [B]y and large we prefer not to do the trading" (US2); nevertheless, during the tour of the gallery, which he gave after the interview, I spotted secondary market artworks by modern masters like Jasper Johns and Robert Rauschenberg that the gallery offered for sale.

In order to counter this stigmatization, different strategies exist. The New York art dealer David Zwirner, whose main gallery is located in Chelsea, separated the primary and secondary markets to some extent by opening another gallery on the wealthy Upper East Side of Manhattan; this gallery, co-owned by the Swiss art dealer Ivan Wirth, is exclusively devoted to the secondary market.[19] In my interviews, I frequently encountered attempts to legitimate the secondary market dealing in different ways. Dealers told me, for instance, that they use the revenue of secondary market activities to finance the promotion of innovative, experimental art. They said that they could hardly keep their doors open when they would restrict their business to the primary market: an art dealer that feels committed to promoting new, innovative art in the front room can only do so by creating revenue from secondary market activities in the back room. "You don't survive on the shows," as one dealer put it bluntly: "The primary market is small, and it is much more the labor of love. (. . .) So if I want to do a money-losing show in the gallery, I could support it by selling a painting of Gerhard Richter, or something of Bruce Nauman" (US16).[20] Another frequently encountered argument to legitimize secondary market activities is that the artworks that are involved in these activities provide a cultural and historical context for the artists that the gallery represents on the primary market. Secondary market activities may also be considered legitimate as far as they lend credibility to the work of young artists who do not have a reputation yet. To that purpose, some dealers say they only buy work on the secondary market which "makes sense" and "does not look odd" next to the work of "their" own artists (US17).

"Make Me a Pink One"

Although a dealer may talk intensively with the artist about the develop-
ment of her work, the artistic choices that an artist makes in her studio
are considered to be beyond the dealer's control: it is taboo to ask an
artist to create works in a particular style, color, design, subject matter, or
even size which the dealer expects to sell more easily (cf. Abbing 1996).[21]
"Of course I will tell an artist what people think of an exhibition and
which works they appreciate in particular," a Dutch avant-garde dealer
admitted, "but you have to do it very carefully. Otherwise you intrude on
artistic integrity. So you have to use very 'artistic' language in order to get
away with that. I will never say that they should make more of certain
works" (NL4). "Make me a pink one" was an insider's joke that was
passed on to me during an interview. It underscores that the studio is
explicitly removed from the demands of the market.

For the same reason, the transition of artworks from the studio to the
gallery is a precarious one, no matter how carefully the front room of the
gallery is defined as a noncommercial realm. This first-time transition of
an artwork into a commodity phase, in the words of the anthropologist
Appadurai, is made all the more precarious because of the modern notion
of "the man-and-his-work": one of the stronger conventions of the art
world is that a work of art can ultimately not be separated or alienated
from the artist who created it.[22] It is therefore noteworthy that this tran-
sition into the commodity phase is highly ritualized. Gallery shows on
the primary market usually open with a *vernissage*. Contingent on the
resources of the gallery and the number of people invited, visitors to these
opening parties are treated to wine or beer and appetizers. More than
serving sales, these openings are social gatherings where the artist may
celebrate his artistic achievements with friends and clients of the gallery.
The moment that a collector has decided to make an acquisition and an
artwork is about to leave the commodity phase is frequently celebrated as
well, albeit on a smaller scale: the dealer and collector may have a drink
and make a toast on the acquisition. "Every sale gives rise to a dance of joy;
always I appreciate it if somebody thinks it is worthwhile to acquire an art-
work, it remains magic," as a Dutch dealer explained this practice (NL6).

In between the opening of a show and the possible closing of a sale, no
ostentatious efforts that are customary on other retail markets are made
to sell the art. The shows that the gallery hosts are advertised regularly in
art magazines and newspapers. But whereas advertisements for most
consumer goods actively and blatantly aim at seducing and persuading
consumers to purchase these goods, advertising activities on the art mar-
ket are restricted to providing the most necessary information such as the

Opening of an exhibition at a gallery in Chelsea, New York. Photo: author.

name of the artist who is exhibiting, the title of the show, and the address of the gallery, all printed in sober black and white design and sanserif font. Images and compelling texts, so customary in advertisements of most retail stores, are often absent.

During the exhibition, an assistant or, in the case of a small enterprise, the owner is sitting behind a desk in the front room, unlikely to approach a visitor with information or explication of the art that is exhibited. Information about the exhibition is available in the form of a press release, newspaper clippings, and, in some cases, an exhibition catalogue that are lying on the desk. The dominant exhibition practice is to present solo rather than group shows, which usually last five or six weeks. The variety of works on display is thus restricted, which obstructs "shopping" or "browsing" behavior on the part of consumers. On a regular basis, a gallery may show work that is difficult or impossible to commodify, like installations, video art, and performances. I also visited gallery exhibitions where a large number of works were not even for sale, but only served to complement the exhibition or were exhibited as "conversation pieces."[23]

Like promotion (sober advertisements, absence of sales rhetoric), place (the covert location of the gallery), and product (no influence of the

dealer on the production of the art), price is not conceived of as a legitimate marketing tool on the art market. For instance, when I asked a dealer if he ever used evidence of past auction prices for an artist's work in order to persuade a collector to buy a work in the present, he answered: "if people ask you that kind of question, that is indecent. You either like the work or not." Also, end-of-year sales, temporary offers, or so-called "just-below," "threshold," or "odd" prices like $999 or $1990, which sellers on other markets set to make expensive consumer goods seem cheaper, are explicitly avoided by art dealers (cf. Blinder et al. 1998, p. 25; Huston and Kamdar 1996). Instead, artworks are almost invariably sold for "round" prices. Table 1.1 shows more precisely that the ten most frequently encountered numerical values of prices for contemporary artworks sold in the Netherlands in the 1990s are all multiples of 250 (I come back to these data in chapter 4, where I analyze determinants of prices of art). The interpretation I suggest in light of the other evidence presented here is that the round gallery prices serve a symbolic purpose which is to suppress the commercial connotations of art on the market.

WAITING VERSUS BROKERING GAME

It has been noted before that the art market is a communication market, in which gossip, word of mouth, and permanent access to information are key to survival (Klein 1994); the relevant information may be related to emerging artists that deserve closer attention, to upcoming shows in

TABLE 1.1
"Round" prices for Dutch works of art

	Selling price (guilders)	Frequency	Cumulative
1	1,250	567 (3.5%)	3.5%
2	12,500	524 (3.3%)*	6.8%
3	4,500	485 (3.0%)	9.8%
4	3,000	463 (2.9%)	12.7%
5	2,500	459 (2.8%)	15.5%
6	3,500	456 (2.8%)	18.3%
7	4,000	431 (2.7%)	21.0%
8	5,000	419 (2.6%)	23.6%
9	1,500	404 (2.5%)	26.1%
10	6,000	307 (1.9%)	28.0%
N	16,110		

*This price level coincides with the initial upper limit of the loan arrangement.

museums and other nonprofit spaces that artists of the gallery may want
to participate in, or to artists that the gallery may be interested in repre-
senting in the future. To these informational ends, dealers and directors
not only spend large amounts of time talking to other members of the art
world, they also tend to visit many parties, openings, and other social
gatherings. The front room of the gallery is not the dealer's daily habitat,
although he does appear there on request or by appointment. His pres-
ence there is hardly even called for, since making sales on the primary
market is by and large staged as a *waiting game*, in which the artwork
supposedly has to sell itself. The prewar art dealer Kahnweiler expressed
this ideology a long time ago in his autobiography: "I don't have any
secrets. I know only one way to sell paintings, which is to get hold of
some and wait for people to come buy them. No mystery about it . . . It's
all so simple" (Moulin 1967 [1987], p. 45). Likewise, one of my respon-
dents compared selling art to finding a partner for a romantic relation-
ship—"[i]t is a matter of the right person for the right painting"—while
others talked as if certain works are predestined to end up in the hands of
a specific collector.

The dealer's role in this waiting game is not the role of a salesperson
but of a critic, who judges with the artist which works of art are worthy
of being exhibited, and of an educator, who tries to advertise a specific
artistic program, and create a particular aesthetic sensibility among the
collectors that frequently buy from him. Therefore, as far as rhetoric is
used to market art in the front room, it is the rhetoric of the cultural
expert: a mastery of critical discourse is a key asset for an art dealer in the
avant-garde circuit (cf. Bystryn 1978, p. 402). Also, art dealers actively
stimulate critical acclaim for their artists by inserting their work into the
art world's taste-making machinery: they induce critics to write about the
shows, they try to interest museum curators in exhibiting the artist's
work, and they ask influential collectors to recommend the artist's work
to others. Persuasive efforts are, in other words, as much directed at
potential collectors as they are at experts. Subsequently, dealers pass the
expert's judgments on to collectors, thereby attempting to translate criti-
cal acclaim into commercial success.

The business repertoire of the secondary market is less restrained. As
opposed to the passive waiting game of the primary market, the sec-
ondary market is an active brokering game. In order to be successful on
this secondary segment, an art dealer therefore needs to have another set
of skills. Instead of being able to produce critical acclaim for the artists
she represents, she needs to have access to a dense information network,
to financial resources, and to a network of clients that are able and willing
to buy these works. Tapping into this information network, some dealers
seem to talk endlessly on the phone in order to negotiate a profitable

transaction. Also, they only acquire secondary market works if they have strong expectations that they will be able to sell them within a reasonable amount of time for a profit. In order to make that happen, sales rhetoric is blunt and does not fail to elaborate on the solidity of the economic value of the work. The same dealer who refused to talk prices in order to make sales on the primary market, remarked about the secondary market: "you have to do that, you have to substantiate a price, you have to say this is this much because that is that much. Auction records are important here" (US16). Another dealer explained: "The game of brokering paintings is all about putting the buyer together with a seller. And sometimes things are hard to sell or hard to find. (. . .) [Y]ou just have to start lifting up the rocks and see what you can find" (US15).

This does not mean, however, that anything goes as far as business practices are concerned on the secondary market. Even this brokering game has its own "dos and dont's," its legitimate and illegitimate ways of conduct. For instance, some dealers claim that secondary market activities should be limited to buying works from and selling them to collectors that are already affiliated with the gallery. Others maintain that they only want to do business with collectors on the secondary market when these transactions are instigated by one of the three D's, as jargon has it: death, divorce, or debt. In order of appearance, dealers consider these the most legitimate reasons for a collector to sell some of his holdings.[24] Still others say that if they know a collector owns works by an artist that the gallery represents, it is acceptable to approach this collector even if it was not the gallery itself who sold her these works. Dealers consider it to be illegitimate, by contrast, to call strangers repeatedly, and to "bark an offer into the phone" for a work the dealer has only seen in an art history book or heard about from others. The general rule is that the weaker the tie to the collector, the less legitimate secondary market activities are; this explains why some masterpieces that appear on the secondary market go through the hands of a series of dealers, who all receive a small commission, before they end up with their new owner.

Wrong and Right Acquisition Motives

The opposition between the sacred world of art and the profane world of commerce is not only homologous with an opposition between the front and the back space of the gallery, and between the waiting game of the primary market and the brokering game of the secondary market, but also with a distinction that dealers make between two types of acquisition motives. Neoclassical economists have argued that collectors are willing to pay for an artwork for different reasons: because of the aesthetic qualities of the work (aesthetic value), because the owner derives

status from its possession (social value), or because it is a sound eco-
nomic investment (investment value) (Grampp 1989). Although neoclas-
sical economic theory is ultimately indifferent to what motivates a
collector to buy the work, the motive has been almost exclusively con-
cerned with is investment. Indeed, in the many studies that economists
have conducted in order to find out how investing in art compares to
investments in ordinary portfolios consisting of stocks and bonds, the
implicit assumption is that art is a financial asset which functions as a
store of value, and can be resold at a later point in time against a higher
price (for an overview of these studies, see Frey and Eichenberger 1995).
In fact, aesthetic motives only come into these studies as a residue. Upon
discovering that returns on paintings are lower than on other invest-
ments, neoclassical economists have argued that art is bought for other
than just speculative reasons. Since buyers of art, like other economic
agents, are maximizing utility, some other, non-monetary revenue must
have compensated the lower rate of return on their investments in art:
they derive utility from looking at the painting. In this interpretation, the
difference in return between investing in art or in other financial assets
becomes a measure of the aesthetic utility that paintings yield on top of
their monetary returns.[25] As John Picard Stein put it: "Any superior per-
formance derivable from paintings can be attributed entirely to the view-
ing pleasure they provide, not capturable by speculators" (Stein 1977,
p. 1035; Fase 1996).

Art dealers, however, do care about the motives of collectors, since
they may affect the future biography of artworks; they make a distinction
between collectors who buy for the "right" and those who buy for the
"wrong" reasons. Collectors who buy for the right reasons are those who
claim to be motivated by love for art, and who act accordingly. They
think about art as an "intellectual pursuit"; they have "dialogues" with
the work, want to get together with the artist, and follow the gallery in
its artistic choices; they travel to openings of shows in which the artist is
represented and have an interest in the artist's career. Moreover, these col-
lectors are willing to buy work that is difficult to commodify such as
installations. What is crucial for art dealers is that the collectors do not
consider reselling the works they have bought, even when such a resale
would be profitable. In the United States, collectors who buy for the right
reasons ideally donate (part of their collection) to museums, or, in a rare
case, fund a museum of their own. Such donations, like direct sales to
museums, are attractive because of the credibility or legitimacy they lend
to an artist's oeuvre as well as to the gallery itself; indeed, for artists and
collectors, the number of works that they either directly or indirectly
manage to sell to museums is a source of status. Another reason for art
galleries to be pleased with collectors who donate work to museums is
that the work of art, once part of a museum collection, becomes, in the

words of the anthropologist Igor Kopytoff, a "terminal commodity": unless the museum decides to deaccession the work, which happens only rarely, it will never enter a commodity phase again (Kopytoff 1986, p. 75; Thompson 1979).[26]

By contrast, the wrong reasons for buying art are reasons that have to do with investment, speculation, status, or, to a lesser degree, decoration. Both in the hands of status seekers who see the price as something admirable about the work, and in the hands of speculators, the artwork fails to get rid of its commodity character after leaving the commodity phase. This is deplored by dealers, since they "want the work to function properly, to provide a good context for it, and to prevent it from becoming an object of financial speculation (. . .), from getting in touch with money again," as a Dutch dealer phrased it (NL11). Says another dealer: "You can tell a speculator very quickly. (. . .) Just the kind of questions they ask, and what they ask for. It is almost like they are wearing a sign. A speculator would come, and look at your gallery program, and ask for the two things that are most sure to increase in value. (. . .) When we see each other, they know exactly what I think of them, and they know they cannot buy here, no matter what they want to buy" (US16). Renee Steenbergen has shown in her dissertation about Dutch collectors of contemporary art that collectors among themselves make a similar distinction between buying for the right and buying for the wrong reasons; buying art for profit is explicitly condemned among collectors. One of Steenbergen's respondents compared a collector who sells an artwork to a husband who ditches his wife. The only legitimate reason to sell is to "upgrade" the collection or to generate resources that can subsequently be used to buy work by young, emerging artists who are in need of support (Steenbergen 2002). In short, whereas economists assume that acquisition motives are irrelevant, dealers as well as collectors seem to care a lot about these motives. Of course, the extent to which these discursive distinctions can be enacted in practice depends among others on material circumstances; in case of excess demand for an artist's work, an art dealer can permit himself to be more selective about customers than in weak financial times.

The reasons why dealers are so concerned about the motives of collectors is summarized as follows by an Amsterdam dealer I interviewed: "I believe it is important to place the work well—it is like putting your kid in the right hands, or if you have a pet and you place it with a good person" (US13). In fact, some works of art will long remain within sight of the dealer as well as the artist, who both try to keep track of them meticulously even after the first gallery sale. This is made easier when the works circulate within an arts community of which the artist herself is a part. Dinner parties organized by the dealer or a collector as well as the

numerous other social occasions where a select company of artists and their patrons meet, cancel out the alienation of an artist from his work to some degree. When Michel Callon argues that "to transform something into a commodity, and two agents into a seller and a consumer, it is necessary to cut the ties between the thing and the (. . .) human beings," this does not seem to hold on the art market. When an art work is sold, it is only partially decontextualized, dissociated, detached, and disentangled from its maker (Callon 1998, p. 19; Thomas 1991). Frequently the artwork remains entangled with the dealer who sold it and the artist who made it. In fact, by seeking to be in contact with the artists whose work they bought, collectors who buy "for the right reasons" actively re-entangle these works with their makers.[27]

THE DIGNITY OF SELLING TRADITIONAL ART

An opposition between art and commerce does not just structure the avant-garde art gallery internally; it also structures the art market in its entirety. As Bourdieu and others have noted, the art market is characterized by an opposition between an avant-garde and a traditional circuit. More than just profits are at stake in this opposition. Ultimately, Bourdieu argues, it coincides with an opposition between two social classes, between the dominated and the dominant fractions of the dominant class: those with cultural power but less economic wealth are affiliated with the avant-garde circuit, while those with economic power but less cultural wealth are affiliated with the traditional circuit. In other words, a class conflict between two fractions of the dominating social class is transfigured in the form of a "conflict between two aesthetics" (Bourdieu 1993, pp. 101–2). What distinguishes the two circuits, however, is not just the type of art that is sold, or the disparate amount of institutional recognition that artists and their dealers receive from well-known museums, national newspapers, or major art magazines, or the social background of the members of each, but also the business repertoire of either circuit.

Contrasting with the covert location of galleries in the avant-garde circuit, the most prestigious galleries in the traditional circuit are located in wealthy tourist towns or in fashionable urban areas such as Beverly Hills, Palm Beach, and Santa Fe. In the New York art world of the 1990s, these galleries established themselves firmly in SoHo, in between expensive furniture stores and exclusive designer boutiques. They filled up the spaces that galleries active in the avant-garde circuit left when these moved north to Chelsea. Their Amsterdam counterparts are heavily concentrated in streets close to the Museum Quarter, where they intermingle

with exclusive antique stores. For people who are not "insiders" to the art world, these locations make the galleries more easily accessible. The less consecrated and less expensive versions of these businesses, which often rely on selling frames and posters as their major source of revenue, settle for shopping streets throughout Amsterdam; in the United States, they are also found amidst other retail stores in shopping malls (cf. Fitz Gibbon 1987, p. 113).[28]

Gallery spaces in the traditional circuit tend to be dimly lit. They have lush carpets, or shiny, polished wooden floors, and a comfortable chair or couch to flip through expensive-looking catalogues; prices are displayed next to the works of art, or a price list is available at the entrance of the gallery. The almost invariably transparent shop window of the gallery contains an attractive artwork, which may serve as a test case for what catches the attention of passers-by. In SoHo, many dealers leave their doors open in order to make clear that all visitors, not just insiders, are welcome. With classical music or Muzak playing in the background, they resemble other retail stores more closely than museum spaces. Says Martin Blinder, director of a chain of art retail spaces in the United States that operates at the lower end of the art market: "Our galleries are very invit-

Storefront of traditional gallery Elisabeth Den Bieman de Haas in Amsterdam. Photo: author.

Storefront of avant-garde gallery Paul Andriesse in Amsterdam. Photo: author.

ing places. If nothing else, they provide a respite from a busy shopping day."[29] The gallery personnel are well dressed and pay attention to customers entering the gallery; men may combine their immaculate suits with artistic details like a risqué tie, symbolizing the values of customer-friendliness and artistry at the same time. The tone of conversation is mild, while the stateliness of the gallery owner may be underscored by a pretentious accent. Promotion is accomplished by informative, persuasive advertising, glossy information leaflets, and, in some cases, special promotional offers.

Often the galleries on the traditional circuit do not represent a small number of artists exclusively. Instead of organizing solo shows, they may have exhibitions with an eclectic, wide variety of works in different media, subject matters, and styles. This enables customers to browse through different types of art, rather than coming to grips with one single oeuvre. Sometimes the gallery has an electronic database that is searchable for artworks with the help of criteria like the name of the artist, the size of the work, the subject matter, and the price. Just as on the avant-garde circuit, no homogeneity exists in the type of work that is offered for sale. In terms of visual characteristics, the artwork tends to build on traditional genres like landscape, portrait, or still life (cf. Moulin 1967 [1987],

p. 26). Almost always figurative, the style ranges from seventeenth-century realism, to impressionism and expressionism (Fitz Gibbon 1987). Some of the artists that are represented have a following of their own, and sell their work for four-digit prices. Apart from original works of art, dealers on this circuit may also sell prints made in edition sizes of 50, 100, or 200, enabling people to own a work of art without paying the concomitant price.

Both in the United States and in the Netherlands, the non-consecrated fraction of the traditional circuit—the lowest end of the art market when it comes to both prices and recognition—is well organized. Trade organizations exist which publish their own trade magazine; annual or semi-annual trade fairs take place where retailers can buy prints as well as posters, postcards, and frames from wholesalers or publishing firms that often operate internationally; the work that is sold ranges in wholesale price between €50 and €1,000. At these trade fairs, salespeople make an aggressive effort to sell their merchandise to retailers and to bulk buyers such as restaurant and hotel chains, treating the works they offer for sale as ordinary commodities. Wholesale traders openly call work "commercially interesting" and recommend specific works as "easy to sell for retailers." In the case of originals, which seem to constitute the minor part of their trade, the artworks they offer for sale have been made "by the dozen" (Moulin 1992, p. 34); the studios where these types of paintings are made employ several artists, whose joint annual output can be several thousands of paintings. The production of these works is often located in countries such as China, where artists can be found who not only have traditional skills, but are also willing to work for relatively low wages. The production process is highly rationalized: each painter may have his own specialization and make ten or more paintings of the same kind a day; or several painters might work together on one series of identical paintings subject to a strict division of labor in order to increase labor productivity, one of them focusing on painting the background, another on the scenery, and so on (Moulin 1992, p. 37).

Competition on the wholesale market for art is largely based on price; quality concerns are almost completely absent in the sales rhetoric of this market. Indeed, one immaculately dressed salesman, with whom I interacted as a participant observer, admitted bluntly that "I would not want to have the majority of this art in my own house." Prices and market conditions are frequently mentioned in conversations, for instance in order for the dealers to distinguish themselves from competitors. In an attempt to persuade a retailer to buy wares from him, I overheard a wholesaler emphasize time and again how strong the retail market for art was at that moment. For the wholesale market, however, times were more difficult, since "competition from Taiwan is fierce" (NL18).

Retailers within this non-consecrated fraction of the traditional circuit tend to have unassuming spaces. Their main source of income is usually the business of framing works of art, photographs, and prints that customers bring themselves; they supplement this income with the sale of prints as well as original paintings. If not bought at the wholesale market, these originals are often made by local artists who, apart from some attention in the local press, have careers that go by and large unrecognized.[30]

The sales rhetoric that is used on the traditional circuit is highly ambivalent. Apparently not just dealers on the avant-garde circuit, as Bourdieu argues, but also traditional art dealers constantly walk a "tight-rope," as Heather Fitz Gibbon calls it in one of the rare studies of this circuit, between catering to the demand of the public and maintaining the aura of unique, individually created artworks (Fitz Gibbon 1987, pp. 122–23). On the one hand, their sales rhetoric draws on mundane arguments: they claim that the work is a bargain, that it has a high decorative value, and point out which artists are "investment-worthy." As an announcement for a show at a Dutch gallery in this circuit reads: "The art investment world is currently highly interested in the work of [this artist] because of the favorable quality price ratio, and the expectations for the future." In spite of such claims, however, this investment value is questionable, since a secondary or resale market often does not come into being for the work of artists sold on this circuit. Auction houses are either unwilling to put them up for sale, or if they do, these works only raise a fraction of the original retail price.[31]

On the other hand, dealers on the traditional circuit incessantly invoke artistic values like "originality," "craftsmanship," and "unbridled creativity" when making sales. The painters whose work they sell command an "almost flawless artistic intuition," resulting in paintings which offer "emotional and spiritual stimulation." Dealers emphasize that the authenticity of the works they sell is "unconditionally guaranteed," and do not fail to prove that by means of a certificate. They draw up biographies of artists which mention that the creator is "as refreshing and spirited as his paintings," that he "communicates the nobler side of man's endeavors and issues a call to humanity, challenging us to recognize truths that are universal to all creation—whether it be organic or geologic in nature," or that he is a "deliberate provider of perspective on our modern lives."[32] These biographies also connect the artist's work to masters in the history of art like Cézanne, Van Gogh, and Rodin, who are said to have served as a source of inspiration. To further lend value to the art that is exchanged, this circuit has given rise to its own legitimating institutions, which insure that artists have a museum record of their own, are internationally acclaimed, see their work represented in major

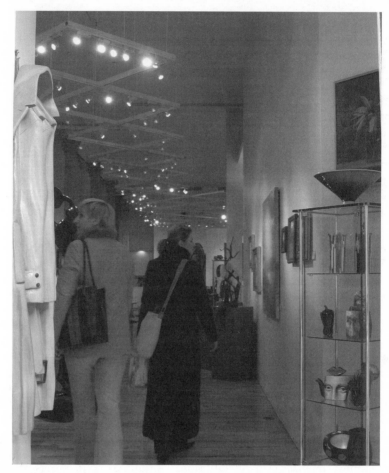

Shoppers at a traditional gallery in SoHo, New York. Photo: author.

collections, and have received "prestigious prizes" (cf. Fitz Gibbon 1987, p. 115).[33] Prints in large editions by modern masters like Chagall, Dali, Miro, and Picasso, which the gallery offers for sale, are supposed to lend further credibility to the program of the gallery.

Art dealers within this circuit negotiate their apparent commercial identity by invoking not only artistic values, but also moral ones. In my interviews I encountered a strong discourse of resistance against the avant-garde circuit. Commercial dealers repeatedly accused their avant-garde colleagues of arrogance and snobbery, claimed that the avant-garde definition of art and quality is narrow-minded and artificial, and brought out their own straightforwardness and honesty. In order to enact these moral values, some dealers within the traditional circuit present them-

selves as missionaries who make art accessible to a wide audience. They state that they explicitly reject the cold, hostile atmosphere of gallery spaces of the avant-garde circuit, and instead like to give people a warm introduction into the world of the arts. With respect to taste, dealers in the traditional circuit see a virtue in selling pictures that can be appreciated and comprehended with an untrained eye, without anybody telling the viewer, as one dealer put it, "if it is good, what it means, or why it is significant" (us19). Or as another dealer put it in an interview with the magazine *American Artist*: "[w]e use simple language here, and we don't try to impress anybody with our vast knowledge of art history. My employees and I simply love paintings."[34]

My findings suggest that the art market is structured not just along a commercial and an artistic axis, but also along a moral one: whereas dealers on the avant-garde circuit seek to monopolize an aristocratic notion of artistic worth, their colleagues within the traditional circuit invoke a notion of moral worth. In that respect, my findings resemble those of Michèle Lamont in her study of working-class people entitled *The Dignity of Working Men*. Lamont found that members of the working class distance themselves from the upper classes by means of moral standards. In their perception, the upper classes lack integrity and straightforwardness (Lamont 2000). Likewise, the traditional dealers I interviewed claim that there is a dignity in promoting art for above the couch.

CONCLUSION

In order to come to an understanding of everyday commercial practices on the market for contemporary art, it does not make sense to reduce this market to an ordinary retail market, where action is governed by a capitalist logic exclusively. Likewise, one misses the point by endorsing compartmentalized views of society that see art and commerce as entirely separate worlds. Although such views have flourished in social science during the twentieth century, it is now time to acknowledge that reality is more complex than compartmentalized models of society allow for. Indeed, what makes the art market an interesting case from a sociological point of view is exactly that it is a site where two contradictory logics, those of the art world and of the economy, conflict. In their everyday economic life, dealers not only need to match supply and demand, they also have to mediate two contradictory logics.

The upshot of this chapter is that it is too simple to equate a work of art in capitalist society with a commodity (cf. Huyssen 1986, p. 151). As Fred Myers has argued in his discussion of the way aboriginal art has circulated in different regimes of value, artistic meanings and values may

become temporarily subordinated once a work is in the commodity phase, but that does not mean these meanings and values are erased entirely (Myers 2002, p. 331). And if commodification is a solid, discrete category for those who endorse Hostile Worlds points of view, my findings suggests that the question *how* art is commodified deserves at least as much attention as the question *whether* it is commodified. The highly ritualized way in which contemporary art is marketed is not just a matter of cultural camouflage, it is the heart of what the art market is actually about. Therefore it makes sense to study how dealers talk when they conduct business, how they represent themselves, how they try to legitimize their own action, or how they market art. To put it in fashionable terms: when marketing art, dealers are simultaneously making meaning. To study these meanings I have supplemented Bourdieu's structural account of the field of cultural production with a symbolic reading.

Like Bourdieu, I have distinguished an avant-garde and a traditional circuit within the market. Both circuits do not (or not only) differ in economic respects such as profits and prices, or in the wider societal stratification that the opposition between the two circuits makes manifest, but also in the different business cultures that flourish in each of them: the marketing repertoire that dealers rely on differs significantly between the two circuits. Dealers in the traditional circuit present themselves as missionaries who aim at making art accessible to a large, non-elite public; they derive a sense of identity by distinguishing themselves from the "snobbery" of the avant-garde circuit (cf. Lamont and Molnar 2002), and find a dignity in selling artworks which members of the avant-garde circuit think of as kitsch. Dealers within the avant-garde circuit, by contrast, seek to suppress the commodity character of contemporary art. For them it is illegitimate, as a young dealer phrased it, to do business like "used car salesmen showing Basquiat and Warhol all the time, from stock" (us6). In order to separate art from commerce, these dealers divide the front and the back of the gallery architecturally. Whereas the front rooms are constructed as an exhibition space, the back rooms function as the commercial nerve center of the gallery. The opposition between the sacred and the profane thus does not inhibit the marketing of art, but is incorporated within the very marketing apparatus.

Exchanging Meaning

VINCENT AND HIS BROTHER

During his lifetime, Vincent van Gogh hardly sold a single painting. Unable to support himself with his art, and unwilling to let sidelines keep him from his work, Van Gogh was fortunate to have a brother who supported him generously. From the early 1880s, when Van Gogh started to focus on his art fanatically, until his death in 1890, Theo van Gogh sent his brother amounts such as 50, 100, or 200 French francs once or twice a month. The character of these monetary transfers seems straightforward at first sight: they were *gifts* from Theo, who made a decent living as an assistant at the famous Parisian art dealership Goupil, to his older, unmistakably destitute brother.[1] These gifts being an expression of brotherly care, no reason seemed to exist to reciprocate. Vincent apparently felt comfortable asking for the money when he needed more, or when Theo delayed his payments. By writing his brother sentences like "Thanks for your letter and the enclosed fifty franc note," which he repeatedly did, the issue seemed to be settled.[2] Indeed, to date, the majority of artists manage to continue making their art with the financial support of a spouse, kin, or intimate friends (see Abbing 2002). Together they are the small-time successors of yesteryear's illustrious patrons of the arts.

However, from the many letters that Van Gogh wrote to his brother, a more complicated picture arises. The monetary transfers were a frequent, often heated subject of dispute between the two brothers. This led Van Gogh to define and redefine the monetary transfers that he received from his brother on a number of occasions. First of all, he certainly did not conceive of them as voluntary gifts that need not be reciprocated. Instead, Van Gogh was aware of the debt he was accumulating with his brother, and of the possibility that this debt would have spillovers to the personal domain (letter no. 360; Van Gogh 1980, p. 229); judging from his letters, the more money he received, the more guilty and dependent he felt. The gifts even restrained him in his private life. This became apparent for instance when Vincent took good care of a prostitute during his stay in The Hague in 1883, and Theo, disapproving of this seemingly promiscuous relationship, asked him to break it off. In anger, Vincent wrote in a letter that "the rein of money is drawn in to let me feel that it 'is in my own interest' to conform to your opinion" (letter no. 358, p. 233).

In a letter he sent from the Dutch village Nuenen to his brother in Paris on February 1, 1884, Vincent decided that the debt, as he alluded to it, could not be allowed to increase any further. Therefore he proposed that Theo would start buying his work and insisted that "I can consider the money I will receive from you after March, as money that I earned myself" (letter no. 360, p. 229). Although the actual transactions hardly changed (Van Gogh had sent his brother drawings in the past as well), Vincent redefined the meaning of the monetary transfer from a *gift* into a *compensation:* he proposed to conduct a market exchange with his brother. Theo would now compensate Vincent's efforts by paying a price for the artworks he obtained.[3]

Early in 1886, when Theo postponed his payments briefly because of his own financial obligations to some creditors, Vincent responded with outrage. Another redefinition took place of the monetary transfer's meaning. Vincent now perceived the money neither as a gift nor as a compensation, but as an *entitlement.* Theo not only owed money to creditors but also to him, Vincent wrote. And the difference between him and the creditors was that he was a friend as well. Vincent continued his tirade as follows: "do you have a good understanding of how demanding the work is everyday, how difficult it is to arrange models, and how expensive the things that are necessary for painting? (...) And that I *have to* paint, that too much depends on continuing to work here with aplomb, immediately and without doubt" (letter no. 443, pp. 310–11; emphasis in original). Thus Van Gogh claimed the right to receive payments for his artistic efforts, without regard to the economic value of his output or to the financial situation of his brother.[4]

Soon afterwards Theo resumed his payments, and Vincent's anger disappeared. The final redefinition happened in 1888. This time Vincent flattered Theo by arguing that the money he gave to him and other modern painters (on an incidental basis, for instance, Theo also supported Vincent's friend and at times idol Gauguin) turned him into a fellow artist or co-producer more than just a financier: "I wish I could manage to make you really understand that when you give money to artists, you are yourself doing an artist's work, and that I only want my pictures to be of such a quality that you will not be too dissatisfied with *your* work" (letter no. 550, Rewald 1973 [1986], p. 32; emphasis in original). Now the same monetary transfer was defined as a productive act, and Vincent underlined this definition by speaking of "we" when discussing the artistic advancements he had made himself. Indeed, inspired by his relationship with his brother, Vincent dreamed in the same letter of reforming the trade in art, so that "the dealer will join hands with the artist, the one for what one may call the housekeeping side, to provide the studio, food, paint, etc., the other to create" (letter no. 550).

FATHER RELATIONSHIPS

When it comes to the social relationships that govern the exchange of art-works, artists, dealers, and collectors on the art market act no differently than Van Gogh. Modern dealers, from their emergence in nineteenth-century France onwards, saw themselves and were seen as patrons, who thought it was their duty to assume responsibility for their artists and to provide them with support, recognition, and praise.[5] Nowadays, rela-tionships between dealers and artists still hardly look like the anonymous interaction that has come to be associated with a logic of capitalist markets. Non-economist observers of the interactions between dealers, artists, and collectors as well as these actors themselves invariably stress their social, intimate, and binding character (Klein 1994; Simpson 1981, p. 46). As Arnold Glimcher, founder of the prestigious Pace Gallery in New York, said in an interview with *The New York Times:* "A dealer is a combination of family, friend, banker and baby sitter, besides being a prime interpreter and promoter of the artist's work."[6]

Also in my interviews, metaphors of marriage, family, and community prevailed when dealers described their relationships to artists, collectors, and colleagues. Like Van Gogh, they are permanently defining and redefining their manifold exchange relationships as well as the concomi-tant meanings that the economic transactions they engage in generate. Many dealers claimed that economic issues should never dominate these relationships. Their desire to present themselves as patrons often super-seded their pride in their role as merciless gatekeepers to the art world. Indeed, art dealers claimed that making good art is in the end not a suffi-cient condition for them to start a long-term engagement with an artist; they also have to get along on a personal level, and trust each other. In order to build such trust relationships, some dealers keep day-to-day con-tact with the artists they represent, spend hours with them on the phone, and visit them regularly even when these artists are living abroad. Depending on their character, artists may ask not only for practical assis-tance and business advice, but also moral support and input in their artistic endeavors.

The way dealers go about adding a new artist to their gallery resembles courting rituals more than business negotiations. Rather than viewing slides that anonymous artists send them, or looking at work that artists bring to their galleries, they rely primarily on introductions, referrals, and recommendations, often by artists that they already represent, and sometimes by other members of the art world whose taste they trust. Cautiously, they start talking to an artist, paying a visit to his studio, and including a work by him in a group show. They consult friends about the

Art dealer Ronald Feldman and artist Hannah Wilke. Photo: Peggy Jarrell Kaplan (1975). Courtesy Ronald Feldman Fine Arts, New York.

artist, and follow her work whenever it is exhibited. Only when both the dealer and the artist feel confident about the relationship that they have developed do they proceed to discussing the terms on which the gallery might represent the artist. Often, one of these terms is exclusive representation; the relationship between an artist and a gallery is in those cases supposed to be monogamous. As Andras Szántó notes, some galleries deliberately choose to represent artists that have affinities with each other because of demographic traits, personal attachments, and aesthetic agendas (Szántó 1996, p. 4). Indeed, throughout history, the artists that a gallery represents have become friends, sharing considerable leisure time together, either inside of the gallery or outside of it.

This does not mean that artists, especially in the beginning of their career, do not complain about the dealer's (lack of) efforts to promote their work, or about the size of the cut he takes from gallery sales. In fact, the history of the modern art market knows many examples of relationships between artists and dealers that have gone astray, to put it mildly. For instance, when art dealer Pierre Matisse, son of the Fauve painter Henri Matisse, feared that the Spanish painter Joan Miro had tried to find a new dealer, he warned Miro in a letter: "I am too well aware of the savagery of the art trade and of the people who are apparently close to

you. If it comes to competition, you will be surprised to know how many Miros I still have. The only way to defend myself—and I shall resort to it, if necessary—will have a disastrous effect upon the market" (Russell 1999, p. 271). Matisse was threatening to flood the market with works by Miro, which would have a negative, harmful price effect. The French painter Jean Dubuffet, who also did business with Matisse, discovered after a long time that Matisse had only sold 100 of his works to collectors, even though Dubuffet had sold more than 500 works to Matisse himself. The artist reacted with outrage to the fact that a large part of his oeuvre was still owned by Matisse. Matisse, however, argued that he had paid for the works, so that they were his own property, which nobody could interfere with (Russell 1999, pp. 283, 295). On numerous occasions, other artists have likewise spoken in a hardly friendly way about their dealers, claiming that the interests of the dealer ultimately lies with the client, not with the artist, and with money, not with art. Even in these cases, however, they have underscored the friendship logic that underlies their business relationship in the art world by expressing their dissatisfaction in terms like "neglect" or "abandonment" by their dealers.

The intimate nature of ties between artists and dealers is paradoxically revealed when these ties are dissolved: if the start of an artist-dealer relationship resembles courtship rituals, its end resembles a divorce. The reasons for such a divorce may be diverse: in slack seasons, galleries may want to terminate their relationship with an artist because her work continuously fails to meet its commercial expectations, whereas in good days, an artist may let herself be seduced by another gallery who is willing to represent her under more favorable conditions such as higher prices, advances against sales, or the potential of more sales to museums. Also, an artist may have the feeling that a dealer does not do enough work for him, that the dealer does not possess the contacts that help the artist get critical acclaim, or that the artist's work no longer fits into the artistic program of the gallery.

Sometimes, as in a friendship, the ending of a artist-gallery relationship is a gradual process, in which an artist is not invited for a long time to exhibit at the gallery, and has to assume that the business relationship is over. Such a termination may manifest itself symbolically when the artist decides or is invited to pick up art at the gallery which was consigned but has never been sold. At other times, however, when either the artist or the gallery decides to terminate the relationship unexpectedly and one-sidedly, this tends to be remembered as an emotional, painful experience, not unlike a nasty divorce. Some galleries that have a reputation for discovering artists and nurturing their careers find that other, more powerful but less adventurous galleries try to seduce their artists away from them once they are successful (cf. Coppet and Jones 2002, p. 395). In

general, then, what looks from the outside as a division of labor between so called discoverer and exploiter galleries, may from the inside be perceived as interference in a "happy marriage," which results in disappointment and anger. It may lead members of the arts community to snub the artist for being overtly motivated by financial concerns, and for not paying respect to the dealer whose hand fed him. Conversely, it may create respect for an artist who refuses offers from more powerful galleries, and who stays with the gallery where her career got started. Also, some dealers I interviewed distance themselves from deliberate interference in the relationship between other dealers and their artists. Although they do not deny that they are always looking around for emerging artists, these dealers claim not to "buy" artists away, and to only make an attempt when the other dealer involved is not a friend, and when they know that the artist is dissatisfied with the way he is represented by that dealer.[7]

Although their discourse with respect to collectors had a less emotional character, the dealers I interviewed refused to simply characterize them as business clients. Instead, dealers considered some collectors as supporters of the gallery, others as friends, followers, or as people who had confided in them. They emphasized that theirs is not a walk-in trade, which means that sales made to people who they do not know yet are the exception rather than the rule. The prevalence of intimate ties between dealers, collectors, and artists is not restricted to the discursive level, but is also enacted in the exchange of gifts of all sorts, from material goods to nonmaterial favors, in the avoidance of business contracts, and in the way seemingly *quid pro quo* transactions are framed. Many dealers furthermore underscore the fluidity between their private and commercial life, by on the one hand buying works from the shows they host for their private art collection, and on the other hand selling works from this private collection to their clients.

ENLIGHTENED SELF-INTEREST

From a Hostile Worlds point of view, this use of family and romance metaphors is remarkable. Scholars as diverse as creative writing professor Lewis Hyde, cultural economist Arjo Klamer, or critical art historian Paul Wood have argued that the *quid pro quo* of a market transaction in art has destructive effects. Their arguments, like those of many anthropologists, are founded on a sharp distinction between market exchange of commodities and gift exchange of cultural goods. Adopting the assumptions of neoclassical economics, these adherents of a Hostile Worlds model see market exchange as anonymous, transient, and impersonal. Market agents buy and sell commodities as "impersonal bundles of use value and

exchange value," without attaching themselves to the objects they trade or committing themselves to the persons they deal with (Carrier 1995, p. 18). On the basis of this notion of commodification, Hyde concludes that "it may be possible to destroy a work of art by converting it into a pure commodity" (Hyde 1983, p. xiii). For critics like Klamer, the explicit monetary measurement of value, which market exchange presupposes, corrodes the artistic experience (Klamer 1996).

In order to protect artists and artworks against the detrimental effects of such *quid pro quo* exchange, Hostile Worlds adherents propose to transfer artworks by means of gifts. Indeed, Hyde's starting point is that the making of art and gift exchange are so strongly intertwined, that there can be no art where there is no gift: artistic activity contains the spirit of the gift by definition (Hyde 1983, p. xiii). The attractiveness for these scholars of gift over market transactions resides in the idea that gifts prevent adversary relationships and antagonistic sentiments from coming into being. Gift exchange replaces the presupposed anonymity of market exchange with a moral transaction that brings about enduring personal relationships. Artists and artworks flourish in such a setting, since the gift would not lead to commodification, alienation, and the disentanglement of the artwork from its maker (Wood 1996). In other words, gift exchange respects the inalienability of art without removing artworks from societal traffic altogether. Coming from an Aristotelian perspective, Klamer furthermore argues that reciprocal gift transactions do justice to the essential nature of art because they circumvent measurement and commensuration, and provide "roundabout ways of financing the costs of producing the good" (Klamer 1996, p. 24).[8]

Neoclassical economists have likewise presupposed that market exchange is anonymous, with the crucial difference that their normative assessment of this state of affairs is the very opposite of Hostile Worlds views. If individual agents are perfectly informed about the conditions of exchange, and markets are populated by sufficiently large numbers of price-taking agents, there is no need for enduring social ties, trust relationships, or sociability. Reasoning from the assumption that individual agents try to maximize profits, goods are sold to buyers with the highest willingness to pay, no matter what social ties they have to the seller (Hirschman 1982 [1986], pp. 122–23; Portes 1995, p. 3).[9] In fact, if the accounts of dealers are truthful, this would imply that the art market is highly inefficient: if artworks are not sold on a regular basis to buyers with the highest willingness to pay, but instead to friends, this means that scarce resources are not allocated optimally. The detrimental effect of social ties on the efficiency of the market will be even larger if they are accompanied by gift exchange. In that case, consumption choices are made

for the consumer rather than *by* him. This type of exchange is inefficient, as Joel Waldfogel wrote in an article with the ominous title "The Dead-weight Loss of Christmas," since the allocative decisions made by the gift giver are not likely to match the preferences of the receiver: the receiver gets stuck with an object that does not satisfy his desires optimally. If the gift would have been in cash rather than in kind, the receiver would most certainly allocate the money differently. Thus gift exchange results in foregone utility, which economists call a *deadweight loss* (Waldfogel 1993, p. 1328).[10]

In spite of this bias against gifts, it is possible to make sense of them from a neoclassical economic perspective. Within a Nothing But model of the market, one reason why family and romance metaphors are used to characterize social relationships between dealers, artists, and collectors, why contracts are avoided, and so many gifts are exchanged, has to do with so-called "enlightened self-interest": according to this type of reasoning, which some economists but also an increasing number of sociologists have endorsed, social relationships have instrumental, economic value and enhance rather than impede efficiency (Fukuyama 1995, p. 26; Kollock 1994). Nobel Prize winner George Akerlof, for instance, has provided an economic explanation for gift exchange on labor markets with the help of the notion of implicit contracts: when employers do their workers a favor by paying them more than the market wage dictates, it is likely that workers will return these gifts in disguise by working harder and producing more than the minimum work standard demands (Akerlof 1982). Another property of gift exchange is that it functions as a cement of social relationships on the market. These relationships, in turn, are crucial in a situation of uncertainty or in case relevant information about the transaction is asymmetrically distributed over transaction partners; in such a situation, trust relationships may enhance rather than corrode efficiency. They serve as a less costly, more efficient alternative to contracts (see Caves 2000).

Let me explain in detail how this argument can be applied to the art market. Economic relationships between artists and dealers can take three forms: first of all, dealers can employ artists to make their work. In the history of art, for instance, artists have long worked at courts (Warnke 1985 [1993]). Also, art dealers in the sixteenth and seventeenth centuries would sometimes employ painters to make copies of a popular original owned by the dealer himself (De Marchi and Miegroet 1996). Nowadays, employment relationships are only found on the lower end of the art market, where paintings are produced in a rationalized way. Employed by art gallery chains or art wholesalers, artists produce artworks in semi-mass production for the traditional circuit discussed in the previous chapter (see Fitz Gibbon 1987).[11] Secondly, dealers can purchase artworks directly from artists, and sell them at a price, moment, and under

conditions of their own discretion. This model was common in the late nineteenth and early twentieth-century France. Art dealers like Paul Durand-Ruel or Ambroise Vollard would try to negotiate exclusive contracts with artists, which gave them the right to buy their entire output in a certain time period (cf. Jensen 1994, p. 52; Gee 1981). These contracts effectively turned dealers into monopolists with respect to the artist's oeuvre. They held the artworks in inventory until they managed to find a buyer, which in some cases lasted several decades. When the New York scene for contemporary art galleries emerged in the 1940s and 1950s, some dealers tried to imitate this system of direct acquisitions; however, the French system, as it is referred to, was by and large abandoned, due to limited financial resources of postwar art dealers, in Amsterdam as well as in New York (Lerner and Bresler 1998, p. 4; Robson 1995, pp. 101–2).[12]

By far the most common economic arrangements between artists and dealers are consignments: the artist consigns his artworks to a dealer, who exhibits them either in a solo or a group show, and meanwhile tries to sell them. If a work is sold, the proceeds are divided according to a predetermined ratio; if works remain unsold, the dealer can keep them in her inventory, without transfer of property rights, or the artist can take the work back. From an economic perspective, these consignment relationships are in the interest of dealers because risks are shared with the artist, which is crucial, given the uncertain economic value of contemporary art. A second advantage of consignments is that the capital intensity of the dealer's enterprise remains low: since she does not buy works from the artist, she does not need to tie up capital in the inventory.

A major disadvantage of consignment relationships is, however, that the dealer has to make investments that are specific to the artist. First of all, she incurs costs when searching for, assessing, and selecting the artist; subsequently, to promote the artist's work she needs to invest in marketing, including publishing catalogues and organizing exhibitions. In case the artist decides to terminate the relationship, the dealer's investments lose their value and need to be considered as so-called sunk costs: they cannot be recovered, and need to be written off (Bonus and Ronte 1997, pp. 113–14; Merryman and Elsen 1979, pp. 142–43). On top of these risky investments, the dealer has no guarantees about the quality and quantity of the future supply of works by the artists she represents. Also, it is difficult to insure that the artist will not sell art to collectors directly from his studio, without giving the dealer a commission.[13] Conversely, an artist faces similar uncertainties and information problems with respect to his dealer. For instance, he does not know if the dealer is selling his work for the price they agreed upon, and if she invests sufficient time and money in promoting his career. Also, the artist has to entrust his precious artworks at least temporarily with the dealer.

Legally binding contracts hardly provide a solution to these fragile commitments. Indeed, although standard contracts exist for consignment relationships, these relationships are often conducted without them. One reason is that many relevant terms cannot be stated in a contract. For instance, an artist cannot be contractually enforced to continue producing valuable works of art in the future. Second, if a contract is written up, it is still difficult for one party to "monitor" the other and to make sure that all terms of the contract are complied with. Third, litigation is expensive in the case of breach of contract and may damage the reputation of the artist, the dealer, or both (cf. Macaulay 1962 [1992]). Transaction costs, as these contractual, monitoring, and litigation costs are referred to, are in other words high in the case of consignments. Finally, although it is likely that an artist can receive financial proceeds in case he successfully sues a dealer, in the opposite case this is questionable, given the lower average income of artists (cf. Merryman and Elsen 1979, p. 138).[14]

In such an uncertain environment of so-called asset-specificity of investments, asymmetric information, and high transaction costs, trust relationships, loyalty, and gentleman's agreements are a viable alternative to contracts (Moulin 1967 [1987], p. 115; Plattner 1996, p. 194). Thus, from an enlightened economic perspective, it is understandable why dealers and artists represent their relationships by means of socially powerful metaphors such as family and marriage. As Richard Caves summarizes the economic argument: "The infeasibility of explicit contracting leads the parties into the language of moral obligation, with reputation the insurance of reasonable performance in the absence of legally binding obligations" (Caves 2000, p. 41). What looks like benevolence and sociability can in other words be understood as self-interested, economizing behavior (see Davis 1992 for a critique of such reasoning).[15]

Although it cannot be denied that the social fabric of the market and its texture of gift exchange have economic meanings, the "enlightened self-interest" argument has four pitfalls. First of all, it does not answer how this social fabric comes into being, and how it is maintained; instead, the functionalist undertone is that economic relationships arise at the moment that they enhance the efficient functioning of the market. In particular, the causal direction from economic need to social outcome is privileged, while the opposite direction is denied. However, it is easy to imagine not only that the fragility of economic exchange requires intimate ties but also that the intimacy of these ties dictates the form of exchange between artists and their dealers. As New York art dealer Leo Castelli put it: since there is "a family situation at my gallery (. . .) contracts are not worth the paper they're written on" (Merryman and Elsen 1979, p. 137). Secondly, the "enlightened self-interest" argument does

not recognize that the social fabric of the art market may have other meanings that just an economic one. Identical economic arrangements, whether consignments, *quid pro quo* acquisitions, stipends, or discounting schemes, may end up having different meanings due to the timing of these arrangements and the way actors frame them. Third, not only do gifts serve a functional purpose of strengthening the social fabric of the art market, they also symbolize intimate relationships. For instance, as I will show in the remainder of this chapter, gifts enable actors to differentiate the social ties they have (cf. Zelizer 2000a, p. 819). As markers of relationships, they enable transaction partners to signal the strength of ties to each other, and enable them to come to a common understanding of these ties (Cheal 1988, p. 91). At the same time, gift exchange has a performative quality: it not only marks a social relationship, but can reinforce or even create one. Therefore, gifts need to be appropriate to the mutual perception of a social relationship; a bouquet of roses given by a businessman to one of his female clients is likely to generate different meanings than a leather briefcase (cf. Davis 1992, p. 41). Rich, contextual knowledge is in other words needed to insure that gifts have their intended meaning. Fourth, the predictions that the "self-interest" argument provides are disproved by reality. For instance, it predicts that dealers only acquire works directly from an artist if the economic value of the artworks is firmly established (Caves 2000); in such a case, there is no need for trust, since the uncertainty of consignment relationships is replaced with a *quid pro quo* exchange. In my fieldwork I discovered, however, that some dealers buy a work from an artist every now and then, and that both parties consider these transactions to be highly significant. Conversely, some dealers said that they prefer to work on a consignment basis with all artists, no matter how solid their reputation. How should we understand these transactions?

FRAMING TRANSACTIONS

Meanings of exchange, whether of gifts or commodities, emerge from an intersection of situational circumstances, specific social relationships, and frames which economic actors actively construct. As a result, two identical transactions may generate entirely different meanings. Take the case of market exchange. Cultural economist Hans Abbing has pointed out that an artist, in order to receive payments she is entitled to from her dealer, may have to reframe or redefine these payments as gifts. This means that she has to play the role of the needy artist who is not able to pay her monthly bills, freezes in her studio, and sees her paint turn viscous from cold; by relying on this model, artists allow dealers to play the

desirable role of the benevolent patron who has partial control over the artist's well-being (Abbing 1996, p. 139; Abbing 2002). Apart from being a strategy for an artist to get paid, the dependence of the artist on the dealer is reproduced though the framing of the transaction; it suggests that gift exchange may be about power and inequality as much as about benevolence and sharing. While some experience this as degrading, others deliberately frame market exchange in gift terms. The American artist Chuck Close, for instance, tries to avoid the *quid pro quo* meaning of market transactions, by establishing a cognitive boundary between his own artistic labor, the artworks that leave his studio, and the money he receives in return: "I try to fool myself and make believe that there's no relationship between the pieces I make and the checks that come in. I prefer to think I'm on a stipend or welfare" (Caplin 1989, p. 342).

In the case of direct acquisitions from artists, the antagonistic meaning of a *quid pro quo* exchange can be redefined into its opposite. Anthony d'Offay, for instance, a former leading art dealer located in London, used to express his care and admiration for "his" artists by buying their artworks himself, even though regular gallery sales were made on a consignment basis (Meij 2001, p. 30). Also, direct acquisition can be made in order to support the artist morally and financially.[16] Whereas successful artists are flooded with attention from collectors, curators, and critics, and even need to be protected against an overkill, many others are deprived of such attention. Direct acquisitions help in compensating that situation. Also, when a show is commercially unsuccessful, or an artist is in financial trouble, a dealer may buy a work, or may waive the commission on a work he did manage to sell. Here the timing and the socioeconomic circumstances transform the antagonistic, competitive connotations of market exchange into an act of care and support. These transactions are anomalous from an economic perspective, however, since the prospects for the dealer of reselling such works at a profit are poor. Dealers are expected to avoid such acquisitions out of risk aversion or because of limited financial resources.

In exchange for these gifts, artists can do the dealer favors such as allowing payments to be postponed in case the dealer himself is short of liquidity. Another practice I encountered was the request by a dealer for an artwork in order to compensate the gallery for additional or exceptional expenses which are incurred to promote the artist (cf. Robson 1995, p. 78). Direct measurement of the value of goods and services which the dealer and the artist trade is avoided in this arrangement; also, a time lag is introduced between the transfer of a good or service on the one hand and the compensation for it on the other. As a result, the relationship between artist and dealer is transformed into one of mutual obligation (cf. Carrier 1995). Further, some of my respondents said that

they were eager to buy works from artists they represent once they appear on the secondary market. In that manner, they try to support the price level at auction and to protect the market of an artist. Subsequently, if they managed to resell these secondary market works, they would give the artist a percentage of the resale price on a voluntary basis. These transactions strengthen the relationship between the dealer and the artist: the dealer "protects" the artist's market, while the percentage of the resale which the artist receives has the character of a gift. A Dutch dealer, however, remarked about this practice: "If it makes an artist happy to sell work from his studio every now and then, he should do that. But I have to be content as well, so he will also have to do something for me, so to say. If I get a work every now and then, it is fine. (...) I don't care as much what artists do, as long as I am honored for the fact that I am busy with this gallery every day. (...) It is about doing each other favors. If an artist sells from his studio, and those works re-enter the market, I do not feel responsible to acquire them" (NL11).

Multiple meanings, akin to those of direct acquisitions, arise from the practice of paying artists monthly stipends. Their meanings vary widely, since these stipends are or have been transferred as seemingly benevolent gifts, but also as payments for direct acquisitions and as advances in case the dealer and the artist work on a consignment basis. In late nineteenth- and early twentieth-century France, for instance, when the modern art market came into being, detailed acquisition contracts not only stipulated the number of works a gallery would buy from the artist per time period, but also a monthly or annual stipend the artist would receive in exchange. Thus the primary meaning of these stipends was a competitive one: artists like Picasso, whose work was in high demand, would let several dealers compete over the amount of the stipend before awarding one of them an acquisition contract (Robson 1995, pp. 78–79; White and White 1965, p. 95). However, this competitive meaning was contested and redefined from the outset, when early modern dealers like Paul Durand-Ruel recreated the role of the patron through stipends: if Durand-Ruel did not manage to sell an artist's work, he would nevertheless continue buying from the artist and paying him a stipend. Thus he expressed trust in the artist's future career (White and White 1965, p. 126). Likewise, when stipends were imported into the United States, they were mostly used to provide security for the artist and to generate confidence (Robson 1995, p. 93). By means of these stipends, dealers enacted the role of a patron.

New York art dealer Castelli accentuated this benevolent definition of stipends and presented them as proper gifts. For instance, Robert Rauschenberg and Jasper Johns, two influential pop artists whom Castelli had "discovered" and promoted, received a monthly stipend of

$500 for rent and artist materials (Robson 1995, p. 101); minimalist artists Richard Serra and Donald Judd received monthly stipends for three and fourteen years respectively. Castelli received works in exchange for these stipends, but even when the works of the beneficiaries failed to sell, he continued to support them. Castelli himself claimed that his generosity was an expression of "my faith, my absolute certitude that they were, all of them, great artists." Richard Serra reconfirmed: "It was like getting a Rockefeller grant. (. . .) Leo has always been generous, supportive, intimate and friendly, a throwback to another century." Thus Castelli's role was akin to a nonprofit foundation or a governmental institution, which awards grants and subsidies that need not be reciprocated. In the end, however, the earlier stipends were reciprocated generously when the reputation of most artists that Castelli represented became firmly established, resulting in a sharply rising economic value of the works he managed to sell. Also, as a result of these generous stipends, artists were unlikely to desert his gallery.[17]

Tying artists and dealers together, the social meanings of stipends can be stronger than either party finds desirable. When Monet, for instance, the most successful of the impressionist painters, became dissatisfied with Durand-Ruel's promotional efforts and his repeated long stays abroad, he wanted more freedom to explore other commercial opportunities. Therefore, he asked Durand-Ruel to end the monthly payments and proposed to work on a cash basis instead (Rewald 1973 [1986], p. 27). One of my respondents had objections to stipends comparable to those of Monet, which he worded as follows: "[A system of stipends] is very binding, it is very intense. It is also very hard to discontinue psychologically. (. . .) Ultimately you want to be as close as you can to the artist, but also to leave some distance" (us16).[18] At an anecdotal level, these comments confirm the performative quality of monetary payments: it is not just the case that payment structures symbolize or mark specific social ties; to some extent they also have the effect of creating and shaping them.

SONNABEND V. HALLEY

In the relationship between neo-geo painter Peter Halley and the Sonnabend Gallery, at the time located in SoHo, New York, these very meanings of stipends were disputed wholeheartedly, aggressively, and legally. In the late 1980s and early 1990s a large number of artists left their New York galleries and entered the stables of competitors. Some were looking for better prices and a sound future in the economic turmoil of those days, while others fell prey to their gallery's restructuring policy induced by the crash of the art market (Lerner and Bresler 1998, p. 3).[19]

One of the most controversial and most widely discussed cases was Halley's move from the Sonnabend Gallery to the Gagosian Gallery in February 1992. The Sonnabend Gallery, an established gallery owned by Castelli's former wife Ileana Sonnabend, had represented the artist since 1986 on an exclusive basis. Initially, the young painter of large, colorful geometric paintings was hardly known, but his reputation grew fast in the second half of the 1980s. Like other successful painters in those days, Halley received a monthly stipend. Following the artist's success, the stipend was increased from an initial $12,000 up to, eventually, $40,000 a month. No formal contract had ever been written up between the Sonnabend Gallery and Halley; instead, the relationship was based on the oral agreement that the artist would have biannual exhibitions at the gallery. Proceeds of sales would be split equally between the two parties.

In June 1991, Halley and Sonnabend agreed on a new show for which the artist would make eleven paintings; prices were set in advance at $75,000 each, except for one diptych priced at double the amount. The show, which was initially scheduled for March 1992, was postponed twice at Halley's request; it would eventually open in May. On February 27 of that same year, however, Halley sent a letter to the gallery to let them know he would leave in order to join the Gagosian Gallery. The artist wrote that he wanted to be represented "by a dynamic gallery" that "takes a more activist stance towards the artists it represents." Also, he was troubled by the fact that he did not have a contract with the gallery.[20] Sonnabend, one of the most influential galleries in the postwar New York art scene, could not deny its reputation in that respect. In the 1970s, the artist Jim Dine had left the gallery because of Sonnabend's "byzantine accounting methods." Said Dine: "I never saw a statement. If you asked her for money, she would pull out this wad of bills in every possible currency, and peel off a few." Other artists would follow Dine in subsequent decades.

In early May 1992, Gagosian announced in advertisements that Halley was going to show new work in his gallery from May 16 to June 27. Sonnabend responded by seeking an emergency injunction which would prohibit Halley from doing so; the Sonnabend Gallery proceeded to prevent work from the exhibition being sold; it also sued Halley and the Gagosian Gallery for breach of contract and for damages. The legal case that followed revolved around more than just the disputed right to exhibit and sell eleven paintings. First of all, the nature of relationships between artists and dealers was at stake, provoking questions similar to those which Van Gogh had addressed in his letters: are dealers and artists friends, mutual partners in a cooperative enterprise, or competitors, or is the dealer an employer of artists in disguise? Secondly, and inextricable from the first set of questions, the case was about the meanings of

monetary transfers between the parties: was the monthly monetary sum Halley received part of an implicit employment contract, did it have properties of a charitable gift from a benevolent patron, or was it just an advance against the sale of works consigned by the artist? Finally, the character of the art world and the art market was symbolically contested in the lawsuit. Was the art market a special circuit whose rules of conducting business and governing relationships, and whose shared values, idealism, and love for art, set it apart from other markets? Or was the art world falling prey to the laws of capitalism, which would irreversibly transform it into either an ordinary retail business or, alternatively, into a branch of Wall Street's financial markets?

Halley, who was described in the court papers as a "young and celebrated artist," acknowledged a friendship relationship in the letter he sent to the gallery announcing his leave. After being represented by the gallery for six years, he felt a "debt of gratitude" to Sonnabend herself and to Antonio Homem, the director of the gallery; he expressed feelings of "admiration" and "friendship" for both of them. In turn the gallery presented itself as a patron who engages in a moral or caring rather than a business relationship with artists. Homem emphasized that the gallery had been "careful to protect our artists from the negative effects of the secondary market." This made it particularly bitter for the gallery that Halley was leaving for Gagosian, since the latter had a reputation of buying and selling aggressively on that stigmatized market segment, without much concern for the artists involved. When Gagosian decided to become a primary rather than just a secondary market dealer, he allegedly did not do so by promoting new talent himself, but rather by "stealing" artists away from other galleries.[21]

The moral, fragile nature of the relationship between Halley and Sonnabend was underscored at court. In order to prevent Gagosian from selling Halley's work, the Sonnabend Gallery argued that its "reputation and standing in the art community will be irreparably harmed if the new paintings are permitted to be exhibited and sold by Gagosian Gallery." The suggestion was that it was a marriage rather than a business relationship that was being dissolved. Paradoxically, however, in supporting its claim that it would suffer irreparable harm from Halley's leave, the Sonnabend Gallery argued that the case should be analogized to, among others, an ice cream franchise, where similar injunctions had been granted based on exclusive licensing and distribution agreements. Justice Arber of the New York Supreme Court, unconvinced of this analogy, ruled: "It is difficult to understand how plaintiff-gallery can on the one hand argue the sensitivity of the artist/dealer relationship and on the other hand analogize it to a (. . .) franchise. Since what is involved here

is eleven paintings and not unlimited ice cream cones the analogy to a distribution agreement leaves a great deal to be desired."

Neither could the oral agreement between the artist and the gallery be likened to an employment contract. Courts in the state of New York refuse to order an individual to perform a contract for "uniquely personal efforts." That this applies to services provided by artists to dealers was self-evident to the judge. Here the court papers read: since "little can be said to be more personal than artistic efforts," the production of art "finds anathema in compulsion of any kind." In other words, contrary to the "Nothing But" reasoning of neoclassical economists, the court recognized the exceptionality of the art market and ruled that employment contracts cannot be reconciled with the freedom of artistic production. Indeed, mere hints of employment relationships had been a source of conflict in the art world before. As the established American artist Robert Motherwell remarked about a contract he was supposed to sign with a syndicate of galleries, involving a large amount of money: "I couldn't sign. If you paint by a system, such a contract may work. But I paint by impulse and it's terrible to be under pressure to have an impulse. It's like being under pressure to make love every day" (Merryman and Elsen 1979, p. 138). Another problematic feature of employment relationships in the art world is that they may give too much credit to the dealer, and subordinate the artist. Thus when in the early 1980s the cover of business magazine *Forbes* depicted the flamboyant dealer Mary Boone center and in the foreground, with the celebrated artist Julian Schnabel in the background and off-center, this made people within the art world gossip. The artist himself remarked cynically about the subordinate relationship with his dealer that this picture symbolized: "I was expected to have on a little blue cap and shorts." The tremendous success of the artist those days all of a sudden seemed attributable to the skillful operations of his middleman. Indeed, after having left her gallery, Schnabel complained about Boone that "it was as if the artists were tubes of paint, and she was the real visionary. We were the earrings to embellish her *aura*."[22]

Another argument that the Sonnabend Gallery put forward in the lawsuit was that it had already pre-sold the works exhibited in the Gagosian Gallery to committed buyers affiliated with the gallery. However, in June of the same year Justice Arber ruled that Sonnabend had insufficient evidence to prove this claim. As a consequence, the court refused to grant the injunction to the Sonnabend Gallery, and allowed Gagosian to exhibit and sell the paintings. According to court documents, the Whitney Museum of American Art bought the diptych priced at $150,000; another work was sold to the Stedelijk Museum of Amsterdam. While the injunctive relief was denied to the gallery, Justice Arber eventually did

allow Sonnabend to go to trial with its claim of breach of contract. In May 1993, a motion of the Gagosian Gallery to have that suit dismissed was denied. If Sonnabend could prove that the oral agreement with Halley was as binding as a written contract, it could receive substantial punitive damages. According to Sonnabend, this breach cost the gallery more than half a million dollars.

One of Sonnabend's arguments to make a case that breach of contract was at stake was that the Gagosian Gallery had allegedly paid Halley a $2 million bonus to make him leave the Sonnabend Gallery. According to a legal guide, this could be interpreted as "tortious interference," that is, an illegitimate interference of Gagosian with the oral contract between Sonnabend and Halley (Lerner and Bresler 1998). Alternatively, this monetary transfer could be interpreted as "economic duress," that is, illegitimate pressure on Halley with the intention to force him to enter a contract with Gagosian. It would, in other words, cast a doubt on the voluntarism of Halley's move. Both Gagosian and Halley denied the transfer of a $2 million sum, however. To a reporter of *The New York Times*, Halley said that he would not have been comfortable with such a bonus.

The Gagosian Gallery did admit that it would pay Halley a higher stipend than the monthly $40,000 paid by the Sonnabend Gallery. From a benevolent gift out of the pocket of dealers like Castelli, stipends had become a financial incentive, as one of my respondents put it, to "steal" artists away from other galleries. In the art world of the mid-eighties and early nineties, such incentives were not uncommon among superstar artists and their galleries. For instance, in the years before the Sonnabend-Halley case, rumors went that the Pace Gallery had paid Schnabel $1 million for his transfer from Mary Boone, while Boone herself had offered Malcolm Morley a $1 million advance if he would leave his dealer Xavier Fourcade, who was at the time dying of AIDS; Morley would receive half of the advance at once upon signing the contract. Thus when Donald Judd left the Paula Cooper Gallery for the Pace Gallery, Cooper remarked cynically: "Artists today are like baseball stars." In the light of the large number of artists changing galleries in the second half of the 1980s, looking for a more profitable deal, one other observer of the art market noted that there is "not much sense of community" anymore. Journalist Carol Vogel commented in a similar vein on the Sonnabend-Halley case in *The New York Times*: "Apparently, a handshake doesn't mean what it used to in the art world, at least not to the New York artist Peter Halley (. . .). It also is one more indication of the increasingly corporate approach to the artist-gallery relationship, a change from the nurturing, informal days when galleries helped artists and expected loyalty in return. Today celebrated artists are more often calling the shots,

demanding written contracts and more money." In short, the changing, disputed meaning of Halley's stipend had come to symbolize a changing art world.[23]

In the end the suit was settled out of court. Both sides signed an agreement not to discuss the exact terms of the settlement. According to an informant of *The New York Times,* Halley agreed to pay Sonnabend $162,500, a figure that the artist had already mentioned as his debt to the gallery in the original letter announcing his leave. The amount represented the stipends he had received and production expenses he had incurred before leaving the gallery. Remarkably, after the Gagosian Gallery represented Halley for only two years, Halley left again. In spite of the fact that the parties had drawn up a written contract, Gagosian allegedly did not pay the agreed-upon stipend for a number of months, since the artist's work had not been selling well.[24]

"Be Classy"

In the middle of the lawsuit between Halley and his gallery, Eugene Stevens, a Chicago collector, expressed his doubts to a reporter of *The New York Times* whether he would still be able to buy the painting which he had discussed with Halley. The planned acquisition of a painting by Halley was backed by a relationship with Sonnabend which went back years, and although Stevens did not mind doing business with Gagosian in principle, he did not have a comparable relationship with him.[25] Stevens's worries indicate that in case of popular artists like Halley, pre-existing social ties with the dealer are critical in order to purchase an artwork. As I explain in detail in the next chapter, if excess demand exists for an artist's work, it is largely at the dealer's discretion who to sell the works to. This puts dealers in the position of a benefactor in disguise: just as they can redefine the meaning of direct acquisitions from artists into a gesture of care, they can also redefine the *quid pro quo* meaning of sales to collectors into favors: the collector is made to feel grateful for the fact that he was allowed to buy a particular work out of an exhibition.

Such framing activity, made possible by the rare case of excess demand for an artist's work, points to a more general gift discourse in the interaction between dealers and collectors. Without noticing their remarkable use of language, many dealers phrase sales by saying that they "*gave* a work to a collector for only $4,000."[26] What is a market exchange in practice is transformed into a gift in discourse. One of my respondents used this gift discourse self-consciously: "actually I feel like I am giving people a gift. I never feel like I am taking advantage of anyone, which is a good feeling. Someone will call me 100 times because he is eager to get

something, and when I finally get him something which is so excellent, he will say, 'ok, what is the best price?' To which I reply: 'it is a gift, so say thank you'" (us17). This gift discourse is also invoked when dealers want to redefine the impure, negative meanings of secondary market transactions into the opposite by framing buying and selling on the secondary market as benevolent services to collectors. Said one dealer about buying on the secondary market: "It could be that you make that phone call, and that the guy says 'yes fantastic, I am just buying a house, and I need the money,' or he says, if it is a piece of video art, 'I do not have it up in my house, I never see it, so it is great if I can sell it.'" The same dealer continued about selling on the secondary market: "I find it sometimes very gratifying if you find something on the secondary market which is exactly what somebody is looking for. They spend a lot of money, but still they say 'thank you, I cannot believe that you found this.' That is really fantastic" (us16). By framing these transactions as a service, dealers manage to redefine a stigmatized transaction into a benevolent one.

Apart from this discursive framing of buying and selling, dealers give material gifts and do actual favors to collectors on a continuing basis. Think of in-kind gifts such as catalogues of the artist's work or other precious books, a small artwork for free in case a collector buys a large work or two works at once, monetary gifts like "picking up shipping" or paying the sales tax, or intangible services such as privileged involvement in social activities of the art world, invitations to after-opening dinners, and visits to the artist's studio. Although to a lesser extent, such gifts are reciprocated with counter-gifts from collectors. In my empirical research I encountered three different types of counter-gifts. First of all, collectors can frame a direct acquisition as a gift by buying a work from a show that was financially unsuccessful for the artist, the dealer, or both. Under normal circumstances, they may not have bought a work to begin with. Supporting young and upcoming artists, these art collectors "double as philanthropists," as one painter put it in *The New York Times*. They do not only buy out of passion for art, but also for philanthropic or altruistic reasons.[27] A second type of gift involves assisting the dealer in promotional activities for the artist. Once a collector owns the work of an artist, she can bring it to the notice of fellow collectors or other stakeholders in the art world. Thus collectors participate in establishing the reputation of an artist and building a firm market for his work. A third type of gift from collectors, albeit only a small group, is to provide financial services to a dealer. For instance, collectors occasionally serve as "backers" of the gallery in case the dealer is short of financial resources. Also, collectors may provide loans to a dealer when he needs to make substantial investments, such as rebuilding the gallery space or acquiring an expensive but potentially profitable work on the secondary market.[28]

Neoclassical economists may emphasize at this point that these reciprocal gift exchanges serve the economic interests of both parties. After all, they are an instrument in the management of customer relationships for a dealer, and safeguard the continuity of sales. For collectors, such reciprocal relationships increase their chances to get access to desirable, scarce, and highly valuable artworks (cf. Caves 2000, p. 46). Sometimes, this happens on a quasi-coerced instead of a voluntary basis: some dealers, especially in the 1980s, required collectors to buy works of other artists represented by the gallery before they could acquire a particular work that was in high demand.

Without wanting to defend a romantic interpretation of gifts (some artists prefer *quid pro quo* transactions exactly because of their relative clarity in mutual responsibilities and obligations), my claim is that such "Nothing But" self-interest claims are untenable. First of all, motivations for engaging in reciprocal gift exchange are complex, differ per person, and cannot be reduced to either self-interest or benevolence. If a collector buys a work from an unsuccessful show, he may not have increased chances of buying desirable work in the future on his mind, but may do so, as a young, struggling gallery owner put it, "just to be nice, just to be classy" (us1). To deny that a sense of responsibility, considerateness, or "noblesse oblige" rather than just self-interest informs behavior of economic actors amounts to reductionism, or, worse, cynicism. Second, reciprocal gift exchange on the art market also serves to strengthen, differentiate, and mark relationships between two parties. The gift that is chosen is in other words specific to the relationship, while the monetary value of this gift does not necessarily correspond to its strength. A collector can be offended if he does not receive the "gift" of an invitation to an after-opening dinner, but receives an expensive catalogue instead. Whereas the catalogue may be given to a collector the dealer has a weak tie to, intimate social events are restricted to a small group of collectors which the dealer has been close to for a longer period.

Discount Economy

Just like gifts, price discounts serve relational and economic purposes simultaneously. Although money does not seem to have the differentiating capacity which in-kind gifts have, dealers manage to use it for these purposes anyway. Undoing the uniform, monetary nature of discounts, they vary their magnitude and furthermore make distinctions between different types of discounts. The size of the discount is not just the outcome of bargaining power; it also symbolizes the tie that is at stake in the transaction. With respect to the type of discount, courtesy, museum, as

well as flexibility discounts can be distinguished (Robson 1995, p. 72). This differentiation largely coincides with the social, cultural, and economic values that constitute their respective meanings.[29]

Courtesy discounts are awarded without a direct economic need and express social values of different sorts. Some of them are meant to create, in the literal sense of the expression, *prix d'amis*. Collectors who have proved their loyalty to the gallery in the past receive them, and so do students, young collectors, or buyers with very limited financial means. By giving a discount, dealers convey a sense of gratitude to a collector. "[I]t is valuable for someone to go out there and select work. It is not that common. We have to cherish that, it is a lot of money," as one dealer put it (US4). Museums almost invariably get discounts, at least if they ask for them, since they have limited acquisition budgets, and since museum acquisitions are to the benefit of the artist's future career. According to another dealer, selling to an institution is "the best sale you can possibly make," so a discount should make that "as easy as possible" (US3). Collectors who commit themselves to donate a work to a museum can count on a similar museum discount, in particular if they stipulate that their donation is not to wait until they die, but to occur in the near future.

If awarding courtesy and museum discounts has a long-term rationale, flexibility discounts are informed by short-term economic circumstances. They are awarded when the dealer has set the price too high, when a collector commits himself to paying quickly or in cash, or, in particular, when sales are slow. Flexibility discounts are, in other words, the fine-tuning mechanism of the market. Indeed, discounts flourished in the early 1990s, when the art market had just collapsed. Take N. R. Kleinfield, who visited New York art galleries in 1993, presented himself as a collector, and subsequently reported his findings in *The New York Times*. Discounts of up to 30 percent were offered to him even at well-known galleries, accompanied by statements like "I haven't done that for anyone else," "I can give you 20 percent off. That's what we give dealers," or "[w]ell, we give collectors 10 percent off. Are you a collector?" When Klein replied to the latter statement: "No, I'm new to this," the employee said: "I think we can give you the 10 percent anyway."[30]

Such flexibility discounts can hardly function as markers of social relationships, given their overtly economic meaning. Nevertheless, the accompanying bargaining process turns a clinical, *quid pro quo* transaction into something different, if only into a game which brings about excitement. In this game, collectors explore different ways to pocket the largest discount possible, while galleries invent persuasive arguments to resist or circumvent them. Also, dealers allow for this game to be played by building a "cushion" into the prices they list. After a deal has been struck, collectors may boast to their peers about the size of discounts they received, while galleries can express their economic strength to colleagues

by mentioning how rarely they are forced to discount their prices. Apart from being the reflection of mutual bargaining power, the status of economic actors is defined in this game: the status of the collector among her peers, the status of the dealer among his colleagues, and the status of the collector vis-à-vis the dealer. That the New York PaceWildenstein Gallery allegedly does not award discounts to anybody besides museums is therefore interpreted as a sign of its strength.

Although discounts symbolize social ties, they can also lead to the opposite effect of corroding them. This happens when a collector demands a discount, while a dealer considers that demand inappropriate. As Halley's former dealer Sonnabend answered when a collector asked her if she knew who he was, apparently to negotiate the price down: "Yes, I do, and the price will be a little higher."[31] In such cases, price negotiations reveal that the respective interpretation of the social relationship diverges. A Dutch dealer worded her frustration about this as follows: "[a]mong big collectors there are people that manipulate me. They tell me: 'I am such a large collector, it is so important for the artist to be part of my collection, I show it to so many people. Therefore I want a discount.' To be honest, I do not appreciate that. For if you are in a position to spend so much money on art, you might as well just pay that cool €500 or €1,000 that you want to have off. It makes me think: why does it have to be at the expense of the artist and the gallery, who have to fight to make some money out of each exhibition? One of my best clients runs a multinational, and he does not ask for a discount. I stand in awe of that" (NL6).

CONCLUSION

Neoclassical economics, imperialistic as the discipline is, has started analyzing family and friendship relationships in the last two decades in terms of a capitalist logic of costs and benefits, allocation, and efficiency (see Becker 1976). In this chapter, I have made the opposite move: I have interpreted the way market relationships are governed in terms of a non-market logic. Contemporary art dealers mark and symbolize social relationships with artists and collectors by framing economic transactions in different ways and by redefining the meanings which their transactions generate. Reciprocal gift exchange, which infuses market relationships, fulfills the same relational purpose. Furthermore, with the help of price discounts, art dealers make distinctions between different ties they have with collectors. If market transactions and the objectifying nature of the price mechanism are contested in the art world, framing efforts, gifts, and price discounts "de-objectify" these same transactions. Such relational practices are so endemic on the art market, that the distinction between a

non-market logic which equals sociability, and a market logic which equals anonymous exchange, is ultimately a false one.

My interpretation of familial or friendly ties on the art market and dense gift exchanges differs from an economistic analysis that reduces gifts and trust to "nothing but" a "social glue" which enhances the efficiency of markets. My interpretation also differs from the Hostile Worlds approach of the humanities; I claim that the art world does not need to have recourse to a pure gift economy in order to avoid the alleged harmful effects of *quid pro quo* market exchange. A dealer's caring relationship to an artist can be marked by a direct acquisition in case hardly any works have sold during a gallery show. Likewise, a dealer's intimate, long-lasting relationship to a collector may be marked by a courtesy discount, by privileged treatment in case of excess demand for an artist's work, or by dinners with the artist and other collectors. By contrast, an anonymous customer who enters a gallery and wants to buy a work on the spot—the type of transaction assumed in economic theory—is the exception rather than the rule. Such a buyer can receive a flexibility discount at best, and only if the gallery faces hard economic times.

My findings suggest that the structure of the art market is supported by more than just the monetary influx of collectors buying art for hedonistic or financial purposes. Instead, the market relies on a dense fabric of mutual gifts and favors: dealers subsidize artists, artists donate works to dealers, collectors occasionally buy works to support an artist or a gallery, or enact the role of the dealer's moral and financial backer. I do not want to suggest that self-interest is absent within this social fabric, or that the art market could be set apart from other markets because of some benevolent disposition of artists, dealers, and collectors. Indeed, the legal case of the artist Peter Halley versus his former dealer, the Sonnabend Gallery, underscores that the large amounts of money involved in the selling of artworks lead to tensions in social relationships or even to gradual changes in the character of the art world. The legal case supports my overarching argument, however, since it largely revolved around multiple meanings of the stipend that the artist received from his gallery.

Apart from addressing the density of exchange relationships on the art market, this chapter has raised two new questions: first, why do dealers prefer to "give" desirable artworks away to favored collectors in case of excess demand, instead of increasing prices for those works? Second, why do dealers award flexibility discounts instead of decreasing prices in case of "slow sales"? To answer these questions, we need to develop a better understanding of how prices are set on the primary market for art.

Promoters versus Parasites

INTRODUCTION

In December 1999 the German photographer Andreas Gursky had a solo show at the Matthew Marks Gallery in Chelsea, the foremost gallery area of New York City. At that time, Gursky ranked 38 in the top 100 list of the world's most famous contemporary artists, published annually by the German business magazine *Capital*. A number of books had appeared on his oeuvre, museums all over the world were showing Gursky's work, and the New York Museum of Modern Art had just decided to devote a solo show to the photographer in the spring of 2001. The career of Gursky's New York dealer, Matthew Marks, was no less successful. At the age of 31, Marks had left one of the world's largest dealers, the London-based Anthony d'Offay Gallery, where he had worked as an assistant. He opened his own space in New York in 1990, and in spite of the fact that the art market had just collapsed, Marks managed to establish a strong reputation within a decade. Apart from representing a small number of the world's most famous living artists, his gallery was handling the estate of important modern masters such as Willem de Kooning.[1]

At the solo show, Gursky's large, sometimes solemn, but always colorful pictures, printed in an edition of six, sold out for prices around $50,000. On top of that the artist had a waiting list of international collectors eager to buy his work. Two weeks before the opening of the show, an older photograph by Gursky came up for sale at Christie's evening auction of contemporary art in New York. The work, *Prada I* (1995), pictured an elegantly designed showcase of the Italian fashion house; the edition size and the dimensions of the print were the same as the prints sold in the Matthew Marks Gallery. Still, the work, which carried an estimate of $40,000 to $60,000, sold for a record price of $173,000 to the dealer Robert Shorto, located amidst prestigious dealers in old masters on Duke Street in London. In the years to follow, his photographs continued to sell at auction for record prices. *Prada II* (1997) went one year later at Christie's for $270,000 to the Geneva-based dealer Andrea Caratsch. *Prada III* (1998) sold in the fall of 2001 for $310,500 at Phillips, de Pury & Luxembourg, Christie's and Sotheby's new rival on the auction market; in the same auction week, an older picture by Gursky, *Paris, Montparnasse,* sold for $600,000 to an anonymous buyer.

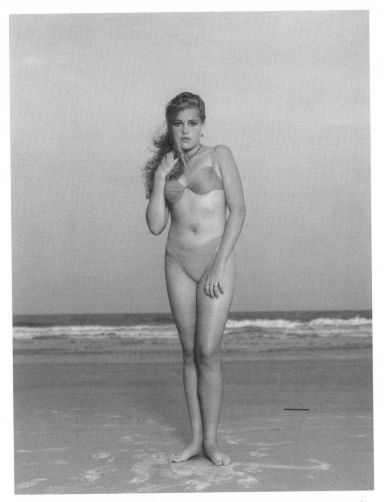

Hilton Head Island, S.C., USA, June 24, 1992 was part of a series of six photographs by the Dutch artist Rineke Dijkstra, which was sold at Christie's (5.14.2002) for $405,500. Courtesy Marian Goodman Gallery, New York.

Three months later, Gursky's picture *Untitled V,* depicting a display cabinet of training shoes, sold at Christie's in London for approximately $610,000, setting the record for a photograph by a living artist.[2]

Marks had of course adjusted the gallery prices for Gursky's work in the meantime, but these upward adjustments did not keep pace with the sharply rising auction prices. The peculiar price structure that resulted—high auction prices, low gallery prices for the same or similar work—was

no isolated incident. At the same auctions where Gursky's pictures were sold, pictures by other contemporary photographers such as Thomas Struth, Rineke Dijkstra, and Cindy Sherman also sold for many times their gallery price. *Soliloquy VI,* a work by the English artist Sam Taylor-Wood, fetched a price of $110,300, while at the same moment Taylor-Wood's gallery in London, White Cube, was selling work from the same series for less than $6,000. The new owner of *Twenty Million Sweethearts,* a painting by a young art star named Cecily Brown, paid $87,000 for it at auction; only a year before the gallery price of the work was less than half. Brown had quickly established a reputation in New York due to the interest influential art dealers like Gagosian and Jeffrey Deitch took in her work.[3]

The majority of contemporary artists face the opposite situation. Either their work does not have a resale market at all, or the price level in their galleries is higher than auction prices for their work. In an interview, one established Amsterdam dealer said, for instance, that "[i]t just happens to be the case that you offer something for sale here [in the gallery], and the day after you would not be able to get the same amount if you would bring it to auction" (NL7). Others acknowledged that it "would simply be the end of it" if prices would be set by means of auctions for some of the artists they represented (NL16).

These unsystematic observations about price differences on the art market prompt two questions: first of all, why are fixed, posted prices rather than the auction mechanism used to set prices on the primary market? This question is all the more relevant, since economic theory predicts that unique, high-value goods like art, for which clear standards of value are lacking, tend to be priced by means of auctions. Second, why do primary market dealers fail to adjust the prices they set upwardly or downwardly to the level of the secondary market? Challenging common wisdom about markets, I will unravel the structure of the art market in order to answer these questions. I show that the art market, apart from performing allocative functions, is a definitional mechanism, where the proper identity of an artwork—commodity versus cultural good—is permanently under dispute (cf. Smith 2003). This definitional mechanism extends to prices themselves: far from being neutral, different price mechanisms lead to prices that have entirely different meanings to actors on the market; dealers sharply and categorically distinguish the prices established in their own circuit—the prices of the promoters—from the "parasitical" prices established at auction. As a result, the price for a work at auction can only poorly be compared along a single metric with a gallery price. In their attempt to limit the possibility of future resale and investment potential of an artwork, dealers restrict rather than enhance the liquidity of artworks: they construct moral and even semi-legal boundaries

between the auction and the avant-garde circuit to prevent arbitrage from taking place. In that respect, the primary market for art hardly answers to the neoclassical ideal type, where everybody has access to goods and is free to buy and sell those against the current market price. Instead, art dealers actively seek to control the "biography" of artworks that leave their gallery by administering sales in detail. This behavior of dealers may be irrational from a narrow economic point of view, but it makes sense when one takes into account that their goal is to promote artists, and safeguard the long-run stability of prices. There is, in other words, a rationale to maintaining price differences, albeit not a strictly economic one.

BAROMETERS OF VALUE

In modern economies, three mechanisms exist to set prices. First of all, in case of private negotiations, individual sellers and buyers negotiate about the details of a transaction including the price, which has not been fixed in advance. The mutual bargaining power of parties willing to exchange a good is measured on the spot, with the price level as the main outcome of the process. Private negotiations predominated in pre-modern economies and still do in the bazaar economies that have been documented in detail by economic anthropologists (see Alexander and Alexander 1991; Fanselow 1990). The second mechanism to set prices is the auction. In its most simple form, buyers and sellers of a good convene at a specific place and time. During the auction, an auctioneer calls prices in order to find the equilibrium price where supply and demand meet; in other words, supply and demand interact directly in order to establish the price. Textbook economic theory, with its supply and demand graphs, implicitly assumes that prices for all goods in an economy are set by means of an auction mechanism.[4] In reality, however, only few categories of goods that circulate in modern economies, such as perishable goods like fruit, flowers, and fish, or agricultural products and primary metals, are sold at auction (Okun 1981, p. 134); more recently, online auction houses such as eBay have increased the number of goods that are sold by means of auctions dramatically. The third, dominant mechanism to establish prices in modern economies is the fixed or posted price: before the sale takes place, the seller sets a price for a good and posts it. Subsequently, by buying a good a customer implicitly agrees with this price. Posted prices were introduced when trade became directed at an impersonal public in the nineteenth century, and the intensive interaction of private negotiations became too costly (Carrier 1994, p. 373).

On the art market, all three price-setting mechanisms can be found. Private negotiations sometimes determine a price at the artist's studio, although guidebooks to the art market advise artists to fix prices beforehand. As the author of one of these books warns: "[w]hen a studio sale is imminent, it is easy for an artist, seduced by the excitement of the moment, to abandon powers of logic and reason and succumb to some rather unreasonable request concerning the terms of a sale, such as granting a large discount" (Michels 1992, p. 58; see also Klayman and Steinbreg 1984, p. 64; Katchen 1978, p. 83). Furthermore, both primary and secondary market dealers may every now and then abstain from posting prices for the inventory that is stored in the backroom of the gallery, and instead negotiate the price on the spot. Auctions are almost exclusively used on the secondary or resale market, where the market is dominated by two established auction houses, Christie's and Sotheby's, and one newcomer, Phillips, de Pury & Luxembourg. Dictating the rhythm of the market, they organize their main modern and contemporary art auctions in New York in May and November; apart from the auction houses themselves, dealers heighten their activities before and during these weeks, investigating the works that come up for sale, and deliberating whether to bid on these; also, primary market dealers may put up shows of their most well-known artists around this time, since major collectors are expected to be in town for the auctions.

Apart from some exceptions, however, auctions have not made their way into the primary market throughout the history of Western art. In 1891, the post-impressionist artist Paul Gauguin auctioned off his own works in order to quickly generate cash for his planned trip to Polynesia, although hardly with success (Rewald 1986, pp. 79–80). Santa Monica art dealer Robert Berman organized an auction for new, contemporary art in the early 1990s, desperate to get sales started after the market had crashed. In his own words, he needed to "get things moving" in the midst of the recession, and "find out where the market [was]." A Dutch artist auctioned off all her work as a symbolic gesture at the end of a museum show, so that she could start from scratch afterwards. And, on a more regular basis, charities organize benefits, for which artists and their galleries are asked to donate new works of art on a voluntary basis, which are subsequently auctioned off.[5] Apart from such exceptional cases, however, the auction mechanism has been avoided on the primary art market. Indeed, when my questionnaire prompted me to ask if they had ever considered organizing regular auctions for the artists they represent, most dealers reacted uncomprehendingly, dismissively, or even hostilely. Selling to the highest bidder was considered "immoral," "very unethical," and "extremely controversial." There is clearly a strong taboo on

the use of auctions on the primary art market. Without exception, dealers prefer to sell art by means of fixed prices.

From an economic perspective, this predilection for posted prices rather than auctions is anomalous. Economic theory predicts that artworks will be sold through an auction mechanism for a number of reasons. First of all, as Preston McAfee and John McMillan argue in a review of auction literature, in case the seller is a monopolist he should prefer to sell by auction rather than by posting prices, since he does not know the bidders' valuations; the advantage of auctions is that all buyers have to reveal their willingness to pay for a good by bidding on it. Secondly, auctions are optimal when there are only a few units of a good to sell. Thirdly, auctions should be the preferred price mechanism if widely accepted standards of value are lacking; and fourthly, they should also be preferred if the goods that will be sold are expensive.[6]

Applying these arguments to the primary art market, the case for auctions could not be stronger: art dealers are, at least for the artists they represent, monopolists; they only have a small number of units to sell; the value of each unit is high, while clear standards of value are lacking. The latter consideration, which is doubtlessly the most important one, has been addressed by all previous studies of the market for contemporary art. The American anthropologist Stuart Plattner noted in his economic ethnography of the St. Louis art market, for instance, that the present "disarray of aesthetic theory about merit" and "[t]he bankruptcy of art criticism and evaluative art theory (. . .) means that value is mysterious, socially constructed, and impossible to predict a priori without an expert's knowledge" (Plattner 1996, p. 195). Journalistic accounts of the art market have called prices likewise "elusive," "unpredictable," "speculative," "manipulative," or "irrational."[7] It is therefore remarkable that auctions are only encountered on the secondary or resale market, where the need for them to "resolve" uncertainty has been reduced to begin with: economic and artistic values have already been established when works appear on the secondary market, since their art historical standing and economic worth have been partially decided upon.

For sure, dealers in the past as well as in the present have long recognized auctions as the main arbiter of value on the market. For instance, when modern art developed in early twentieth-century Paris, auction sales functioned as an "easily available indicator of taste, helpful for prospective collectors in the face of dealer secrecy" (Robson 1995, p. 8). In the middle of the twentieth century, New York art dealer Betty Parsons insisted upon distinguishing gallery and auction prices sharply for similar reasons. Whereas a "false value" was expressed by gallery prices, "auctions have become a sort of barometer for pricing art," she said (Coppet and Jones 2002, 29–30).[8]

Auction prices have earned their status of a reliable and preferred standard of value because of their responsiveness to supply and demand, and because of their public character. Major auctions are covered by newspapers and magazines, and their prices are publicly available. By contrast, gallery sales have an exclusive, private character; details of a transaction, including the price, are difficult to find out for outsiders. And while demand *does* influence the gallery price by inducing price adjustments, compared to the auction mechanism the influence of demand is far from direct (McAfee and McMillan 1987). The art dealers I interviewed also confirmed the barometer character of auction prices. The owner of an old, established Dutch gallery explained: "I know that the actual price is the price at auction, because only at auction do supply and demand meet." (NL7). An American dealer said likewise that "[t]he auction is of course for all of us the indicator as far as prices are concerned. Everybody has got access to those prices, even the customer, if he wants via the internet. Even the most shrewd dealer will therefore be careful when deciding how much he is going to offer a work for. As a result prices have become much more predictable" (US12). These dealers contrasted the reliability of auction prices with gallery prices, which they characterized as being "based on air," "speculative," or "one-sided": the art dealer and the artist may have agreed upon the price, but they don't know the collector's willingness to pay.[9] An Amsterdam dealer elaborated that "[a] price determination of an artwork is purely an assertion. It has nothing to do with anything, not with raw materials or production costs. You just say: this is worth that much. Then you have to make sure, of course, that you can get away with it" (NL11). In other words, a gallery price list may read $300,000 for a painting by the art star Eric Fischl, but, as one dealer put it, "you can write anything in the price list." Fischl's art dealer, the Mary Boone Gallery, was suspected of putting orange stickers on the price list even if the works of art had not been sold at all, or for considerably less than the price list stated.

THE CASE AGAINST AUCTIONS

If dealers recognize auctions as the barometer of value, the fact that the auction mechanism is fiercely rejected on the primary art market becomes all the more puzzling. Nevertheless, within the dealers' model of the market, there are good reasons for this rejection. First of all, I found that dealers consider the volatility and contingency of the auction mechanism harmful to the value of art; by fixing prices, they gain control over the diachronic price development of an artist. The second reason has less to do with auctions as a means of setting prices than it has with the structural

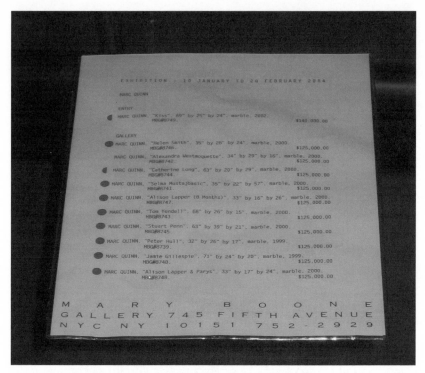

Price list at the Mary Boone Gallery, New York. Photo: author.

position of auction houses in the art world, which dealers consider to be parasitic. Thirdly, dealers not only seek to gain control over the price development of an artist's work, but also over the future biography of the artworks; using auctions would undermine this desired control. Let me discuss these arguments in detail (see table 3.1).

Although dealers are willing to admit that auctions are the main barometer of value, my respondents were at the same time convinced of the contingency of auction prices. Paradoxically, they maintained that auctions reflect supply and demand so directly that it confers an elusive quality on them. Therefore, dealers called auction prices "chancy," "bizarre," "very hard to pin down," or "unpredictable," and emphasized that establishing a high auction price "only takes two people in the whole world" (us15). Invoking the value of prudence, some called auction prices "not real" or "inflated." Rather than being founded on repeated sales, auction prices were thought to rely on the "excitement" of a single night: "The auction market is based on the time of the year, if it is raining outside, the mood of the audience, who attended that night, what's in

TABLE 3.1
The auction versus the avant-garde circuit

	Auction circuit	Avant-garde circuit
Pricing principle	Supply and demand	Posted price, assertion
Character	Public	Private
Marketing	Aggressive, open	Subtle, covert
Goal	Profit maximization	Protection of artist
Reliability	Single sale, chancy	Repeated sales, stable
Volatility	High	Low
Excess demand	Price mechanism	"Social" rationing

the auction itself, and how much excitement it generated," as one dealer put it (US14).[10] In academic literature, Charles Smith has argued likewise that real auctions deviate significantly from the economic model. Unlike the assumptions of economic theory, estimates of bidders are based on collective opinions which are highly subject to modification. As a result, prices do not reflect a simple composite of individual evaluations, but rather, complex, collective evaluations which are subject to intra-group influences (Smith 1989).

This contingency of auction prices is aggravated by a number of institutional features of auctions. For instance, reserve prices can be set so as to insure a minimum selling price (cf. Ashenfelter 1989); when the price is not met, the auction house may contact dealers in the days following the auction to sell the work privately. Also, auction houses have been accused of inflating prices in the past by providing loans to buyers with the artwork as collateral.[11] The transparency of auctions is further reduced by the strategic behavior of buyers, dealers, and sellers. Although prohibited in the United States under the Sherman Antitrust Act, dealers can "pool" or "ring" bids by refraining from bidding against one another. In that case, they allocate the work after the auction according to an agreed-upon principle (Smith 1989). Auctioneers have been accused of inventing bids of a telephone bidder in order to increase the price. Allegedly, some collectors have been eager to "overpay" at auction in order to increase the value of works by the same artist they had acquired before (Marquis 1991, p. 255; Gee 1981, p. 32; cf. Smith 1989, p. 38). These infringements on the validity of auction prices led one of my respondents to conclude that "[e]very big collector who buys or sells at auction must just be insane" (US12).

By contrast, the fact that supply and demand do not interact directly to set prices on the primary market is considered to be a vice, but a virtue at the same time: it enables dealers to administer prices, provide a sense of

structure to the market, and keep the uncertainty that prevails about the value of art under control. Two Dutch dealers, for instance, who direct a gallery at the upper end of the Dutch art market, emphasized on a number of occasions that one's pricing policy has to be as plain and transparent as possible: "people think anyway that they buy air when they buy art, or, at least, a good whose value is difficult to measure. If you start messing with prices (. . .) they become very uncertain" (NL16).

Administering Prices

The dealer's objections to auctions concern not just the volatility and opaqueness of their prices, but also the structural position of auction houses in the contemporary art world. Since the 1970s, auctions have increasingly paid attention to contemporary art; in 1998, Christie's even started organizing semiannual auctions devoted to art made by living artists. As a result, auction house and art dealer have become competitors for the collector's money. The crucial difference between the two competing parties is, however, that dealers are an active part of the support system of the art world, whereas auctions are not (Robson 1995, p. 11). In contrast with dealers, whose intimate ties to artists and collectors were discussed in the previous chapter, auction houses do not maintain ongoing relationships with artists, and make hardly any efforts to promote their work. Therefore dealers reproach auction houses for being exclusively profit-oriented and for being "greedy" (see also Sagot-Duvauroux et al. 1992, p. 96). My respondents expressed their own and the artist's frustration about the fact that "everybody is profiting" from high auction prices except for dealers and artists themselves. Said one dealer: "I think the real problem with the secondary market is the auction houses. They are the ones that really conflict with the galleries when it comes to promoting the artists. All they do is live off the artist. (. . .) They may be necessary in another format, but as far as helping the artists is concerned, they are really the parasites of the art world. They are just turning it over and making a buck" (US8). Another dealer argued even more aggressively: "It is a parasitic culture. (. . .) They have no loyalty to the long-term integrity of the art world. I think it is disgusting" (US18).

At the auctions sales where Gursky's picture *Paris, Montparnasse* and *Untitled V* were sold for record prices, this very structural position of auctions was at stake. The photographs were sold by Hans Grothe, a German real estate developer and well-known collector of contemporary art. In 2001, he decided to sell 48 works from his collection at Christie's in order to finance the construction of a hotel and office complex in Düsseldorf. In its press release, the auction house emphasized that Grothe

Auction of modern art at Sotheby's in Amsterdam. Photo: Sotheby's Amsterdam.

had close personal relationships with many of the artists whose work he bought: "Grothe met several of these emerging artists, including Imi Knoebel, Blinky Palermo, Sigmar Polke and Gerhard Richter, in the 1970s at the Ratinger Hof, a bar and café near the Academy of Art in Düsseldorf. (. . .) He considers these lifetime friendships an essential element in his collecting activity."

In an article about the sale published in the German weekly *Der Spiegel*, Gursky confirmed that Grothe did indeed have a comradely relationship with artists. However, when some of the artists found out that Grothe intended to auction off their work, they were outraged. The four German photographers Thomas Demand, Thomas Ruff, Thomas Struth, and Gursky himself, who each saw several of their works being auctioned, decided to send Grothe a letter, in which they told him that they considered the sale an instance of "repulsive behavior" and exemplifying a mind that is hostile towards both art and artists. The photographers also accused Grothe of breaking his promise to abstain from selling the works during his lifetime, and to accommodate them in a museum. Because of that promise, the artists had been willing to part with their work under "extraordinary conditions," which probably means below market value. With hindsight, however, they concluded that Grothe abused his connections with museums in order to increase the economic value of his work. Apart from failing to profit from the rise in the value

of their work, the artists were concerned about the meanings which art-works acquire at auction. Indeed, one of the objections of Demand was that he did not want to have anything to do with the mercantile environment of auctions, "in which everybody just has dollar signs in their eyes when looking at my work."[12]

Whereas art dealers permanently try to suppress the commodity character of art in their galleries, this very character is made explicit at auction. In that respect, auctions are no less theatrical and symbolically charged than art galleries. Major works of art that will be auctioned off fly to capitals around the world well before the sale in order to stimulate demand. At viewing days, talking openly about the economic value of artworks that will be auctioned off is a common practice; the commensurability of artworks is underscored by established collectors and curious spectators who compare price estimates of artworks without the scruples encountered in contemporary art galleries. Attendance of the most prestigious evening sales of Sotheby's and Christie's in May and November is by invitation only. A select number of financial titans and celebrities, dressed in gala, look out over the auction room from the private, windowed room of a skybox. During the sale itself, masterpieces are presented as fetishes, standing on an altar against the background of velvet curtains. If a piece commands a record price, the audience often responds with a standing ovation, thus underscoring the fetishization of the art object. Subsequently, in case of smaller sales, payments can immediately be made at a cashier's office, which may be located close to the exhibition rooms; no attempt is made to separate art and commerce in the architecture of the auction house. Illustrative of the different logic of auctions are also the comments of a chief executive of auction house Phillips, de Pury & Luxembourg, who said in an interview with *The New York Times* that her background in the internet business was no disadvantage to her new job: "The businesses are very similar. It's trading. Buying and selling."[13]

Social scientists have called auctions "tournaments of value" or "status contests." At stake in such tournaments is not only an economic transaction, but also the establishment of the rank of artists, and the status and fame of collectors who can afford to buy their work (Appadurai 1986, p. 21; cf. Baudrillard 1981).[14] A SoHo art dealer, active on the secondary market, characterized the public nature of auctions in a similar vein as follows: "Millions of people are seeing it. (. . .) Put it on the block and you do a Miss Popularity contest" (US13). Another dealer said that "[o]nce an artist has been subjected to auctions, his work is no longer discussed for its merits or its ideas, all discussion centers on the prices it achieved or didn't achieve, fifty thousand or two thousand. If those prices are high, it's just as bad as when they are low. Young artists

deserve a grace period in which what they do can be viewed as a work of art, not as a price tag" (Coppet and Jones 2002, p. 313).

It is this very association of artworks with status, snobbism, and public spending of money which is avoided in the avant-garde circuit. Dealers I interviewed contrasted their own covert business strategies with the aggressive sales methods of auction houses. They held auction houses responsible for the fact that collectors are constantly reminded of the economic value of the work they own. An American dealer characterized the atmosphere of the art market as follows: "The whole market is a lot more aggressive, there is no such thing as an indecent proposal since the auction houses are doing it 24 hours a day, 365 days a year. If you are a collector, you get a call or a letter if you want to sell. They come to your house and say, 'this is this much, that is that much.' So all the collectors are constantly living with values as much as they are living with art. It is much more extreme in America than in Europe" (us15).

What these comments hint at is that dealers and auction houses are not only engaged in a business competition over the collector's money, but also in a twofold definitional struggle (Smith 2003). First of all, whereas dealers seek to establish artist's careers, auctions market individual works of art. Secondly, whereas artworks are defined as commodities by auctions, dealers seek to repress this commodity status, and define them instead as cultural goods. This definitional struggle between auctions and galleries not only becomes manifest in symbolic practices such as the way their spaces are fitted out, in the way artworks are staged, in dress codes of actors in both institutions, or even in the accents when they speak, but also in different prices: within the dealer's model of the market, prices established at auction and in galleries differ not only in quantitative but also in qualitative respects. Art dealers maintain that gallery prices, the prices of the promoters, are set with a long-term orientation in mind, focusing on stability, trustworthiness, and care for the artist; auction prices, by contrast, the prices of the parasites, are perceived as short-term prices, directed at maximizing profits.

Since auction houses do not have long-term relationships with artists, their prices are established according to dealers at the expense of the artist. Auction house Christie's, for instance, has been accused of "not only inflating the prices of artworks beyond their gallery prices but also prematurely testing the market for some younger artists." The immoral strategy of auctions, interviewed dealers said, is as follows: auction houses wait until a high auction price is set for a contemporary artist. Subsequently they start approaching collectors who own a piece by the same artist, and aggressively advise them to sell, using the argument that "tomorrow will be doom day. The market will collapse, so this is the time to sell" (us18). As a result, the market is flooded with works by that

artist, and the high auction price is not reached again. The auction house's strategy is in other words a self-fulfilling prophecy.[15] The large number of works that appear on the market is nevertheless in their interest, since it increases their revenue, but it is, as a dealer puts it, "a very unfair test for the artist" (US18). It interferes with the prices which have been carefully been built up with the help of repeated sales by dealers. Thus art dealer Paula Cooper, comparing her own prices to those of the parasites, concludes: "the best prices for a living artist are always at the artist's home base—the gallery."[16]

These objections of art dealers to auction houses reach the core of neoliberal discourse on the market: the idea that everyone has equal access to markets, that goods are distributed freely on the basis of willingness to pay, and that no buyers and sellers are privileged or put at a disadvantage on social or cultural grounds (cf. Friedman 1962 [1982]). The logic of the art market is a different one. Seeking control over the biography of the work, dealers want to be able to decide who will own a work of art, and therefore try to undo the freedom that neoliberals associate with capitalist markets. If the artwork is sold at an equilibrium price at auction, in galleries this function of the price mechanism is deliberately restricted. Keeping forces of supply and demand at bay, dealers prefer to administer the sale of artworks for which excess demand exists by underpricing, that is, setting prices lower than demand allows for. In other words, they do not let prices clear the market by selling works to the highest bidder, but rely on alternative rationing mechanisms.

The first administered alternative to the price mechanism is to sell works that are in high demand on a first-come, first-serve basis. According to some dealers, this is "[t]he only fair way to do it." The established New York dealer Ivan Karp maintained in the magazine *Art in America* that somebody who is willing to pay the price "has the right to acquire the work (. . .) That is an ethical point that must be respected." The second alternative, which is encountered more frequently, is to develop a waiting list and subsequently sell works of art to favored collectors.[17] In this case, museums, which are of strategic importance to the development of an artist's career, are always privileged. Apart from museums, works are sold on the basis of loyalty, the status of the collector, and the importance of her collection. An Amsterdam gallery owner remarked about the latest show of one the most successful artists he represents: "It is not the case that all works of this artist were really sold before the opening, but I am always busy 'stationing' works in one collection or another. I just want to know where artworks end up. (. . .) It is no democratic affair; I do not guarantee that the one who enters first, will also be served first. It is not the case either that the person who throws most money on the table, will get the work. As far as that is concerned, I do not have a rela-

tionship with money, and neither do the artists. We have a relationship with art" (NL11).[18]

Crucial in this rationing process is the strength of the tie between the dealer and the collectors, which, as we saw in the previous chapter, is expressed by repeated purchases by collectors, and dense reciprocal exchanges of gifts and favors. An American dealer characterized this process as a "chess game" which invariably makes some people happy but also leads to social friction (US16). Some wealthy collectors who expect to be able to acquire a work are offended when they feel passed over by a less wealthy peer. Others are disappointed when their dealer offers them a work that does not match their expectations perfectly; they realize, however, that once they reject this offer their position on the waiting list will drop. In short, with rationing being based on social rather than just economic principles, the art market is far from a democratic institution.

THE LAW OF ONE PRICE

With these objections of dealers to auctions in mind, let me now return to the original puzzle of price dispersion on the primary and the secondary market. Economists expect that in a reasonably competitive and efficient market, all prices level out. When price differences occur, they can last only briefly: arbitrage, that is, buying where goods are cheap and selling them where they are expensive, will assure the so-called law of one price. "Prices (. . .) serve as guideposts to where resources are wanted most, and, in addition, prices provide the incentive for people to follow these guideposts," as Milton Friedman put it (Friedman 1962, p. 10). However, unsystematic observations suggest that the "law of one price" does not hold on the art market. In her study of the French art market, Moulin found that the same or similar work may be offered for sale at different locations at several prices (Moulin 1967 [1987], p. 137). Systematic quantitative data on price dispersion across the auction and the gallery market is hard to collect, but available evidence suggests that price dispersion is structural rather than incidental on the art market. In short, the market for art seems to be characterized by what economists call "price dispersion equilibria."[19]

In my research, I found that dealers actively prevent some forms of price dispersion from coming into being. For instance, if an artist is represented by more than one dealer on the primary market, a single price is mutually agreed upon, or enforced if one dealer acts as the primary gallery of the artist and administers all sales. Many dealers emphasized the troubles and toils of establishing such a consistent price structure

throughout the market. I understood that it was no option for them to let the forces of supply and demand establish such an equilibrium without their direct interference: they argued that collectors feel cheated if they run into similar works at different galleries for different prices; at art fairs, where several galleries may show works by the same artists, such discoveries are particularly painful. Galleries therefore continuously try to prevent price dispersion on the primary market from coming into being. This suggests that the law of one price is not an "automatic" outcome of equilibrating market forces, as economic theory postulates it, but needs to be actively imposed by galleries. And that requires hard work, dealers assured me.

However, when it comes to differences between their own prices and those established at auction, I noticed that dealers deliberately abstain from making price adjustments, whether upward or downward. The price differences that result from this raise a number of questions with respect to the behavior of dealers, as well as collectors and artists: why don't dealers make a profit from arbitrage, buying cheap at auction and selling dear at their gallery? Why do collectors buy works at auction, if similar works are for sale at lower prices in the gallery, or in the gallery, if similar works are cheaper at auction? Why do artists allow their dealers to forgo profit opportunities when they price the work lower than the auction level? In short, if a price difference occurs and persists, there must be a good reason for it.

The most obvious economic explanation for persistent price differences on the art market is that artworks are unique goods, whereas the theorem that all price differences will be leveled out only holds for a perfectly competitive market for standardized, homogeneous goods. Price differences between works that look alike and match each other in characteristics such as size, subject matter, and style, can thus be attributed to less conspicuous differences in quality. A particular artwork may have originated in a crucial phase, or it may have "scarcity value" because it was made in a less prolific phase of the artist's career; it may be the case that most of his works are in public collections, and will therefore not appear on the market again, or, in case of photographs, that the edition of the work is close to selling out. From an economic point of view there is no reason to believe that these price differences will be leveled out, because they simply reflect differences in the consumer's willingness to pay for goods whose desirability varies. In particular, whereas galleries apply a general script of pricing according to size, as I explain in the next chapter, at auction works are valued on a piece-by-piece basis. As a result, perceived quality differences translate into price differences at auction.[20]

In the absence of quality differences, neoclassical economists have come up with alternative, more fine-grained explanations for an empiri-

cal reality that does not conform to their crude theories. Chicago economist George Stigler argued in an early and influential article on "The Economics of Information" that the existence of price differences is a manifestation or measure of the level of ignorance on the market. Such price differences can persist because consumers are not aware of them, and mistake the price they are offered for the single market price. Especially markets with a constant influx of new, relatively uninformed consumers will therefore be characterized by price dispersion (Stigler 1961 [1971], p. 70).[21] Although only at an anecdotal level, this hypothesis is confirmed with respect to the art market: price dispersion is found especially in market segments for relatively easily accessible art, which cater to the demand of infrequent buyers. A reporter of the magazine *Forbes* recounts the story of an American surgeon who was delighted when he bargained over the price of a set of eight lithographs of the popular Mexican painter Rufino Tamayo at a gallery in Stuart, Florida, and managed to negotiate the price down from an original $45,000 to $35,000. A year later the surgeon ran into a similar set of prints at another gallery for $24,000; at about the same time, the lithographs appeared at auction with a reserve price of only $22,000, and even that reserve was not met. The surgeon could have apparently saved money if he had informed himself before purchasing the work. The fact that he subsequently encountered only two prints out of the set for $20,000 at a posh gallery in the winter resort of Vail, Colorado, offered some consolation. Likewise, a Dutch art dealer who sells "accessible" prints of so-called Cobra artists complained about the price differences across different galleries who sell identical prints: "Percentage-wise there are enormous differences in prices. If you would do research on that, you would find very peculiar results" (NL14).[22]

In the absence of such consumer ignorance, price differences can arise because of differences in transaction costs. For instance, given the fact that buyers have to pay a premium to the auction house, usually ranging from 10 to 25 percent, the auction price they are willing to pay is likely to be lower than the posted price of the gallery. Auction prices may also be lower because artworks can only be bought a couple of times per year at auction; a collector who desires to purchase an artwork immediately may be willing to pay a higher price at the dealer, instead of waiting until it appears at auction. A final economic explanation for price dispersion equilibria is in terms of search costs: economists have argued that even when consumers know that price differences exist for a good they want to buy, it takes time to locate the store that sells it for the lowest price. Search costs reflect the value of the time that is spent finding the same good for a lower price. Given the high average income of art collectors, the opportunity costs of this time are high. A utility-maximizing collector

will therefore proceed to buy a good before the lowest price is found because the expected price difference does not outweigh the additional costs of extra search efforts. For instance, even when a collector knows that a work that is offered at auction is also available at some dealer, he may proceed to buy it at auction against a higher price, since he does not want to incur the search costs related to finding that particular dealer. Conversely, some dealers will abstain from lowering their prices even if they know they are being underpriced by the auction houses; since their profit margin per unit sold will be higher than the margin of their competitors, these shops will not necessarily be driven out of business. Thus a market equilibrium may come into being which allows for price dispersion (Okun 1981; Phlips 1988).[23]

Erecting Boundaries

On the basis of the structural opposition between auction houses and galleries, I propose an alternative explanation. In order to avoid the harmful volatility of auction prices, art dealers deliberately allow for differences between their own prices and those established at auction. Dealers have a strong interest in stabilizing the long-term development of the price level of an artist's work, and controlling the biography of the artworks they sell. Therefore, they do not adjust their own promoter prices to the parasitic prices established at auction. They certainly realize that a situation in which gallery and auction prices are not identical is a hazardous one. On the one hand, when gallery prices are lower than auction prices, dealers unwillingly and unintentionally provide collectors with opportunities for arbitrage: a collector who has bought at the gallery may resell this work for a profit at auction. On the other hand, when gallery prices are higher than auction prices, which happens more frequently in the careers of artists, this "casts a doubt on gallery prices," as a former Dutch dealer remarked (NL5). Other dealers called auction prices that are lower than gallery prices "humiliating" and "painful" for artists and a "worst-case scenario" for themselves. In spite of that, however, they abstain from decreasing their prices. Says a Dutch dealer: "If auction prices are lower than gallery prices, that certainly does not mean for contemporary art that you will decrease prices, because decreasing prices is a very problematic issue" (NL7). The reasons for refraining from decreasing prices must be strong, since it results in exhibitions where works remain unsold. Also, by refusing to decrease gallery prices, dealers run the risk that collectors start buying works at auction rather than in the gallery.

To understand how dealers get away with these price differences nevertheless, and how the market functions in spite of this unstable equilibrium, we need to realize that the dealer offers services on top of selling an

artwork: her role of educator and confidant warrants a price premium if compared to the auction house, which merely matches supply and demand. Indeed, sociologists Paul DiMaggio and Hugh Lough hypothesize that price dispersion is caused by buyers who are willing to pay a higher price as long as they know their transaction partner; the price premium can be seen as an insurance premium, which should guarantee the quality of the work (DiMaggio and Louch 1998, p. 636).

If gallery prices are lower than auction prices, the problem paradoxically coincides with the solution: in this situation collectors may be able to make a quick profit from arbitrage (buying at the gallery and subsequently selling at auction), but at the same time dealers can control the future biography of an artwork by being overly selective when it comes to the collectors they allow the work to go to. Television producer and collector Douglas Cramer recounts how he needed two introductions to Leo Castelli, a visit to the artist's studio, and subsequently a lunch with the dealer and the artist before he could buy a work by Jasper Johns. Cramer recalls: "That was the closest thing to a papal appointment in those days."[24] What dealers effectively do in this situation is to erect boundaries between their own and the auction circuit, which reduce the fungibility of auction and gallery prices. One of my respondents remarked with an understatement that Gursky's New York art dealer Matthew Marks is "probably very concerned that they do not sell the works to people who are kind of known as speculators. (. . .) I am sure they took great efforts to make sure the work went to museums or collections where the collectors are not known for doing that kind of thing. They don't want the work on the market" (us15). This can be achieved by putting a clause in the invoice of a sale, which obliges the collector to give the gallery "first right of refusal" in case he wants to resell the work, as for instance New York art dealer Andrea Rosen does (Coppet and Jones 2002). In this case a semi-legal boundary is erected between the gallery and the auction circuit. Another possibility is to simply avoid selling to buyers who are suspected of buying for speculative motives. I was told that blacklists circulate of collectors who have a reputation of frequently reselling work and mainly buying contemporary art for speculative reasons. Almost invariably, the English collector Charles Saatchi was mentioned as a collector who needs to be treated with caution. The most common arrangement, however, to prevent the work from appearing at auction is a gentleman's agreement; this means that collectors are expected to abstain from reselling work. According to dealers, collectors understand that resale will harm their future relationship. Says one dealer: "If there is a Luc Tuymans on the secondary market, that is here, not at the auction houses. Because the collector does the right thing, he gives it to us, so that we feel good about him buying other works, even by this artist. If he would put it at auction, we would never sell to him again,

we punish him" (us15). By contrast, collectors who are not part of the gallery's circle of favored collectors have no other option than buying work of popular artists at auction, where they have to pay a higher price. A premium is thus paid if no loyalty exists between a dealer and a collector interested in a specific work.[25]

Conclusion

In order to understand the mechanisms used to set prices on the art market, our conception of markets needs to be stretched. My interview data suggest that markets are not only allocative mechanisms, but also sites for definitional struggles: art dealers have an interest in promoting careers of artists, rather than selling individual works of art; also, they seek to suppress the commodity character of a work of art, and want to prevent it from being in contact with money after its initial sale. This market agenda conflicts, however, with that of auction houses, who by and large treat artworks as commodities, and seek to make a profit from selling individual pieces.

This chapter started with the puzzle that works by a contemporary photographer could sell for auction prices that surpass the price level in his gallery more than four times. Rather than an isolated incident, price dispersion is a structural feature of the art market. I have tried to account for this feature by analyzing the price mechanism in terms of two separate circuits, an avant-garde circuit, and an auction circuit. The prices established in either circuit not only differ in quantitative terms, but also qualitatively. Art dealers interpret their own gallery prices differently, and attach moral connotations to them which emerge from the gallery's caring, protective role towards the artist. By contrast, auction prices are prices of the parasites, who are eager to make a quick profit. According to galleries, artists need to be "protected" against these "unreal" auction prices. They do not use the price mechanism to sell the work to the highest bidder in case of excess demand, but ration the work by means of waiting lists instead. These waiting lists enable the dealer to decide who gets the works, and puts her in charge of the long-term price development of an artist's oeuvre. The opportunities for arbitrage that she thereby creates are undone by erecting boundaries between her own circuit and the one of auctions: dealers prevent arbitrage from taking place by means of a gentleman's agreement or even by legal stipulations, which give them first right of refusal in case a collector wants to resell. What has remained obscure in this analysis, however, is how the fixed prices that galleries prefer over the tainted auction mechanism are being determined. To this issue I now turn.

Determinants of Prices

INTRODUCTION

The question of whether any regularities exist in prices for works of art has intrigued economists throughout the history of economic thought (De Marchi 1999). For different reasons, classical economists such as Adam Smith or David Ricardo, marginalist economists like W. Stanley Jevons, and the founder of modern economics, Alfred Marshall, agreed that no systematic explanation exists for the prices of rare and irreproducible goods like art. The upshot of Adam Smith's analysis of paintings was that the cost of producing them could not account for their selling price. Because of their limited, fixed supply, "fancy and means" of buyers would "drive a wedge between costs (. . .) and price," as Neil De Marchi and Hans van Miegroet summarize Smith's analysis (De Marchi and Van Miegroet 1999, p. 393). For the same reason, the nineteenth-century classical economist David Ricardo considered "rare statues and paintings" an exception to his labor theory of value. The value of rare art, Ricardo wrote, was "wholly independent of the quantity of labour originally necessary to produce them, and varies with the varying wealth and inclinations of those who are desirous to possess them" (Ricardo 1817 [1925], p. 6). The reason was that the supply of these rare artworks was fixed, just like the supply of other irreproducible goods such as scarce books, coins, or wines. As a result, fluctuations in demand could not result in changes in supply, but would inevitably lead to changes in price.[1]

When W. Stanley Jevons subjected the classical labor theory of value to critique in his *Theory of Political Economy,* he cited Ricardo's very remarks on the exceptionality of prices for paintings. Since Ricardo's labor theory of value could not account for these prices, Jevons wrote that it was "a doctrine which cannot stand for a moment" (Jevens 1871 [1970], p. 185). According to Jevons's alternative, so-called marginal utility theory, market prices are to be explained in terms of demand rather than supply-side factors. Economic value, Jevons argued, origi-

The analysis in this chapter is based on a publication which was co-authored with Merijn Rengers (Rengers and Velthuis 2002).

nated from the fact that people derive utility from consuming a good. The more units of a good they consumed, the less utility they would derive from each extra good. Therefore, Jevons theorized, the price people would be willing to pay equals the marginal utility of the good, that is, the utility provided by the last unit consumed. Nevertheless, just like Ricardo and Smith, Jevons was forced to treat rare art as an exception. The reason was that artworks are unique, indivisible, and incomparable objects "which do not admit of the conception of more or less." In other words, his assumption that we derive more or less units of a good did not apply to the case of rare art. This rendered the notion of marginal utility meaningless with respect to these artworks. Jevons suspended the issue by remarking "there was no approach to rule or congruity . . . the arbitrary fancy of some monarch or wealthy person is the only rule" (cited by White 1999, pp. 71–72).

In the founding text of modern economics, *Principles of Economics* (1890), Alfred Marshall combined the classical, labor theory of value with marginal utility theory: just as it is impossible to determine "whether it is the upper or the under blade of a pair of scissors that cuts a piece of paper," Marshall argued that it is impossible to tell "whether value is governed by utility or cost of production" (Marshall 1890 [1982], p. 290). Instead, Marshall claimed that prices are established by supply and demand. With respect to prices of paintings and other rare goods such as wine, however, Marshall argued that they are beyond systematic economic analysis. The reason was that these prices were too chancy: "the price at which each is sold, will depend much on whether any rich persons with a fancy for it happen to be present at its sale." This, however, should not bother economists, Marshall added, since the case of art and other irreproducible goods may be "put aside as of little practical importance" (Marshall 1890 [1982], pp. 276–77).

Financial Assets

Contemporary economists, unlike their nineteenth-century counterparts, have largely addressed the question of regularities in prices for art by means of quantitative data. With the help of so-called hedonic price functions in particular, some cultural economists have tried to make claims about the reasons why buyers demand goods like artworks that are more precise than the crude categories of supply and demand allow for. The underlying assumption of hedonic price functions is that goods consist of bundles of characteristics which consumers value separately. If observa-

tions can be collected on prices of certain goods whose quality varies with respect to some characteristic, the willingness to pay for each characteristic can be estimated with the help of a hedonic price function. This function expresses the price of a good in terms of all its relevant characteristics. For a work of art, this technique should make it possible in principle to tell how much people are willing to pay extra for a large painting over a small one, a canvas over a work on paper, a work made by a well-known artist over a work by an emerging one, a work offered for sale at an established gallery over one exhibited at a starting one.

The shortcoming of hedonic price functions is, however, that they do not explain if price-determining factors are related to the demand or the supply side of the market. For instance, if wine of a higher alcohol percentage is more expensive, this may be because consumers value this attribute of wine more highly, but it can also be caused by the fact that such wine is more costly to produce for suppliers. When it comes to art, prices can in other words be identified with factors related to preferences of collectors, but also with cost factors for artists (Nerlove 1995, p. 1699).[2] With the caveat of this identification problem, we can consider hedonic price functions to study the art market. A small number of studies have regressed the price of artworks on characteristics such as its size, the style of the work, the technique used, the age, reputation or institutional recognition of the artist, or the type of gallery where it was bought.[3] In the remainder of the chapter I will compare their results with the results of my own analysis.

The present analysis differs in two respects from previous ones. First of all, whereas other studies invariably use auction data from the *secondary* or resale market for art, I study the *primary* art market; in other words, the prices I analyze are gallery prices established for the first-time sale of an artwork. Due to limited availability of data and the lack of transparency of the primary market, economists have so far largely ignored this segment. However, the primary market deserves special attention because most artists do not have a secondary or resale market to begin with. After being sold on the primary market, their work will never appear on the market again.[4] This analysis relies on the first and, to date, only extensive data set on Dutch gallery prices and a large number of their potential determinants; no quantitative data are available on New York gallery prices. The second difference from previous studies concerns methodology. Whereas almost all studies so far have been based on ordinary least-square regression analysis to estimate determinants of prices, this chapter uses multilevel analysis (for a detailed explanation of the technique and its advantages, see appendix D).

Description of the Data

The data that I use are derived from a Dutch subsidy arrangement designed to stimulate sales on the primary art market in the Netherlands. The Dutch government provides private buyers of contemporary art at a large selection of galleries in the Netherlands with interest-free loans.[5] The entire acquisition price is prefinanced by the government, after which the buyer pays for the work in monthly installments. The selection of galleries that participate is largely based on their professionalism.[6] For living artists, both Dutch and foreign, and for Dutch private buyers, no restrictions exist for participating. Initially there was a lower price limit to art acquired through the arrangement of €227 (this lower limit was later raised to €454). No upper limit exists for the price of the works of art that can be bought via the arrangement, but the interest-free loan was originally restricted to €5,682 (this upper limit was later raised to €6,818; see Gubbels 1995 for details of the arrangement). The government arrangement does not intervene in the market directly; neither does it affect the price level: comparable works of art are sold for identical prices in a gallery, whether collectors make use of the arrangement or not.[7] Indeed, the works sold via the government arrangement account for

TABLE 4.1
Characteristics of artworks sold on the Dutch market

	Mean	Standard deviation
Selling price	€2,227.60	€1,613.81
Size		
Surface (cm²)	8,161.15	8,069.27
Height (cm)	55.47	38.96
Relation Price–Size		
Price per cm²	0.28	
Price per cm height	40.00	
Material (percentage of total sales)		
Painting	50%	
Print	7%	
Sculpture	21%	
Drawing	4%	
Watercolor	6%	
Glass, ceramic	9%	
Other	3%	
N	11,869	

no more than approximately 10 percent of total gallery sales in the Netherlands.

The data set which is derived from the arrangement contains prices and characteristics of over 16,000 works of art, sold between 1992 and 1998 for a total amount of over €34 million (almost €5 million on an annual basis). These works have been produced by more than 2,400 artists and were sold in over 230 Dutch galleries. The data were supplemented with available data on living visual artists in the Netherlands, which provide detailed histories of any type of government involvement, from individual subsidies to works that have been acquired by government-subsidized museums. The prices in the analysis are actual selling prices, not posted or listed prices. Transactions at the lower and upper end of the market are underrepresented in the data set: I assume that collectors who are rich enough to purchase expensive works of art are less likely to obtain the interest-free loan. Lower priced artworks are also underrepresented in the data, since the galleries that sell these works are unlikely to participate in the government arrangement. Thus I leave the high and low price extremes aside, and focus on the middle range of the Dutch art market. Before analyzing them, let me describe the data concisely.

The number of works included in the analysis is almost 12,000 (table 4.1).[8] The mean price of an artwork sold through the arrangement between 1992 and 1998 is €2,228. The average surface of the two-dimensional works is 8,161 square centimeters. This means that one square centimeter of art costs about €0.28 on the Dutch market.[9] The factor height is included for three-dimensional works of art, such as sculptures and (glass) objects. They measure 55 centimeters on average. The works of art have been categorized in seven different techniques. Paintings constitute the largest category of works of art sold on the Dutch market, followed by sculptures and glass or ceramic objects.

The data set contains information on 2,089 artists (table 4.2). The average number of works sold by an artist between 1992 and 1998 is 5.68. The "best-seller" sold for nearly €700,000. The average artist, however, earned approximately €12,500 over the period 1992–98; the average revenue per artist per year is therefore only €1,800. The art sold through this arrangement is not the only source of market income for artists. Nevertheless, the low figure is a tentative confirmation of previous research, which indicates that only a small percentage of artists can make a living from selling their work on the commercial market (see for instance Rengers and Plug 2001).

Not all works of art that artists sell through the arrangement have been executed in the same technique. On average, each artist sells works that are made in more than one and less than two different techniques; for instance, artists sell both paintings and drawings through a gallery. Their work is usually represented by more than one gallery (on average 1.44).

TABLE 4.2
Characteristics of artists active on the Dutch market

	Mean	Standard deviation
Total sales per artist	€12,657	€30,351
Sale characteristics		
Number of works sold	5.68	11.70
Number of different galleries	1.44	1.09
Number of different mediums	1.36	0.70
Demographics		
Age	50.03	11.92
Female	25%	
Foreign nationality	20%	
Place of residence		
Amsterdam	21%	
Rotterdam	4%	
Abroad	22%	
Other	53%	
N	2,089	

The majority of artists live in Amsterdam, which is the cultural center of the Netherlands. Their age is 50 years on average; apparently, it takes a long time before an artist starts selling on the art market.[10] Furthermore, male artists represent approximately 75 percent of the artists selling through the arrangement. This is striking, since almost half of the total population of visual artists in the Netherlands is female (Brouwer and Meulenbeek 2000).

A large number of galleries (about one third in the sample) are situated in Amsterdam (table 4.3). The oldest gallery that participates in the arrangement has had its doors open since 1941, the "youngest" since 1995; the galleries in the sample have been in business for 15 years on average. Between 1992 and 1998 the average gallery sold €130,248 worth of art via the arrangement; the average number of works sold per gallery was approximately 58. The distribution is skewed: one gallery sold over €18 million via the arrangement, while another gallery only sold artworks worth €794 (not in the table). Two dummy variables were introduced for the institutional affiliation of the gallery ("experimental" or "avant-garde" art versus "traditional" or "easily accessible" art) on the basis of membership in the two main gallery associations in the

TABLE 4.3
Characteristics of galleries selling on the Dutch market

	Mean	Standard deviation
Total sales per gallery	€130,248	€217,389
Sale characteristics		
Number of works	58.47	80.18
Number of artists	15.33	13.69
Location		
Amsterdam	32%	
Rotterdam	6%	
The Hague	8%	
Other	54%	
Demographics		
Age of the gallery	14.95	9.69
Affiliation		
Traditional/easily accessible	35%	
Avant-garde/experimental	33%	
No clearly distinguishable affiliation	32%	
N	203	

Netherlands, and participation in two large Dutch art fairs (Gubbels 1995; Abbing 1998).

MATERIAL EFFECTS ON PRICES

Let me now discuss my findings. To begin with, the slump of the art market, which happened in the Netherlands as well as abroad, is reflected in a negative price effect for works of art sold between 1993 and 1996, when the market started to recover.[11] With respect to artworks, my findings are as follows: of all techniques used by artists, paint (oil, acrylic, or tempera) on canvas, which serves as the reference category, is most expensive (table 4.4). On average, for instance, a print is €1,991, a watercolor €683 cheaper than a painting. Also, for every extra standard deviation of size, the price of an artwork increases by €630 (with a t-value of 52.5, this variable is a very strong predictor of prices).[12] Larger works of art are, in other words, more expensive on average. These effects of size and technique on price have also been found for the French, the American, and the international art market.[13]

The question is how to interpret these findings. According to hedonic theory, these price effects represent the consumer's willingness to pay for larger size artworks and for paintings.[14] With respect to medium, they confirm the sociological hypothesis that, given the widespread preference for authenticity and originality, buyers value artworks according to the "proximity" to their creator. Therefore, the price of paintings is likely to be higher than for works made in edition (Zolberg 1990, p. 87; Sagot-Duvauroux et al. 1992, p. 94; Herbert 1987, p. 13). At the same time, however, the higher price can be related to the supply side of the market. A large oil painting takes longer to execute than a small drawing and is more costly in terms of materials; therefore artists will ask a higher price for it. Also, works that are made in edition such as lithographs are per unit less costly to make for an artist than unique works.

Thus the model does not satisfactorily answer the question of how the strong correlation between price on the one hand, and size and material on the other, is caused. Nevertheless, it casts doubt on the claim, which has frequently been made by other sociologists, that "[a]rt is one of the few commodities where the relationship between production costs and price is practically nonexistent."[15] Such assertions seem to be based on a relatively small number of transactions that have received disproportionate attention, in the media and elsewhere, because of their extraordinary prices.

VEBLEN EFFECT

A second set of determinants concern artists rather than artworks. The effect on price of the number of works an artist sells is clearly positive.[16] Consumers are apparently not willing to pay a "price premium" for the rarity of the work they buy (Koford and Tschoegl 1998). This can be interpreted in a number of ways. First of all, previous studies have argued that success on the art market manifests itself in a simultaneous increase of sales and prices (Rouget et al. 1991, p. 113). Alternatively, the positive correlation between numbers of artworks sold and price can be understood as a penetration strategy that dealers may opt for: they start pricing low and increase prices only when a critical level of sales has been made. Another interpretation is in terms of a "Veblen effect." Art can be considered as a quintessential example of what Thorstein Veblen called conspicuous consumption; in the *Theory of the Leisure Class*, Veblen argued that consumption behavior of the socioeconomic elite that he called the leisure class is governed by "pecuniary canons of taste" (Veblen 1899 [1994], ch. 6). Following these pecuniary canons, members of the leisure class value goods in proportion to their monetary costs. Also, they seek to emulate their companions by means of invidious consumption, that is, consumption of objects which is meant to confer status

TABLE 4.4
Multilevel hedonic price function for the Dutch art market

Variable	Coefficient	Standard Error	t-value
Constant	882	198[c]	
Characteristics of works of art			
Material			
Painting	0	0	
Print	-1,991	63[c]	-31.60
Sculpture	-318	43[c]	-7.40
Drawing	-725	67[c]	-10.82
Watercolor	-683	59[c]	-11.58
Glass	-425	64[c]	-6.64
Other	-329	83[c]	-3.96
Standardized size $*10^3$	0.63	0.012[c]	52.50
Characteristics of artists			
Sale characteristics			
Number of works sold	7.64	2.45[c]	3.12
Number of works sold squared	-0.033	0.010[c]	-3.30
Number of different galleries	30.69	17.16[a]	1.79
Number of different mediums	-0.75	27.3	-0.03
Demographic characteristics			
Age	10.89	2.61[c]	4.17
Female	-138	48[c]	-2.88
Foreign nationality	268	105[b]	2.55
Geographic characteristics			
Amsterdam	138	55[b]	2.51
Rotterdam	-200	106[a]	-1.89
Abroad	525	99[c]	5.30
Other	0	0	
Institutional recognition			
Participated in BKR	155	52[c]	2.98
Received small grant	-125	60[b]	-2.08
Received large grant	-165	67[b]	-2.46
Received government commissions	174	70[b]	2.49
Sold works to a museum	87	67	1.30
Average price of museum sales	0.05	0.001[c]	50.00
Characteristics of galleries			
Sale characteristics			
Number of works sold	2.98	0.71[c]	4.20
Number of artists	-7.87	4.59[a]	-1.71
Percentage artists selling to museums	2.09	1.92	1.09

TABLE 4.4 *(Continued)*
Multilevel hedonic price function for the Dutch art market

Variable	Coefficient	Standard Error	t-value
Location of the gallery			
Amsterdam	181	98[a]	1.85
Rotterdam	95	162	0.59
The Hague	99	133	0.74
Other	0	0	
Demographics			
Age of the gallery	7.98	4.84[a]	1.65
Affiliation			
Traditional/commercial	86	105	0.82
Avant-garde/experimental	20	110	0.18
No clearly distinguishable affiliation	0	0	
Year sold			
1992	0	0	
1993	-164	59[c]	-2.78
1994	-118	63[a]	-1.87
1995	-13	63	-0.21
1996	-73	67	-1.09
1997	259	63[c]	4.11
1998	371	63[c]	5.89
R^2	.27		
N (works of art)	11869		
N (artists)	2089		
N (galleries)	203		

[a]significant at 90% level. [b] significant at 95% level. [c] significant at 99% level.

on their possessor: "the utility of these things to the possessor is commonly due less to their intrinsic beauty than to the honour which their possession and consumption confers, or to the obloquy which it wards off" (Veblen 1899 [1994], p. 79).[17] Or, as economist Harvey Leibenstein later rephrased Veblen's ideas, collectors derive utility not only from looking at the painting, but also from the high price they have to pay for it (Leibenstein 1950).

The number of different techniques that an artist uses does not have significant effects on price. Neither did I find a "monopoly effect," according to which artists who sell at fewer galleries receive higher prices because of reduced competition between galleries. This contradicts previous qualitative (Moulin 1967 [1987], p. 8) and quantitative (Frey and Pommerehne 1989, p. 90) findings. One tentative explanation is that successful artists, whose prices are high, are more likely to be represented by

several galleries simultaneously than their less successful colleagues: many galleries want to work with these successful artists, while simultaneously these artists can afford to disagree with the condition of exclusive representation that many galleries insist on.[18]

Geographic variables do have significant effects on the price level. The most expensive works of art are those of foreign artists living abroad; their foreign nationality accounts for a price increase of €268 on average, and the fact that they live abroad for another €525. A smaller price premium is evident for Amsterdam artists. Compared to the reference group of artists living elsewhere in the Netherlands, the works of Amsterdam artists are on average about €140 more expensive. Artists living in Rotterdam receive on average €202 less for their work. Again, these geographical price effects can be explained in terms of both supply and demand factors. On the supply side, it is likely that Dutch galleries which sell the work of artists living abroad—no matter what nationality they are—charge higher prices, since these galleries incur considerable costs in order to display this work. These costs relate to for instance shipping and insurance. Also, in case the Dutch gallery is not the main representative of the artist, a commission has to be paid to the artist's primary gallery abroad. Further, living and working abroad may be more expensive than in the Netherlands (a studio in Paris, London, or New York costs more than a studio in Amsterdam). Likewise, living in Amsterdam is more costly than in the rest of the Netherlands. This induces an artist to ask higher prices for his work.

On the demand side, consumers may interpret the foreign nationality of an artist as a sign of success. As a result, they are willing to pay more for a foreign artist. It is however unlikely that consumers also have a preference for Amsterdam artists, no matter what their work looks like. Nevertheless, the geographical price effect can be related to demand factors. The Dutch art market, like many foreign art markets, is structured in terms of a center and a periphery (see Plattner 1996, pp. 76–77). The center is where demand is concentrated, reputations are built, and the density of social networks is highest. By any of those standards, Amsterdam is the center of the Dutch art world. Artists who are part of a dense network may have easier access to sales networks, critics, and important colleagues. This can enhance their visibility, reputation, and therefore the price level of their work.

INSTITUTIONAL RECOGNITION AND PRICES

Works of older artists are more expensive than the works of their younger colleagues. Every year of age difference equals a price gap of €11 between artists on average; similar effects of age on price have been

found before.[19] From a labor economic perspective, this suggests that age, interpreted as an indicator of experience, influences the supply of art: older artists may make more mature, valuable work, and may have skills that allow them to be more productive than their starting colleagues.[20] On the demand side, collectors may be willing to pay for age because they interpret it as a sign of quality. Also, the correlation between age and price can be explained as analogous to the price effect of geographical factors: although there is no reason to expect that collectors have a general preference for older rather than younger artists, older artists have had more time to enhance their visibility, reputation, and therefore the demand for their output (cf. Sagot-Duvauroux et al. 1992, pp. 91–92; Bowness 1990).[21]

I also studied reputation effects separately by looking at "institutional recognition," the amount of attention that an artist receives from museums and other institutions of the art world. The effects of institutional recognition on the price level are mixed: museum acquisitions have a strong positive effect. If a museum has acquired one or more artworks by an artist, the price level on the private market is €87 higher on average. On top of this fixed effect, the amount of money involved in the museum acquisition matters: the higher the price level which a museum paid for an artist's work, the higher the average price level on the private market. Furthermore, some grants have a positive effect on the price level of an artist's work, others lead to a downward pressure on price. Artists who have received a small grant to cover professional costs from the government tend to sell for slightly lower prices; receiving a large individual subsidy also has a negative effect of €165. Works by artists who were part of the so-called Visual Artists Arrangement (*Beeldende-Kunstenaars-Regeling*, abbreviated as BKR), a welfare program for artists which was abolished in the late 1980s, are €155 more expensive than works by colleagues who did not receive such a subsidy. Receiving a commission from the government to execute a work for a public space or government building, is a source of recognition which likewise results in a positive price effect on the art market.[22]

How should the effect of institutional recognition on price be interpreted? Official institutions like museums may enhance the reputation of the artist and function as a "proof" of quality by acquiring the artist's work. The same is true for government bodies which award grants and commissions to individual artists. If an artist's work has been bought by a museum, this is a quality signal to private collectors, which positively affects demand. Also, museum acquisitions raise the "visibility" of artists, which helps collectors economize on information costs: artists that are represented in museums are more well known, which may be a stimulus to demand for their work (Pommerehne and Feld 1997). Also,

as Dominique Sagot-Duvauroux (et al.) put it in an explorative study of prices: "[f]or consumers, demand may be higher because they derive higher prestige from a well known artist, whereas the financial risk of buying his work is lower" (Sagot-Duvauroux et al. 1992 p. 92; Heilbrun and Gray 1993, p. 164).

If the museum effect can easily be explained, the effects of grants and commissions on the price level are puzzling. I had expected that these effects depend predominantly on the amount of money involved and the exclusiveness of each subsidy arrangement: small grants with a liberal selection process having small reputation effects, larger grants having a strong effect on the reputation of an artist and the price level of her work. Instead, my analysis showed that large, prestigious individual grants have a negative effect on the price level; by contrast, artists who participated in the least prestigious arrangement of all, the Visual Artists Arrangement (BKR), sell their work for higher prices.

Finally, female artists receive on average €138 less for their work. A similar gender-induced wage gap has been reported for the American (Alper et al. 1996) and the Australian art sector (Rengers and Madden 2000, p. 256). A separate stepwise analysis was performed (not reported here) to explain this gender gap. Initially, before controlling for the effects of other variables, the gross price difference between works of male and female artists was €231. Including dummy variables for technique and the year in which the artwork was sold increased the gender gap to €270. Including size (-€27), city of residence (-€8), career characteristics (-€36), and most importantly, age (-€54), reduced the gender gap to approximately €144, which almost equals the gender gap reported in table 4.4. This final gap shows that the market discriminates between male and female artists.[23]

What Do Galleries Do?

Remarkably, most characteristics of galleries do not have a significant effect: the affiliation of the gallery (traditional versus avant-garde) does not influence the price of works sold; neither does the reputation of the gallery, measured in terms of the number of artists it represents that sell works to museums. A small positive effect exists for the number of works sold through a gallery (almost €3 for every additional work), but the magnitude of this gallery effect is much smaller than the comparable price effect of numbers of artworks sold by an artist (see previous section). Galleries that concentrate their sales efforts on a small number of artists sell works at a higher price level than galleries that divide their energy over a larger group, but again this effect is marginal. The age of

the gallery only has a small, albeit significant effect: for every additional year the gallery exists, prices increase on average by approximately €8 per artwork. The explanation is that older galleries, just like older artists, have been able to devote more time to establishing their reputation among experts and to enhancing their visibility in the art world. Also, collectors may interpret the age of the gallery as a quality signal, for which they are willing to pay.

Compared to the rest of the Netherlands, galleries located in Amsterdam sell artworks that are on average €181 more expensive than works sold by their competitors elsewhere in the country. This may be caused by the supply-side effect of higher rents and therefore higher operating costs in Amsterdam. On the demand side the same argument which I used to explain the positive price effect for artists living in Amsterdam can be applied: demand is concentrated, relevant networks are dense, and reputations are established in Amsterdam. Other locations of galleries had no significant effect. Overall, the many insignificant effects of gallery characteristics suggest that galleries are not able to add economic value themselves. The role of the gallery seems to be limited to the matching of supply and demand on the art market: from an economic point of view its role seems confined to first selecting artists and their works, and subsequently marketing these to collectors.

Changes in Explained Variance

How do these characteristics of artworks, artists, and galleries affect the variance in prices of artworks sold on the Dutch art market? The total explained variance (R^2) of the model is .27 (table 4.4). Given the large number of variables that the model includes, this suggests that variance in prices is to a large extent random, and can by definition not be accounted for. In other words, although regularities clearly exist, prices for contemporary art do not seem to behave in a strict, law-like way. At the same time, it should be acknowledged that there may be sources of reputation for both artists and galleries which the data do not include.[24]

The advantage of multilevel analysis, compared to ordinary regressions used by other studies, is that changes in explained variance can be measured across different levels of analysis. Table 4.5 shows how this happens by successively adding variables related to artworks (I), artists (II), and galleries (III). The initial variance is related for almost two-thirds (65 percent), either in a systematic or in a random way, to the level of works of art; 24 percent can be attributed to artists and 11 percent is apparent among galleries.

TABLE 4.5
Changes in (un)explained variance by adding variables

	Initial variance	I*	II*	III*	Final model
Work of art	1,654,307 (65%)	−29%	−29%	−29%	1,175,816 (63%)
Artist	608,083 (24%)	+14%	−7%	−7%	564,252 (30%)
Gallery	292,713 (11%)	+5%	−34%	−55%	133,116 (7%)
Total	2,555,103 (100%)	−15%	−24%	−27%	1,873,186 (100%)

*All changes in variance are relative to the initial situation.

The first step (I), including characteristics of works of art, explains 15 percent of the total variance in market prices. This main effect breaks down into three separate effects: the variance among works of art drops 29 percent, the variance among artists *increases* rather than decreases (14 percent), and the variance among galleries also *increases*, (5 percent). This finding indicates that *within* the oeuvre of one artist, price and size correlate strongly. However, the characteristics of the works are not helpful for the explanation of price differences between artists. On the contrary: size and other material differences *between* works of art partly mask price differences between the work of different artists, as the increase in unexplained variance on the level of artists indicates.

The next step (II) is to include characteristics of the artists in the model. The overall unexplained variance drops 24 percent (relative to the initial situation), which is due to reduced variance among artists (−7 percent) and particularly among galleries (−34 percent). Apparently, price differences between galleries are partially explained by characteristics of artists. In other words: "expensive" galleries are expensive because they sell works of "expensive" artists (old, foreign, male artists, for instance). This implies that one function of galleries is to "pass on" price-increasing (or price-decreasing) characteristics of artists to the general public. As we saw, this mechanism does not occur between works of art and galleries: when variables related to artworks were added (I), the variance on the level of galleries increased rather than decreased (5 percent). Thus galleries choose expensive or cheap *artists*, rather than expensive or cheap *works of art*.

The final step (III) is to include gallery characteristics. This does not alter the (un)explained variance among artists or works of art; it does improve the explanatory power on the level of galleries with another 21 percent. As a result, the model explains 55 percent of the original variance on the level of galleries. In the complete model, 63 percent of the

total remaining variance can be attributed to works of art, 30 percent to artists, and only 7 percent to galleries. In terms of explained variance, the model performs best with respect to galleries, whereas it turns out to be most difficult to explain variance related to artists.

CONCLUSION

Suppose you are requested to estimate the price of an artwork without seeing it. To determine the estimate, you are allowed to ask three questions relating to the maker of the work, the work itself, or the gallery where it is for sale. Which questions do you ask in order to establish a reliable estimate? This chapter has provided a tool to comply with such a request. A statistical model was developed which predicts prices of artworks sold in the Netherlands with the help of characteristics related to artworks, artists, and galleries. The model helps exploring prices of a category of goods that have puzzled economists throughout the history of economic thought. Also, I have provided detailed figures on prices, materials, and sizes of artworks sold in the Netherlands, as well as a large number of characteristics of the artists that made these works, and the galleries where they were sold.

My findings can be summarized as follows: if you are asked to give a reliable estimate of the price of a work without seeing it, ask what the size is of the work, which technique the maker used, and for what price the maker may have sold artworks to museums. These are the most reliable predictors of the price of artworks in the Netherlands; other strong overall predictors of the price level are the age and place of residence of the artist. We also saw that characteristics of galleries, such as their age, reputation, or institutional affiliations, hardly influence the price level. Simultaneously, characteristics of *artists* explain a large amount of variance on the level of *galleries;* in other words, the fact that galleries sell expensive art has more to do with the artists they represent than with their own characteristics.

Other noteworthy findings are a positive correlation between price and number of artworks sold, which can be interpreted as evidence of what Marxist-inspired art historians have disapprovingly called commodity fetishism or what Veblen has called pecuniary canons of taste: it may be the case that collectors admire the price of art, without paying proper attention to its visual qualities. A high price, rather than inhibiting them, induces them to buy a work of art. An alternative, less spectacular interpretation, however, is that once an artist becomes successful, this translates simultaneously into higher sales as well as higher prices.

One of the most precarious relationships that the model indirectly addresses is the relationship between the quality and the price of a work. Especially in what I have referred to as "Hostile Worlds" thinking, we find the *topos* that price, on the one hand, and quality or value, on the other, are dichotomous categories: the assumption is that price is established by the impersonal economic forces of supply and demand, without taking the quality or value of a work of art into account. The conservative critic Hilton Kramer noted in the 1980s that "the enormously high prices that works of art now bring (. . .) bear absolutely no relation to the quality of the object, but then prices rarely do" (quoted in Grampp, 1989 p. 27). Alan Bowness, former director of the Tate Gallery in London, argued in a similar vein that financial success is "quite irrelevant to the quality of the work" (Bowness 1990, p. 59).

Although I don't have a direct measure of quality—the more so since I implicitly assume that quality is, in the end, not a given but a social construction—my indirect measure (which is institutional recognition) does correlate with the price of the work. At least, artists with a high institutional recognition, whose work is being collected by museums, sell their work for higher prices on the commercial market. Apparently, the artistic or aesthetic judgment of museum experts, who deemed the work of an artist worth acquiring, are in line with the commercial judgment of the market.

The claim that economic and artistic value are consistent rather than contrary, and that excellent artists are rich rather than poor, has been given empirical underpinning before. One source that economists have frequently looked at is the *Kunstkompaß*, compiled by the late German journalist Willi Bongard. From the early 1970s onwards, Bongard collected data on the international market for top artists. He noted prices of more than hundred world-famous artists and registered among others how many times an artist was mentioned in a periodical, how many works of the artist were bought by a public museum, and how many times the artist had a group or solo exhibition. To all these forms of institutional recognition, he assigned a numerical value. For instance, a work bought by the Museum of Modern Art in New York equaled an increase of 300 units in the artistic standing of the artist, whereas the Art Institute of Chicago added only 200 points. By adding up all these numerical values, Bongard established an overall indicator of artistic value. Starting in 1970 he published this hit parade of artists annually in the German glossy business magazine *Capital*. Bongard died in 1986, but with the cooperation of his wife Linde Rohr-Bongard the *Kunstkompaß* still appears (see Verger 1995, pp. 85–89; Bonus and Ronte 1997, pp. 105–9).

Edition 2001 of Kunstkompaß, the annual list of the 100 most valued artists of the world, published by the German business monthly *Capital*.

Analyzing Bongard's data in a model which relates prices of artworks to their respective determinants, Bruno Frey and Werner Pommerehne conclude that "[t]he often stated claim that the prices of works of modern art are completely unrelated to their artistic value is (. . .) not borne out by the analysis. If anything, the contrary tends to be true: the painters and sculptors with the highest prices are, on the whole, those with the highest artistic achievement" (Frey and Pommerehne 1989, p. 93). Economist David Galenson has likewise taken issue with the fact that "art

auctions—particularly those of contemporary art—have often been dismissed by art critics as having little relevance to art appreciation, with prices determined by wealthy collectors whose purchases are of little scholarly interest" (Galenson 2000, p. 91). Instead Galenson shows that artworks that are included in museum retrospectives and catalogues of contemporary American artists date on average from the same period as the artworks by the same artist that have achieved the highest prices at auction. Galenson concludes that "the auction market produces valuations over the course of artists' careers very similar to the evaluations of scholars" (Galenson 2000, p. 98).

The question is to what extent the model presented in this chapter, which is based on Dutch data, can be generalized. Although the average price level on the Dutch art market is much lower than in other countries, many of my findings are in line with previous studies conducted in, among others, the United States (Agnello and Pierce 1996; Galenson 2000). However, to make detailed claims about the New York art market, a separate analysis would have to be conducted, and this is not possible, given the lack of data on New York gallery prices. Also in other respects, the results of the model that was developed in this chapter are exploratory and do not warrant decisive judgments about the functioning of the price mechanism on the market for contemporary art. Indeed, apart from answering questions, they also raised new ones, many of them related to the hedonic technique: for many price effects, it is impossible to tell if their determinants are related to the consumer's willingness to pay for certain characteristics of an artwork, or to the costs of producing exactly those characteristics on the part of artists or galleries. In more general terms, the analysis reveals a number of statistical regularities, such as the strong correlation between price and size, but gives no answers about the causal mechanisms involved: the chapter does not provide detailed insight into the way prices are actually set by galleries.

Chapter 5

The Art of Pricing

INTRODUCTION

In the year World War II started, R. L. Hall and C. J. Hitch, two Oxford economists, published a paper which examined "the way in which business men decide what price to charge for their products and what output to produce" (Hall and Hitch 1939, p. 12). Hall and Hitch collected the empirical data for the paper by means of interviews and questionnaires that were, even in those days, unconventional methods for economists. Their findings were no less controversial. The interviews indicated that the applicability of economic theory was limited, since entrepreneurs were unaware of the entities, functions, and data (for instance marginal cost, marginal revenue, and price elasticities) which, according to the then prevailing economic theory of pricing, a firm needs to know in order to maximize profits. Instead, the interviews suggested that entrepreneurs "are thinking in altogether different terms" (Hall and Hitch 1939, p. 18): when setting prices they applied a rule of thumb, according to which prices were set at "full cost" of producing goods, increased by a markup. This pricing rule was relatively uncomplicated for entrepreneurs, but following economic theory it could only result in maximum profits by coincidence. The findings were, to some extent, an early instance of what Herbert Simon would later coin "satisficing"—as opposed to "optimizing" or "maximizing"—economic behavior (Simon 1957).[1]

Hall and Hitch's article was disputed on a number of grounds, including the reliability of interview techniques, the representativeness of their sample, and the interpretation of their results.[2] The most profound, albeit indirect, contribution to the lengthy debate which ensued was Milton Friedman's essay on "The Methodology of Positive Economics" (1953), which would exert a strong influence on the future methodology of modern economics. Friedman argued that it is a "largely irrelevant question whether businessmen do or do not in fact reach their decisions by consulting schedules, or curves, or multivariable functions showing marginal cost and marginal revenue" (Friedman 1953 [1984], p. 15). For economic theory, the more relevant question is if they behave *as if* they do. The ultimate scientific criterion, according to Friedman, is not the

descriptive accuracy of a theory, but its capacity to predict economic outcomes: "[t]ruly important and significant hypotheses will be found to have 'assumptions' that are wildly inaccurate descriptive representations of reality, and, in general, the more significant the theory, the more unrealistic the assumptions" (Friedman 1953 [1984], p. 14). In other words, Friedman granted that the abstract models of neoclassical economics are not descriptively accurate, but rejected this as a valid critique of modern economics.

The debate is pertinent to the question how Amsterdam and New York art dealers arrive at the prices they post in their galleries. Following Friedman's dictum, a study of prices for art could be confined to the model developed in the previous chapter, which analyzes prices in terms of its determinants. However, such a study of *prices* needs to be distinguished from the study of *pricing*, that is, the decision-making processes that prices are the outcome of (Eichner 1987, p. 1558). In this chapter, I conduct the second type of analysis. The quantitative analysis of the previous chapter leaves the causal mechanisms "behind" the statistical relations unidentified; most importantly, it does not explain if these regularities are related to the supply or the demand side of the market. Therefore, I proceed to study the decision-making processes that account for these quantitative regularities in qualitative detail (cf. Heiner 1983).

Although artists are sometimes in a position to dictate prices to a dealer because of their reputation and the bargaining position which is bound up with it, dealers usually have the last word in the pricing decision. They are not only the ones who have to "work" with these prices, dealers are also more knowledgeable about the market. My main finding is that dealers do not set prices on a fully informed, isolated, case-by-case basis. Instead, dealers make pricing decisions on the basis of what I call *pricing scripts*. I define these scripts as a set of routines which function as a cognitive manual for the variety of pricing decisions that a dealer needs to make at different stages of an artist's career. After embedding the notion of scripts both historically and theoretically, I will show that pricing decisions which these scripts facilitate include setting prices of an artist's work at the beginning of her career, the frequency and magnitude of price increases, or the percentage-split of revenues between the gallery and the artist. Pricing scripts are supplemented with *reference values,* which provide exact numerical values for certain types of pricing decisions; examples are conventional minimum and maximum prices for particular media and sizes of artworks (cf. Abbing 1989, p. 168). Scripts relate to reference values much as the grammar of a sentence relates to the words the sentence is composed of.

THE TACIT KNOWLEDGE OF SCRIPTS

A key advantage of using these pricing scripts is that they are based on criteria such as the reputation of an artist and the size of her work which are easier to measure than the quality of her output. Indeed, the most striking convention on the primary market for art is to avoid pricing according to quality at all times. Scripts lend structure, consistency, stability, and thus predictability to the price mechanism. They help avoid or counter confusion about the economic value of contemporary art among potential buyers (cf. Diamantopoulus and Mathews 1995, p. 74). "It is not science, but it is some yardstick to begin to use," as a New York dealer excused himself after explaining one of the pricing rules of his script (US10). Analyzing pricing decisions in terms of scripts and reference values does not amount to denying that supply and demand influence price levels. The more important questions, largely ignored by neoclassical economic theory, are how entrepreneurs identify and perceive supply and demand factors, how they understand them, and how they subsequently translate them into prices and price adjustments. Finding the right price for an artwork is, in other words, an art in itself.

The notions of pricing scripts and reference values fit in a vast body of marketing studies which indicate that pricing is a complex, multifaceted decision-making process; the upshot of these studies is that pricing decisions can only be understood by taking institutional contexts into account (for an overview, see, e.g., Dorward 1987; Diamantopoulus and Mathews 1995).[3] The notion of scripts also underscores research on the "behavioral theory of the firm" (Cyert and March 1963) as well as recent institutional currents in economics (Dosi and Egidi 1991; Hodgson 1998) and sociology (Powell and DiMaggio 1991). This literature suggests that, given the combination of a large number of parameters, incomplete information, and limited cognitive resources, decision-making processes in the economy are structured by habits, rules of thumb, reference points, schemata, and scripts.[4] Pricing scripts are an instance of what Paul DiMaggio has called "event scripts," which enhance automatic or "thoughtless" rather than deliberative processing (cf. DiMaggio 1997; Etzioni 1988, p. 166). Therefore, in an uncertain environment such as the art market, where information is costly to collect, the pricing decision is subject to bounded rationality (Simon 1957). The notion of scripts is also in line with Ronald Heiner's hypothesis that "greater uncertainty will cause rule-governed behavior to exhibit increasingly predictable regularities, so that uncertainty becomes the basic source of predictable behavior" (Heiner 1983, p. 570). Like the business repertoires that were discussed before, these scripts are no individual artifacts, but

are shared to a smaller or larger extent by the community of art dealers. Whereas some scripts are universal for art markets in Western European countries, others are only shared by collectors, dealers, and artists within a particular circuit. Indeed, many dealers refer to the pricing decision as a communal one, for which friends and colleagues are consulted.

Pricing scripts are, like the business repertoires of previous chapters, not invented by individual dealers, but are instead shared, supra-individual understandings of how art can be priced and marketed in a legitimate way. They are neither written down nor formally institutionalized; instead, scripts are a form of tacit knowledge, to put it in terms of Michael Polanyi (Polanyi 1958 [1974]), or a form of "knowing-in-action," to use Donald Schön's words (Schön 1983). Since these tacit rules are hardly reflected upon consciously, it is difficult for dealers to conceive of alternatives for their business decisions (DiMaggio and Powell 1991, p. 11). Given their tacit nature, it is hardly surprising that dealers did not make explicit claims about the diffusion processes in my interviews. Formal, professional institutions such as the American Art Dealer Association (ADAA), the Dutch Gallery Federation (*Galeriebond*), and the Dutch Association for Galleries (*Nederlandse Vereniging voor Galeriehouders*) have limited power in diffusing, implementing, or enforcing such scripts, just as they have little power in diffusing business repertoires. Instead, their diffusion largely takes place informally by means of imitation processes. On-site education or "learning by doing" constitutes one of these imitation processes: many dealers have started by working as an assistant or director at a gallery before opening their own. In that capacity, they learned the dos and don'ts of the art business, including those relevant for the pricing of art (cf. Klein 1994). Other forms of diffusion are the many visits dealers pay to their colleagues, the informal networks they are members of, and the social gatherings such as Friday afternoon openings of gallery and museum exhibitions.[5] As Paul DiMaggio and Walter Powell argue, such imitative processes are likely to occur in an uncertain environment, of which the art market provides a quintessential example (DiMaggio and Powell 1983, p. 151; DiMaggio and Powell 1991, p. 10; Etzioni 1988, p. 170).

Pricing scripts nuance the sharp distinction made in industrial organization literature between price setters and price takers. Since monopolistic competition approximates the structure of the art market most closely, art dealers are price setters in principle. However, given the rule-following behavior that pricing scripts imply, their agency in setting prices is reduced significantly. Scripts are potentially detrimental to the efficiency of markets, since they inhibit the flexible adjustment process of prices towards a market equilibrium (Fengler and Winter 2001). In other words, they are one potential source of the price rigidities that have

concerned mainly Keynesian economists (see, e.g., Blinder et al. 1998). The economic rationality of scripts is, however, that they simplify the pricing decision to a considerable degree. Since scripts circumvent estimating the quality of an artwork directly, they allow dealers to set prices systematically. By coordinating economic action informally among art dealers, scripts also structure the formation of prices and render the economic value of art transparent. This transparency, in turn, creates understanding for otherwise elusive prices among consumers of art.

Before discussing these properties of pricing scripts in detail, I will describe how they have emerged historically. A brief excursion through the economic history of the art market teaches us that pricing scripts are stable in the short run. In the long run, however, they evolve under the influence of large-scale social and cultural processes such as the emancipation of the artist in the Renaissance, the rise of the notion of genius, and the innovative urges which propelled the development of modern art from the nineteenth century onwards. Subject to these developments, the history of the art market reads like a continuous accumulation of uncertainty with respect to the artistic and economic value of art. On the basis of present studies, it is fair to say that contemporary artists, dealers, and collectors face more difficulties in finding the right price for an artwork than their predecessors did centuries ago.

THE RISE OF GENIUS

In a quarterly magazine edited by himself, the early twentieth-century Dutch art dealer J. H. de Bois recounts how he traveled to Switzerland with a self-portrait by the nineteenth-century Dutch artist Matthijs Maris in his suitcase. The purpose of the trip was to show and ideally sell the painting to a collector. Arriving at the Swiss border, De Bois was taken by surprise when a customs agent searched his suitcase, took out the painting, inspected it carefully, and then decided: *"Zollpflichtig"* ("liable to import duties"). As soon as De Bois understood that he needed to pay customs duty, he realized that the money he had on him would not suffice for the painting, which was of considerable, albeit undetermined, value. In the meantime, the agent took the painting to a colleague, put it on a balance, computed the customs duty based on the weight of the object, returned to De Bois, and charged him 13.50 francs—a negligible sum (Heijbroek and Wouthuysen 1993, pp. 34–35).

De Bois was confronted at the border with a script for determining the value of a material object, albeit an extraordinary one in the context of the contemporary art market. Throughout the history of art, different scripts have been used to determine prices of individual works of art.

Until the Italian Renaissance and, in Northern Europe, until the sixteenth century, painters were by and large considered artisans. Rather than being rewarded for his originality, an artist would execute the wishes of the church, the court, or a private commissioner who had hired him. In many cases, the iconographic program of a painting was invented by the patron rather than the artist himself (Baxandall 1972 [1988]); the average buyer of art settled for a copy, while the satisfaction of owning an original, so self-evident today, was less important to him (De Marchi and Miegroet 1996, p. 50).

Without the need of rewarding elusive values such as the originality or genius of an artist or the uniqueness of his work, late medieval and early Renaissance contracts between artists and their commissioners were mostly concerned with the material aspects and the subject matter of the work (De Marchi and Miegroet 1996, p. 53). The labor time involved in executing the panel or fresco and the material costs constituted the main rule of this pricing script. The amount and preciousness of pigments would be specified in detail in the contract; as a proxy for the labor time, the number of people that were portrayed could be used (Baxandall 1972 [1988]). Up until the seventeenth century a composite script was used to compute prices, based on the number of hours the artist had spent on the work. Factors like its size and the number of details in the picture would be taken into account separately (Bok 1998).[6] For individual portraits, artists like Rembrandt applied fixed rates depending on whether the commissioner wanted a head-only or life-size portrait.[7] The pricing script for the many group portraits that Dutch guilds commissioned in the seventeenth century often involved a fixed sum per person. An individual commissioner could pay an extra fee, which allowed the artist to devote more time to him in order to increase the likeness of his image. With the labor time as the most important determinant, the price of paintings decreased when the rapidly growing market of the Dutch Golden Age induced artists to cut down the time spent on each painting (cf. North 1992, p. 101; Montias 1987).

Gradually, however, the pictorial skills of the artist replaced material properties as the prime determinant of price. Starting in the Renaissance, producers of art gradually evolved from ordinary artisans into individual, creative artists with a special status in society. Genius rather than craftsmanship, originality rather than expense, uniqueness rather than conformism were the new constituents of value (cf. Koerner and Koerner 1996, p. 297). The signature of the artist, seldom present on pre-Renaissance works, served as their simultaneous symbolic and economic seal.[8]

Embedded in this change in the cultural values of the art world and the position of the arts in society, differences in payment emerged that set one artist apart from his fellows (cf. Hauser 1951, p. 318; Baxandall 1972

[1988], p. 14). As early as in the Renaissance, a commissioner of a work by the Italian artist Piero della Francesca required, for instance, that "no painter may put his hand to the brush other than Piero himself" (Baxandall 1972 [1988], p. 20). After all, the patron had paid to reassure himself that he was being served by the master himself. The problem of the introduction of individual skills as a determinant of value, however, was that they were difficult to measure precisely, unlike material or painting-related factors. They could not be translated into an easily applicable script. This change in pricing method, from a material script towards an immaterial appreciation of the artist's skills, introduced considerable uncertainty on the art market (cf. Smith 1989, p. 24).

Material, painting-related factors did not lose their relevance entirely, however. For instance, in the seventeenth century, art-historical standards with respect to the subject matter of paintings translated into price differences: paintings with a religious theme, so-called genre paintings, and historical paintings were valued higher than landscapes and still lifes (North 1992, p. 99; White and White 1965, p. 63; De Marchi and Miegroet 1994, p. 118). It was only in the nineteenth century that the economic, measurable impact of these different genres waned. In this era, the focus in appraising art shifted decisively, as Harrison and Cynthia White argue, from individual canvases to careers of artists (White and White 1965). Like earlier developments, this change in focus was embedded in macro-sociological changes related to the identity of the artist and the place of the arts in society. In the nineteenth century, a cult of the creative individual came into being. This cult was expressed, for instance, by art critics who increasingly took the life of an artist into account when writing about artworks (cf. Green 1987, p. 71). It went hand in hand with the rise of the avant-garde in art and the birth of the anti-bourgeois, bohemian artist (Grana 1964). In my quantitative analysis, this shift from canvases to careers was reflected in the previous chapter in the large variance in prices by artists (65 percent of total variance), as opposed to the limited variance in prices by artworks (24 percent of total variance); this suggests that characteristics of the artist are stronger determinants of prices than characteristics of the artworks (see appendix D).

The result of this historical process is that dealers in the present era face considerable uncertainty when posting their prices: shared standards of value are lacking, while the willingness of collectors to pay is almost impossible to estimate. Therefore, it should not come as a surprise that the pricing decision is frequently represented as a haphazard one. In an interview with the *Boston Globe,* an art dealer claimed that deciding about prices is "the most subjective thing that happens in the gallery,

even more than deciding what you like." In the American magazine *ARTnews,* the well-known New York dealer Richard Feigen characterized the pricing decision as follows: "It's an inexact science involving a finite commodity, and somehow we have to struggle to transmute that inexactitude into something concrete." His colleague Matthew Marks described the impact of this uncertainty as follows: "All of a sudden, you have this slightly sick feeling—Did you sell it for enough?"[9]

I noted comparable comments in the interviews I conducted. "The topic is an easy one," the owner of an old, established New York gallery told me on the phone when I called to schedule an interview. "Of course," he admitted, "art is unique, it is no ordinary commodity that you find in any store"; yes, he said, he was fully aware of the fact that many people do not understand why one piece costs $100, and another $100,000. "But the interview will be short," he warned me, for "there is nothing mysterious about prices." A couple of days later I met him in his gallery office, located in SoHo, the former center of the New York art world where an entire generation of galleries and artists established their reputations in the 1980s. In his large gallery space, much larger than any of its counterparts in Amsterdam, this dealer exhibited massive, odd-looking installations, incomprehensible artifacts which outsiders would not even recognize as art, as well as relatively low-priced, popular prints of a small number of well-known artists. During the interview he explained the methods he used to establish a price, the "dos and don'ts" of the pricing game, the mistakes he had made in the past and the financial successes that came his way unexpectedly. At one point, he smiled and summarized his pricing strategy, no doubt with irony, as follows: "I simply make them up." When I pursued how he knew the right price for the large installation that was currently on view, with a monkey riding on a train through a fantastic, absurd landscape, the dealer remarked wryly: "I pray" (US10).

Although other dealers who were new to the field would not allow themselves such ironic statements, I recorded similar comments from reputable and not so reputable dealers, from dealers in Amsterdam as well in New York, from dealers who specialized in avant-garde, conceptual work, but also from their colleagues who clung to precise, realist canvases. They would call prices "a wild guess," "arbitrary," "subjective," or "a game of perception," and spoke about the effect of prices on sales as "a mystery." Two young dealers whom I interviewed felt so uncertain about pricing that they did not dare to tell an artist that the prices he had suggested struck them as "over the top" (NL13).

Towards the end of the interviews, I tried to have dealers discuss the prices of specific artworks by artists they represented in detail, if possible

while looking at those works in the exhibition space or in the stock room. During this stage of the interview, coincidental factors and idiosyncratic reasons were frequently mentioned to account for prices. For instance, in the fairly small space of a Dutch dealer, an English artist was exhibiting large ceramic sculptures. Pointing at the major piece of the exhibition, the dealer explained: "At the moment a museum for religious art happens to be interested. I know this museum has an annual budget for acquisitions of 40,000 guilders. That would mean that they run out of their whole budget if they buy this sculpture (. . .). When I set the price, I took into account that I want it to go there. Therefore I have set the price of this sculpture (. . .) at 35,000 guilders, from which 10 percent will probably be discounted if they purchase it. But then, you cannot make another sculpture of the same artist much more expensive, because the price has to be reasonable in relation to that particular work." The dealer, who had made a quick reputation in the 1990s, and talked about his business lightheartedly, concluded: "In the beginning, you just decide upon something, and that haphazard decision becomes your point of reference afterwards. Frankly, the whole venture is somewhat awkward" (NL4).

TESTING THE WATERS

If the history of Western art can be read as a continuous accumulation of uncertainty with respect to the value of a work of art, what yardsticks are left for contemporary art dealers to found their pricing decisions on? The most difficult and, in some respects, most crucial pricing decision is "to test the water," as one dealer called it: determining prices for work made by an artist who has not sold any work before. The reason is that the art dealer cannot rely on the previous judgments of others in this case, while no previous prices exist to tune the new price to (Crane 1987, p. 111). Also, the willingness to pay of consumers for new work is difficult to estimate, and can only be found by means of a trial-and-error process. However, the trial-and-error process is risky, since the initial price can have long-term consequences: if the price is too high, this may inhibit the career of a young artist to develop, since price decreases are deemed impossible.

To set initial prices within this constraint, a twofold rule is used (see table 5.1). First of all, the rule is to start as low as is reasonable. "I always say very honestly to my artists, very crudely, if your first show has been raped, then they were the right prices," as a young art dealer located in New York's Chelsea phrased it (US8). The other, explicitly imitative rule is to adopt existing price levels by comparing new art to works similar in style and size, made by artists of comparable age, with a comparable

résumé, credentials, or background (Michels 1992, p. 53; Warchol 1992, p. 315). If these contextual factors are not taken into account, imitative behavior may lead away from, rather than towards, the right price. As an art faculty member of the University of Pennsylvania remarked in Krystyna Warchol's dissertation on the art market: "Unfortunately lots of people price their work in comparison to people who are successful. Let's say Rauschenberg gets $100,000 for a painting, so a student says $6,000 is reasonable" (Warchol 1992, p. 319).

If an artist does have a pricing history, whether on the secondary market or in another gallery, the existing price level is adopted and extrapolated. This means that price setting on the art market is path-dependent: the current price level is always based on the past level. This path-dependent nature has empirical basis in Frey and Pommerehne's economic study of the art market, which shows that past prices are a very strong predictor of future prices (Frey and Pommerehne 1989; cf. Bonus and Ronte 1997). In this path-dependent process, the reputation of the artist and the size and technique of the work are the three most important guideposts for setting prices. From an economic perspective, it is remarkable that output is generally ignored in the pricing decision. When a gallery represents both highly and hardly prolific artists, their price level will usually not differ substantially because of it (cf. Abbing 1989, p. 167).

Almost all galleries I interviewed, both in Amsterdam and New York, price according to size *within* the oeuvre of an artist; price differences between works of the same size within the oeuvre of one artist are at all times avoided, even when differences in quality are perceived (Zolberg 1990, p. 84; Abbing 1989, p. 169). This explains why size is such a strong predictor of price in the quantitative model. The size rule, which constitutes one of the most striking elements of contemporary pricing

TABLE 5.1
Pricing scripts

Event	Script
New artist	Set low and compare to similar work
Artist with price history	Adopt and extrapolate Size, medium, reputation
Price increases	a. Reputation-based b. Sales-based c. Time-based
Price decreases	Avoid

scripts, is rooted in the late nineteenth- and early twentieth-century French art world; at the time, the price of a work was expressed in number of francs per point, which was computed as a composite of the size and the genre of the work—portrait, landscape, or seascape (see Moulin 1967 [1987], p. 183; Gee 1981, p. 9).[10]

The reputation of the artist as well as the size and technique of the artwork are functional and operational as pricing rules because they dissociate economic and artistic value; they guarantee that a dealer does not have to estimate the quality of a work directly when setting the price. In themselves, however, reputation, size, and technique are meaningless criteria: a drawing on paper could be of higher quality than an oil painting on canvas, an unknown artist may make better works than a well-known one, while a small work may require as much labor as a large one. In a community like the art world, which is passionately, on a day-to-day basis, concerned with quality, with assessing the merits of an artist, and with making distinctions between the artistic value of different works, the fact that quality is avoided explicitly as a direct determinant of price is paradoxical to say the least. Indeed, this pricing rule has historically been contested and is hardly understood by artists, experts, or people who are not involved in the art market. Allegedly, the eighteenth-century painter Salvator Rosa would set prices strictly according to quality. Therefore, he refused to accept any advance payments for his work: after all, the collector could not predict the quality of the finished painting (Warchol 1992, p. 45). Or to mention another anecdote related to the size rule: an insistent American collector who made his way to the studio of the impressionist painter Edgar Degas was told by the artist that he charged a fixed price of 100,000 francs for every work he created, no matter what size or technique (Brown 1993, p. 275). For the contemporary situation, many artists likewise consider this pricing rule to be an insult to artistic values (Warchol 1992, p. 326). Dealers do not hesitate to emphasize, however, that quality is too elusive to function as an understandable pricing principle.

Scripted Price Increases

For price increases, three different rules exist: a rule based on demand, on time, and on reputation. For all three rules, the amount of the increases varies, but usually equals 10 or 20 percent of the most recent price level. According to the first rule, prices are increased in response to excess demand. Such a situation is recognized by a dealer if the last gallery show of the artist was a "sellout situation"; a sold-out show is, in other words,

an event which prompts a price increase. A particular version of this rule is used for increasing prices of works made in small editions such as photographs. They are often priced incrementally according to "where the picture is in the edition": the closer the edition is to being sold out, the higher the price will be. Following the second rule, prices are increased periodically, i.e., annually, biennially, or every time the artist has a show at the gallery. This rule resembles administered wage increases on the labor market following a seniority principle. The third rule induces dealers to increase prices with the level of recognition the artist amasses. Following this rule, price increases are justified by referring to museum exhibitions, publications, or other sources of praise for the artist's work.

Price differences between equivalent works of different artists mainly come into being because the amount and frequency of price increases varies between artists. These amounts may differ according to the cautiousness or aggressiveness of the art dealer, as will be discussed in the next chapter. With respect to the frequency of increases, the demand-based rule will lead to price differences if the demand for the work of an artist rises faster or slower than the average of all artists on the market; likewise, dealers who apply a reputation-based price will establish different prices for the artists they represent if the reputation of these artists does not grow synchronically.

Even though all three pricing rules can in principle lead to the same frequency of price increases, dealers distinguish sharply between the rules. One New York dealer, for instance, argued: "I really don't believe in supply and demand, contrary to the 1980s when everything was about supply and demand, all about Mary Boone [a well-known, successful dealer of those days] saying there are only three paintings, and 20 people want them so it is . . . 500,000 dollars. The way I want to raise prices is according to the way the career is going. That means which collections are buying, if museums are buying, and what exhibitions they are in. If you reach those kinds of successes, I think we have a valid right to raise the prices. Supply and demand is a very silly thing" (US17). Diametrically opposed, a Dutch dealer in the same segment as this New York gallery argued as vehemently: "If you are really sensible, you will not increase your prices faster than the speed of demand. You should not think, 'oh, he has had three museum exhibitions, so I can raise prices.' No, three museum exhibitions—more demand—increase prices. That is a rule which is not respected in the Netherlands" (NL10). Thus, both dealers construct mental models of how the art market works; on the basis of these models they come to their respective pricing decisions, which are both rational, but only within the context of their own local model of the market that they are part of (cf. Dobbin 1994).

Reference Values

Apart from pricing scripts, reference values serve as guideposts to finding the right price (see Briesch et al. 1997). Pricing scripts relate to these reference values as the grammar of a sentence relates to its words: scripts provide pricing rules, while reference values provide specific numerical values to facilitate price setting. Like scripts, reference values are based on mental models or account schemes that dealers and collectors learn and construct while being active on the market (Thaler 1999; Heath et al. 1995). In these models, artworks with given properties are linked to specific price levels. These levels are based on past market experience which mental models translate into expectations about future prices. In marketing studies they are known as psychological pricing points, above or below which consumers dramatically adjust their demand for a good (see, e.g., Fengler and Winter 2001).

I encountered such reference values in two different versions. First of all, reference values exist for specific types of pricing decisions, no matter what the characteristics of the work are. In the case of young artists who have not sold any work before, we saw that the rule is to set prices low and to make comparisons with the work of other starters on the market. On top of that, galleries use reference values in order to make such pricing decisions more exact. I was frequently told in interviews, for instance, that in the Netherlands photos of a medium size should cost €450 or less for a starting artist; large paintings may not be priced above €2,250 in the Netherlands for a work of standard size (1.50 x 1.50 m). In New York photos in edition sizes of 10 to 15 cost $1,000 to $1,500 for small and $1,500 to $3,500 for medium-size work. Large paintings by an unknown artist, I frequently heard, should be priced at $3,000 to $5,000 in New York. These reference values may differ per gallery. A gallery that, for one reason or another, frequently sells expensive works to collectors in high-income brackets can ask relatively high initial prices for young artists. Collectors who frequently visit such galleries are accustomed to these high prices; according to the mental models that they have constructed in the past, these price levels can be expected and are considered reasonable for artworks. Thus it may be the case that two starting artists who make similar work and are equal in all other respects receive different prices for their work in different galleries (cf. Warchol 1992, p. 264).

The second use of reference values are for minimum and maximum prices, which dealers say they avoid transgressing downward or upward (cf. Plattner 1996, p. 136). Although the exact minimum prices that were mentioned differed considerably, Dutch dealers were uniform in their

notion of a maximum price of 10,000 guilders (approximately €4500).[11] One dealer said: "beyond 10,000 guilders you really end up in a different zone. You have to ask yourself if you want to cross that psychological border" (NL4). Apart from having a cognitive basis in mental accounting schemes of collectors, this so-called glass ceiling of the Dutch art market can be explained in structural terms. The Dutch situation is characterized by a broad base of collectors who buy work for relatively low prices, coupled with an apex of a few collectors who buy work for high prices (see Gubbels and Voolstra 1998; see also Steenbergen 2002).[12] This means that the market is thin at higher price levels, especially compared to countries like the United States. Institutional factors can also be involved in the making of a glass ceiling. Two young dealers hypothesized that the ceiling above the Dutch market is explained by the fact that companies who collect art often authorize the curator of their collection to buy works under 10,000 guilders at his own discretion; above that level, curators have to consult the company's executives, thus creating an incentive for galleries to keep prices under the threshold value.[13]

The glass ceiling above the market is not just a manifestation of its structure, it also co-determines this structure. First of all, it hampers the representation of foreign artists by Dutch galleries, since their prices easily surpass the glass ceiling (Gubbels 1999; Velthuis 2001). Secondly, because of the limited "spread" of prices, the division of labor between discoverer galleries, who sell experimental artworks for relatively low prices, and exploitative galleries, who take successful artists aboard and raise their prices considerably, is absent in the Netherlands (Bystryn 1978). Finally, galleries who represent artists with an active market outside of the Netherlands are forced to choose between two evils: either they adopt relatively high foreign prices on the Dutch art market, in which case sales on the Dutch market will be by and large inhibited; or they set prices according to local circumstances of the Dutch market, in which case price differences will emerge between the Dutch and foreign markets. In the latter situation, dealers run the risk of insulting foreign collectors when these collectors find out that they could have bought similar work in the Netherlands for lower prices.

Unlike pricing scripts, minimum and maximum prices are amenable to short-term change by imaginative or risk-taking entrepreneurs. In New York, dealers like Larry Gagosian and Mary Boone allegedly increased the "acceptable" maximum price considerably in the 1980s, assisted by the economic climate of those days; in the Netherlands, the art dealer Loek Brons is said to have accomplished the same change in the 1990s for realist art. As a result of such creatively destructive action, some of

my respondents claimed, the glass ceiling of the Dutch art market was eroding around the turn of the twenty-first century.

Pricing scripts and reference values exist not only for prices, but also for price discounts which are awarded to collectors and for the commission which a gallery receives for selling a work. Just as scripts are used to avoid setting prices on a case-by-case, fully informed basis, applying reference values for commissions and discounts circumvents costly and potentially harmful case-by-case bargaining processes between dealers, collectors, and artists. Reference values for commissions are as follows: galleries usually receive a 40 or 50 percent commission for their sales. Percentages tend towards 50 percent for starting artists and towards 40 percent for mid-career, relatively successful artists (cf. Caves 2000). In the case of world-famous artists selling for high prices, dealers usually take a 30 percent commission or even less.[14] With respect to photographers or sculptors, who incur high production costs, the dominant rule is to either reimburse the artist for these costs before splitting the revenue, or decrease the commission that the gallery takes. Another reference value is that the main or primary gallery of an artist receives a commission of 10 or 20 percent in case another gallery makes a sale.[15] If price discounts are awarded, they amount to 10 or 20 percent in most cases. The most important rule with respect to price discounts is that they are split between the artist and the gallery on an equal basis. However, if discounts are given as a courtesy to acquaintances or friends of the dealer, the rule is usually that she "swallows" the full discount herself. In all cases, the distribution of profits over the dealer and the artist is fine-tuned by means of the allocation of costs related to generating publicity, producing catalogues, printing invitations for the opening of a show, or organizing the party which takes place at this opening.

CONCLUSION

Contemporary art galleries are almost continuously faced with pricing decisions, unlike auctions, where prices are set by the direct interplay of supply and demand. In order to find out how dealers cope with the uncertainty that is endemic in this pricing process, I decided to study this process not just in quantitative but also in qualitative detail. I found that supply and demand are no clear-cut "forces" for dealers. Supply and demand need to be perceived and made intelligible by them; only afterwards can they be acted upon. Moreover, the interviews I conducted with art dealers in New York and Amsterdam reveal a multifaceted decision-making process. In an economic environment which is characterized by

radical uncertainty about the economic value of art, the challenge is, in the words of an author of a guidebook to the art market, to establish "uniformity in pricing, some basic standards for establishing the monetary value of a piece of work" (Grant 1991, p. 17). Dealers do so with the help of what I call *pricing scripts*. These scripts are a set of tacit, cognitive rules which enable them to set prices systematically; these scripts are supplemented with *reference values,* which provide exact numerical values for specific pricing decisions. Different pricing scripts are applied at different stages or events, as if an artist's oeuvre goes through consecutive pricing funnels in the course of the career of its maker. Mastering these scripts constitutes the art of pricing and guides a dealer in her search for the right price. The frequency and size of price increases may differ to a great extent across artists, depending on factors such as the policy of the gallery, the reputation of the artist, and the strength of demand for his work. As a result, price differences between the work of different artists come about.

The sharp distinction between price takers on competitive markets and price setters on markets characterized by monopolistic competition is blurred by the use of pricing scripts: dealers are price setters, but scripts reduce their agency to make pricing decisions on a conscious, fully informed, case-by-case basis. Although the rationality of pricing scripts does not conform to the strictly maximizing or optimizing rationality of neoclassical economics, it is nevertheless subject to an economic logic. It helps dealers economize on information and decision-making costs; also, it enhances sales, since it makes prices understandable and predictable to collectors. The composite of pricing scripts and reference values is effective in constructing an economic reality that producers, distributors, and consumers of art can grasp, understand, and respond to (Berger and Luckmann 1996 [1991]). However, rudimentary as the notion of pricing scripts is, it does not do justice to the large number of small, seemingly contextual factors that enter in the decision-making process. In the next chapter, I will further enrich my account of price setting by studying the narratives in which dealers embed different types of prices.

Chapter 6

Stories of Prices

INTRODUCTION

In this chapter I study how art dealers conceptualize, perceive, and make sense of prices in their everyday models of the market. These everyday economic models hardly resemble the abstract, impersonal, and mechanistic models that we find in academic, neoclassical economics. The dealer's everyday economic discourse is by and large a moral discourse; it is riddled with stories, invokes concrete characters, and leans on dramatic narratives. When it comes to prices, everyday models of the market not only allow for quantitative differences in the monetary sum paid for a picture; they are also sensitive to qualitative differences in the type of price this monetary sum refers to. Through the unlikely medium of the price mechanism, which is commonly considered to be devoid of any meaning at all, dealers express the values they endorse in their business practices. Just as dealers distinguish their own prices from those set at auction, they differentiate the prices which they set themselves from those of their colleagues, and attach moral importance to these differentiations. In particular, in the dealer's discourse of the market, prices are embedded in three different narratives: an *honorable,* a *superstar,* and a *prudent* narrative. Although these narratives are invoked by dealers that are currently in business, they are derived from three consecutive stages in the development of the art market from the 1950s onwards.

Apart from the fact that this everyday economic discourse is interesting in its own right, not in the last place because of its sharp contrast with academic discourses, two reasons warrant paying attention to it in particular. First of all, the narratives which actors construct in order to make sense of the world they inhabit motivate them to act (cf. Boje 1991); in other words, even though their knowledge of the economy may be false from an academic point of view, it has real implications insofar as it guides their economic action. As anthropologist Roy Dilley has argued: "the extent to which the price mechanism operates within any form of market must (. . .) be seen as a function of the social, cultural and political matrices through which the index of price must pass, as well as a function of the bodies of culturally specific knowledge through which notions of price are apprehended" (Dilley 1992, p. 9). Secondly, the

notion of different prices is directly relevant for both "Nothing But" and "Hostile Worlds" perspectives. Since art is patently incommensurable or singular from a "Hostile Worlds" point of view, pricing negatively affects the way we value a work, the terms we use to do so, and the relationship we have to it. Marx already had argued in the *Economic and Philosophical Manuscripts of 1844* that money possesses an "overturning power." As "the existing and active concept of value," it leads to "the confounding and compounding of all natural and human qualities" (Marx 1844 [1978], p. 105). Georg Simmel claimed in a similar vein in his magnum opus *Die Philosophie des Geldes* that a radical contradiction exists between money, that "colorless and indifferent equivalent of all and everything," and personal values: "The more money dominates interests and sets people and things into motion, the more objects are produced for the sake of money and are valued in terms of money, the less can the value of distinction be realized in men and objects" (Simmel 1900 [1999], pp. 366–67).

Adherents of a "Hostile Worlds" model invariably invoke record prices to argue that pricing contaminates the value of an artwork. In the 1980s, for instance, when record prices for art were compared by journalists to the price of an artificial heart, an office building, a commercial airliner or two F-16 fighter planes, the costs of President Reagan's inauguration, a mile of interstate highway, or a baseball team, art critic Robert Hughes concluded that art has lost "a certain freedom of access": its aesthetic meaning collapses "under the brute weight of price" (Hughes 1990, p. 20, 400; for an overview of record prices, see appendix C). Another art critic, Douglas Davis, expressed his concern in the magazine *Art in America* as follows: "In the midst of the most quantitative era in the history of man, when figures are compiled and stored on every aspect of life and love, art has become the dearest of quantities. No quantitative shift of such magnitude can fail to carry qualitative implications. Of course, the making and meaning of art is transformed. (. . .) The precious but fragile notion that art is 'above' the world, an ideal once nourished in countless poems, classroom lectures and aging textbooks in which art is considered useless and beautiful, like a flower in a field, may be about to crack."[1]

To put it bluntly, then, by differentiating prices, dealers "annul" or "undo" the commensurating effect of prices that neoclassical economists consider to be a prerequisite for the efficient functioning of markets, and that scholars within the humanities have time and again deplored because of its contaminating effect on unique, incommensurable goods. Some dealers not only isolate superstar prices, they also judge these prices and distinguish the prices in their own galleries sharply from them.

A Rhetorical Divide

Most academic economists have ignored everyday discourses on the economy such as the art dealer's discourse on prices or have referred to them pejoratively as *ersatz* economics, that is, "a less organized, inchoate version of the knowledge produced by academic economists" (see Amariglio and Ruccio 1999, p. 26).[2] Others, however, such as neo-Marxist economists David Ruccio and Jack Amariglio, have made a case for the distinctness of everyday economics by arguing that this type of economics has its own "discursive structures"; unlike abstract academic theorizing, they argue, it is focused on "producing and narrating economic stories" that are "inextricably bound up with the construction and contestation of social identities" (Amariglio and Ruccio 1999, p. 33). Arjo Klamer and Thomas Leonard, working within the so-called rhetorical tradition, argue likewise that a sharp rhetorical divide exists between the metaphors, narratives, and models used in academic discourses on the one hand and those in everyday or laymen's discourses on the other.[3] Whereas logic, fact, and static modeling dominate in academic economic discourse, everyday discourse is infused with dynamic storytelling, vivid characters, dramatic narratives, and anthropomorphic, pregnant metaphors. With respect to prices, for instance, Klamer and Leonard notice that "people are in need of some coherent story that justifies their expensive house, the $37,000 salary, and the Ameritech stock in their portfolio" (Klamer and Leonard 1992, p. 13; see also McCloskey 1990, p. 11).[4]

Empirical studies of the way notions of fairness figure in the economy likewise show that prices are evaluated on the basis of moral, rather than just utilitarian deliberations. For instance, apart from economists themselves, most people tend to favor allocation mechanisms other than the price mechanism in specific circumstances, and reject economies that are exclusively based on monetary incentives (Frey 1986; Frey 1997).[5] In a by now classical experimental study, economic psychologists Daniel Kahneman, Jack Knetsch, and Richard Thaler found that respondents deemed the auction mechanism inappropriate as a means of selling goods in case of excess demand. Their experiments also indicate that pricing is subject to community standards of fairness; for instance, when an unexpected snowstorm increases the demand for shovels, in the eyes of many it is not legitimate for a hardware store to increase prices subsequently in order to exploit demand for these shovels (Kahneman et al. 1986). Also, even though demand exceeds supply for dinner at popular restaurants on Saturday evening or for haircuts at good barbershops on Saturday morning, price premiums fail to be implemented in these situations. And

whereas economists would propose to auction tickets for sports events or rock concerts, most of these tickets are still sold on a first-come, first-serve basis. These pricing patterns cannot be explained with the self-interest models of economic theory, Robert Frank contends, but need to be addressed in terms of everyday concerns about fairness (Frank 1988, p. 177; cf. Becker 1991).

The rare studies on pricing conducted by sociologists and anthropologists have recognized to an even greater extent that prices are a social rather than just an economic fact. Apart from showing that notions of fairness interfere in pricing decisions, these studies underscore that prices lend themselves to differentiation. In the rise and the further development of a notion of a women's wage, for instance, prices on the labor market have not only been conceptualized as "just" or "fair"; both proponents and opponents of a women's wage furthermore distinguished "family," "living," "luxury," and "necessity" wages (Kessler-Harris 1990, p. 2). Also, the very meaning of "price" may vary across different economies. On the Indonesian island of Java, for instance, the equivalent of the English "price" has the connotation of "price range" rather than "fixed price," while an exact equivalent of the Western concept of "price" does not exist (Alexander and Alexander 1991). With respect to money, Zelizer has argued likewise that people make conceptual distinctions between different types of money, in spite of the fact that money is universally perceived as an equalizer of differences. Zelizer shows how everyday users of money in the nineteenth century resisted the introduction of modern monetary systems and money's claim to uniformity by "furiously differentiating, earmarking, and even inventing new forms of monies" (Zelizer 1994, p. 138–39).

"IT DOES NOT WANT THAT PRICE YET"

My interviews with art dealers on the primary art market lend support to the idea that everyday economic discourses are not just a kind of "ersatz economics," but constitute a type of economic thinking in their own right. In particular, I distinguish three characteristics which render the art dealer's model of the market distinct from neoclassical economic discourse: (1) its rich, ornate vocabulary used to characterize and interpret the transactions dealers engage in and the prices they set, (2) the multiplicity of standards that are used to justify price levels, and (3) the qualitative distinctions that are made between different types of prices.

First, some of the terms in the dealer's everyday vocabulary may be viewed as neutral alternatives to concepts that are also encountered in

academic discourse. Dealers speak, for instance, of a market with a "small" or a "weak," a "broad" or a "firm" basis; they regret having to "eat" or "swallow" discounts; in order to prevent their own profitability from falling because of such discounting practices, dealers respond to them by building in "cushions" in the prices, as they put it, or by asking artists to provide them with "some flexibility to play with the price." Other terms in their vocabulary, however, had an anthropomorphic, dramatic, and emotional nature, which is entirely absent from economic theory. My respondents called prices "humble," "seductive," "understandable," "offensive," "cautious," "outrageous," "daring," or "sympathetic." They realized that prices can cause "irritation" and "madness" among collectors, or that they can be "scary" and "dangerous" for artists. If collectors asked for price discounts larger than 20 percent, or made them an extraordinarily low offer for a work they wanted to acquire, some dealers considered this to be "insulting," or even "disrespectful." One New York dealer felt like he was burdened with "doing the dirty job of raising prices": according to him, the European dealers that he cooperated with were afraid to take the initiative in raising prices themselves, out of fear that these higher prices would harm the strength of the artist's market. Talking about the possibility of cooperating with other dealers in risky but potentially profitable transactions, the same dealer remarked that he "did not want to get in hot water with everyone." Another one spoke of "punishing" collectors for reselling precious artworks which they had previously bought in the gallery, whereas a third one told me that he was engaged in a "battle" with "unseemly arrogant" young artists to keep prices reasonable.[6] This rich vocabulary suggests that the economy of the arts is not understood in a bare economic discourse; rather, in order to motivate themselves and persuade others, dealers need to inspire the commercial lifeworld they inhabit with a sense of drama.

The second characteristic of the dealer's everyday models of the market concerns the standards that are used to evaluate prices. I found that dealers hardly ever account for their pricing decisions in straightforward economic terms like supply and demand: if the market "bears" a price, this does not necessarily mean that the price is "right." A contemporary New York dealer remarked about an emerging artist he represents that his work cost $2,500, whereas its actual worth is $4,000, but, he added, "it does not want that price yet." Conversely, the same dealer mentioned the case of an artist whose price level he considered too high, but whose work sold easily anyway: "In Berlin people were wild about her, and we sold stuff we did not have there, just by the pictures. I think her prices are too high, but apparently the public does not"—upon which the dealer laughed heartily

(US8). Similar comments from his colleagues suggest that dealers do not take the market for granted as the sole arbiter of economic value.

Instead the interviews indicate that prices or price changes always need to be justified, whether in economic or in noneconomic terms. Value and price may be equated in economic theory (Heilbroner 1988), rendering the notion of a moral price meaningless, but in everyday life consumers and producers constantly evaluate and judge prices, wondering if a good is priced too high, if it is outrageously expensive, or if it is a rare bargain. In doing so, people drive a conceptual wedge between the market price and their own deliberations about the "true," "just," or "fair" value of the good. As a consequence dealers not only have to price artworks "right," but they also have to anticipate how artists and collectors will interpret the prices and, subsequently, accept or reject their validity. In order to justify prices to their customers, art dealers can draw on a broad repertoire of arguments. Some of these arguments refer to the rarity or the artistic value of the work, while others are directly related to the demand side or the supply side of the art market. With respect to rarity, a dealer may argue that the work dates from an older period in the artist's career and remained in her studio for a long time, or, in the case of photographs and prints, that the work is the last one in an edition. He may rely on a notion of artistic value to substantiate prices when he tells a collector that museums or well-known collectors have already bought other works by the artist in question, that her work is well-documented in the press as well as in catalogues, or that curators wish to include her work in exhibitions.

With respect to the demand side, a dealer may argue that presently other collectors are "waiting for the work," or, in the case of an artist who sells on different continents, that demand for the artist's work elsewhere is driving prices up. Most frequently, however, prices are legitimated by referring to the supply side of the art market. In some cases it is the technique or the costs of materials that should justify a certain price level, but more commonly prices are legitimized by referring to qualitative or quantitative aspects of the labor that the artist has invested in making the work. Remarkably, whereas a labor theory of value has by and large disappeared from academic economic discourse since the late nineteenth century, it still figures prominently in everyday models of the market. Invariably, the argument is that an artist *deserves* a certain price level either because of the skills he masters, the training he received, and the experience he accumulated, or because of the amount of labor he spent on making the work.

As a result, dealers can legitimately claim high prices for both prolific and unprolific artists: on the one hand, a prolific artist deserves high

prices because his prolificness is not a given, but a skill which needs to be rewarded. As an Amsterdam dealer defended the high prices of drawings by one of the most successful artists he represents: "if you do not possess the skills to make such work, it will be very labor intensive, because it embodies twenty years of practice" (NL11). On the other hand, the price level of the work of less prolific artists can be legitimated by referring to the amount of labor these artists expended to make a work. In particular, I found such an implicit labor theory of value with dealers in painstakingly realistic artworks. Note that these arguments are not necessarily based on the actual labor time of the artist. Given that, for a collector, there is no way to tell how hard an artist actually works, the argument can be invoked for purely opportunistic reasons. Says one dealer in detailed, realistic work: "The public at large always likes it if a painter spends a long time on a work. So if they ask how much time the artist spent on a work, you always have to say 'a year,' no matter how long he actually worked. On one painting he may spend a month, on another he may have spent two years. Those are no criteria, so you'd better reconfirm that the artist spent a long time on it. Otherwise, you just disappoint the customer. Dutch people will start thinking, 'one per month . . . twelve per year . . . well, he earns well'" (NL9).

Particularly in artist's guides to the market, prices may also be legitimated by referring to the notion of a living wage: regardless of the number of hours the artist spends on each work of art, the price level should be high enough for her to make a living from selling her work, without relying on other financial sources (Cochrane 1978).[7] Invoking a similar notion of desert, one dealer explained in an interview that not only the labor of his artists but also his own efforts need to be rewarded, no matter what: "In theory, when you have not sold anything, the price should always be the same until you come to a moment in time that you can sell them. (. . .) But that is not what I am thinking. I am thinking that we are going on and doing shows for the artists. The artist is being written about and is going to exhibitions. No one is buying it, but still, a history is developing for his work. The artist is investing more time and energy in it, and the gallery is doing the same thing, and so are all those historians. (. . .) And my sense is that that is valuable . . . if you were not smart enough to buy in year one, and ten years later you decide that [the work] was really important, then you are going to pay the price. (. . .) I realize that the works are incredibly special and if nobody understands that, I am going to shock them, and tell them 'this is what it is worth, and you'll have to pay that to get it'" (US10).

Dealers are ready to provide such elaborate legitimization of economic values not only to collectors, but also to artists. The commission that a

dealer receives from an artist is not simply established on the basis of mutual bargaining power (cf. Moulin 1967 [1987], p. 55). Instead, negotiations about commissions are phrased in terms of entitlements, fairness, and, again, desert. In these negotiations, not only the time and energy of artists are at stake, but also those of dealers themselves. Says a Dutch gallery owner: "I make big efforts for my artists, among others editing and publishing small catalogues on individual artists written by recognized people in the field. That's why I am inclined to ask 50 percent of artists. Especially given the fact that one of the most renowned artists I represent only wants to have 50 percent, it is not done to ask less of young, relatively unknown artists" (NL1). Commissions higher than 50 percent are considered "unethical," however. Dealers who do ask more than this percentage violate a moral code, since they take advantage of the multitude of artists who are desperately looking for a gallery to represent them. Commissions lower than 50 percent are also legitimated in moral terms: "If paintings are starting to sell for 150,000 dollars, why would I take 75,000? I don't really deserve it," as a New York dealer explained (US17).

Obviously, this rich repertoire of arguments is not devoid of an economic logic; in fact, many arguments that dealers use can effectively be translated into standard economic terms. For instance, the price level of prolific artists is high because of the human capital they possess; the price level of less prolific artists is high because of the rarity of their work; what dealers call artistic value may correlate with high prices because of the informational advantages that artists who are recognized by the institutions of the art world have in attracting demand for their work. The point is, however, that it does not suffice to tell collectors that the price they ask is a market price: bare economic reasoning would fail to persuade collectors of the appropriateness of the wide range of price levels on the art market. Instead, when dealers and their exchange partners make sense of these price levels, they are reframed in moral terms.

Price Differences versus Different Prices

The third and most intricate element of the everyday economic discourse of dealers is its implicit notion of different prices. When dealers talk, they differentiate the seemingly monolithic concept of price itself by embedding it in different narratives of the market: they constantly make substantive, qualitative distinctions between different types of prices and pricing strategies, much like the distinctions I discussed in chapter 3 between gallery and auction prices. In particular, I encountered three narratives

that contemporary art dealers invoke to account for the development of the art market since the 1950s. In doing so, they identify themselves and their current market practices with one narrative, and distinguish themselves from the others.

Each of these three narratives, I claim, is centered around a specific notion of price: "honorable," "superstar," or "prudent." In the dealer's narratives, honorable prices stand for the postwar gallery circuit that is remembered, both in New York and in Amsterdam, for its intimacy, dignity, and confined size; superstar prices are characteristic of the circuit of the New York art market in the 1980s, when prices were sharply rising and artists were treated like superstars; prudent prices dominated the comparatively cautious commercial scene when I was conducting my research in the late 1990s.

I will treat these three different prices as ideal types, for in reality many combinations of them can be found within the practices of a single dealer; also, the pricing policy of hardly any dealer conforms to all the characteristics that each ideal type consists of. These different prices do not necessarily coincide with absolute price levels, as figure 6.1 shows: a price tag of $20,000 may be a superstar price for a work by one artist, an honorable or prudent price for a work by another. Following the prudent narrative, a dealer starts pricing the work at the beginning of the artist's career as low as is deemed possible within the art world (figure 6.1). After the first couple of shows, prices hardly rise; only when the dealer and the artist feel secure that an artist's market is established, prices are cautiously increased. According to the honorable narrative, prices are primarily based on a notion of modesty, need, and desert. Hardly changing throughout the artist's career, these prices fail to exploit increasing demand. Superstar prices are set high, and are increased frequently and sharply; dealers that invoke a superstar narrative aggressively exploit fluctuations in demand; the risk is, however, that price levels cannot be sustained in the long run, with equally sharp price decreases, and the early ending of artists' careers as a result. Members of the art world need to interpret prices in order to determine what type of price they encounter on the market. In doing so, they need to take contextual factors into account such as the stage of the career of the artist, her productivity, or her price level on the secondary market. For instance, if the dealer sets a high price for the work by an artist at the beginning of her career, if prices increase sharply and frequently, and if they are not "backed up" by auction prices, the dealer is likely to identify himself with a superstar narrative of the art market. Conversely, if the same price would have been set late in the career of an artist, based on a large number of gallery sales, and substantiated by auction prices of a comparable

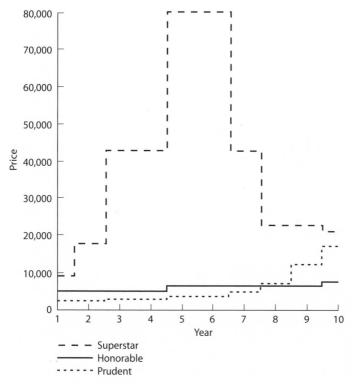

FIGURE 6.1. Ideal types of different price developments

level, the dealer that set the price probably invokes a prudent narrative of the market.

Apart from being sense-making tools, these narratives and the corresponding different types of prices have strategic importance for dealers, to the extent that they inspire them to act in one way rather than another: the notion of different prices helps explain why the art market is characterized by dramatic price differences, in spite of the uniformity suggested by the notion of pricing scripts developed in the previous chapter. In turn, differences in pricing strategy enable dealers to distinguish themselves from their colleagues, and have moral importance to them in that capacity: distinguishing different prices is a means for art dealers to express the values they endorse in their business life. By doing so dealers engage in boundary work, setting themselves apart from some colleagues, and identifying themselves with others. To a certain extent, then, the three different narratives coincide with three different circuits of commerce

within the primary market for art, which each have their own business practices (cf. Zelizer 2004).

The notion of different prices suggests that pricing strategies are part of the dealer's identity. In a market that has to reconcile a fierce opposition between commercial and artistic values, and that has to commodify goods whose essence is considered to be non-commodifiable, dealers, artists, and collectors find ways to express and share non-economic values through the economic medium of prices. Different prices thus provide an instrument to negotiate legitimate practices on a market that is riddled with value conflicts. Let me now discuss these different prices in detail as well as the narratives of the market they are embedded in.

A WATERSHED IN THE ART MARKET

In October 1973, the New York auction house Parke Bernet, since the 1960s owned by Sotheby's, sold fifty contemporary artworks from the collection of Robert Scull, a New York taxi tycoon, and his wife Ethel. It was not the first time that contemporary artworks were sold at auction; in fact, the Sculls had sold some of their holdings eight years before, but the revenue of that sale was earmarked for a foundation that would support young artists. The 1973 sale was the first in the United States to be devoted to contemporary art exclusively.[8] In the presence of distinguished dealers like Sidney Janis, Andre Emmerich, Leo Castelli, and Ivan Karp, the revenue of the sale totaled an unprecedented $2.2 million, including record prices for many living American abstract expressionists and pop artists.

The Scull sale is remembered in the art world for two reasons. First of all, the sale has been identified as a watershed in the development of the New York art market as well as the art world that it was embedded in (Haden-Guest 1996, p. 17). In the models of dealers and other members of the art world, the high prices that were established at the sale changed the atmosphere of the marketplace, and turned it from an *art* market proper into a *commodity* or *investment* market. As an art critic argued with hindsight in the magazine *Art in America*, it "marked a new awareness of the potential of investment in contemporary art." The second reason why the Scull sale has been stored in the collective memory of the art world is because the high auction prices left the artists who actually made the works largely uncompensated. The instance that received most attention was *Double Feature*, a work by the American pop artist Rauschenberg. The Sculls had bought *Double Feature* in 1959 for $2,500, and sold it at the 1973 auction for $90,000 dollars. Rauschenberg was infuriated,

Art dealer Leo Castelli in 1953. Peter Stackpole / Time Life Pictures.

and allegedly told Scull on the spot that "I worked my ass off for you to make that profit." Afterwards, he remarked that his relationship with the Sculls used to be based on "love"; the auction sale, however, marked the divorce (Haden-Guest 1996, p. 10).[9]

In particular, older dealers whom I interviewed talked nostalgically about the art world as it was before that watershed (see table 6.1). In that art world, with its much smaller number of artists, dealers, and collectors, the atmosphere was more intimate, they said. They characterized the "old" art market as a true community, where gallery openings were social gatherings, and had not yet turned into the pastime for the fashionable that they would later be. In New York, the epicenter of this gallery circuit was 57th Street, where dealers like Grace Borgenicht, Betty Parsons, and Samuel Kootz were located; in Amsterdam, galleries like Espace and Collection d'Art opened their spaces close to each other on one of Amsterdam's canals, the Keizersgracht. Art dealers ran their businesses as small, seemingly nonprofit enterprises and were motivated by love for art. New York dealers would take their time to travel to Europe to study the history of art; back home, they continued taking care of "their" artists. Given the small size of the art world those days, dealers felt like there was a distinct need for them to open their doors, and considered it their duty to take a serious look at the work by artists that came to their gallery, eager to find somebody that could represent them. Artists, collectors, and dealers would get together in the back room of the

TABLE 6.1
Different circuits in the art market

	Setting	Values	Market practice	Plot
Honorable ('50s–'70s)	57th Street	Fairness desert	Consolidation, maintain status quo	Tragedy
-------------------*Scull sale (1973)*--				
Superstar ('80s)	SoHo	Glamour, success	High risk, high short-run profit, aggressive marketing	Success story
-------------------*Collapse of the market (1990)*--				
Prudent ('90s)	Chelsea	Rationality, prudence	Market development, demand and supply	*Bildungsroman*

gallery, where they had passionate discussions about art. Grace Borgenicht, an esteemed dealer of that era, contrasted those days with the times that would follow: "It was quite different then from today. There wasn't this hype—promotion, art scene, superstars and media conscience. I held exhibitions and people came in, it was very relaxed. Charles Egan had a gallery above mine on 57th Street and he would go out to Schraffts, a bar on 58th Street. He would sit there and leave his door open with de Koonings on the floor and nobody cared. It was different then, really" (Klein 1994, p. 34). Most importantly, these dealers were not interested in money, the narrative goes. Betty Parsons, for instance, herself an artist, "lost interest in an artist the moment he began selling at high prices," as one observer writes (Bystryn 1978, p. 398). In a joint interview with her father, Nina Sundell, daughter of Leo Castelli, remarked that "I never heard anything about money until the eighties," while Castelli himself said with hindsight that "[a]t that time it was bucolic. . . . Money was not so important."[10]

Collectors, in turn, allegedly did not care about status or investment, but were exclusively concerned about art and artists. An old New York dealer I interviewed remarked that there is "a whole generation of collectors who died. I could name twenty really powerful collectors from the 1950s, 60s, or 70s, and they were independent collectors who were not responsive to the commodity market in the arts. They are not with us anymore, and we have not observed a generation to replace them at this point" (us14). Artists themselves were satisfied with modest prices in this

era. One of my Dutch respondents contrasted high prices for contemporary art with the earnings of Karel Appel, one of the most famous postwar Dutch painters, in the 1950s: "There are young Dutch artists who just say: 'this costs €7,500.' That makes me think, 'pfff, Appel got a packet of cigarettes, or went out for dinner with somebody, and got a mailbag to paint on.' You cannot mention that to a young painter nowadays. The charm is gone. People want to have a studio now, and make work of 15 by 15 foot, bigger, bigger, bigger" (NL15). The Scull sale, in short, marked the decline of an art world that a distinct group of contemporary art dealers look back upon as a community of honorable art lovers, who claimed to keep commercial interests out of sight. Prices, which were allegedly set modestly, and sprang from a mutual recognition of the artist's and the dealer's needs as well as resources, symbolize the character of the art world within this narrative.[11]

The issue here is not whether this narrative, or, for that matter, the ones that will follow, is true to historical reality or not. In fact, its truth content is questionable to say the least. Betty Parsons, for instance, who represented artists like Mark Rothko, Jackson Pollock, and Clifford Still when these were still early in their careers, saw one after the other leaving because of her own alleged lack of professionalism. Some of them, among them Pollock, left to go to the gallery of former shirtmaker Sidney Janis, where they expected their careers to develop more speedily (Goldstein 2000); no doubt money was on their mind, among other things. But however fictional or even mythical the honorable narrative may be, it does enable actors nowadays to make sense of the way the art market has developed. In fact, resembling the "Hostile Worlds" view discussed in the first chapter, the plot of this narrative is a tragedy, in which the art world falls prey to the laws of capitalism (cf. White 1973): the dominant characters of the art world mischievously change from true art lovers into collectors who resemble the speculators of financial markets, into artists who are more concerned about their celebrity status than about the quality of the work they make, and into dealers who seek to make a quick profit by creating hype around the artists they represent.

THE NARRATIVE OF THE SUPERSTAR

The prices achieved at the Scull sale were the prologue to an era marked—and in the eyes of some stigmatized—by high, superstar prices (see table 6.1). An indication that the times had definitively changed was the acquisition of Jasper Johns's painting *Three Flags* by the Whitney Museum in New York. The Whitney Museum paid the collectors Burton and Emily

Tremaine $1 million for it, which was at the time, 1980, believed to be the highest price ever paid for a work of art by a living artist.[12]

In order to explain such high prices, neoclassical economists have understood the art market in terms of a "winner-take-all" model: like an increasing number of professions and disciplinary fields, the art market is subject to an extremely skewed distribution of income, with a broad base of artists who hardly earn anything, and a few artists at the top who receive superstar rewards (Frank and Cook 1995; Abbing 2002). According to some economists this skewed distribution of income results from a matching problem: a large number of consumers desires the output of a small number of talented sellers. The output of these talented sellers can only "imperfectly" be "substituted" for by the output of other sellers. As a result, prices for the work of these talented few will rise steeply (Rosen 1981, pp. 845–46). Others have argued that this phenomenon can also emerge without differences in talent among artists. It suffices to assume that an individual benefits most from consuming art if she can share her enjoyment with others (Adler 1985, p. 212). In order to realize this, the attention of all consumers will naturally be focused on a limited number of producers. This focus of demand leads in turn to high market prices.

Contrasting with the deductive models of neoclassical economists, flush with algebra and diagrams but sparing of drama and character, the treatment of the same phenomenon in everyday economic discourses is rich in symbolism, involves distinct, outspoken subjects, and gives rise to sharp moral judgments. In fact, for dealers, superstar prices symbolize the New York art world of the 1980s, the downtown neighborhood of SoHo in particular, a specific set of dealer's practices, and a concomitant artist's career. Although a small number of Dutch artists like Rob Scholte embodied the superstar phenomenon as well, the impact of these practices was not as pervasive in the Netherlands (cf. Haden-Guest 1996).[13] Nevertheless, two phenomena that the superstar narrative seeks to come to terms with, a rapidly expanding art world and a strong influx of financial means, were encountered in the Dutch art world of the 1980s as well (Gubbels 1999).

Artist Julian Schnabel is a representative character of the superstar circuit.[14] The young Texan painter of expressive canvases had his first solo show in New York in 1979. Even before the opening of the show, all works, priced at $2,500 to $3,000, had been sold. Afterwards, his equally young and soon-to-be successful art dealer Mary Boone, known for wearing stiletto heels, started "structuring" his career strategically by "placing" his works in well-known private collections, and raising public interest aggressively. Two years later, Schnabel had a "double show" at Boone's and at Leo Castelli's gallery on West Broadway; Castelli had until then only been showing work by established artists like Robert

Rauschenberg, Jasper Johns, and Roy Lichtenstein. At the show, cards next to some of the works displayed the names of famous collectors who had already bought these beforehand; other international collectors were on a waiting list to buy "a Schnabel." *The New York Times* characterized these collectors as a "tribe" who "follow trends in contemporary art as closely as brokers watch the stock market. There are those who hold that Mr. Schnabel's rise has not only to do with being a talented painter, but with the show biz–stock market mentality of today's art market, whose products share the volatility of, say, pork belly futures."

In 1984, when the Whitney Museum of American Art and the Metropolitan Museum in New York had already acquired his work, Schnabel moved on to the even more prestigious Pace Gallery, whose stable included modern masters like Picasso, Jean Dubuffet, and Mark Rothko. "No one except Degas gets catalogues like that," the art dealer Castelli, who had been deserted by Schnabel, commented on the catalogue of Schnabel's first show at the Pace Gallery. The catalogue reproduced every single work on a full-color page. In 1987, when Schnabel had a retrospective exhibition at the Whitney Museum, the catalogue essay of the show pronounced that "the age demanded him." No less modest, Schnabel himself mentioned in an interview that he considered Van Gogh and the Italian Renaissance painters Giotto and Duccio as his peers. In the meantime, business, lifestyle, and other popular magazines such as *Forbes, Vogue,* and *Rolling Stone* covered Schnabel's artistic and private life, zooming in on details like the rides he would take in his Bentley through the streets of Palm Beach, Florida.

The price level of Schnabel's work symbolized the rapid success of his career and the fame he was enjoying. In 1981, two years after his first solo show, prices of Schnabel's work had more than tripled; his most expensive new work sold for $35,000 at the time. Schnabel was not satisfied, however, and criticized the pricing policy of his dealer in the art magazine *ARTnews* for being too conservative. At his first show in the Pace Gallery his work was selling for $50,000 to $65,000, while five years later, new work was priced at $300,000. Schnabel remarked about this price level: "People see it from one of two sides; either they feel 'He's getting all that money so the work must mean something,' or they're jealous and think, 'He's getting all that money just for that?'" The established art critic Robert Hughes doubtlessly belonged to the second camp. In *Time* magazine, Hughes called Schnabel's work "callow," "pretentious," and "corny."

Schnabel was part of a small group of artists, most of them of American, German, or Italian descent, who enjoyed a superstar status in the art world of the 1980s. The studios of some came to resemble production lines, where the artist prided himself on being a manager-entrepreneur,

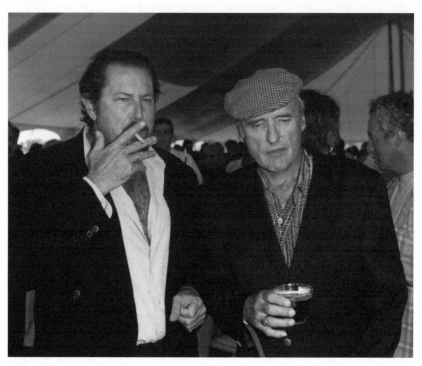

Julian Schnabel and Dennis Hopper at a party. Photo: Eric Striffler.

who oversaw a small battery of assistants executing his work (Szántó 1996, p. 81). The work that these studios put out was marketed aggressively by high-profile dealers in New York, Cologne, and Zurich, the global art capitals of those days. Some of these dealers were eager to "steal" each other's artists once they became successful, seducing them with financial incentives such as the high monthly stipends discussed in chapter 2; others preferred to cooperate and established informal networks across different countries to launch an artist's career on a global scale.

Although the superstar phenomenon waned after the market crashed in the early 1990s, the art dealers I interviewed in the late 1990s nevertheless referred to superstar prices frequently. Superstar prices had become absorbed into the everyday economic models of dealers as symbols for a specific type of artist's career and dealer's practices. They were invoked much less frequently in Amsterdam than in New York, which is unsurprising given the glass ceiling on the Dutch market discussed before. Still, commenting on such superstar aspirations in the late 1990s, one Amsterdam dealer saw artists rise "like a rocket, and subsequently

[go] down again as a meteor (. . .). The burnout speed is very high and the majority of younger artists do not notice that. I can show you the *Flash Art* or *Metropolis M* [an international and a Dutch art magazine] of some years ago which mention people I never hear about anymore" (NL7). An American art dealer who represents a number of European artists characterized the difference in prices as follows: "Europe has a culture of keeping artworks low," but in the United States there is the Gagosian model which is "to take a young artist and jump it way up. And some people think that is sexy, that that is hip, 'let's go buy him'" (US13).

The dealer in question apparently did not agree to that meaning of superstar prices, as he revealed by his comments on the career of Jenny Saville, a young British artist who painted large canvases of reclining women with Rubenesque figures. At her first solo exhibition in New York, which took place at the "superstar" Gagosian Gallery, the paint-ings were priced at around $100,000. Said the dealer: "That girl is 29 years old. If she is not going to make it, she is never going to have a career ever. That's like live and die, these are live and die prices, mother-fucker. We are going to kill your ass, or you are going to make it, let's see. You want to be famous? We are going to make you famous or you are going to be unknown tomorrow. Then you are not even going to be an artist. You are going from 150 grand down to 15, and that is a lot of humble pie. I don't know if most artists could handle that" (US13).

More than anybody else, Saville's dealer, Larry Gagosian, had become identified with the latter days of the superstar phenomenon. Gagosian earned his nickname "Go-Go" because of his aggressive conduct on the resale market in the New York art world of the 1980s. With his monetary offers that were impossible to refuse, and his persistence in wresting works from collectors, he made as many enemies as friends. Currently Gagosian employs over 50 people; his enterprise includes galleries in New York (with 22,000 square feet, one of his two New York galleries, located in Chelsea, is considered to be one of the largest commercial gallery spaces in the world), London, and Beverly Hills. The Gagosian Gallery is said to be engaged in a permanent struggle over being the largest New York dealer in contemporary art with the Pace Gallery, and over being the most reputed one with the Mary Boone Gallery, his direct neighbor in Chelsea. Gagosian's openings are frequented by an amalgam of celebrities of the art world, the music business, and the movie industry. In 1988, Gagosian assisted publishing mogul S. I. Newhouse, Jr. of Condé Nast in bidding on a Jasper Johns painting. With a $17.1 million price, the sale not only established a record for the artist, it was also con-troversial since Newhouse was suspected of merely trying to increase the market value of the other paintings by Johns he already owned. Apart

from Newhouse, Gagosian's other clients include actor Steve Martin, advertisement agent Charles Saatchi, perfume merchant Leonard Lauder, and medicine producer Sam Waksal. Because he allegedly helped the latter evading sales tax in putting together his art collection, Gagosian was sued by the American government in the spring of 2003.[15]

As in the case of the honorable narrative, the truth content of the superstar narrative is debatable. Gagosian himself, for instance, is abused by his colleagues, but simultaneously praised because of the high quality of the exhibitions that he puts together, and because of the grand projects he is able to finance through his secondary market operations. Also, the aggressive superstar pricing strategy was not adopted by everybody; some dealers prided themselves on not changing their pricing strategy in the 1980s. As one of them said in an interview: "We used to maintain a certain dignity and stateliness in pricing, you know, using good sense" (us14). Finally, defying or at least complicating the superstar narrative, the 1980s were not just the era of commodification, but also the era of renewed "institutional critique": some artists deliberately rejected the superstar path, and set themselves to making artworks whose aim it was to subject the social, economic, and political underpinnings of the art world to critique (see, e.g., Wallis 1984; Foster 1996).

For sure, the plot of the superstar narrative is a success story according to some: they claim that in the 1980s, the art world was finally getting the attention it deserved. After the false consciousness regarding money of the previous decades eroded, the financial resources that the art world tapped into manifested themselves in unprecedented energy. As a result, artists, dealers, and collectors managed to secure a prominent position for themselves in society (see, e.g., the interview with art dealer Jeffrey Deitch in Coppet and Jones 2002). Most members of the art world look back on this era, however, with disapproval. They compare the art world of that period to a mixture of show business, Hollywood, and Wall Street; the artists it brought forth resembled arrogant rock stars, whose major virtues were their lifestyles and looks rather than their artistic skills. Their high and sharply rising superstar prices symbolized values like glamour and success as well as an extravagant life, defined by endless partying and the inevitable use of cocaine. The modesty of prices within the honorable narrative of the market contrasts sharply with the hyped-up prices of the 1980s, which had nothing to do with desert, fairness, or community spirit. Speaking of these superstar prices, some art dealers singled out the corrupting force of the art market, akin to the "Hostile Worlds" view of the humanities discussed before. In other words, these dealers recognize the potentially contaminating effect of the market; rather than attributing this effect to the market per se, however, they locate it within a specific era.

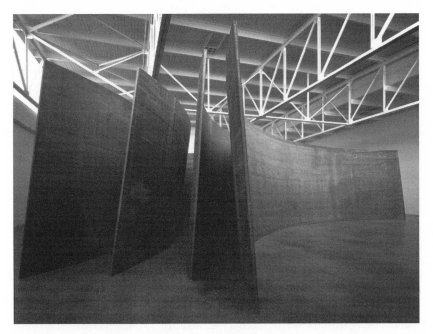

Richard Serra's installation *Switch* at the Gagosian Gallery in New York.
Photo: Robert McKeever, Gagosian Gallery, New York.

Their colleagues who continue to set superstar prices, are stigmatized by most of my respondents, since they violate the code of honor of contemporary art dealers in a number of respects: first of all, they are considered irresponsible towards their artists, aspiring to short-term rather than long-term success. At the time I was conducting my interviews, apart from Saville, a group of young British artists became very popular, attracted widespread media attention, and received high prices for their work. In many interviews with New York dealers, the way the careers of these artists developed was commented on in pejorative terms. Dealers maintained that the superstar prices of these artists would ruin their integrity and would make them "end up in trouble." As one young, emerging dealer remarked: "when I was an undergraduate, a friend of mine became this huge success in London. He won the Turner prize (. . .) but when I went to see him in 1994 or 1995, he was that burnt-out alcoholic, bitter, old horrible art world prune. You know, he became so hot, and then it was like . . . pffft" (US1). Second, superstar dealers trample the morals of the market, treating an artwork overtly as a commodity, with status as well as investment overtones. They deviate, in other words, from the dominant habitus of the art world, which is in Bourdieu's words

to denegate the economy (Bourdieu 1993). Third, given the high-risk character of superstar prices, the pricing practice of these dealers could in the eyes of their colleagues destabilize the art market; this, in turn, would not only have an impact on the business of superstar dealers themselves, but also on the wider market.

REMOVING ARTIFICIAL INFLUENCES

Just as the Scull sale marked the historical transition from an honorable to a superstar narrative, the collapse of the art market in the late 1980s marked the transition from the superstar to the prudent narrative of the market. In 1990, times had changed for art star Julian Schnabel. When a work by him appeared at Sotheby's, interest had waned dramatically. As a result, the canvas failed to raise a single bid. A reporter of *The New York Times* noted how "[a]fter some silence, cynical laughter and a round of applause followed." By that time, the superstar years of the art market had ended. Japanese art imports fell 5,000 percent in less than two years, from $607 million in the year preceding July 1990 to $12 million in the year preceding March 1992 (Szántó 1996, p. 85). At auction, both prices and sales figures went down rapidly (see figure 6.2), art dealers had to close their businesses, collectors aggravated the slump by selling their holdings in an attempt to limit their losses, while careers of artists stagnated or came to a sudden end.[16] Dealers that did manage to survive had to cut down their expenses, such as lunches for employees, taxi rides, lush catalogues, and expensive gifts for artists (Szántó 1996, p. 112).

To neoclassical economists studying the rate of return on investments in art, the collapse of the market manifested itself in a dip in the profitability of these investments. In the everyday discourse of dealers, however, the collapse of the market is, to repeat, represented in more dramatic terms. Paradoxically I found that many dealers do not interpret this collapse as a catastrophe, but as a purification. Indeed, these dealers sharply distanced themselves from the practices of the superstar circuit. Those who established their reputations in the 1990s said they preferred to work with reclusive artists who shun rather than seek public attention. They are not "lifestyle people," art dealer Barbara Gladstone remarked about the generation of artists that emerged in the 1990s. One of my respondents characterized them likewise as follows: "They are humble, very humble. (. . .) This generation of artists is very stunned by what happened in the 1980s: big careers, lots of money, thousands of paintings, and then . . . splash. These artists are not looking for thousands of dollars, they are looking for future" (US17).[17]

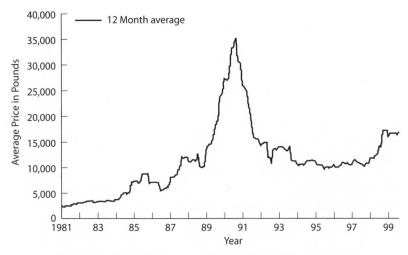

FIGURE 6.2. Auction prices for contemporary works of art, 1981–99.

Apart from raising moral concerns, dealers have commercial objections to the use of superstar prices. These prices are considered to be "inflated," "mythical," "unreal," "unsustainable," or not "trustworthy." The issue for dealers is that superstar prices are neither backed up by a solid career, nor firmly grounded in the market. Dealers made similar objections to other artificial influences on price levels, which run against the "reality of prices," as one of them phrased it. Such influences include demands by artists for high prices on the basis of emotional or aesthetic concerns, or because the artists feel entitled to a living wage (cf. Meyer and Even 1998, p. 279).[18] The reason why dealers were frowning upon these demands is that they do not take into account "what the market can bear." One prestigious Dutch art dealer explicitly opposed another one of those artificial influences, namely the connection between labor time and prices: "I would say: 'produce more.' There can only be a relationship between labor costs and the price of a work if there is a market for it. The fact that somebody lacks the fantasy to be productive is no excuse to ask for more money for each work he delivers," he said (NL11). Another dealer complained likewise that young artists in the Netherlands do not have an understanding of the market. According to him, this is due to an institutional factor, namely the fact that "a terrible atmosphere reigns within the academy: frustrated teachers who represent a very anticommercial way of thinking. As if artists could earn money by the hour. . . . Old socialists, they are. Academies thrive on such illusions. In those cases I think, 'oh boy, are you insane?'" (NL10).

Another disturbing factor that dealers mentioned, albeit in Amsterdam rather than New York, were subsidy schemes. In the Netherlands, the state and local governments used to commit themselves to buying work of Dutch artists on an annual basis as part of the Visual Artists Arrangement (*Beeldende-Kunstenaars-Regeling,* BKR). The goal of this arrangement was to provide artists with a minimum income. Many of these subsidized artists did not sell their work on the free market, and if they did, the "real" price level tended to be lower than the prices they received for similar works from the government. A large-scale official evaluation of the arrangement disclosed that advisory committees, which had to give price estimates for the acquisitions made by the government, failed to use the standard of the market. Instead, they based their estimates on characteristics of the work, on the asking price mentioned by the artist, and on a notion of a living wage (Baaijens et al. 1983, p. 48). Although these prices should have been adjusted to prices on the free market, the evaluation pointed out that so-called "BKR prices" were on average three times higher than market prices (Muskens 1983, p. 90).[19] The Dutch art dealer and former art critic Lambert Tegenbosch referred to these prices as "state prices" (Gubbels 1999, p. 81). Although the arrangement was abolished in 1987, I heard art dealers complain in the late 1990s about its continuing influence. Arguing that Dutch artists are "slightly spoiled and have excessive expectations" (NL10), they saw the remnants of the BKR in the prevailing mentality of the art world; it would hinder the artist's sense of reality, and induce him to ask unreasonably high prices for his work (NL7). This may explain the remarkable positive price effect for artists who were part of this arrangement in the statistical model of determinants of prices developed in chapter 4. This effect may be puzzling given the low prestige of the BKR arrangement, but it makes sense once it is recognized that the arrangement instilled high pricing expectations in its beneficiaries.

A PRUDENT MARKET

Prudent pricing strategies, which dominated the narrative of the market at the time that I was conducting my research, seek to counter these artificial influences on prices and embrace prudence, caution and rationality instead (see table 6.1). The prudent narrative of the market invokes the genre of the *Bildungsroman*: the plot is one in which the protagonist, after taking several hurdles, reaches maturity. Dealers who endorse prudent prices strive for a no-nonsense market, in which actors treat each other in a businesslike, albeit respectful manner. In order to reach this goal, the art market has to free itself from romance, high hopes, and nos-

talgia, as well as from the extraordinary, hardly businesslike practices that have come to be associated with the art world.

Prudent prices are directed at establishing a "firm," "extremely secure," or "trustworthy" market; they symbolize the era of the 1990s, when dealers were still shocked by the sudden collapse of the market in the beginning of the decade, and were determined to prevent the occurrence of another collapse. Therefore, dealers characterized their pricing strategy as taking the "slow and steady route" or as "a safe bet" (US13).[20] As one dealer put it: "if we increase the price we do not fake it. It is real. It is real since we put the market to the test" (US16). In order to do so, prudent prices are low early in the career of artists. Only when a firm demand for the artist's work exists will prices be cautiously increased (see figure 6.1). Because prudent prices are set at a level that is lower than what the dealers expect the market to "bear," some gallery shows may be easily sold out. Subsequently, rather than doubling or tripling prices, which is common in the superstar circuit, increases will be limited to 5, 10, or 20 percent. Also, such price increases need to be "substantiated" by the reputation of the artist, or, if the artist is successful, by prices on the resale market. If economic theory assumes that prices reflect market forces by definition, the notion of prudent prices indicates that this is to some extent a matter of choice and deliberate action on the part of art dealers.

Dealers are aware that prudent prices are more attractive for collectors than they are for artists.[21] They make it "seductive" and "easier" for collectors to make their purchasing decisions, but for most artists pricing prudently means that they cannot make a living from their work. Here two different types of prices contradict: the honorable, desert, or needs-based prices that artists demand are difficult to reconcile with the dealer's notion of prudent prices. As one Dutch dealer, who quickly built a strong reputation in the Dutch art world, remarked: "[a]rtists want to keep prices high. And I can imagine that. If you look at the hourly wage they are left with . . . it is so little. So they are asking for a fair price. But still it is better to keep prices low first, so that the work can be bought easier by companies and can end up in other collections. Thus the fact that artists get lower prices than is actually fair, is an investment in the future" (NL4). The dealer's remarks suggest that even prudent prices are set with more than just economic deliberations in mind. On top of these economic deliberations, he and other dealers expressed a sense of pride in prudent prices: the pride of carefully building the career of an artist, and lending credibility to a market that is associated with fragility, artificiality, and uncertainty.

When prices rose sharply in the late 1990s, when I was conducting my interviews, dealers did their very best to distinguish these high prices

from superstar prices out of anxiety that the market would become over-heated again. They invoked the "selectivity factor," arguing that buyers are looking at quality, and rely on advice before buying something; in the 1980s, by contrast, collectors would buy works without even having seen them, they alleged. Also, dealers insisted that the market was firmer, more orderly, and based on rational principles in the late 1990s. In fact, they attempted to distinguish the market of their own days from the one of the 1980s so frequently and so vehemently, that these attempts sounded more like mantras than like business reasoning.[22]

CONCLUSION

When prices are questioned by buyers in modern markets, the response of sellers is often not in terms of the principles of supply and demand which are supposed to govern prices. Instead, the seller will come up with a range of arguments in order to legitimate or justify the price. It is most likely that the seller will tell a story, in which concrete subjects, anthro-pomorphic notions of the economy, a sense of drama, and moral values surface. The models of the market that we draw on in everyday economic interaction thus differ significantly from academic models of the econ-omy. In this chapter I have studied the dealer's models of the market for contemporary art in particular. Talking about prices, dealers permanently invoke a wide range of non-economic values such as fairness, honesty, arrogance, success, or prudence. Furthermore, their prices are embedded in three narratives, which account for the development of the art market since the 1950s. The first narrative takes the form of a tragedy, in which a small art world, populated by honorable art lovers, falls prey to the laws of capitalism; the event which symbolizes its downfall is the Scull sale of 1973, the first American auction sale devoted to contemporary art exclusively, in which a large number of artworks fetched record prices. The narrative that followed was the narrative of the superstar, which was all about the artist as a star, the collector as an investor, and the dealer as an aggressive marketeer. This narrative is symbolized by high and rapidly increasing prices. At the time that I was conducting my interviews, deal-ers by and large condemned these superstar prices. After the crash of the market in the early 1990s, the ensuing narrative was the narrative of "the prudent" or "the real": this narrative inspired dealers to make efforts to get rid of all artificial influences from their business realm, and establish a firm, healthy market, in which solid, long-term careers of artists could be grounded.

Surely these narratives are no true accounts of the way the market really functioned in the last decades. They are tools for dealers to make

sense of the historical development of the art market, thereby establishing a moral order in markets of the past, present, and future. These narratives are more than that, however: they enable dealers to endorse some business practices and distinguish themselves from colleagues whose business operations differ from theirs. In other words, different narratives of the historical development of the market coincide with different circuits, which each has its own, shared notion of what pricing is about.

Chapter 7

Symbolic Meanings of Prices

INTRODUCTION

Pricing, as the previous chapters have suggested, is not just an economic, but also a signifying act: by distinguishing different types of prices or by identifying auction and gallery prices with different sets of values, art dealers turn pricing into a meaningful activity. In the present chapter I will elaborate on these meanings by interpreting the price mechanism as a symbolic system. The purpose of the chapter is to address two major anomalies of the price mechanism with the meaningful, symbolic, or expressive dimension of prices in mind. The first anomaly is the existence of a strong taboo on price decreases. This taboo has been widely recognized in academic literature on the art market, it appears in artists' guides to the market, and it is universally acknowledged by the dealers I interviewed.[1] When I questioned them about price decreases, I received answers like: "a work of art is never decreased in price, never" (us14) or "I have a moral responsibility to maintain the price, a responsibility towards the community I am involved in" (us11). In fact, art dealers and artists seem to behave more like *price* than *profit* maximizers. In their everyday models of the art market, the concept of price elasticity, which is so important in academic economic thinking, plays a subordinate role. From an economic perspective this may make sense as far as the negative effect of price decreases on the investment potential of art is concerned. The finding must also be puzzling for neoclassical economists, however, since it inhibits the movement of the market into equilibrium: if lowering prices is really impossible, the market cannot be cleared in case of excess supply. In particular, we saw in chapter 3 how this taboo prevents a single price equilibrium from coming into being on the auction and the gallery market.

The second anomaly that I address in this chapter is the fact that artworks of the same size, within the oeuvre of one artist, almost invariably have the same market price. In chapter 4 the strong correlation between price and size was established with the help of a quantitative model; subsequently I explained this strong correlation in terms of pricing scripts and rule-following behavior. Dealers who abstain from following this rule are fully aware of this and are ready to provide a legitimization for

their deviating behavior. One old, established Dutch dealer argued, for instance, that she could not intervene in the practice of some of her artists who price according to quality rather than size, given their standing, age, and exclusivity. Therefore she let them price "masterpieces" higher (NL12). An American dealer said that occasionally, when an artist has an established reputation, she considered pricing according to "importance" or "difficulty" for the following reason: "Ultimately collecting should be about love. (. . .) I think it is good to challenge people and to do things with new prices" (US17).

The rule of pricing according to size is anomalous, since it implies that art dealers miss out on a price premium on works they expect to sell more easily; they fail to exploit excess demand for some works, in other words. This is indeed acknowledged by the dealers I interviewed. As one of them put it: "there is always somebody's favorite piece in the show that you can sell ten times over" (US8). From a "Hostile Worlds" perspective, the size rule adds insult to injury: if dealers claim to be concerned about quality, why do they refrain from expressing those concerns in the prices they set? Why do they say, as one of my respondents did, that "[i]t is a code in the gallery circuit to conceal which artworks you value higher than others"? (NL2) In fact, the same dealers who distinguished themselves sharply from the immorality of the secondary market had to acknowledge that secondary market dealers *do* price according to quality. Is the size rule indeed one of the "odder tribal rituals of the art world," as a journalist of the *New Yorker* alluded to it in the 1970s?[2]

These anomalies can be understood by taking social and cultural meanings of prices into account. My ethnographic material shows that prices are suspended in a web of meanings, of which their impersonal, businesslike meaning is only one. This web of meanings relies on mental accounting schemes which are composed of cognitive associations and which connect prices with quality, reputation, and status (Thaler 1999). Mental accounting schemes, in turn, are established through a process of semiotic socialization. Members of the art world who have detailed knowledge about prices and pricing conventions can interpret or "read" these meanings of prices, notice deviations, and extract meaning from them. The price mechanism is, in other words, not just an allocative system, but also a semiotic, communicative system akin to language (Zeruvabel 1997, chapter 5). However, the meanings which prices have are not identical to all members of the art world, and even less so to its outsiders. In that respect, prices function as boundary objects: on the one hand, they are robust enough for people to recognize them as symbols; on the other hand, they are flexible enough to allow for different meanings to different people (Star and Griesemer 1989, p. 393).

The perspective on pricing which I propose in this chapter builds on literature in the sociology of the arts, which states that aesthetic, artistic, or cultural values are socially constructed: the value of an artwork does not reside in the work itself, but is, under conditions of uncertainty, produced and constantly reproduced by artists, intermediaries, and audiences, subject to numerous conventions and cultural codes of art worlds.[3] In this social construction several elements interact. First of all, the appreciation of an artwork depends on the physical context in which an artwork is seen: is the work displayed at home, in a museum, or in a gallery? How are these spaces furnished, where are they located, how is art displayed in them?[4] The second, related element in the social construction of value is the existence of previous appraisals by cultural institutions and cultural experts. This so-called institutional recognition manifests itself in the inclusion of artworks in museum shows, retrospective exhibitions, prizes that an artist has received, or favorable discussions of the artist's work by art critics. Institutional recognition influences the way the wider audience perceives an artwork: before belief in its value emerges, art needs to be consecrated by symbolic capitalists, to put it in terms of Bourdieu.[5] This construction of value is path dependent, since experts do not cast their vote in isolation from their peers. Whereas at the beginning of an artist's career, chance and luck are crucial in the establishment of cultural value, succeeding acts of valuation will depend on the previous ones. Thus, institutional recognition emerges in a gradual, social, and path-dependent process (Bonus and Ronte 1997, p. 109; see also Merton 1968). Third, previous market appraisals are involved in the social construction of value. The audience may be influenced by the reputation of the gallery where the artist currently exhibits, by the galleries where he has exhibited before, by private collectors who have acquired work by him in the past, or by the commercial success of the current exhibition. The latter is, as we saw, frequently indicated during exhibitions by orange dots next to an artwork on a gallery wall, which signal that the work has already been sold.[6]

My claim is that the price mechanism and the meanings that are generated through it also contribute to constructing the value of art. What distinguishes meaningful prices from other elements in the social construction of value is their numerical character. The commensurating or objectifying effect of the pricing decision, which is considered destructive from a "Hostile Worlds" point of view, can have constructive moments in a field that is riddled with uncertainty and subjectivity. The virtue of pricing, like other forms of commensuration, is that it "offers standardized ways of constructing proxies for uncertain and elusive qualities," as Espeland and Stevens argue. Or as Rob Scholte, a Dutch art star of the 1980s, once put it in more ironic terms: "the only real thing about an artwork is the price."[7]

PRICE DIFFERENCES AS QUALITY SIGNALS

How does the price mechanism contribute to the audience's valuation of an artwork? When setting prices, dealers take into account that collectors make inferences about the quality of the work from its relative price or from a price change. First of all, the danger of low prices, dealers think, is that collectors do not take the work seriously. If a work is priced lower than the conventional or expected price level, collectors may be pleased, but at the same time it incites distrust about the quality of the work. As an American dealer said: "Sometimes you can find work that is greatly undervalued, and people say 'wow, is that only that price?' [Confidential tone:] That makes them nervous, they think it should be a higher price. It is a psychological factor" (US10).[8]

The second manifestation of the constructive, meaningful role of prices is encapsulated in the script of pricing according to size. The rationale to avoid pricing works of the same size differently is that by allowing for price differences, dealers would convey implicit messages about differences in quality of the works exhibited. Such messages are avoided for a number of reasons. To begin with, they would create a sense of disorder in a market where uncertainty already reigns. As one dealer put it: "Let me miss out on that upper part of the price I am not able to ask. Stability is more important than that extra bit of money" (NL9). Also, many dealers question whether their own value judgments are similar to those of their customers; they said that they cannot predict how collectors will evaluate individual pieces in a show. By pricing all artworks equally, dealers seek to let buyers decide themselves what they like. Says a Dutch dealer: "Who am I to determine that this painting is more interesting than the painting of the same size hanging next to it? It has frequently happened that I think 'I would buy this and that work,' but that the first work people buy is one I would never have guessed" (NL6). Another dealer argued that to make such distinctions in quality by means of price differences is "doing art history rather than dealing in contemporary art" (NL11). Finally, a straightforward economic rationale for the size script is that attaching a higher price to one work may complicate selling the lower-priced works in a show. One of my respondents, for instance, admitted that pricing according to size rather than quality means that "the real hits" are less expensive than they could be, but, he continued, "you violate another system if you would comply with that. You will have a more difficult time selling the rest. In fact, you reconfirm that the rest is less desirable" (NL9).

The third contribution of prices to the construction of value is related to price changes rather than price differences or absolute price levels.

Contrary to other markets, including those for cultural products such as literature or music, success on the art market is measured in terms of rising prices rather than rising sales.[9] An increase in the price level of an artist's work therefore conveys the message that her career is developing or that her art is being accepted in the art world; simultaneously, it makes collectors feel secure about the acquisitions which they have made in the past or which they intend to make in the future.

The positive meanings of increases encourage dealers to be price rather than profit maximizers: since high prices are perceived as a sign of success, dealers and artists have an incentive to actively produce scarcity. This provides a tentative explanation for the fact that galleries, both in the past and in the present, deliberately restrict the number of works they hang in an exhibition (cf. Grampp 1989, pp. 86–87; Gee 1981); for the fact that even highly successful artists like Mark Rothko, Francis Bacon, or Picasso left a large number of works when they died; and for the fact that art dealers are eager to restrict the edition size of photographs and prints. All these practices suggest that artists and their dealers aim at maximizing prices.[10]

The opposite argument applies to price decreases. Price decreases affect more than just the return on investing in art. In fact, such a direct economic effect was not even mentioned in the interviews. Instead, dealers were concerned about the meanings which those decreases convey to both artists and collectors. However strong the economic logic of a price decrease may be, by lowering the price an art dealer conveys a message about the worth of an artist's work and thereby affects her self-esteem. Says an *éminence grise* of the New York gallery scene: "[A price decrease] has a caustic reverberation. If the artist goes down, it means the gallery has lost confidence in him, or the collectors have lost confidence, or he lost his audience. Those are the implications, and you must never allow for those implications, because if you continue to exhibit him, it means that you continue to have faith in him. And if you continue to have faith in him, that means you believe that the artist's progress is ongoing. It is injurious to an artist if he finds that he cannot sustain his price level. That is a blow to his self-esteem" (us14). Indeed, even the most well-known dealers I interviewed, representing famous artists who sell their work to museums for prices well over $100,000, confirmed that prices are a "personality issue": they seriously affect the pride of artists.

Price decreases generate comparable meanings for collectors. They create "suspicion in the audience," as one dealer put it; as a result, collectors will "distrust your instincts" and will "lose faith." If the collectors' belief in the artistic value of the work is harmed because of a price decrease, the consequences can be dramatic. One dealer said that "if [the price] is going down, they will start asking what's wrong with it. That can have a

huge backlash and can destroy a career at the beginning" (us8). Another dealer confirmed with regret that, when an artist has hardly been selling for a considerable amount of time, "[y]ou drop the artist, because you cannot drop the price" (us19). Art dealers are particularly reluctant to decrease prices, since they expect that information about such decreases spreads fast in the art world.[11]

The dramatic consequences of price decreases on the collector's appraisal, combined with the effect they have on the artist's self-esteem, shed light on the script of starting low which I discussed before. Cultural economists have argued that dealers "underprice" artworks, since it is difficult to attract the one buyer willing to pay the exact equilibrium price on a thin market like the art market (Heilbrun and Gray 1993, p. 153). The alternative explanation which my interviews suggest is that the taboo on decreasing prices generates an incentive for galleries to underprice from the outset, and increase prices as slowly as possible.[12] Nevertheless, in the unfortunate case of prices that are higher than the market "bears," there is a repertoire of strategies to decrease prices less visibly. The repertoire lacks the legitimacy of most other pricing decisions, which means that dealers only make use of it in emergency situations. First of all, the size of the work which the artist and the dealer select for an exhibition can be increased while keeping prices on the same level; *de facto* this reduces the selling price per unit of size, albeit in a concealed way. The second strategy is to "restructure" the prices of an artist's work once he changes gallery. If an artist, either voluntarily or involuntarily, leaves a gallery and finds representation at another one, the taboo on price decreases is temporarily annulled, which makes it legitimate to start from scratch with prices. As a director of a large, multinational art dealership affirms: "Because of a kind of bubble or inflated period in time, an artist can be doing fantastic prices, and then show no activity. (. . .) That is an opportunity to bring on very good people who are already very established, who need representation and will agree to lower their prices. (. . .) There were certainly some people who left [during the crisis of the art market in the early 90s]. The other ones who entered the gallery were very well known, and agreed to restructure their prices. So when there is a recessionary period, you jumble around and readjust" (us2).

The third component of the emergency repertoire which I encountered is to decrease prices when an artist experiments with a new technique or develops a new body of work. Finally, the most frequently used technique to achieve price decreases is to award discounts. Indeed, whereas courtesy and museum discounts serve a relational purpose, as was shown in chapter 2, flexibility discounts are given in order to make sales. Although such flexibility discounts are only given when the market dictates it, they provide dealers the best of both worlds: on the one hand, they can

maintain high prices that signal quality, while on the other hand, dealers reaffirm social ties to collectors.

An economist may interrupt at this point that the phenomena I have discussed and the dealer's understandings of them accord with predictions of standard economic theory. My findings confirm the existence, for instance, of what Harvey Leibenstein called a "Veblen effect": the utility which consumers derive from art not only depends on its inherent qualities, but also on the price paid for it. For this reason, Leibenstein argued, it is necessary to distinguish the real price and the conspicuous price of a good: since consumers derive utility from the conspicuous price, but want to buy the good at a bargain nevertheless, middlemen have an incentive to set posted prices high, and subsequently discount them (Leibenstein 1950, p. 203).

Furthermore, the taboo on price decreases that I encountered can be seen as a manifestation of price stickiness, which has been found on many markets other than the art market (Blinder et al. 1998). Given the radical uncertainty about quality on the art market, and the asymmetric distribution of information, which was discussed in previous chapters, this price stickiness can be explained with the help of signaling theory. Nobel laureates Michael Spence, George Akerlof, and Joseph Stiglitz introduced "signaling" and related terms like "screening" and "efficiency wages" into the analysis of markets where, comparable to the art market, the quality of goods is difficult to assess (see Riley 2001; cf. White 2002, pp. 14–16). The overarching argument is, in the words of Stiglitz, that "price serves a function in addition to that usually ascribed to it in economic theory: it conveys information and affects behavior" (Stiglitz 1987, p. 3). When this information concerns the quality of goods, disequilibrium situations may persist: when the price is lowered, demand may decrease rather than increase, since the lower price can be interpreted as a signal of lower quality.[13]

With respect to labor markets, my findings resemble the phenomenon known as wage rigidity. Just as price decreases are avoided on the art market, economists have long recognized that wages do not fall if unemployment occurs; their explanations do not contradict my finding that price decreases have a negative impact on the self-esteem of artists. John Maynard Keynes stated in chapter 2 of the *General Theory* that workers are mainly concerned about relative wages, that is, their own wage compared to the wage of others. As a result, employers avoid wage decreases, unless all firms cut wages simultaneously (Keynes 1936). Other explanations of such rigidities by economists like Robert Solow and Georg Akerlof suggest that price decreases have a negative effect on the morale of workers. Wage decreases may result, in other words, in lower productivity (Bewley 1999; cf. Tilly and Tilly 1998). Also, just as price is a signal

for the quality of goods, wages may signal the productivity of workers. Thus, in a situation of excess supply on a labor market, wage decreases will be difficult to achieve, since they send out a negative signal about the quality of the labor supply (Stiglitz 1987).

Finally, the fact that dealers use discounts and find a legitimization for decreasing prices merely proves the efficiency of markets: it shows that the art market has developed its own alternative equilibrating mechanisms. The most intricate of these mechanisms may be that artists and dealers whose pricing strategies are efficient will have staying power, whereas their colleagues with erroneous strategies will not be able to sustain themselves on the market. Because of these differences in survival rates, the market will head in the direction of ever-increasing efficiency (see Hodgson 1993). It can be expected, in other words, that a Darwinian selection process operates on the market. That this is indeed the case to some extent is suggested by the high death rate of galleries on the art market: according to estimates, 75 percent of contemporary art galleries survive no more than five years (Caves 2000, p. 44).

Is there anything new under the sun? an economist may thus ask. In fact there is. As I will show in the next sections, price signals do not just serve the economic purpose of making sales to collectors or maximizing productivity of artists. Meanings of prices and price changes also prompt dealers to enact their roles as gatekeepers and patrons of artists; they contribute to establishing status hierarchies among collectors and artists; they structure the art world on a supra-individual level. Prices have, in other words, not just signaling, but also organizational attributes. In the terms of Harrison White, who argues that markets should be understood as networks where firms position themselves either upstream or downstream, the art market can be understood as a market where dealers seek to stabilize their relations upstream, that is, with suppliers. In their capacity of a ranking device, prices simultaneously construct and structure the market space (White 2002). A final deviation from signaling theories that will be discussed is that meanings of prices are always contextual; because they are interpreted differently in different circuits, these meanings are invariably equivocal. This interpretive aspect to prices has been ignored by neoclassical economists.[14]

Enacting the Dealer's Role

The fact that art dealers refuse to price according to quality is not just related to the signaling effect of prices. They also refuse to do so in order to enact their role as gatekeepers of the art market. This gatekeeping role not only means that dealers function as a selection mechanism for new artists entering the market, but also that the gallery is supposed to screen

every individual artwork. By accepting price differences in works of the same size, dealers would implicitly admit that differences in quality exist in the works for sale. Thus, their gatekeeping role would be undermined, they say. As an American dealer explains: "[pricing works differently] implies that the integrity of the artist is not consistent throughout, that he has made this one piece better. I think that that is playing an immoral role, it is an inappropriate role. You make sure he is not going to put in a piece of crap; you make sure he is going to edit his work himself, and that the dealer does so as well" (US8). The moral nature of this pricing rule was likewise underscored by a Dutch dealer who argued that pricing works differently "is condescending towards the audience, because it presupposes that you determine on your own what is good and what is not. (. . .) It may be true that you like one work better than another, or that it is easier to sell, but nevertheless you have to guarantee that if somebody buys at your gallery, he won't buy rubbish. No second rate art" (NL16).

Just as the rule of pricing according to size symbolizes the dealer's gatekeeping role with respect to collectors, the rule of pricing low expresses his caring role towards artists. Especially young artists, who have high expectations and whose self-confidence has grown once they find a gallery, are eager to price their work high; they lack the experience about pricing strategies and knowledge about customary price levels. Dealers told me that they see it as their duty to "protect" these artists against themselves and against their market. Instead of granting those artists the sweet pleasure of high prices, an art dealer can provide them other sources of self-esteem, such as taking their work to art fairs, or achieving critical attention from museums and critics. Such forms of attention serve as a less risky substitute for high prices.

Apart from symbolizing the dealer's role in the market, price signals are a sense-making tool for collectors. Even when a collector has already acquired a work, and has no intention of reselling it, rising prices are crucial, since they provide a sense of reassurance to collectors who spend vast amounts of money on goods which have no apparent utilitarian value. Says an American dealer who advises a small number of billionaires in their acquisitions of artworks, sometimes over $1 million each: "They permanently have to explain to themselves why they spend so much money on art, sometimes up to 40 percent of their total net worth. So they want to hear all day long that it makes sense what they do" (US2).

Also, prices are a source of identity and confirm status hierarchies among art dealers, collectors, and artists. This shows that prices are not just about objects, as economists assume, but even more about the people that make, distribute, or buy these objects. Rising prices enable collectors and art dealers to express their "aesthetic eye" and the heroic role they

play in the art world: by contrasting the low level of the original acquisition prices with the high present market value of their holdings, they tell how early they were able to spot the quality of an artist's work. The Dutch collector Frits Becht, for instance, recounted in an interview with a Dutch weekly how he bought work by the Dutch artist Co Westerik for €75 in the 1950s, and emphasized that he could sell it 30 years later for 1,000 times that price. Likewise Sidney Janis, a famous postwar gallery owner in New York, remarked in an interview how difficult it was to sell works of abstract expressionist painters when they had their first exhibitions in his gallery. Work by Willem de Kooning was sold for $1,800, while a work by Jackson Pollock cost $8,000 in 1952. Janis comments: "Twenty years later I bought it back for $350,000 and gave it to the Museum of Modern Art. We sold *Blue Poles*, a somewhat smaller picture, for $6,000, and eventually it was sold to the *Canberra Museum* in Australia for a reputed $2 million" (Coppet and Jones 2002, p. 39). In another interview Janis emphasized how "over the past decade the works of every one of the artists [he represented] have at least tripled in value, while those of several have gone up eight or tenfold."[15] For him, as for many collectors and dealers, the gap between the original acquisition price and the present market value functions as a status symbol.

This means that some collectors are triggered by low prices when they buy art. Keen on potential increases in value, and reassured of their own capability to "spot quality," they refuse to buy for high prices (cf. Steenbergen 2002). The American collector Paul Cummings, for instance, likened the excitement of collecting paintings to buying "strawberries . . . when they're plentiful and cheap" (Robson 1995, p. 197). Likewise one of my respondents said that he tried to "sell work as cheap as possible, because (. . .) I want to grant people the pleasure of getting it for a bargain if they have the guts to buy work of an unknown artist" (NL4). Thus dealers need to have personalized, contextual knowledge in order to know in which cases they should signal quality by means of high prices, and in which cases they should emphasize the discoverer character of low prices. Also, when setting prices, dealers and artists can take into account that different prices entice different collectors. One of my respondents said he priced art as low as possible in order to make sure that "people look with their eyes, and do not pay attention to status" (NL4). A colleague of his said likewise: "Look at the difference between something that costs €10,000 or €50,000: you will get another audience with either price level, and you may find one sort of public nicer than another, to put it in general terms. Maybe it is more pleasant to sell things that cost €10,000 guilders, because the people that can afford it are nicer to deal with and speak to" (NL11).[16]

Just as the difference between the original and the present market value of art is a status symbol for collectors, prices establish status hierarchies among artists. Ruth Towse noted that "monetary payment is a ranking device; if artist A is paid more than artist B, he feels more valued thereby. Many artists accept the judgment of the market" (Towse 2001, p. 487).[17] Given that artists interpret such rankings as judgments over their self-worth and the quality of their work, they are fiercely contested. During group exhibitions, the ranking effect of prices is particularly evident, and may be a source of dispute among artists. An eminent New York art dealer spoke of the tension which "permeates the entire art community, that certain artists are achieving very high prices, and that other artists think they are not worthy of those price" (us14). Anticipating such status hierarchies, a Dutch art dealer said that she priced a young artist's work relatively low, even though the quality of her work would allow for prices as high as those of older, more established colleagues. Likewise, for a dealer I interviewed who represented Indian artists in the Netherlands, translating hierarchical differences into price differences was a rule rather than an exception: "In India there is a strong hierarchy between artists anyway (. . .). Young artists look up to artists who are older. So a younger artist will not mind if prices for the work of an older colleague are higher. I could not get away with pricing work of a younger artist higher, even if the quality of his work is much better. That is out of the question" (NL3). In short, art dealers are confronted with ranking effects of prices when they do business. As Szántó noted, these effects may appear more easily in galleries that represent artists who are relatively similar in terms of age, reputation, and the work they make (Szántó 1996, p. 267). However, since artists primarily gauge the quality of a work of art, and expect the price level to accord with their quality assessment, they may take issue with high prices for works made by any artist, no matter if she is similar or different to them in terms of age, sex, or career.

Structuring the Art World

Another phenomenon which signaling theories in economics do not account for is that price signals do not just concern the level of individual artists, but also entire artistic movements or the position of countries in the international art world. By confirming the rise and decline of artistic movements, the price system structures or provides order to the art world as a whole. To give some examples in the history of art: in 1914, the outstanding collection of a small group of French investors known as *La Peau de l'Ours* ("Bearskin"), came up at auction at the Parisian Hôtel Drouot. The group had bought new, predominantly cubist artworks by

artists such as Picasso before their careers had been firmly established. The success of the auction was perceived by art critics as "a confirmation of the art's importance that their own aesthetic evaluations could not confer" (Fitzgerald 1995, p. 17; Gee 1981, pp. 22–23). In the late 1990s, the record prices for photographs made by contemporary artists such as Gursky were likewise interpreted as the ultimate confirmation that the medium of photography was finally taken seriously in the art world.

Conversely, decreasing prices have been interpreted as the defeat of artistic movements, or even as evidence of a country's waning position in the international art world. When abstract expressionism rose in New York after World War II, this was at the expense of an older generation of American artists whose prices subsequently plummeted (Guilbaut 1983, p. 179); the same drama unfolded for many artists who established their careers in the 1980s. Unable to sustain the price level which they had built up so quickly in the superstar circuit, many saw their careers ruined. In a recent report commissioned by the French government, the fact that prices of contemporary French artists, unlike their nineteenth-century predecessors, are lagging behind the international standard, was interpreted as a sign of the sorry state of the contemporary French art world.[18]

Apart from structuring the art world internally, high prices also structure the relationship of the art world to the remainder of society. As art historian Frances Haskell has pointed out: historically high prices "raised the whole status of art in the eyes of the world" (cited by Fitzgerald 1995, p. 6). This status-raising effect of prices has practical, unintended consequences. It results in a concentration of resources directed at preserving artworks rather than other objects which societies have manufactured throughout history. Thus high prices contribute to the preservation of art for future generations. As a gallery owner claims: "There is a very important moral function carried out by high art prices, by the fact that this makes art valuable. A society can preserve only things that are valuable (. . .) the great moral contribution the market makes to art is the value it imputes to art which in turn leads to its preservation" (Klein 1994, pp. 65–66).[19]

CONTESTED MEANINGS OF PRICES

A final rebuttal of economic signaling theories is that meanings of prices are far from unequivocal, and always need to be interpreted by actors. These meanings are based on conventions which are mastered through a process of "semiotic socialization" within the arts community; without knowledge of prices for art, a certain price difference, price level, or price

change will be meaningless. Also, an outsider to the arts community may not understand or contest the meanings which prices convey. Thus when sociologist David Halle studied artworks on display in private houses in New York, and asked their owners about the meanings these works had for them, he recorded the following statements: "Some of the modern stuff is o.k., but a lot of the stuff is either ugly or a put-on. These million-dollars price tags are a big put-on. Most of the French Impressionists could paint; they really did wonderful things. But a lot of the modern artists can't paint. Jackson Pollock is a big hoax. It's 'Nothing But' drips." Another respondent said: "I stand looking at two blobs, trying to find a meaning in it. The meaning is that they can get fantastic sums of money for the works!" (Halle 1993, p. 125, 127).

In the Netherlands, such contestation of meanings of prices has frequently arisen when museums acquire works by modern or contemporary artists with tax money. Acquisition of, among others, Piet Mondrian's *Victory Boogie Woogie,* Bruce Nauman's *Seven Figures,* and Jeff Koons's *Ushering in Banality,* all difficult to appreciate for outsiders of the arts community, were followed by heated media debates over the legitimacy of prices paid by the museums or foundations involved (€36,400,000, €291,000, and €114,000 respectively). As the Dutch art critic Sven Lütticken commented: "The prices modern artworks received were always an efficacious instrument to make an issue of the aversion to them. It made that abject modern art even more repulsive." Nevertheless the disputes serve to reinforce the communitarian character of the art world; they mark its difference from the remainder of society, and create a boundary between those who understand the legitimacy of high art prices, and those who don't.

Also within the art world, however, the price mechanism may lead to confusion, misunderstandings, and contestation. This becomes apparent at various occasions such as when an artist is insulted by the low price a dealer sets for his work, when collectors mistrust prices that are either lower or higher than they expect, or when dealers ridicule the high prices which a colleague has set. I ran into dealers who thought of an artist and her cautious pricing preferences as too modest, and into others who interpreted their artist's demands for high prices as a symbol of a misplaced sense of superiority. Market prices are not definite, specific, or concrete at all for actors on markets. Contrary to what economic signaling theory presupposes, prices may have many different meanings simultaneously. In that respect, they are no different than other symbols. To be more specific, due to the existence of different circuits within the art market, meanings of prices are often contested meanings. A high price established in the auction circuit will be interpreted differently by dealers than a high price set in a gallery after years of careful promoting efforts.

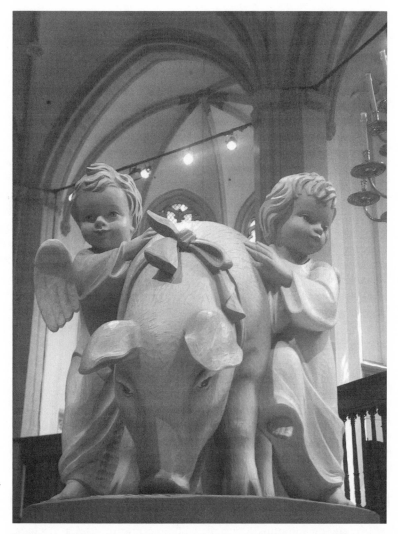

Jeff Koons's *Ushering in Banality,* in the Nieuwe Kerk in Amsterdam.
Photo: Robbert Roos, *Kunstbeeld Artmagazine.* Courtesy Sonnabend
Gallery.

An American dealer told the following story about this: "a painter I work
with constantly wants me to raise the prices, raise the prices. She is very
confident, thinks she is the best painter alive. Well, I am not sure (. . .).
Her prices are around $20,000, but she wants them at 25 or 30. (. . .) I'd
rather keep them lower, even if it is frustrating for her. But her argument

is, look at Cecily Brown. At auctions her work has gone for $75,000, because people are crazy, and I cannot make that happen for her" (us17). Artists asking for such superstar prices are considered arrogant or reckless by dealers who feel part of an "honorable" or a "prudent" circuit. And if an artist expresses a special, emotional attachment to a work through higher prices, this may simply indicate to a dealer with a prudent pricing strategy that he is not prepared to sell the work.

Disputes over meanings of prices are particularly outspoken between the avant-garde and the traditional circuit discussed in chapter 1. Dealers, artists, and collectors in the latter circuit dispute the high prices which artworks achieve in the former. For them, the high prices of the avant-garde circuit symbolize the vacuity of modern art. Art critic and artist Diederik Kraaijpoel, affiliated to a traditional circuit, commented in a Dutch weekly about the Stedelijk Museum's acquisition of Nauman's *Seven Figures,* a light sculpture which depicts several men engaging in promiscuous sex: "Something that costs 800,000 guilders cannot be funny; you do not pay that much for a good joke. A large expensive artwork has to carry a considerable amount of cultural luggage. It does not have to be the Sistine Chapel right away, but the ambitions of the maker, the gallery owner and the buyer will have to tend in that direction."[20] Also, dealers in the traditional circuit question the pricing strategies of the avant-garde circuit. One of my respondents, for instance, a dealer in traditional, figurative art, deliberately decided to deviate from the rule to price according to size. She priced masterpieces higher, since she assumed that collectors do not rely on the artificial signals which the avant-garde circuit, according to her, is suffused with. "Even uneducated collectors tend to have a good eye, they know it is good, which is why it is so much fun selling representational art, you see them recognize. Also in case of a masterpiece . . . they are not confused by a higher price, they understand it instantly," she stated (us19). All these misunderstandings and disputes which prices generate are not accounted for by signaling theories in economics; ignoring the fact that price signals need to be interpreted before they become meaningful, economic signaling presupposes a mechanistic relation between price and quality.

A PRICE AS A SACRIFICE

Adherents of a "Hostile Worlds" point of view may argue in turn that, in responding to economic arguments, I merely underscore that prices have contaminated the art world profoundly. It confirms their fear that the way artists, collectors, and dealers relate to each other and to their art has become inseparable from monetary values. My defense is that the

commensuration process that pricing entails is more complex: its effects are more varied than "Hostile Worlds" views allow for. In the last two chapters we have already seen that dealers undo the commensurating effect of the price mechanism by making qualitative distinctions between different types of prices; let me here elaborate on other meanings of prices that go unrecognized in a "Hostile Worlds" model.

To begin with, the price mechanism reinforces rather than just undermines the incommensurability of art. The reason is that the large amounts of money for which artworks are bought and sold sets them apart from other goods. Indeed, if Simmel argued in the *Philosophy of Money* that monetary measurement flattens out unique values, he conceded at the same time that high prices have the opposite effect: "it must be emphasized here that what is generally true is that the degradation and humiliation of human value decreases if the purchase prices are very high. For money value in very great sums contains an element of rarity which makes it more individual and less interchangeable and thus more appropriate as an equivalent of personal values" (Simmel 1900 [1999], p. 374). These sums install a good with "that 'superadditum,' with fantastic possibilities that transcend the definiteness of numbers," (cited by Zelizer 1985 [1994], p. 163). Anthropologist Igor Kopytoff has argued likewise that the pricelessness of artworks is confirmed rather then denied by the fact that artworks enter the commodity sphere at regular times, achieve an extraordinary market price, and return to the closed, non-commodified sphere of private and public collections immediately afterwards (Kopytoff 1986, p. 82).[21]

There is a second way in which Simmel counters his own as well as the "Hostile Worlds" resistance against monetary measurement and against the uniformity of prices. Value, Simmel maintains, comes into being only when something needs to be sacrificed in order to obtain it: "The valuation arises only from the fact that something must be paid for a good: the patience of waiting, the effort of search, the application of labor-power, the abstinence of things otherwise desirable." Usually, however, the sacrifice is made by paying a price in monetary terms. Thus Simmel concludes that value does not come into being without price (Simmel 1990 [1999], chapter 1). Such a bold conclusion raises more questions and warrants more extensive discussion than I can go into here; it contradicts the semiotic, ultimately Saussurian idea put forward in this chapter that the value of goods is derived by comparing them with other goods (Velthuis 2003; Velthuis 2004; cf. Graeber 2001; Appadurai 1986).

Nevertheless, Simmel's notion of value adds to our understanding of the art market, and provides one more reason to scrutinize the "Hostile Worlds" perspective once again. In her research on Dutch art collectors, for instance, Renée Steenbergen encountered such a Simmelian notion of

sacrifice in the decisions of Dutch art collectors, whose passion for collecting forced them to raise mortgages or to take loans. These collectors denied themselves luxury expenses such as new cars or frequent holidays; some of them performed manual labor such as painting their house in order to save money for their art addiction. For others, the sacrifices they were willing to make for art were even related to the fact that they were not able to have children (Steenbergen 2002).[22] These sacrifices are not just experienced by the collectors who have to make them, but also by the artists who benefit from them. The Dutch artist Ad Arma argued that the acquisition price a collector pays has to hurt him like an "ulcerating toe" (Theuns 1994, p. 15). His colleague Sam Drukker claimed likewise that he gets "a kick out of the fact that people are willing to give three monthly salaries for a painting of mine."[23] Their remarks suggest that the price which collectors are willing to pay for the efforts of artists does not corrupt their self-esteem, but provides them with an emotional reward.

In turn, collectors themselves feel inclined to demand a sacrifice from others who want to obtain a work out of their collection. Take the case of the American couple Tremaine, who ranked among the world's biggest collectors in the 1980s. When they donated work to a museum, which they did with some frequency, the Tremaines often saw it disappear into storage. Displeased with this outcome, the couple decided to sell work to museums rather than donate them. As a dealer recounts: "With good reason, Emily [Tremaine] thought the museums appreciated works most if they had to pay for them. When the Metropolitan paid a great price for a work, people came to see it, and even if tainted by commercialism at the moment, it was displayed as a major work of art with the full prestige of the museum behind it" (Coppet and Jones 2002, p. 168). The fact that a museum had to make a sacrifice to purchase an artwork, induced curators to exhibit the work more frequently than donated works for which no apparent sacrifice was made.[24]

Apart from transmitting a notion of sacrifice, prices can be a more clear-cut and therefore more meaningful type of praise or recognition for artists than reviews by critics and peers, attention from cultural institutions, or compliments by collectors and dealers.[25] This meaning of prices invokes the notion of a "market experience," as political scientist Robert Lane calls it. Lane argues that apart from generating income, participating in the market and its social fabric is a source of emotional satisfaction in itself: it contributes to human development and to establishing a sense of worth (Lane 1991). Take the case of Tim Rollins, a New York artist who, highly influenced by Marx, was concerned about the wasteful culture which capitalism created. In order to counter what he called "waste of human resources," in 1982 he established the art program *Kids of Survival* (K.O.S.), which was directed at developing the innovative and cre-

ative talents of learning-disabled and emotionally handicapped teenagers in the New York neighborhood of the South Bronx. In an interview with the magazine *Art in America,* Rollins expressed his pride in the commercial success of the program, since it enriched the material life of a group of teenagers, whose future would otherwise have been destitute. His pride was not only related to economic success, however, but also to artistic success. His Marxist background notwithstanding, Rollins conveyed the artistic achievements of himself and the South Bronx teenagers by talking prices. Because of the exceptional group of collaborators, the artist recounted, he "had to defy the expectations and prejudices that people generally have about a bunch of kids and a schoolteacher." He continued: "I think we have done that—from $5 bricks in 1981 to over $150,000 for a major work today."[26]

Finally, unlike what the "Hostile Worlds" point of view assumes, artists are not passive victims of the meanings which prices convey, but instead can shape these meanings in order to actively put them to their own use. The American sculptor David Smith, for instance, set prices so high that only a very small group of the most persistent admirers could afford to buy his work; thus he expressed "a scornful attitude to a world that he believed had too long ignored and disdained him," as one observer put it (Grant 1991, p. 17). With a more playful or ironic twist, a number of avant-garde artists have scrutinized meanings of prices in the work they make. An example is Yves Klein's solo exhibition "The Blue Epoch" in a Milan gallery in 1957. Although the works which Klein, one of the major postwar French artists, exhibited in the gallery were identical in all respects, including size, the prices for the works were different. "Of course," Klein explained, "thus I am looking for the real value of the picture." Klein saw his project succeed. In a mystifying language typical for the artist, he argued that since buyers were willing to pay different prices for identical pictures, "the pictorial quality of each painting was perceivable by means of something else besides the material appearance" (Duve 1989, p. 78).

Stephen Keene, a New York artist, ridiculed the snobbism of the art world and the status effect of high prices for art in *The Miracle Half-Mile: Ten Thousand Paintings by Stephen Keene,* a solo exhibition at the respected Santa Monica Museum of Art. Keene painted 10,000 canvases, which visitors to the exhibition could buy on the spot for prices ranging between $3 and $100. Thus he commented on the art world's focus on high prices. Likewise the Boston gallery@greenstreet organized a show in 1999 called "100 x 100," in which 100 artists exhibited 100 works, each priced $100. A journalist for the English-based *Art Newspaper* interpreted the show as a gimmick, and therefore read the selling price as an indicator of the poor value of the work. The journalist did not know,

however, that the artists, whose work almost invariably cost far more than the selling price, had donated them to the show. James Hull, founding director of the gallery, defended himself in the subsequent issue of the *Art Newspaper* as follows: "The common practice in the art world today of equating the sale price of a work of art with its artistic value or historical importance has taken the place of scholarly appraisal of contemporary work of art's innovation and cultural value. (. . .) We think that accessibility should include an economic component—what better way to encourage collecting than to have events where artwork is exceptionally affordable."[27]

Stephen Keene painting 400 canvasses per week, to be sold for a few dollars each, in the window of Goldie Paley Gallery at Moore College of Art and Design. Photo: David Graham, Time Life Pictures / Getty Images.

CONCLUSION

This chapter started with two anomalies: the strong taboo on price decreases and the fact that artworks are almost invariably priced according to size within the oeuvre of an artist. In order to come to a proper understanding of these phenomena, we have to take the meanings of prices and the cognitive processes that produce these meanings into account. A price increase of the work of a particular artist may mean that demand exceeds supply from a conventional economic point of view, but the artist himself will primarily interpret it as a sign of progress. Because of the uncertainty about artistic or aesthetic value that prevails on the art market, price decreases will conversely harm belief in the value of the work an art dealer has carefully built up. Likewise, deviating from the rule that dictates that dealers price according to size would result in negative price signals about the quality of some works exhibited in a show.

Although these findings merely suggest that economic signaling theory was right after all, the picture that my interview data provide is richer and more complex than that. By signaling in some cases and consciously refusing to do so in others, a dealer enacts her role as gatekeeper of the art world and patrons of artists. Prices serve to construct status hierarchies among collectors as well as among artists. Says one dealer: "[t]here are two things that I hear from artists both whom I show and in the art world in general—one is, 'my work is better than a lot of work out there' and the other is, 'if my work is better than a lot of that work out there which is selling for a lot more, why aren't my works more expensive?'" (Klein 1994, p. 80). Low prices may enhance sales, but keeping them low for too long will affect the dealer's relationship to an artist, who is denied a significant source of self-esteem. It goes to show that prices are not just about objects, but also about the people who make, distribute, and acquire them.

Another finding of this chapter is that there is nothing clear-cut about meanings of prices. Instead, dealers operate in webs of meanings, which may become a symbolic minefield when prices start leading to misunderstanding, confusion, and dispute. A high price for an artwork can be interpreted as a signal of quality by some, but it can also be ridiculed as a symbol of fraud by others. For some collectors, low prices are attractive, since they contain the pride of being a discoverer, while other buyers may be uncertain because of the lower prices. Even economically successful and culturally esteemed art collectors seem nothing like rational, self-interested economic man, but all the more like ordinary moral beings who long for praise from their peers, are uncertain about their decisions, and seek widespread approval for their actions. Given what is at stake

with the meanings which prices generate in this circuit, art dealers have good reasons to talk about prices intensively, albeit not in terms of supply and demand.

The upshot of this chapter is that the radical separation between quality or artistic value on the one hand, and price on the other, is in the end untenable. This separation is based on a misconceived, "undersocialized" conception of economic and cultural value, to use a term of the sociologist Denis Wrong (cf. Granovetter 1985 [1992]). Just as economic theory assumes that preferences are individually given and that social factors do not interfere in the economic valuation of goods, "Hostile Worlds" adherents implicitly assume that it is possible to appreciate the aesthetic value of art in a social vacuum, without paying attention to contextual factors (Halle 1993, p. 2). This chapter suggests instead that the relationship between price and value is more intricate than the dominant strands within humanities, or, for that matter, neoclassical economics have allowed for. Value and price seem to be entangled in an ongoing dialectic, whose unraveling can only partially be accomplished (cf. (Moulin 1967 [1987], p. 177). Therefore, when art historian Christopher Steiner wonders in the *Art Bulletin* if one can "ever hope to assess an object's aesthetic worth without taking into account its economic worth," if there is, in other words, "such a thing as what Kant called in *The Critique of Judgment* 'a pure aesthetic value'" (Steiner 1996, p. 216), the answer of this chapter is an unambiguous "no."

Chapter 8

Conclusion

PRICES, I ARGUED IN THIS BOOK, tell stories that are not only about money, value in exchange, or monetary measurement. They are about much more than the point where demand and supply meet. By listening to the way art dealers talk when they deal with prices and by observing what they do when they market art, I found that prices tell rich stories about the caring role which dealers want to enact, about the identity of collectors, about the status of artists, or the artistic value of art. Art dealers, artists, and collectors, who operate in a market where commerce is opposed, find ways of communicating non-economic values through the medium of price. They succeed in twisting and turning prices in all kinds of ways to make sense of their economic life.

A wonderful illustration of the rich stories that prices tell is Yasmina Reza's play *Art*. The play, which was a major success in theatres around the world in the second half of the 1990s, revolves around three friends—Serge, Marc, Yvan—and one painting. In the opening scene of the play, Marc and Serge are looking at the painting, a monochrome, white canvas with a couple of diagonal scars, Serge's latest acquisition.[1] The following dialogue ensues about the painting:

MARC: Expensive?
SERGE: Two hundred thousand.
MARC: Two hundred thousand?
SERGE: Huntingdon would take it off my hands for two hundred and twenty.
MARC: Who's that?
SERGE: Huntingdon?
MARC: Never heard of him.
SERGE: Huntingdon! The Huntingdon Gallery!
MARC: The Huntingdon Gallery would take it off your hands for two hundred and twenty?
SERGE: No, not the Gallery. Him. Huntingdon himself. For his own collection.
MARC: Then why didn't Huntingdon buy it?
SERGE: It's important for them to sell to private clients. That's how the market circulates.
MARC: Mm hm . . .

SERGE: Well?

MARC: . . .

SERGE: You're not in the right place. Look at it from this angle. Can you see the lines?

MARC: What's the name of the . . . ?

SERGE: Painter. Antrios.

MARC: Well-known?

SERGE: Very. Very!

Pause.

MARC: Serge, you haven't bought this painting for two hundred thousand francs?

SERGE: You don't understand, that's what it costs. It's an Antrios.

MARC: You haven't bought this painting for two hundred thousand francs?

SERGE: I might have known you'd miss the point.

MARC: You paid two hundred thousand francs for this shit?

After the initial confrontation between Marc and Serge, Marc meets their mutual friend Yvan, describes the Antrios, and invites him to estimate how much their mutual friend paid for the work. When Yvan wants to know first of all how fashionable the painter is, Marc responds in irritation: "I'm not asking you to apply a whole set of critical standards, I'm not asking you for a professional valuation, I'm asking you what you, Yvan, would give for a white painting tarted up with a few off-white stripes."

In the scenes that follow, the acquisition price turns into a symbol of the emerging animosities between the high-brow character Serge and his down-to-earth friend Marc. Marc fails to make sense of the price of the work, and therefore it infuriates him that his friend paid 200,000 francs for it. Afraid that Serge will start fancying himself "in some grotesque way" as a collector, that Serge values the Antrios more than himself, Marc perceives the price as a major obstacle to their future friendship. "I give a fuck about you buying that painting. I give a fuck about you spending two hundred grand on that piece of shit," Marc snaps when the drama reaches a climax. In response to Marc's indignation, Serge adds insult to injury. Defending the 200,000 franc acquisition price, he tells Marc that the painting "conforms to laws that you don't understand," that the modern art museum Centre Pompidou in Paris owns other works by Antrios, and that the painting contributes to a profound, intellectual tradition which Marc, alas, is apparently unaware of.

Serge and Marc are characters in a play, yet real-life people may recognize themselves in their roles. Like Serge, numerous collectors of contem-

porary art see themselves faced with the difficult task of explaining, not just to friends, relatives, and acquaintances, but also to themselves, the large, seemingly irrational sums they annually spend on buying art. Conversely, outsiders like Marc view the art market as a commercial scene marked by absurd price levels, rapid price increases, and extraordinary price differences that are impossible to make sense of. As a result, everyday encounters of outsiders with the art world, which take place for instance when an artwork is acquired for a record price with public means, are suffused with emotional, indignant, or hostile responses.

I encountered similar attitudes to prices in my research on the primary art market; dealers would have an endless list of arguments to legitimize the price level of the artists they represented; they explained in detail why they refused to work with artists who are hard to please about their prices, or why they felt insulted by a collector's offer for a work far below the listed price; my respondents talked about artists who got jealous at seeing the price tags of their colleagues' work in a group show, and invoked examples of collectors who denied buying art for investment purposes, but nevertheless emphasized the increasing economic value of their acquisitions ostentatiously. Their stories told me that the value of prices in social life cannot be underestimated: a price is not just an economic, but also a social, cultural, and moral entity. On the art market, prices convey meanings which vary from describing the development of an artist's reputation, characterizing the "aesthetic eye" of collectors, or expressing the status of a gallery in the avant-garde field. A price increase may signal that demand exceeds supply from a conventional economic point of view, but for an artist the more prevalent meaning may be that her work is being accepted in the art world; conversely, the motivation and self-esteem of artists is shaken once a price decrease has to be carried out. This suggests that the stories which prices tell involve artists, dealers, and collectors as much as artworks or commodities. In the end, a dealer needs to be sensitive to all these meanings of prices, not just to the economic ones.

The language of money is ultimately not a universal language, for meanings of prices are understood differently across different circuits within the market. In Reza's Art, for instance, Serge's underlying message to Marc is that you need to be an "insider" to the art world in order to understand the economic and cultural values at stake. When the drama unfolds, the price of the painting, so legitimate to Serge but so incomprehensible and insulting to Marc, suggests that the two characters are part of different social circuits, at least when it comes to art. Likewise, art dealers make conceptual distinctions between different prices such as their own prices and those of the auction circuit. Whereas they consider their own prices to be promoters' prices, which are carefully built up in

an attempt to protect the artist against volatile market forces, auction prices are, as they see it, established at the expense of an artist's career. Therefore dealers consider auction houses to be exploitative and parasitic. I noticed furthermore that a price that an artist would like to have for a work may be modest to some dealers, but can be interpreted as a sign of arrogance or recklessness by others. High prices symbolize success for members of a "superstar" circuit within the art market; simultaneously they may suggest to members of an "honorable" circuit that the art market has fallen prey to the laws of capitalism; prices that are legitimate within an avant-garde circuit may be dismissed as symbols of fraud by members of a traditional circuit where the dominant position of the "high" art world is contested. In short, by symbolizing and marking the differences between circuits, prices and the ways they are interpreted contribute to a sense of identity for their members.

Circuits of commerce can not only be distinguished by their respective discourses on prices but also by their business rituals and repertoires. For instance, the sensitive, culturally charged movement of a work of art into and out of the commodity context of the gallery tends to be accompanied by parties and celebrations. In an attempt to further separate art from commerce, the front exhibition rooms of an avant-garde gallery are separated sharply from the back rooms where trading may go on. Avant-garde art dealers are also concerned about the potentially detrimental effects which market forces have on an artwork once it is targeted by speculators and becomes an unguided, free-floating commercial object. Therefore, they actively reduce the chances that the artwork will appear on the market again by "placing" it in the hands of a collector who buys art for what dealers consider to be the right reasons: artistic reasons, rather than status concerns or profit motives. Since these collectors often wish to get involved with the artists whose work they collect, objects ultimately remain entangled with their makers on the art market. In fact, social ties between artists, dealers, and collectors in general look more like family or friendship relationships than like business contacts. Art dealers differentiate these social ties by exchanging gifts and awarding discounts; also, they permanently define and redefine the meaning of the transactions they conduct by framing activities, the timing of the transaction, or its discursive embedding. Thus the social fabric of the art market hardly resembles the anonymous interaction which neoclassical economic theory presupposes.

On the one hand, then, all avant-garde dealers face similar meaning structures, which are by and large shaped by an opposition between art and commerce; at the same time, however, there are many opportunities for a dealer to shape his identity and set himself apart from his col-

leagues. These opportunities include aspects of his business as different as the level of professionalism of the gallery, the type of moral and financial support provided to artists, the stance towards auction houses, the division of labor between the dealer and his assistants, or the level of coherence in the art that is exhibited. They include subtle sources of status, such as the frequency with which installations and other non-commodifiable works of art are shown in the gallery, the timing of the gallery's move to a new, emerging neighborhood, or the degree of success in preventing artworks that have been sold in the gallery from appearing at auction.

Whereas the meaning structures that galleries face in Amsterdam and New York are by and large identical, their daily operation differs substantially in these two cities. The average gallery in Amsterdam is much smaller, both in terms of turnover and in terms of the number of employees; in fact, most galleries in Amsterdam are one-person businesses. The average price level on the Dutch market is much lower, while galleries are, compared to their New York counterparts, hardly active on the secondary market. As a result, they have less financial means at their disposal. It should therefore not come as a surprise that upon being told that my research involved the Amsterdam as well as the New York market, one Amsterdam dealer remarked that the art market is "too commercial" over there, whereas one of his New York counterparts bragged that a Dutch market does not exist at all.

MORALS OF THE MARKET

Some critics may misread this book as an unjustified apology for a world of superficial glamour and glitter, known for astronomical prices that have more to do with snobbery than with quality, permeated by cultural corruption, and held in custody by a worldwide monopoly of a small group of powerful dealers, superstar artists, and filthily rich collectors. "Art and money have exchanged roles: money becomes 'divine' by being 'translated' into art; art becomes commonplace by being translated into money," as art critic Donald B. Kuspit argued in an interview with the magazine *Art in America*.[2] With his claim, Kuspit invokes the *topos* of "Hostile Worlds," which informs a considerable amount of thinking and theorizing about the art market in the humanities. The core "Hostile Worlds" argument is that artistic, aesthetic, or critical value on the one hand and price on the other are dichotomous categories. When artworks are monetized, their incommensurable value is contaminated or corrupted. The implicit assumption of "Hostile Worlds" is that this contaminating influence of economic forces on the arts is continuously expanding.

Its narrative of the market is, in other words, a tragedy, with artists and artworks as the major victims.

My ethnographic material suggests that the "Hostile Worlds" perspective is untenable. Take a closer look at how exchange in art is conducted, and you will see that prices have a constructive rather than just a destructive effect. In a world that is riddled with uncertainty, they provide one of the means for artists to establish self-esteem. If a collector is willing to make a major sacrifice in order to buy an artwork, this provides a form of praise to its maker. Determined to avoid the *quid pro quo* effect of market exchange, dealers likewise seek to express a sense of care for artists. They can do so by protecting the artist from, in their view, parasitic auctions, or by buying work directly from the artist in case she is in financial distress. Finally, dealers undo the detrimental uniformity of prices by differentiating them along qualitative lines: within their narratives of the market, dealers may distinguish their own prices from those which they deem harmful, overtly commercial, or unethical. In the end, then, the purpose of this book was not to develop a normative judgment of art dealers' practices, but to come to a better understanding of the morals of the art market and the meanings of its prices.

Like "Hostile Worlds" adherents, neoclassical economists have by and large ignored these morals and meanings. Least of all have they considered the effects which the transformation of incommensurable qualities into measured equivalence may have on the way commercial traffic in art is conducted. Insofar as the phenomena which I have discussed influence economic outcomes such as prices, turnover, or sales, they are likely to account for these effects in terms of rational, utility-maximizing action. For instance, the cautious pricing strategies that I encountered can be seen as nothing but "underpricing," not unlike pricing strategies for initial public offerings on the stock market; it can be thought of as an instance of risk aversion on the part of sellers who want to make sure that the good they offer will indeed be sold. The taboo on price decreases that I ran into time and again on the art market is nothing but a manifestation of price stickiness (Blinder et al. 1998); it can easily be explained with so-called signaling theories, which predict that prices signal quality to consumers in uncertain environments. What I have analyzed in terms of marking or framing relationships is nothing but strategic behavior. My analysis merely suggests that trust relationships are a superior, efficient solution in case asymmetrically distributed information or radical uncertainty impede anonymous market exchange. Especially on thin, imperfectly competitive markets like the art market, with its small number of supply and demand parties, and unique, expensive products, such phenomena are likely to occur, a neoclassical economist may say.

BEYOND DOMAINS AND SPHERES

Do we need to conclude that what goes on in circuits of commerce covers up a crude economic reality? Is the difference between neoclassical economic explanations and my own interpretive account of markets in the end terminological rather than substantive?[3] Not at all. By reducing multiple meanings of prices and the negotiated interaction between dealers, collectors, and artists to nothing but another instance of utility maximization, we do injustice to the complexity of these phenomena. I contend that the interpretive approach that I have advocated in this book provides a richer understanding of what markets are about.

In spite of all the idiosyncrasies of the art market, this understanding can be generalized to a considerable extent. In fact, anthropological studies of "primitive" societies, as well as historical studies of the Western world, have persistently revealed exchange patterns which are dense with meaning, allow for a market discourses with strong moral overtones, and involve trust networks as well as reciprocal gift relationships.[4] When it comes to modern, Western times, however, we may have gone too far in endorsing Karl Polanyi's notion of disembedded markets; according to Polanyi, modern markets have become increasingly separate from the social and cultural contexts they were previously embedded in (Polanyi 1944 [1957]). At times this has led social scientists to hold on to a rather naïve opposition between the market and morality (Dilley 1992) or between commerce and culture (Agnew 1986). Countering such oppositions, Fred Myers rightly argues in his book on the circulation and commodification of aboriginal art: "What needs to be recognized and explored further is the market, not as a separate domain, but as a structure of symbolic transformation. It does not necessarily erase all the distinctions embodied in objects (. . .). It is not always the case that the market's domination is complete: other systems of value may coexist, and their meanings may be reconstructed in relation to the presence of market practices. We must imagine that commodities and commoditization practices are themselves embedded in more encompassing spheres or systems of producing value. Such systems not only recognize the existence of distinct regimes of value but combine and reorganize the activity from these various contexts into more complex mediations" (Myers 2002, p. 361).

The art market is obviously not the only market where actors are confronted with different regimes of value and need to play multiple roles simultaneously. Markets for other goods with a strong ethical, moral, or aesthetic value, which can be found in fields as different as religion,

education, health care, and politics, or in more mundane fields like the wine sector and the restaurant industry, are characterized by a similar contradiction of logics. Previous studies of those fields have not only recognized these contradictions, they also show how actors attempt, with different degrees of success, to solve or negotiate them. Zelizer's study *Morals and Markets,* for instance, shows how the market for life insurance emerged in the first half of the nineteenth century. "Putting death on the market offended a system of values that upheld the sanctity of human life and its incommensurability. It defied a powerful normative pattern: the division between the marketable and the nonmarketable, or the sacred and the profane" (Zelizer 1979, p.43). Companies in the field managed to market their products nevertheless by redefining and reframing the meanings that life insurance had, from a price tag on human life, into a generous provision for the dependents that were left behind. In a study of health care in New England, Deborah Stone notices likewise that there is "a clash between the norms of caring in private relationships and the norms of efficiency, professionalism, and accountability in business and government. Professional caregivers deal with these contradictory logics by negotiating between their job definitions and their personal assessments of the care they think people want and need" (Stone 1999, p. 61; cf. Staveren 2001). Unable to terminate the attachments they have to people they cared for professionally, these workers continue visiting them and helping them out in spite of budget cuts. Such coping mechanisms and defense strategies are not unique to care providers, but seem rather endemic on markets where personal services, intimacy, or human emotions are at stake (cf. Hochschild 1983). Even in a profession like boxing, which seems adverse to such fragile values, two contradictory logics need to be reconciled, as Loïc Wacquant has shown: "that of bodily skill and that of money, technique and boutique, hot-blooded ring prowess and cold-blooded cash business" (Wacquant 1998, p. 3). Although compared to art dealers, matchmakers in the boxing field may make less effort to conceal their interest in money, they also need to find legitimate ways to commercialize what is considered to be sacred: the body.

Another aspect of my findings that can be generalized is the relationship between markets and gifts. Because economic anthropologists have traditionally been interested in gift exchange, and economists by and large in markets, gifts have often been discussed in the context of premodern, primitive societies, while market exchange has been tied to modern, Western economies (cf. Darr 2003). A slowly growing body of literature attempts to show otherwise, however. As Nicholas Thomas put it: "the older anthropological construct of the gift depended more upon an inversion of the category of the commodity than upon anything which really existed in indigenous Oceanic societies" (Thomas 1991, p. 203).

On the one hand, primitive societies have long been skilled in integrating commodity relationships into gifting networks. Daniel Miller, studying exchange patterns of pottery families in India, noticed for instance that monetary exchange and market transactions did not replace "ancient and embedded orders," but instead coexisted, and even mutually supported each other (Miller 2002, p. 221); not least of all, these abstracted commodity exchanges were attractive because of the freedom they entailed. On the other hand, social scientists are slowly discovering that modern markets, like pre-modern and primitive societies, are infused with gift giving. This holds not only within organizations in the obvious form of bonuses, vacation money, or Christmas presents, but also on markets themselves. Tobacco auctioneers, for instance, persuade tobacco growers to sell their wares with them by giving them a bottle of whiskey every now and then (Smith 1989); distributors of electronics components construct obligation networks by giving product samples as well as free lunches, drinks, or golf games to their customers (Darr 2003); in spite of being competitors, hotels are found to maintain friendship ties with each other, and benefit from these by recognizing shared interests, mitigating competition, and sharing information (Ingram and Roberts 2000).

In spite of the fact, however, that attention for those gifts within markets is on the rise, most studies still focus on strategic aspects of gift giving and pay only marginal attention to what may be called the language of gifts: what gifts are appropriated in which circumstances? How do actors draw boundaries between (legitimate) gifts and (illegitimate) bribes? How do gifts symbolize social relationships of different strengths? How do gifting practices get diffused and mastered by people within a market? How do gifts like whiskey or golf games serve to reproduce identities of people involved in economic exchange? How do gifts impose power relationships between people, rather than just strategic or benevolent relationships?

The extent to which my findings can be generalized is not limited to relational aspects of the trade, but includes the way prices are set. In fact, a variety of traditions that serve as alternatives to the pricing theories of neoclassical economics can be traced in the history of economic thought. Some of these traditions have recently been reinvigorated by critical, heterodox schools such as post-Keynesian economics and institutional economics (for excellent overviews, see Downward 1999; Lee 1999). In general, the findings of these schools is that fixed costs are far more important in everyday economic life than in the academic accounts of neoclassical economics; that price changes are more frequently inspired by supply-side than by demand-side factors; and that relational concerns may keep firms from raising prices (see Blinder 1991; Blinder et al. 1998;

Lee 1999). Although the findings of these studies do not necessarily agree with those of my own, they are not less critical of the deductivist approach of neoclassical economics, and instead opt for a "grounded," "realist," or "behavioral" approach. Like this book, they start not from the idea that prices are the outcome of the market, but that firms have a certain degree of agency in setting prices. The different forms of rule-following behavior that these studies in heterodox economics have run into invariably accord with my notion of pricing scripts.

Marketing studies have revealed similar intricate, multifaceted pricing processes. These processes tend to follow, as one of these studies puts it, "a much more complex pattern which does not lend itself so readily to mathematical generalization and diagrammatical simplification" (Diamantopoulus and Mathews 1995, p. 20; cf. Dorward 1987). In particular, determining prices for a new product is a challenge, since hardly any information is available on the consumer's willingness to pay, or on the behavior of competitors (Diamantopoulus and Mathews 1995, p. 99; see also Dean 1969). Also, apart from setting prices, retailers need to convince their customers of the legitimacy of the prices they set; like art dealers, they do so by making Saussurian comparisons with the value of other products, by invoking alternative notions of worth, or by explaining in detail why one product is more costly than another (Prus 1999, pp. 140–46). Since not all prices can be fully legitimized, the practice of allowing discounts is pervasive in many markets other than the art market. Marketing studies indicate that 70 percent of industrial companies, and as many as 80 percent of the companies that, like art dealers, use price lists, give discounts on a regular basis (Dorward 1987, p. 115).

Finally, the art market may function as a magnifying glass for the meanings that prices convey, but other markets generate their own meanings, economic as well as non-economic ones. Matchmakers in the boxing economy, for instance, send each other money for mutual help in organizing fights across the country. At the same time, however, they are indifferent to the monetary value of these payments, and see them instead as "a gesture of acknowledgement and goodwill" (Wacquant 1998, p. 25). In a study of financial markets, Mitchel Abolafia found ranking effects of prices that resemble those on the art market: "[m]oney is more than just the medium of exchange; it is a measure of one's 'winnings.' It provides an identity that prevails over charisma, physical attractiveness, or sociability as the arbiter of success and power on the bond trading floor," he writes (Abolafia 1996, p. 30). Clifford Geertz argued, in his famous account of Balinese cockfights and the gambling activity surrounding these fights, that money may be synonymous with utility for gambles in which small amounts of money are at stake; however, in case of "deep play," when the monetary stakes are substantial, money is "less

a measure of utility" than "a symbol of moral import" (Geertz 1973 [1993], p. 433). Likewise, for street vendors selling magazines and books on the sidewalks of New York City, their self-worth rather than just their income is at stake when haggling over the prices of their goods (Duneier 1999, p. 68). These and other incidental studies and observations not withstanding, however, a sociology of prices is still in its infancy. This book can be seen as a contribution to its further development.

To say that all these rich, ritualized exchange patterns, meaningful prices, and interweaving of market and gift transactions merely conceal the skeleton of the market, is to miss the point. Indeed, as Daniel Miller puts it, "skeletons are not agents, they are the dead, remnants left when that which gives agency is stripped away. We can theorize such bare bones academically but that is not how economies or economic agents operate" (Miller 2002, p. 232). It is therefore time that we replace the universalist, but reductionist notion of exchange of neoclassical economics with an equally universalist, albeit anti-reductionist notion of markets as cultural entities. If we want to come to a better understanding of the cultural constitution of markets, rich economic ethnographies and thick descriptions will be fruitful alternatives to formal modeling. Such an approach does not have to suffer from a type of empiricism which is hostile to analytical abstraction; instead, ethnographic studies of markets can stir up theoretical questions that are at the core of social science. One of the theoretical issues that has concerned me in this book is to what extent macro-sociological concepts such as domains, spheres, or institutional logics can, at this point, advance our understanding of economic life. It might be virtually impossible to make sense of the economy without these terms; at the same time, however, the compartmentalized notion of society that they spring from makes it difficult to account for the many contradictions between logics, contingencies of spheres, and overflowings between domains that we encounter in everyday markets. In short, in spite of the fact that markets have been a strong presence in modern life for nearly two centuries, the unraveling of their complexity in social science is yet to begin.

Interview Questionnaire

OPENING TEXT

My research concerns the way prices are established in contemporary art galleries in New York and Amsterdam; the research will result in a Ph.D. dissertation to be finished in the Spring of 2002. I will transcribe the tapes of this interview literally, but in references in the text I will exclude your name, and the names of artists and collectors you mention; I will also remove other characteristics which makes your gallery identifiable.

I. GENERAL QUESTIONS ABOUT THE GALLERY

What are the goals of the gallery? [If unclear: mention goals such as profit maximization, providing income to artists, or exhibiting new art]
Do you experience conflicts between these goals?
If so: how do you solve these conflicts?
What role do galleries play in the contemporary art world, if compared to other institutions like museums, artist cooperatives, and auction houses?

II. RELATIONSHIP TO ARTISTS

How do you select the artists the gallery represents?
Does the gallery work on a consignment basis, or are artworks acquired from the artist?
Does the gallery give stipends to artists?
Is the gallery also active on the secondary art market?
According to what percentage do you divide the proceeds of sales between yourself and the artist?
Can you describe the mutual influence you and the artist have on setting prices?

III. GENERAL QUESTIONS CONCERNING PRICING

What are the determinants of prices of work by contemporary artists the gallery represents?
Do you ever experience difficulties in pricing a work?

Do you ever regret setting prices afterwards?

Do you use any rules of thumb when pricing a work?

What is the relevance of production costs of the artist on prices?

When setting prices, do you take into account that artists try to make a living from their sales?

What is the relevance of the gallery's overhead for prices?

How does the price of a work relate to its aesthetic quality?

Do you ask a higher price for a work that the artist or the gallery judges to be better than his other work? [If not:] Why not?

Does your pricing policy play a strategic role in the development of an artist's career?

Did you ever consider organizing periodical auctions to sell works of the artists you represent?

IV. PRICING THE WORK OF YOUNG ARTISTS

How do you establish the price of work by artists that have no "price history" because they have not exhibited elsewhere?

Do you use any reference prices when establishing the initial price? [If unclear: explain notion of reference prices]

Do you adopt the price level of an artist who has exhibited/exhibits in other galleries?

V. PRICE CHANGES

When do you increase the prices of works by an artist? By how much do you increase them?

Do you increase prices when an artist receives attention from media or museums?

When do you decrease the prices of works by an artist?

[If the dealer says so:] Why is it not accepted on the market for contemporary art to decrease prices?

Do you change prices during the exhibition?

VI. RELATIONSHIP TO COLLECTORS

Do you have price records of the artist's oeuvre?

Do collectors ask for these?

Do collectors negotiate over prices?

Can you describe the moment when sales are closed?

Do you give discounts to collectors and institutions?

[If so:] Why do you give these discounts?
How large are these discounts?

Description of Interview Sample

ALMOST HALF of the 37 galleries of the dealers that I interviewed had existed for a decade or less at the time of the interviews (see table B.1). The oldest of them was founded in 1946, while the youngest opened less than a year before I conducted the interview.

While some galleries are literally operated out of the apartment of the owner, the largest gallery of Chelsea currently measures over 20,000 square feet.[1] The sizes of the galleries whose owners or directors I interviewed likewise vary substantially. The estimates in table B.2 include the exhibition room of the gallery, office spaces, storage space, as well as other spaces adjoining the exhibition space; other branches that the gallery may have in different locations (or storage space that is not located on the premises) are excluded. Some of the numbers were provided by the respective galleries; in other cases I had to make my own estimate.

My estimate of the average price level of artworks in table B.3 is based on works that the art gallery sells in the front room; price levels of secondary market works that the gallery may trade in are excluded. Note that the price spread, that is, the difference between the lowest price and the highest price of works sold in a gallery, is large. My estimates are based on recurrent visits to the gallery as well as, for the Dutch situation, the data set derived from the so-called *Kunstkoopregeling* (i.e., the data used for the analysis in chapter 4).

TABLE B.1
Gallery age

	Frequency	Percent
Pre-1970s	6	16.2
1970s	4	10.8
1980s	8	21.6
1990s	15	40.5
Unknown	4	10.8
Total	37	100.0

TABLE B.2
Relative size of the gallery

	Frequency	Percent
< 1000 sq. ft.	23	62.2
1,000–5,000	9	24.3
> 5,000	5	13.5
Total	37	100.0

TABLE B.3
Average price level of artworks

	Frequency	Percent
< $1,000	2	5.4
$1,000–$5,000	17	45.9
$5,000–$50,000	14	37.8
> $50,000	4	10.8
Total	37	100.0

TABLE B.4
Type of gallery

	Frequency	Percent
Traditional, consecrated	7	18.9
Avant-garde, consecrated	10	27.0
Traditional, non-consecrated	4	10.8
Avant-garde, non-consecrated	16	43.2
Total	37	100.0

In table B.4, I classify the galleries I interviewed according to the two hierarchies identified by Pierre Bourdieu: "consecrated" and "non-consecrated" refer to recognition or attention from museums, critics and other "official" institutions of the art world, while "traditional" and "avant-garde" refer to the type of gallery, its affiliations, and the type of business repertoire it makes use of (see Introduction). The category of "consecrated, traditional" is a *contradictio in terminis* according to Bourdieu, since one of the characteristics of traditional art galleries is that they do not receive attention from official art institutions. I use this category nevertheless to point at the recognition these galleries derive from "non-official" museums, art magazines, corporate art collections, and so on.

Record Prices for Art

IN GENERAL, the list of the ten most expensive paintings sold at auction seems to suggest that modern art commands higher prices than old masters (Peter Paul Rubens's *Massacre of the Innocents* is the exception to the rule). No. 2 and no. 3 on the list were bought by a Japanese paper manufacturer, Ryoei Saito. In the early nineties, Saito announced that he would take the most expensive of them, Van Gogh's *Portrait of Dr. Gachet,* into his grave. In 1992, however, Saito's creditors seized the painting, as well as Renoir's *Au Moulin de La Galette.* Saito died in 1996. Allegedly the Fuji Bank, one of Saito's main creditors, has managed to sell *Portrait of Dr. Gachet* since then, but details about that sale, including the painting's present whereabouts, remain unknown.

Note that the works of art mentioned in table C.1 only concern auction sales. Other works of art may have been sold for even higher prices privately. However, only rumors and no reliable data are available about private transactions. One rumor, which circulated in the fall of 2003, is that Jackson Pollock's *Mural on Indian Red Ground,* which is part of the collection of the Teheran Museum of Contemporary Art in Iran, has been sold for $105 million.[1] Were the rumor true, the painting would be the most expensive work of art ever.

TABLE C.1
Record prices for art at auction, August 2004

	Artist	Artwork	Price*	Auction	Date
1	Pablo Picasso	Boy with a Pipe	104.1	Sotheby's, New York	05.05.04
2	Vincent van Gogh	Portrait of Dr. Gachet	82.5	Christie's, New York	05.15.90
3	August Renoir	At the Moulin de La Galette	78.1	Sotheby's, New York	05.17.90
4	Peter Paul Rubens	Massacre of the Innocents	76.7	Sotheby's, London	07.10.02
5	Vincent van Gogh	Portrait of the artist without Beard	71.5	Christie's, New York	11.19.98

TABLE C.1 *(Continued)*
Record prices for art at auction, August 2004

Artist	Artwork	Price*	Auction	Date
6 Paul Cezanne	Still Life with Curtain, Pitcher, and Bowl of Fruit	60.5	Sotheby's, New York	05.10.99
7 Pablo Picasso	Woman with Crossed Arms	55.0	Christie's, New York	11.08.00
8 Vincent van Gogh	Irises	53.9	Sotheby's, New York	11.11.87
9 Pablo Picasso	Pierrette's Wedding	51.6	Drouot, Paris	11.30.89
10 Pablo Picasso	Woman Sitting in a Garden	49.5	Sotheby's, New York	11.10.99

*Prices in $ million; prices include buyer's premium. Note that due to exchange rate fluctuations, the ranking changes if computed in other currencies than the dollar.
Sources: Sotheby's, Christie's.

Multilevel Analysis of Prices for Art

THE MODEL THAT I ESTIMATE in chapter 4 to find regularities in prices for contemporary art in the Netherlands is based on multilevel analysis. Most previous studies have used the ordinary least square regression technique. By doing so, these studies implicitly assume that they analyze as many data regarding artists and galleries as regarding works of art. In reality, however, the total number of works of art in their data set have been produced by a smaller number of artists, and have been sold at an ever smaller number of galleries (most artists sell not one but several works of art). As a result, previous studies are based on an incorrect number of cases of artists and/or galleries. This may lead to an unjustified increase in the significance of statistical relations as well as to misguided interpretations, which can be illustrated with a hypothetical example. Suppose data are available on the prices of 1,000 works of art, made by five male and five female artists. Statements about the relation between the prices of those works of art and the gender of the artists should be based on 10 cases (n artists) rather than on 1,000 cases (n works of art). However, in an ordinary least square analysis, gender would be implicitly treated as a characteristic of an artwork. As a result, the number of cases is inflated.

Correcting for this error, the use of multilevel analysis has three advantages. First of all, it breaks down variance into different components.[1] It provides information on the variance on one level relative to the total variance. In other words, multilevel analysis makes it possible to see how much of the observed variance in prices is related to characteristics of works of art, how much can be attributed to the artists, and which part is due to gallery characteristics. The second advantage is that the standard errors of the effects are correctly estimated. The reason is that contrary to regression analysis, a multilevel model uses the correct number of cases at each identified level. A third advantage is that multilevel modeling allows effects to differ across levels. It makes it possible, for instance, to study the relation between the average price level and the price of extra centimeters for each individual artist. The following example, based on the assumed relation between the size of an artwork and its price, is included in order to illuminate the technique.

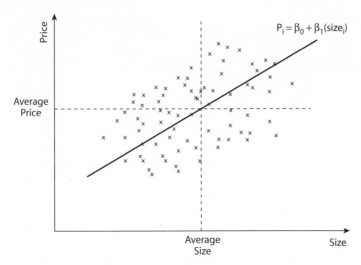

FIGURE D.1. The relation between price and size for one artist.

Figure D.1 illustrates the example of the relation between selling price and size within the body of work of one artist (*ceteris paribus*). In this case, variance only exists on the level of works of art. There is, however, little reason to assume that all artists charge the same amount for every square centimeter of their work. A square centimeter of canvas painted by a world-famous artist is more expensive than a square centimeter painted by an artist who just graduated from an art academy.

Figure D.2 represents differences in the relation between size and price for different artists. In this representation, artists do not differ in the marginal price of extra centimeters, but they do so in their average price level or the initial price when size is not taken into account. In other words: the intercept of the price-size line differs between artists, but the slope of the line does not. In this case, there is variance at two levels: the level of works of art and the level of artists. The variance at the level of artists can be modeled, and is likely to include factors such as experience, education, or previous prices for works sold to museums.[2]

Finally, not just the intercept, but also the slope of the line which depicts the relationship between size and price can vary between different artists. Some artists may, for example, charge less for a size increase of their work than other artists; Vincent Van Gogh's paintings are all expensive, regardless of their format, while in the case of other, less well-known painters, the price may increase with size. In that case the lines in figure D.2 would no longer be parallel, but differ both in intercept and in slope, as in figure D.3.

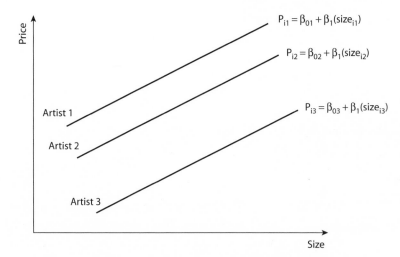

FIGURE D.2. The relation between price and size for different artists.

These three models have a straightforward algebraic representation, as can be seen below. First, a baseline model is shown, then a fixed-effects model that includes explanatory variables at each of the three levels, and finally a random-effects model which allows for differences in the relation between price and size:

FIGURE D.3. Differences in the relation between price and size.

I. The baseline model (figure D.1)

$$\text{Price}_{ijk} = Constant + v_{0k} + u_{0jk} + e_{0ijk} \tag{I}$$

II. The fixed-effects model (figure D.2)

$$\text{Price}_{ijk} = Constant + A_{ijk} + B_{jk} + C_k + v_{0k} + u_{0jk} + e_{0ijk} \tag{II}$$

III. The random-effects model (figure D.3)

$$\text{Price}_{ijk} = Constant + A_{ijk} + B_{jk} + C_k + D_j + v_{0k} + u_{0jk} + e_{0ijk}$$

with

$$D_{1j} = Constant + u_{1jk} \tag{III}$$

In these equations, i, j, and k indicate the three observed levels (work of art, artist, and gallery, respectively); A, B, C stand for vectors of explanatory variables at the level of works of art, artists, and galleries, respectively; v, u, and e represent error terms; D_{1j} is a "random" term that varies between artists (the j-level) with an error term of u_{1jk}. The baseline model, which has no explanatory power, is used to evaluate changes in explained variance (i.e., the three error terms).[3]

THE RANDOM-EFFECTS MODEL

Table D.1 depicts different hedonic price functions with a multilevel structure. The difference between this and the model in table 4.4 (chapter 4) is that here, clusters of determinants are introduced stepwise, and the baseline as well as the random effects model are depicted. Model 1, the baseline model (type I), has no explanatory power but merely serves as a point of reference. In model 2 characteristics of works of art are introduced as determinants of prices; in model 3 characteristics of artists are introduced; in model 4, which is discussed in the main text, all characteristics, including those of galleries, are included.

Whereas models 2–4 are fixed-effects models (type II), model 5 is a random-effects model (type III). In the latter model the relationship between price and size is allowed to vary for different artists; in other words, the (unlikely) assumption that the size effect is identical for all artists is now relaxed. Compared to model 4 it has one extra equation, in which the size effect is modeled (in this case with a constant and an error term). In this representation, the main effect of size is 0.85, which means that on average an increase in size with one standard deviation leads to a price increase of €850. This effect varies between artists, with a normally distributed error term $u_{\text{size }jk}$. The variance of this error term is 0.42, while

the standard error is its square root: 0.64. Therefore, close to two-thirds of the size effects of all artists (what they charge extra for a larger work) lies between €210 and €1,490 for an extra standard deviation of size. The covariance between $u_{\text{size jk}}$ and u_{0jk} is positive (307), which indicates a positive correlation between intercept and slope.

The main advancement of model 5 is that it shows that artists whose work have higher "starting" prices (indifferent of the size of this work) also charge higher prices for each extra square centimeter of art than their colleagues whose "starting prices" are lower. In terms of the example depicted in figure D.3, this implies that the price-size lines for artists with a low initial price level are less steep than the price-size lines of artists with a higher initial price level. This model performs better in terms of explained variance than the fixed-effect models, particularly on the level of works of art. This is mainly due to relaxing the assumption that size has a constant effect. More variance is now found across artists. The effects of the other explanatory variables change little.

TABLE D.1
Multilevel hedonic price functions for contemporary artworks in Dutch galleries

	Model 1 Baseline model		Model 2 Artworks		Model 3 Artworks & Artists		Model 4 Artworks, Artists, & Galleries		Model 5 Artworks, Size, Artists, & Galleries	
Constant	1,978	48[c]	2,131	72[c]	1,268	156[c]	882	198[c]	791	189[c]
Characteristics of works of art (A$_{ijk}$)										
Year sold										
Sold in 1992			0	0	0	0	0	0	0	0
Sold in 1993			-155	60[c]	-156	59[c]	-164	59[c]	-113	55[b]
Sold in 1994			-95	64	-108	63[a]	-118	63[a]	-85	59
Sold in 1995			4	64	-2	63	-13	63	-6	59
Sold in 1996			-56	67	-64	67	-73	67	-60	62
Sold in 1997			266	64[c]	259	63[c]	259	63[c]	310	59[c]
Sold in 1998			372	64[c]	364	63[c]	371	63[c]	402	59[c]
Material										
Painting			0	0	0	0	0	0	0	0
Print			-1,895	63[c]	-1,989	63[c]	-1991	63[c]	-1,886	59[c]
Sculpture			-336	45[c]	-315	44[c]	-318	43[c]	-279	42[c]
Drawing			-711	68[c]	-725	67[c]	-725	67[c]	-670	62[c]
Watercolor			-628	60[c]	-686	59[c]	-683	59[c]	-567	55[c]
Glass			-402	66[c]	-417	64[c]	-425	64[c]	-378	60[c]
Other			-346	85[c]	-329	83[c]	-329	83[c]	-227	78[c]
Standardized size *10^3			0.63	0.012[c]	0.63	0.012[c]	0.63	0.012[c]	0.85 + u$_{size jk}$	0.024[c]

TABLE D.1 (Continued)

	Model 1 Baseline model		Model 2 Artworks		Model 3 Artworks & Artists		Model 4 Artworks, Artists, & Galleries		Model 5 Artworks, Size, Artists, & Galleries	
Characteristics of artists (\mathbf{B}_{jk})										
Sale characteristics (1992–98)										
Number of works sold					8.72	2.44[c]	7.64	2.45[c]	3.88	2.35[a]
Number of works sold squared					-0.037	0.010[c]	-0.033	0.010[c]	-0.017	0.009[a]
Number of different galleries					24.05	17.15	30.69	17.16[a]	26.33	16.74
Number of different mediums					7.97	27.30	-0.75	27.3	16.66	26.14
*Demographics**										
Age					11.20	2.62[c]	10.89	2.61[c]	13.62	2.52[c]
Female					-141	48[c]	-138	48[c]	-156	47[c]
Foreign nationality					263	105[b]	268	105[b]	258	102[b]
Place of residence										
Amsterdam					145	55[c]	138	55[b]	133	54[b]
Rotterdam					-202	105[a]	-200	106[a]	-168	105
Abroad					539	99[c]	525	99[c]	496	96[c]
Other					0		0		0	
Career characteristics										
Participated in the BKR					152	52[c]	155	52[c]	72	50
Received small grant (BKV)					-120	60[b]	-125	60[b]	-109	59[a]
Received large grant (IS)					-168	66[b]	-165	67[b]	-152	65[b]
Received commissions from the government					173	69[b]	174	70[b]	193	68[c]
Sold to a museum					98	66	87	67	62	65
Average price of work sold to a museum					0.05	0.01[c]	0.05	0.001[c]	0.04	0.01[c]

TABLE D.1 (Continued)
Multilevel hedonic price functions for contemporary artworks in Dutch galleries

	Model 1	Model 2	Model 3	Model 4		Model 5	
	Baseline model	Artworks	Artworks & Artists	Artworks, Artists, & Galleries		Artworks, Size, Artists, & Galleries	
Characteristics of galleries (C_k)							
Sale characteristics (1992–1998)							
Number of works sold				−2.98	0.71[c]	2.98	0.66[c]
Number of artists				−7.87	4.59[a]	8.57	4.30[b]
Percentage of artists also selling to museums				2.09	1.92	2.29	1.83
Location of the gallery							
Amsterdam				181	98[a]	223	92[b]
Rotterdam				95	162	29	154
The Hague				99	133	71	125
Other				0	0	0	0
*Demographics**							
Age of the gallery				7.98	4.84[a]	8.16	4.54[a]
Affiliation							
Traditional/commercial				86	105	73	99
avant-garde/experimental				20	110	40	104
No clearly distinguishable affiliation				0	0	0	0

TABLE D.1 (Continued)

	Model 1 Baseline model	Model 2 Artworks	Model 3 Artworks & Artists	Model 4 Artworks, Artists, & Galleries	Model 5 Artworks, Size, Artists, & Galleries
Other statistics					
Total variance	2,555,103	2,180,586	1,933,573	1,873,186	1,710,035
e_{0ijk} (works of art)	1,654,307	1,178,073	1,175,623	1,175,816	917,436
u_{0jk} (artists)	608,083	695,248	564,225	564,252	680,803
v_{ok} (galleries)	292,713	307,265	193,725	133,116	111,796
$u_{size\ jk}$					0.42
Covariance $u_{size\ jk} - u_{ojk}$					307
–2 log likelihood	206,038	202,762	202,353	202,312	200,987
N (works of art)	11,869	11,869	11,869	11,869	11,869
N (artists)	2,089	2,089	2,089	2,089	2,089
N (galleries)	203	203	203	203	203

*Control dummies indicating missing values on demographic variables were included in the analysis. They are not depicted, since they were insignificant. Standard errors in italics; [a] significant at 90% level; [b] Significant at 95% level; [c] significant at 99% level.

Notes

INTRODUCTION

1. See Swidler 1986 for the original idea and Swidler 2001 for an elaboration; see also DiMaggio 1997; Heimer 1999.

2. Zelizer 2000b, p. 3; Zelizer forthcoming; Collins 2000; Velthuis 2005.

3. See Douglas and Isherwood 1979, Sahlins 1976; Appadurai 1986; Miller 1998; DiMaggio 1994; Dobbin 1994; some scholars working in the field of cultural studies, broadly defined, have furthermore pointed at a recent cultural turn within the economy, exemplified by practices such as branding or ethnicity-sensitive advertising (see, e.g., Gay and Pryke 2002). Jeremy Rifkin has argued likewise in his popular book on *The Age of Access* that cultural values such as creativity have become valuable assets for companies, and that artistic metaphors have started influencing corporate culture significantly (Rifkin 2000). The implicit assumption of those claims is that culture is a novel dimension of the economy, related to the rise of what has been referred to as late capitalism (Jameson 1984) or post-industrial society (Bell 1976 [1999]); by contrast, I argue that not just postmodern markets, but every market, including the modern markets of the nineteenth and twentieth century, can and need to be understood in cultural terms (cf. Slater 2002).

4. On life insurance, see Zelizer 1979; on money, see Zelizer 1994 [1997], pp. 137–38; on the value of children, see Zelizer 1985 [1994]; on intimacy, see Zelizer 2000a.

5. Patrick Aspers applies White's perspective to the Swedish market for fashion photography, and concludes that price differences must be seen as the expression of status differences between photographers (Aspers 2001). Reversing the neoclassical economic approach, Neil Fligstein argues that price competition is a source of instability in markets, which firms try to avoid rather than enhance (Fligstein 1996). Ezra Zuckerman has argued that firms pay an "illegitimacy discount," that is, a lower stock price than their industry companions, if they fail to manage their identity properly. The mechanism is that such failures lead to a "coverage mismatch," i.e., a situation in which stock analysts do not recognize the firm as belonging to the industry which the analyst covers. Given the influence which stock analysts have, this depresses the price of the stocks (Zuckerman 1999). Joel Podolny has argued that the status of a firm within the market has consequences for costs, benefits, and the prices that the firm charges (Podolny 1993). Anthropologist Robert Prus found that, "[d]espite its 'depersonalised' . . . referents," price setting on "ordinary" retail markets is a "socially derived activity" (Prus 1985, pp. 89–90).The price mechanism of non-western markets (in particular the bazaar economy) has been studied in detail by anthropologists (see, e.g., Geertz 1979, Fanselow 1990, Alexander and Alexander 1987, Alexander 1992).

6. See Hoogenboom 1994, Jensen 1994, and McLellan 1996, for partial explanations of the rise of the modern dealer. For detailed historical accounts of galleries, see Gubbels 1999 on the Dutch, and Robson 1995 or Goldstein 2000 on the American scene. For a general history of art dealers, see Thurn 1994.

7. Low New York figure: 1997 Economic Census of the U.S. Census Bureau (unpublished report, provided to me by the National Endowment for the Arts, Washington, DC, 2001). High New York figure: Internet Telephone Directory of New York City, heading "Art Galleries Dealers & Consultants," as of February 2002. Low Amsterdam figure: *Galeriegids 2002* (Rijswijk: Kunstbeeld). High Amsterdam figure: Internet Yellow Pages, headings "Galerie/Kunstzaal," "Kunstbemiddeling/Art Consultancy," and "Kunsthandel" (duplicates have been eliminated).

8. Unsurprisingly, in both cities, the density of galleries is higher than in the rest of the country; the majority of New York galleries, 173, are located in Chelsea (32.2%), followed by 106 galleries in SoHo (19.8%), and 79 on 50th–60th street (14.7%); only 36 galleries are located outside of Manhattan (6.7%). See *Gallery Guide New York,* January 2002. The Dutch figure is based on *Alert. Galerie Agenda Amsterdam & Omstreken,* 19 (2), February 2002.

9. Cf. Weber 1922 [1978], p. 246; Biggart 1989, p. 242. Mitchell-Innes's quote is from Lisa Gubernick, "Art Tutor to the Stars," *Forbes,* 12.9.1991. See also Christie Brown, "Collecting: Aspirational Art: Dealers Sell 'Look,' Lifestyle—Are Clients Fashion Victims or Visionaries? Why You Pay More for a 'Castelli Warhol,'" *The Wall Street Journal,* 3.27.1998.

10. For similar distinctions, see also Greenfeld 1989; Peterson 1997; Kempers 1988.

11. Ideally the interviews should have been supplemented with a questionnaire, were it not for the expectedly low response rates of such questionnaires (see e.g., Meyer and Even 1998), and the lack of cooperativeness of galleries in other than interview studies. All interviews except for two have been recorded and fully transcribed; in the remaining two cases, art dealers did not allow me to use a tape recorder. Transcripts of the interviews have been coded. Quotes from interviews are used in the text ("NL" refers to Amsterdam art dealers and "US" to New York dealers); translations of the Dutch interview texts are mine. If prices were quoted in Dutch guilders during the interview, I converted them to euros.

12. In order to avoid remaining in one network, I never used more than one recommendation per dealer.

13. I made fieldnotes of my participant observations, but I do not make explicit references to them in the text. Three good collections of interviews that I used are Diamonstein 1994, Klein 1994, and Coppet and Jones 2002. For the American situation, most press material was obtained from main magazines, *ARTnews* and *Art in America,* and one newspaper, *The New York Times,* 1990–99. Since comparable art magazines are lacking for the Dutch art market, I focused on two daily newspapers with extensive coverage of the visual arts, *de Volkskrant* and *NRC Handelsblad.* Volumes of newspapers were searched systematically with the help of the on-line full-text service *LEXIS-NEXIS Academic Universe* and CD-ROM editions; art magazines were searched with the bibliographical *Art Index.* In both cases, searches were conducted with the help of keywords such as "art market," "auction," "gallery," "price," "pricing," "economic value." References to newspaper and magazine articles are made in footnotes,

using the American notation of dates (*mm.dd.yyyy*). All translations of quotes from Dutch texts are mine.

CHAPTER 1. THE ARCHITECTURE OF THE ART MARKET

1. The quotes are from Jennifer Flay during a seminar on "Art-Market-Value," organized by the postgraduate Jan van Eyck Academy in Maastricht (Netherlands) and from Adriaan Van Ravesteijn, *éminence grise* of the Dutch gallery scene, at an expert meeting on the Dutch art market organized by the Boekman Foundation, Amsterdam. The website is of the Andrea Rosen Gallery in New York. The Andrea Rosen Gallery was frequently referred to in my interviews as a New York gallery that takes good care of the artists it represents.

2. See, e.g., Daniel Akst, "Let 70,000 Canvases Bloom in the Art World," *The New York Times,* 1.7.2001.

3. The two contradictory logics are found in the terms used to denote art galleries. In the United States, the term "gallery owner" may denote the owner of a "vanity gallery," who rents out an exhibition space to artists on a commercial basis; the term "art dealer" denotes an intermediary who actively promotes an artist's career (Caplin 1989, p. 256). In Dutch, however, the term "art dealer" (*kunsthandelaar*) denotes a commercial middleman who exclusively operates on the secondary market, and is predominantly motivated by economic goals; the reverse is true for the term "gallery owner" (*"galeriehouder"*). For policy purposes, the Department of Education, Science and Culture in the Netherlands has defined a gallery as a professional and economically independent public space where, as a major activity, changing exhibitions take place on the basis of a yearly program, directed at the sale of work made by visual artists, designers, or architects ("Toelatingsregeling Galeries 1989," in Grubbels 1992).

4. See respectively Appadurai 1986; Heimer 1999; Walzer 1983; Boltanski and Thévenot 1999; Scott 1987. From a different theoretical angle, Talcott Parsons's model of society likewise separated different societal spheres. With Neil Smelser, Parsons argued that society was built up of different subsystems, which each fulfilled its function in the persistence of society (Parsons and Smelser 1956). This structuralist-functionalist model, as Frank Dobbin writes, "divided the social world in two rigid categories of instrumental action . . . and cultural action" (Dobbin 1994, p. 119). Cognitive sociologist Eviatar Zeruvabel (Zeruvabel 1997, chapter 4) has argued that our mind permanently compartmentalizes the social world. The tendency to divide social goods into the marketable and the unmarketable is in other words not just socially, but also mentally informed.

5. As Roger Friedland and Robert Alford have pointed out, hardly any human action is governed by a single logic. Instead, multiple logics inform human action on many occasions. In doing so, they conflict and give rise to struggles between individuals, groups, and organizations (Friedland and Alford 1991, p. 256).

6. To produce such market-oriented work, a mechanical division of labor came into being which forced artists to focus on one aspect of a painting like the depiction of animals or background elements (Hauser 1951, p. 468; cf. Montias 1987). For a detailed critique of Hauser's account of the socioeconomic position of artists in the seventeenth century, see Montias 1990, pp. 364–66.

7. See respectively Wood 1996, pp. 274–75; Adorno and Horkheimer 1944 [1972]; Bürger 1974 [1996], pp. 51–52; Koerner and Koerner 1996, p. 299. Illustrative of this disregard of visual qualities are the fluctuations in economic value which follow from attributions of paintings to master painters. For instance, the early seventeenth-century work *Immaculate Conception* was attributed in 1990 by a minor auction house to "Circle of Velazquez"; it received a price estimate of $52,000 to $69,000. When the work was resold at Sotheby's four years later, the attribution had been changed to "Velazquez" after close inspection of a number of art historians. Even though the art market was weaker at the time, Sotheby's put an estimate of $9.5 million on the work. Conversely, when it was established that the painting *Man with Golden Helmet* was not made by Rembrandt himself, the economic value of the work decreased considerably; also, museum audience in the Gemälde Galerie in Berlin, which owns the work, lost its interest in the work (Bonus and Ronte 1997, p. 103). See Carol Vogel, "Inside Art: Banking on a Possible Velazquez," *The New York Times*, 7.1.1994.

8. As the early neoclassical economist Léon Walras put it in the nineteenth century: "necessary, useful, agreeable, and superflous, all that for us means only more of less useful. Morality or immorality of the needs to be satisfied by a useful good have not to be taken into account. (. . .) Others can bother very much about the reason why a substance is required, by a physician to heal a patient or by a murderer to poison a family. We, on the contrary, are totally indifferent" (cited in Mossetto 1993, p.40). In the twentieth century, similar statements about the irrelevance of distinctions between major and minor decisions or the irrelevance of "ultimate values" have been put forward by Lionel Robbins (1932) and Gary Becker (1976).

9. For alternative perspectives within cultural economics, see, e.g., Throsby 2001; Klamer 1996.

10. Bourdieu 1993, p. 75; literature on markets for art that builds on Bourdieu's insights include Abbing 2002, Bonus and Ronte 1997, and Gubbels 1999. Some historical studies have made claims that are in line with Bourdieu's approach. Robert Jensen has argued that the "alienation" of the artist was, at least as far as the market was concerned, largely a fiction that served rather than denied the commodification of art (Jensen 1994, p. 10). M. C. Fitzgerald claims that Pablo Picasso, who expressed his hostility towards the market on numerous occasions, excelled not only in creating but also in marketing art, albeit in a covert way (Fitzgerald 1995, p. 3). With respect to the French art market in the 1960s, Moulin, like Bourdieu, noted that "[i]nstant success is suspect and compromising; it casts doubt on the authenticity of the work and on its power to endure. Lack of success can be regarded as proof of the honesty of the artist and presumptive in favor of his genius (Moulin 1967 [1987], p. 127; cf. Plattner 1996, p. 22). Vito Acconci, a renowned performance artist of the 1970s, realized with hindsight that "we might not have provided things to sell, but we provided something that every business needs. We provided advertising, window dressing. If anything, I think we made the art gallery system stronger. They could say, 'look, we can even deal with *this!*'" (Haden-Guest 1996, p. 40). Art critic and artist Martha Rosler, finally, argued more disapprovingly: "dealers have lately supported . . . certain types of trendy art, including performance, which sell little or not at all but which get reviewed because of their art-world currency

and which therefore enhance the dealer's reputation for patronage and knowl-edgeability" (Rosler 1984, p. 318).

11. For other critical appraisals of Bourdieu's work, see Laermans 1991, Laermans 1993, Bourdieu and Wacquant 1992, Calhoun et al. 1993, or Lamont and Lareau 1988.

12. The idea that the marketable and the non-marketable are separate cate-gories can be traced back to the philosopher Immanuel Kant, who argued that "[i]n the kingdom of ends everything has either a price or a dignity. Whatever has a price can be replaced by something else as its equivalent . . . ; whatever is above all price, and therefore admits of no equivalent, has a dignity" (cited by Ander-son 1993, p. 8).

13. If this account is to some extent at odds with Bourdieu's account of the denegation of the economy in the cultural field, it does bear striking resemblance with his reading of the Algerian Kabyle house, whose architecture is organized in accordance with a set of oppositions between male and female, culture and nature, light and dark (Bourdieu 1979). Zelizer has likewise shown how life insurance companies borrowed religious roles and imagery in order to shape their market. "The cathedral-like architectural design of many late nineteenth-century insurance buildings also kept religious symbolism alive, perpetuating the notion that 'life insurance is built on a little lower level than a church,'" she writes (Zelizer 1979, p. 114).

14. See Szántó 2003 for a more detailed description of the emergence of Chelsea as the center of the New York art market.

15. Gluckman is not the only architect who masters this symbolic triangle of boutiques, museums, and galleries. The Dutch architect Rem Koolhaas, for instance, who designed the gallery space of Lehmann Maupin in Chelsea, is famous for his design of the Rotterdam *Kunsthal,* a nonprofit, museum-like exhi-bition space without a collection of its own, but also for his Prada Shop in SoHo, New York. See Raul A. Barreneche, "Building a Specialty in Art," *Architecture,* 85 (11), 11.1.1996; Eve MacSweeney, "Making the Scene," online magazine *Onemedia,* February/March 2001; Fred A. Bernstein, "Post Prada, A Design Star Slims Down," *The New York Times,* 4.24.2003.

16. Douglas C. McGill, "Art Galleries Told to Post Prices," *The New York Times,* 2.10.1988; Hilton Kramer, "The Case against Price Tags," *The New York Times,* 3.20.1988; "NYC to Art Dealers: Post Prices or Else," *Art in America,* April 1988, p. 232; Dwight V. Gast, "Pricing New York Galleries," *Art in Amer-ica,* July 1988, pp. 86–87. Auction houses are usually more explicit about prices and price estimates. Even they, however, usually abstain from mentioning the title and maker of an artwork when they publish selling prices of artworks after the sale. Instead, the information they provide is limited to the lot number of the art-work and the selling price. On the internet, avant-garde galleries usually only list prices of works made in edition, not of original paintings.

17. See Knorr Cetina and Bruegger 2002 and Stark and Beunza 2002 for comparable descriptions of the workings of financial markets.

18. Philip Delves Broughton, "Damien's one of the good guys," *The Daily Telegraph,* 10.3.2000. The codes refer to transcripts of the interviews. "NL" refers to Amsterdam art dealers and "US" to New York dealers. See Introduction, note 11.

19. Robert Knafo, "Upward Mobility: SoHo Stalwart David Zwirner Is Staking a Claim on the Upper East Side," *ARTnews,* October 1999, pp. 62–64.

20. Other galleries, in the Netherlands as well as in the United States, may have one or two best-selling artists on the primary market which make up for losses made on the sale of work by other artists. This business model, in which profitable activities are used to finance loss-leading ones, is often referred to as internal subsidization; it can also be found in other parts of the cultural industries such as the book publishing business (see Velthuis 2001).

21. By contrast, throughout the history of art, the design, colors, and iconographic schemes of artworks have been specified by the commissioner of paintings (Baxandall 1972 [1988]). As recently as in the 1970s, photo-realist artists made painstakingly detailed paintings of photos, which a collector could supply. Since the mid-1990s, an Amsterdam gallery called the "Kunstfabriek" ("Art factory") has sold realist work made by predominantly Chinese artists on a similar basis. Also, a continuous tradition of specialized painters exists who make portraits on a commission basis; in the Netherlands artists frequently make large-scale, commissioned work for public spaces, governmental institutions, and companies.

22. Appadurai 1986; see also Carrier 1995, p. 33; Callon 1998. Appadurai has argued that goods have a "social life," which Igor Kopytoff has referred to in terms of a "biography" (Appadurai 1986; Kopytoff 1986). In the course of this biography, an artwork passes through different "regimes of value." The commodity regime of the art market is only one of these (Appadurai 1986, p. 4); other regimes prevail when an artwork is still in the artist's studio, at a collector's house, or in a museum. In 1992, for instance, when the Museum of Modern Art in New York hosted a large retrospective of the French painter Henri Matisse, artworks were passing through different regimes of value within days. A number of collectors were induced to sell their holdings of works made by Matisse, expecting to profit from the attention that the retrospective generated. In that year, an unprecedented number of 28 works appeared at auction. Three of these works were transported from the museum's walls to the viewing rooms of the auction; after the viewing days of the auction they were returned to the museum, where they could be seen until the end of the exhibition. See Carol Vogel, "The Art Market; Auction Houses Await the Upturn," *The New York Times,* 11.6.1992.

23. In some cases, easily commodifiable work is purposely made less commodifiable by the way it is framed or displayed. For instance, some dealers choose to display small photos in large suites of multiple pictures, rather than as individual pieces; due to a mixture of a higher price, larger size, and limited availability, this reduces the commodity character of the pictures.

24. Carol Vogel, "The Art Market: Making the Best of Lean Times at the Auctions," *The New York Times,* 4.30.1993.

25. Stein defines the efficiency of an asset as "the difference between its observed return over a specified time period and the return that could have been expected ex ante on an alternative, naively constructed portfolio" (Stein 1977 p. 1028).

26. For American collectors, such donations are furthermore attractive since they can deduct the value of the donation to some degree from their income tax. Art dealer Gagosian remarked about the terminal status of artworks in museums: "I don't like to sell paintings to museums . . . because then I can't get them

back"; Grace Glueck, "One Art Dealer Who's Still a High Roller," *The New York Times*, 6.24.1991.

27. In his book on the transformation of aboriginal into a "high art" form, Fred Myers reports on a New York dealer in aboriginal art who claims that it is difficult to sell this work because collectors cannot "get into the life of" the artists (Myers 2002, p. 320–21); some contemporary artists, however, are hardly willing to engage in social encounters with collectors. As the American artist Donald Judd once put it: "We pay 40 percent so we don't have to talk to the cereal manufacturer" (Szántó 1996, p. 4).

28. In Japan, artworks have commonly been exhibited in and sold out of department stores (Havens 1982, p. 140). In the Netherlands, one gallery chain, the Holland Art Gallery, is located in the branches of an upscale department store called *de Bijenkorf*. In the 1940s, New York department stores Macy's and Gimbel's tried to sell artworks as well. They applied selling techniques that they used for other consumer goods, including "just below" prices like $9,999 for a painting by Rembrandt (Guilbaut 1983, p. 93–94).

29. See also David Schiff, "Junk Art: Some Firms Are Cashing In on It," *Barron's*, 10.30.1989; Matthew Schifrin, "McArt," *Forbes*, 141 (5), 3.7.1988, p. 123; Christie Brown, "Resort Art," *Forbes*, 51 (2), 1.18.1993, p. 100; Blake Gopnik, "The New Breed of Art Seller," *The Globe and Mail*, 11.4.2000; Michael Kaplan, "Let Them Buy Art," *Esquire*, April 1988, p. 84; William L. Hamilton, "Wall Décor: It's on the Wall, It's in a Frame, but Is It Art?," *The New York Times*, 3.8.2001. This discussion is based on participant observation as well. One of my respondents provided me access to a trade fair for retailers on this circuit. Since I had noticed that dealers at such fairs are difficult to get access to as a researcher, I decided to pretend to be in the planning stage of opening a small retail art store myself; in that capacity, I started conversations with dealers.

30. The author of an article in the crafts magazine *American Artist* notes that "[t]he nature of decorative art dictates, to some extent, the kinds of subjects that are most likely to sell (. . .) Pictures that convey a positive mood or condition of light have the maximum appeal to this market." The author spots a tendency away from abstract, towards representational styles of art. Pictures with people should be avoided, he argues, as well as depressing or morbid scenes. Instead, "[u]pbeat subjects such as landscapes, boats, birds, beach scenes, and florals are most likely to be purchased." Also, he emphasizes that appropriate color schemes and subject matters differ per region. In Florida, for instance, mountain or snow scenes should be avoided; Richard L. Harrison, "The Mammoth Market Artists Often Overlook," *American Artist*, 56 (596), March 1992, pp. 64–67. The term "original" surfaces in the discourse of the wholesale market as well, but now to denote the difference between a print in edition and a poster, rather than the difference between a unique work and a work in edition (cf. Fitz Gibbon 1987).

31. These works are an example of what Michael Thompson calls "rubbish": they lose their worth, and as a result of that they are not likely to appear on the market again, nor are they likely to be preserved in public or private collections (Thompson 1979).

32. Quotes are from various promotional materials supplied by dealers on this circuit.

33. With respect to these collections, I came across the names of celebrities like Brigitte Bardot, Bjorn Borg, the Marchioness of Queensbury, Margaret Thatcher, Elton John, Ravi Shankar, and Robert Di Niro on the résumés of artists.

34. Karen Frankel, "Artists and Clients First," *American Artist,* May 1999, pp. 27–29.

Chapter 2. Exchanging Meaning

1. Vincent himself had worked as an assistant at the Hague and London branches of the dealership in the 1870s.

2. All references in this section, except for the second to last one, are to Jan Hulsker's edition of Van Gogh's letters (Van Gogh 1980); the numbering of the letters was originally given by Theo's widow Johanna van Gogh-Bonger; translations of quotes in the text are mine. The letters which Theo wrote to Vincent in response have not been preserved.

3. As much as Theo admired his brother's work, he did not manage to sell it at the dealership of Goupil. With great difficulty, Theo did sell some work by other innovative painters of those days such as Monet, Degas, Pissarro, and occasionally Vincent's friend Gauguin (Rewald 1973 [1986]). Although Vincent was mostly confident that the time of his financial success would come, he reproached his brother every now and then for failing to translate his artistic efforts into economic value (letter no. 358, Van Gogh 1980, p. 231).

4. I borrow the tripartite classification of monetary transfers in terms of compensation ("direct exchange"), entitlement ("rightful claim to a share"), and gift ("one person's voluntary bestowal on another") from Zelizer (2000a, p. 819). Claims of contemporary artists in the Netherlands who feel entitled to financial support by the government for their artistic efforts resemble Vincent's entitlement argument.

5. McLellan 1996, p. 439; Green 1987; White and White 1965, p. 126. Nicole Woolsey Biggart has argued that this blurring of business and family ties, although exceptional for a modern, capitalist economy, is common in direct selling organizations that flourish in the American economy (Biggart 1989).

6. Grace Glueck, "In the Art World, As in Baseball, Free Agents Abound," *The New York Times,* 1.14.1991.

7. See Grace Glueck, "In the Art World, As in Baseball, Free Agents Abound," *The New York Times,* 1.14.1991; Daniel Grant, "The Dynamics of the Artist-Dealer Relationship," *American Artist,* 65 (705), 4.1.2001; Daniel Grant, "Ending an Artist-Dealer Relationship," *American Artist,* 67 (727), 2.1.2003; Roberta Smith, "Art World Startled as Painter Switches Dealers," *The New York Times,* 12.23.03.

8. Some sociologists, anthropologists, and legal scholars have likewise plead for a gift rather than market exchange for transactions in goods with a strong human, symbolic, or ethical value (Radin 1996; Komter 1996; Titmuss 1971). Critics of capitalism have made the stronger claim that the widespread introduction

of markets has a general destructive effect on the social fabric and the moral basis of modern society (see O'Neill 1998; cf. Hirschman 1982 [1986]; Zelizer 1988).

9. According to Albert Hirschman, this neglect of the social dimension of economic exchange should be understood as an attempt of modern economists to emulate the rigor and quantitative precision of the natural sciences (Hirschman 1982 [1986]).

10. Waldfogel's estimate of this deadweight loss is 10 to 33 percent of the total economic value of gifts (Waldfogel 1993).

11. In the 1980s, for instance, the late art deco artist Erte was contracted by the Dyansen Corporation, a gallery chain, for a salary of $275,000 plus 5 percent of pretax profits. Erte, like other artists working for these gallery chains, did not produce the sculptures himself, but only the original mold. See Matthew Schifrin, "McArt," *Forbes,* 3.7.1988.

12. An exception in Amsterdam was the art gallery Espace, which showed work by Cobra painters such as Karel Appel, Corneille, and Pierre Alechinsky. Espace preferred to buy works, since it enabled the gallery to set prices without interference of the artist (Gubbels 1999, p. 38).

13. Often the dealer represents artists on an exclusive basis; this means that the dealer expects to receive a commission for all sales, including those made by the artist from his studio. The reasoning is that even those studio sales result from the promotional efforts which the dealer makes. Legal guides maintain, however, that the artist has no legal obligation to pay the dealer a commission in those cases (Lerner and Bresler 1998, p. 7).

14. Nevertheless, some lawsuits have emerged regarding consignment relationships, such as between dealer Sidney Janis and artist Willem de Kooning in the late 1960s. After the business relationship between the two had ended, Janis claimed $3,948.68 which he had advanced to the artist for future sales. These sales, however, never took place. Also, Janis claimed a 33.3 percent commission on sales De Kooning had made directly from his studio. Therefore, Janis kept a number of works De Kooning had consigned to him in the past as liens; see *Sidney Janis Ltd. v. de Kooning,* 33 A D 2d 555 (see also Lerner and Bresler 1998).

15. In an experimental study, Kollock has shown that the higher the uncertainty about the quality of the product and the more information is asymmetrically distributed, the higher the average level of trust and the stronger commitments are between transaction partners (Kollock 1994). For a critique of such strands within economic sociology, see Zelizer 2002.

16. Likewise Peggy Guggenheim's collection of modern art resulted from her practice of buying a work from each exhibition, "so as not to disappoint the artists if I were unsuccessful in selling anything" (Robson 1995, p. 114). In more general terms, Susan Mellon and Tad Crawford write in a booklet on consignment relationships: "by a willingness to share concerns and to work out differences, a truly amicable relationship can be nurtured. After all, people who create and those who sell art are both in business, but their connection to art is usually far more than just a financial one; it is aesthetic and often deeply personal" (Mellon and Crawford 1981, p. 4).

17. See, e.g., Grace Glueck, "Samuel M. Kootz Dead At 83: An Activist for American Art," *The New York Times*, 8.9.1982; John Russell, "Leo Castelli, Influential Art Dealer, Dies at 91," *The New York Times*, 8.23.1999; Carol Strickland, "Leo Castelli Meets Film Maker and Fan," *The New York Times*, 5.12.1991; David Usborne, "Death of a Salesman," *The Independent*, 9.4.1999.

18. The binding nature of stipends was underscored by Jeff Koons, who wanted to end his relationships with the Sonnabend Gallery; his leave was temporarily inhibited by the estimated $3 to 4 million which the gallery advanced the artist over the years. See Carol Vogel, "The Art Market," *The New York Times*, 2.14.1992.

19. Ibid.; Grace Glueck, "In the Art World, As in Baseball, Free Agents Abound," *The New York Times*, 1.14.1991.

20. *Sonnabend Gallery, Inc. v. Peter Halley, Gagosian Gallery, and Larry Gagosian, New York Law Journal*, July 14, at. 21, col. 2 (Sup. Ct. N.Y. County 1992); apart from court papers, my discussion of the case is based on Lerner and Bresler 1998, pp. 12–14; "Recent Cases," *Entertainment Law Reporter*, 14 (11), April 1993; Carol Vogel, "The Art Market: Switching Galleries," *The New York Times*, 3.6.1992; Carol Vogel, "The Art Market: Movable Show," *The New York Times*, 5.22.1992; Carol Vogel, "The Art Market: Sonnabend Loses," *The New York Times*, 6.26.1992; Carol Vogel, "The Art Market: Who Sold What?", *The New York Times*, 3.5.1993; Carol Vogel, "The Art Market: Value of Contracts," *The New York Times*, 6.11.1993; Carol Vogel, "Inside Art: Revolving Door at Gagosian," *The New York Times*, 9.23.1994; Calvin Tomkins, "An Eye for the New," *The New Yorker*, 1.17.2000, pp. 54–64; Deborah Gimelson, "It's a Wonderful Life," *ARTnews*, Summer 1994, pp. 172–74.

21. This was the case, for instance, for David Salle and Philip Taaffe (who both left the Mary Boone Gallery) and Francesco Clemente. See Grace Glueck, "One Art Dealer Who's Still a High Roller," *The New York Times*, 6.24.1991.

22. Eamonn Fingleton, "Portrait of the Artist as a Money Man," *Forbes*, 2.1.1982, pp. 58–62; Cathleen McGuigan, "Julian Schnabel: 'I Always knew It Would Be Like This,'" *ARTnews*, Summer 1982, 81 (6), pp. 88–94; Anthony Haden-Guest, "The Art of Musical Chairs," *Vanity Fair*, September 1987, p. 64.

23. Anthony Haden-Guest, "The Art of Musical Chairs," *Vanity Fair*, September 1987, pp. 64, 72; Grace Glueck, "In the Art World, As in Baseball, Free Agents Abound," *The New York Times*, 1.14.1991; Nancy Hass, "Stirring Up the Art World Again," *The New York Times*, 3.5.2000; Philip Delves Broughton, "Damien's One of the Good Guys," *The Daily Telegraph*, 10.3.2000.

24. Halley continued to show with other dealers. In 1997 he would also be one of the first artists to distribute art, for free, via the internet: visitors of an online exhibition of the New York *Museum of Modern Art* could download and adjust his colorful images, and subsequently print them (Goldstein 2000, p. 321).

25. Carol Vogel, "The Art Market: Movable Show," *The New York Times*, 5.22.1992.

26. "Who Knows When Another Epiphany Will Occur?," *ARTnews*, April 1991, pp. 73–77.

27. Kelly Crow, "Sharing a Love Affair with Each Other and Artists," *The New York Times*, 11.17.2003.

28.The Mary Boone Gallery is frequently mentioned as one of the galleries that put this into practice. See Christie Brown, "Collecting: Aspirational Art: Dealers Sell 'Look,' Lifestyle—Are Clients Fashion Victims or Visionaries? Why You Pay More for a "Castelli Warhol," *The Wall Street Journal*, 3.27.1998; Amei Wallach, "The Collectors: In the Fast Lane for Art," *Newsday*, 5.18.1996; Nancy Hass, "Stirring Up the Art World Again," James Servin, "SoHo Stares at Hard Times," *The New York Times*, 1.20.1991.

29. The frequent use of price discounts is not confined to the contemporary art market. In the nineteenth century, the ledgers of art dealers show similar differences between the official sales price and the eventual acquisition price (Hoogenboom 1993, p. 149).

30. N. R. Kleinfield, "Bargaining at the Art Galleries: A Personal Odyssey," *The New York Times*, 5.7.1993.

31. Calvin Tomkins, "An Eye for the New," *The New Yorker*, 1.17.2000, pp. 54–64.

CHAPTER 3. PROMOTERS VERSUS PARASITES

1. "Kunst Kompass 1999," *Capital*, November 1999, p. 261; on Matthew Marks, see Andrew Decker, "The Making of Marks," *ARTnews*, 97 (10), 11.1.1998; interview with Marks in Coppet and Jones (2002).

2. See Carol Vogel, "Stars of the Last 30 Years Shock and Sell at Christie's Contemporary Sale," *The New York Times*, 11.17.2000; Carol Vogel, "Sensible Shoppers Set Tone at Sale of Contemporary Art," *The New York Times*, 11.13.2001; Carol Vogel, "Solid Contemporary Sale Ends Two Weeks of Auctions," *The New York Times*, 11.16.2001; Mark Irving, "The Broader Picture: Detached at the Hip," *The Independent on Sunday*, 2.17.2002; all prices mentioned include the buyer's premium.

3. See Roger Bevan, "No Ifs, Some Buts in New York Sales: Gary Hume, Sam Taylor-Wood and Cecily Brown Prove That It's Never Too Soon to Be an Auction Star," *The Art Newspaper*, 11.17.2000.

4. This happens with the help of an imaginary, so-called Walrasian auctioneer (named after one of the founding fathers of neoclassical economic theory, the nineteenth-century Swiss economist Léon Walras), who calls off prices until an equilibrium price is established (see Smith 1993)

5. Suzanne Muchnic, "Make Him an Offer: Dealer Robert Berman Wants to Sell You a Painting," *Los Angeles Times*, 7.18.1991; Truus Ruiter, "Hester Oerlemans ruimt op," *de Volkskrant*, 5.30.2002. For benefit auctions, see Sarah Bernard, "The Art of the Party," *New York Magazine*, 8.9.2000; Christine Teminm, "Good Art, Good Cause: That's ARTcetera '92," *The Boston Globe*, 10.14.1992. What makes such benefits different from other auctions is that the prices that are set are not supposed to reflect the bidders' willingness to pay, but their willingness to donate. In Japan, auctions have long been taboo on the primary as well as the secondary market. In the past, art auctions were even prohibited by law in Japan (Havens 1982, p. 119). In the 1870s and 1880s, the dealer Durand-Ruel anonymously sold off part of his stock, which had not appeared on

the market before (Gee 1981, p. 23); so did the international dealership of Boussod & Valadon, formerly called Goupil (Rewald 1973 [1986], p. 21). For other historical cases, see North 1992, p. 90 and Watson 1992, p. 91.

6. For the economic analysis of auctions, see McAfee and McMillan 1987; Phlips 1988, p. 89; Milgrom 1985, p. 18; cf. Smith 1989, p. 16.

7. Addressing the question how the economic value of art ought to be determined for tax purposes, a legal text states that "valuation is still very much an art rather than a science" because it involves "a number of inconsistencies," while an artwork is "inherently qualitative and entirely subjective." See Stephen C. Gara and Craig J. Langstraat, "Property Valuation for Transfer Taxes: Art, Science, or Arbitrary Decision?" *Akron Tax Journal*, 12 (125), 1996. This uncertainty can be exploited for strategic reasons. Auction houses, for instance, are known to provide different official appraisals of art collections, depending on the purposes of their clients. When auction houses Christie's and Sotheby's colluded in the 1990s and, among others, secretly attuned commissions charged to buyers and sellers, court materials included a handwritten memo attributed to Christie's former chairman Sir Anthony, saying: "It's easier for us than for people dealing in goods that can be priced exactly. With a sliding scale based on value, there should be no legal problems because you cannot price-fix a unique object." Carol Vogel and Ralph Blumenthal, "Memos Point to Ties between Auction Houses," *The New York Times*, 5.25.2001.

8. In our own times, auction results carry more weight for the American Internal Revenue Service than private estimates of value, such as expert appraisals or gallery sales of comparable artworks. Stephen C. Gara and Craig J. Langstraat, "Property Valuation for Transfer Taxes: Art, Science, or Arbitrary Decision?," *Akron Tax Journal*, 12 (125), 1996. Journalist Peter Watson recounts the story of a New York art dealer who offers paintings by the seventeenth-century Neapolitan painter Bernardo Cavallino for $600–700,000. One collector seriously considers acquiring them for the price, but at the very last moment he backs out. When the dealer subsequently decides to sell the works at auction, he finds to his surprise that the same collector bids on the works, and ends up buying them at a price of $1,700,000. Whereas the collector was lacking the self-confidence to buy the work privately, the experience that other buyers were willing to bid nearly as high reassured him of the rightness of the price. See Peter Watson, "Investing in Ignorance," *The Spectator*, 3.18.1989, pp. 35–36.

9. In order to make gallery prices more reliable, art dealers in Japan conventionally guarantee the original selling price of an artwork to a collector who wants to return a painting he bought in the past (Havens 1982, p. 122). One former Dutch art dealer I interviewed proposed a similar system. Dealers would commit themselves to buying back artworks which collectors originally bought at their gallery: "The system is all about giving a signal to people that you back up the work; it definitively answers that question if the work maintains its value . . . it is meant to bestow trust on the buyer with respect to the value of the work" (NL5). In practice, all galleries would have to deposit a monthly fee in a fund; out of this fund, collectors would get the original purchasing price refunded in case they wanted to sell the work back to the gallery. The dealer in question never managed to convince his colleagues to put the system in use.

10. This contingency of auctions was illustrated in 2001 when one of the world's largest dealers in contemporary art, the London-based Anthony d'Offay Gallery, decided to fold shop; according to *The New York Times*, d'Offay's subsequent absence from the auction market led to a "definite hole in the market," or, in other words, to lower auction prices for the artists he represented. See Carol Vogel, "Postwar Art Fails to Meet Expectations at Christie's," *The New York Times*, 11.14.2001. On the limited transparency of auctions, see also "There's One Born Every Minute," *The Economist*, 5.27.1989; Michael Kinsley, "The Manet Illusion," *The New Republic*, 1.22.1990; Souren Melikian, "A Transparency Problem: Would You Spend Millions of Dollars in the Dark?," *Art and Auction*, March 1990; Carol Vogel, "Under a Harsh Spotlight, the Art Market Is Sweating: Dealers and Auction Houses Are Terrified as Federal Investigators Ask about Their Private Realm," *The New York Times*, 5.7.1993. In academic literature, the chancy nature of auction is underscored by the so-called winner's curse, in which the person that wins the auction effectively overpaid (Thaler 1992), and the afternoon effect, which holds that prices are higher later in the sale (Agnello and Pierce 1996).

11. In 1988, Sotheby's loans amounted for instance to 206 million dollars; in the case of the record price paid by Vincent Van Gogh's *Irises*, the Australian collector Bond who bought the work for nearly $54 million in the fall of 1987, was not able to repay the loan Sotheby's had provided to him. See Pamela Young, "Masterpieces and Millions," *Maclean's*, 103 (16), 4.16.1990, p. 41; Richard W. Walker, "Flower Power," *ARTnews*, May 1987, p. 31; Carol Vogel, "The Art Market," *The New York Times*, 11.22.1991.

12. Ulrike Knöfel, "Grobe Töne im Kuschelclub," *Der Spiegel*, 11.12.2001; Christie's, "The Hans Grothe Collection, An Unparalleled Collection Of Post-War And Contemporary Art From Germany," Highlights Christie's Fall Sales, press release, Post-War and Contemporary Art, November 13 and 15, 2001.

13. See Pamela Young, "Masterpieces and Millions," *Maclean's*, 103 (16), 4.16.1990; Larry Black, "Painting by Numbers: Art Prices at Auctions Go through the Roof," *Maclean's*, 11.27.1989; Katrine Ames, Maggie Malone, Donna Foote, "Sold! The Art Auction Boom," *Newsweek* 4.18.1988; Carol Zemel, 'What Becomes a Legend Most," *Art in America*, 76 (7), July 1988; "There's One Born Every Minute," *The Economist*, 5.27.1989; Carol Vogel, "An Upstart Auctioneer Digs In," *The New York Times*, 2.28.2002.

14. Jean Baudrillard argues that auctions are not economic but aristocratic measures of value. It is "a competitive field of the destruction of economic value for the sake of another type of value." This other type is "sumptuary" value, akin to Veblen's notion of conspicuous consumption (Baudrillard 1981, p. 113, 115).

15. Carol Vogel, "Stars of the Last 30 Years Shock and Sell at Christie's Contemporary Sale," *The New York Times*, 11.17.2000; for Gursky, and his peers Thomas Ruff and Thomas Struth this became reality when, after a series of high prices, their works failed to sell at Sotheby's contemporary art sale in London, June 26, 2002.

16. Donald Judd reprimanded Cooper nevertheless because the prices collectors received at auction were sometimes more than twice as high as the prices in Cooper's gallery. See Carter Ratcliff, "Dealers Talk," *Art in America*, 76

(7), July 1988, p. 79; Carol Vogel, "Inside Art," *The New York Times,* 9.15.1995.

17. Carter Ratcliff, "Dealers Talk," pp. 78–79. In the 1980s, Mary Boone maintained that popular artists of her gallery like Eric Fischl, David Salle, and Julian Schnabel had waiting lists of over 100 buyers. "There's One Born Every Minute," *The Economist,* 5.27.1989.

18. Like art dealers who seek to control the market of the artists they represent, the Italian sports car maker Ferrari sells the limited edition cars that it every now and then produces to a select list of clients who have bought other Ferrari cars before. The reason for doing so is that Ferrari car dealers want to keep cars from ending up in the hands of speculators, who buy the cars to resell them with a profit; instead they prefer to see them in the hands "people who are loyal to Ferrari," as an American spokesman for Ferrari characterizes this type of customer management. See Dan Neil, "Vicarious Consumption: Latest Toy Goes for a Cool $675,000," *The New York Times,* 1.26.2003; Keith Martin, "Hard-to-Get Cars Are Hot Wheels, but Cold Investments," *The New York Times,* 12.17.1999.

19. Cultural economists Candela and Scorcu found that for the market for prints, price volatility is higher at auction than in galleries, while a long-run relationship between prices established at auction and in galleries for similar prints is lacking (Candela and Scorcu 2001, pp. 224–27; cf. Rouget et al. 1991). Pesando found that prices for identical prints are systematically higher at certain auction houses and in certain countries than in others; the author acknowledges that no satisfactory economic explanation exists for this anomaly (Pesando 1993, pp. 1086–88; see also Pesando and Shum 1996; Anderson 1974).

20. If the auction price of an artwork is lower than the price level in the gallery, art dealers can legitimate the difference by invoking this argument of quality differences. A New York art dealer remarked about the pricing policy of the well-known Pace Gallery: "If something did not reach at auction what they are selling it for, for instance in the case of Julian Schnabel who sells for $75,000 without discounts, and then bombs at auction to $20,000, the Pace Gallery will say 'oh, the work was a really bad example'" (US3).

21. This is typical for bazaar economies, where knowledge of both the quality and the overall price level of products are difficult to obtain. Sellers judge the prior knowledge of customers and adjust their initial offer significantly. Especially if the buyer is a stranger to the bazaar economy, or if his clothing and behavior suggest unfamiliarity with market practices, the seller's offer will be considerably increased (Alexander and Alexander 1987, p. 57).

22. Robert La Franco, "Knowledge Is Money," *Forbes,* 12.18.1995; Christine Temin, "Dealers and the Art of Pricing," *The Boston Globe,* 4.12.1989.

23. Search costs cannot fully explain price differences, however, since they have been significantly reduced by special firms which provide information on prices and availability of artworks by means of newsletters, websites, annual sales catalogues, and guidebooks (cf. Stigler 1961 [1971], p. 73). As Louargand and McDaniel argue, the price efficiency of the art market has been increased as a result of lower transaction costs and higher availability of information (Louargand and McDaniel 1991).

24. Christie Brown, "Collecting: Aspirational Art: Dealers Sell 'Look,' Lifestyle — Are Clients Fashion Victims or Visionaries? Why You Pay More For a 'Castelli Warhol," *The Wall Street Journal*, 3.27.1998.

25. A journalist of the British *Art Newspaper* noted: "[B]ehind those headline figures [at auction] is the stark realisation that the currently popular artists and their galleries simply cannot meet the demands of a swollen contemporary art market. Auction stands to be the continuing beneficiary of disappointed collectors who have lost patience by waiting in line." Roger Bevan, "No Ifs, Some Buts in New York sales: Gary Hume, Sam Taylor-Wood and Cecily Brown Prove That It's Never Too Soon to Be an Auction Star," *The Art Newspaper*, 11.17.2000. Dealer Irving Blum remarked likewise in the early 1980s that "[t]here are 50 people waiting for an extraordinary Stella or Lichtenstein or Johns. The problem is getting the material. Because it's so tight, the interest is there. They'll pay the earth to get the stuff." See Grace Glueck, "Fresh Talent and New Buyers Brighten the Art World," *The New York Times*, 10.18.1981. See also Riki Simons, "Verre van abstract," *Money*, November 1999, pp. 70–75.

Chapter 4. Determinants of Prices

1. See Michael White's (1999) excellent discussion of nineteenth-century British economists and the case of "rare art." Spectacular price differences for art are no contemporary phenomenon. As early as in the seventeenth century, differences in price existed that exceeded a factor 1,000. A painting by the Italian Renaissance artist Raphael sold on the secondary market for 3,500 guilders, while at the same time an ordinary artist producing work for the massive Dutch market could only ask two guilders or even less for his work (North 1992, p. 94). Similar price differences existed in the nineteenth century. In 1886, Vincent van Gogh's brother Theo, who worked for the renowned Parisian art dealership Boussod, Valadon & Co., bought and sold works by impressionist painters like Manet for prices as low as 100 francs. At about the same time, the dealership had a painting for sale by the French artist Alfred de Neuville, *Les Dernières Cartouches*, for 150,000 francs (Rewald 1973 [1986], p. 12, 20).

2. To put it differently: the observations of prices used in hedonic price functions represent a collection of demand and supply equilibria, but hedonic price functions do not model the underlying supply and demand functions. Thus an implicit market exists, as Sherwin Rosen puts it, in which producers "tailor their goods to embody final characteristics desired by customers and receive returns for serving economic functions as intermediaries" (Rosen 1974, p. 36)

3. Examples of such previous studies of art prices are Anderson 1974; Frey and Pommerehne 1989; Rouget et al. 1991; Agnello and Pierce 1996; Galenson 1999. The hedonic technique was developed in the late 1920s by Frederick Waugh, who applied it to the market for asparagus. In order to explain them, Waugh regressed prices for asparagus on their color, the size of their stalks, and the uniformity of their spears (see Nerlove 1995, p. 1698). Subsequently hedonic price functions have been used to measure consumer valuation of non-standardized or

differentiated goods such as real estate (Case et al. 1997), cars (Murray and Sarantis 1999), wine (Nerlove 1995), livestock (Jabbar 1998), or collectibles (Dickie et al. 1994).

4. According to my own estimate, the work of less than 2 percent of Dutch artists appears at auction on a regular basis (Velthuis 2000). According to another estimate, only 0.5 percent of the works sold today will still have market value in 30 years (Caplin 1989, p. 242).

5. According to current estimates, private collectors account for 50 percent of sales on the Dutch art market, companies and institutions for 20 percent, the government for 13 percent, museums for 4 percent, and others for 11 percent (Brouwer and Meulenbeek 2000).

6. In the past, however, "non-consecrated" galleries have been excluded from the arrangement, to the dismay of these galleries. Some of these have proceeded to file suit; eventually the selection criteria and the way they are applied were adjusted (see Gubbels 1992).

7. In 1999 the Mondrian Foundation, which administers the arrangement by order of the government, paid €608,000 in interest on the loans (Annual Report Mondrian Foundation, 1999).

8. Not all data are used in the analysis: the cases for which both size and medium of the work were missing are excluded. Missing values on demographic variables of artists and galleries have been substituted. In the analysis, this substitution is controlled for; it has no significant impact on the results. The description is also based on the valid numbers of observations in the data, not on all the data. Almost all works of art with missing values on medium and size were sold in 1992, the first year included in my analysis. From 1993 onwards, the quality of the data improves significantly. Consequently, almost all transactions for the years 1993 to 1998 are included in the analysis.

9. By comparison, Rouget et al. (1991, pp. 134, 140) found a price per cm^2 of approximately €4.81 for oil paintings made by artists born after 1880 on the Paris auction market; for artists born after 1940, this figure was closer to the Dutch figure (€0.66 per cm^2). The difference can be explained on the basis of differences in reputation of older (sometimes deceased) and younger artists.

10. The average age of Dutch visual artists, including those who don't sell their work on the free market, is around 45 (Brouwer and Meulenbeek 2000, p. 21). On average Dutch visual artists start their career around the age of 28 (Rengers 2000).

11. Since not all sales analyzed in the multilevel model were made in the same year, dummy variables in the analysis control for year-related influences on the price level such as developments in the wider economy—national income, inflation, stock market—and developments on the global art market. The reference year is 1992.

12. Standardized values were used for size in order to make sculptures and (glass or ceramic) objects comparable with two-dimensional works of art. The size of sculptures and pottery is in centimeters height; the size of paintings is in square centimeters.

13. See Rouget et al. 1991, p. 149, for the French market; Agnello and Pierce 1996, p. 369; Galenson 2000 for the American market; or Frey and Pommerehne 1989, p. 99, and Anderson 1974 for the international art market.

14. With respect to size, the demand for works of art of extreme sizes (both small and big) is likely to be lower than for works of "regular" size, since they are difficult to display in a private setting (Frey and Pommerehne 1989, p. 88). Agnello and Pierce (1996, p. 369) found a non-linear relation between price and size: the price of paintings increased with size up to a paint surface of 10,123 inches (about 100 by 100 inches), after which it started decreasing.

15. Plattner 1996, p. 20; see also Moulin 1967 [1987]; Bourdieu 1993.

16. The negative effect on price of the squared number of works sold indicates that the overall effect evens out when the number of works sold increases. The peak of the price influence of the number of works sold lies at 206 works of art.

17. Before Veblen, Adam Smith and Jean-Jacques Rousseau had made similar claims. Smith argued in an essay on the "imitative arts" that "[i]n the arts which address themselves, not to the prudent and the wise, but to the rich and the great, to the proud and the vain, we ought not to wonder if the appearance of great expence, of being what few people can purchase, of being one of the surest characteristics of great fortune, should often stand in the place of exquisite beauty, and contribute equally to recommend their productions. As the idea of expence seems often to embellish, so that of cheapness seems as frequently to tarnish the lustre even of very agreeable objects" (Smith 1982, p. 183). Rousseau argued likewise that prices for luxury goods behave differently than prices for necessities: if their price is high, this may increase their utility. In other words, their value is estimated according to how costly it is to acquire them (see Fridén 1999).

18. See Marc Spiegler, "Too Many Galleries, Not Enough Art," *The Art Newspaper*, February 2004.

19. See Anderson (1974), Rouget et al. (1991), and Agnello and Pierce (1996). There is no evidence that this age effect evens out, since polynomial age terms did not have a significant impact on prices; Agnello and Pierce did, however, find a nonlinear relation between price and age, with a price-maximizing age of 38.

20. In other studies on the economy of the arts, experience does not prove to be an important determinant of the labor market success of artists (see Rengers and Madden 2000; Towse 1996).

21. The idea that recognition by experts such as critics has a strong impact on the economic value of a work of art has been repeatedly recognized in the sociology of art (cf. Crane 1987, Moulin 1994; Beckert and Rössel 2004; Becker 1984).

22. Within the scope of the BKR, the Dutch government committed itself from 1949 onwards to buying work of Dutch artists on an annual basis in order to provide them with a minimum income. In 1987 the arrangement was abolished, among other reasons because of the increasing costs of executing the arrangement and the consequent "mountain of artworks" that nobody wanted to buy or exhibit (Muskens 1983; Gubbels 1992).

23. The artist's profession has "feminized" rapidly over the past decades. Consequently, older cohorts of visual artists consist of a larger percentage of male artists than younger cohorts. Since commercial success on the art market is correlated with age, it is likely that the percentage of men selling through the arrangement will decline in the future in favor of women.

24. Some other studies have managed to explain a larger amount of variance. The high explained variance of those studies is not beyond criticism, however. For instance, the major *explanans* of Frey and Pommerehne's study, which accounts for 60 percent of the variance, is past prices of the same artist (Frey and Pommerehne 1989; see Plattner 1996, p. 16). This finding is unsatisfactory because it merely raises the question of how these past prices have been determined. David Galenson regresses prices for a limited number of separate artists, thereby circumventing the question of how the difference in price level between different artists can be explained (Galenson 2000).

CHAPTER 5. THE ART OF PRICING

1. According to neoclassical theory of price, profits are maximized by equating marginal costs and marginal revenue; this presupposes knowledge about the shape of supply and demand curves and the elasticity of demand for a good.

2. For an overview of the subsequent debate, see Etzioni 1988, pp. 168–71. For a positive assessment in economics of the use of interview techniques to study pricing decisions, see Blinder et al. (1998). They note that Hall and Hitch's study "was both the first and the last interview study of pricing to have a major impact on the thinking of economists" (Blinder et al. 1998, p. 40).

3. According to Dorward, for instance, "[s]tudies of actual pricing decisions taken by businessmen have revealed a very complex decision process. Much of the complexity results from the multidimensional nature of pricing decisions. They usually incorporate many variables, of which the number, composition, and relative importance, together with the form of their interrelationships, can vary between different pricing situations within the same company" (Dorward 1987, p. 1).

4. Biggart notes that economists have traditionally assumed that customs and conventions impede efficiency, and therefore need to be "broken"; see Nicole Woolsey Biggart, "Conventional Wisdom: Efficiency and Social Custom," *ECONSOC*, Economic Sociology Electronic Discussion List, 4th guest editorial, 1999.

5. William Grimes, "When Art Puts on a Party Hat: A Guide to Gallery Openings," *The New York Times,* 2.10.1995; given the small size of Dutch galleries, the first, "on-site" imitation process is less important in Amsterdam than in New York. In general I noticed during the interviews that shared knowledge is extensive. Frequently, dealers would give answers like "You must have heard about the story of. . . ." Such stories concerned cases like the artist Sandro Chia, whose work was sold at auction by collector Charles Saatchi; Mark Rothko, whose estate was the subject of a long and intensive legal dispute with the Marl-

borough Gallery, which had represented him; Robert Rauschenberg, who was infuriated by the 1973 auction sale of collector Scull; Julian Schnabel, who came to symbolize the booming art market of the 1980s; or the artist Jean-Michel Basquiat, whose early death symbolizes the dark side of that same decade.

6. If this formula sufficed for a painter working in a "classical" style, it failed for the new "painterly" style that emerged in the seventeenth century; painterly works were often co-produced in a studio that involved collaborators, each with his own specialty (Bok 1998, p. 105). With the help of 17th-century workshop notebooks, pricing decisions of some artists can be reconstructed in detail. The Dutch painter Adriaen van der Werff, for instance, charged a basic rate of 25 guilders a day and computed the basic price of the painting by multiplying this fee by the number of days he spent working on the painting. Subsequently he added the expenses for framing the picture, packing, and transporting it. If Van der Werff's brother assisted him, he charged another 25 guilders per day to the patron for his brother's labor (of those 25 guilders, he only paid five to his brother). Finally, Van der Werff upgraded the price based on his estimate of "what the market would bear" (Bok 1998).

7. For instance, Rembrandt charged 50 guilders for a head-only portrait and up to 500 for a life-size portrait; every individual in a group portrait paid 100 guilders (North 1992, p. 87). Some contemporary portrait artists apply similar pricing rules; in an article on "Pricing and Selling Portraits," published in *American Artist* (April 1990), Pat van Gelder notes that contemporary portrait artists charge an extra 50–75 percent for each additional figure, and 25 percent extra for the addition of an animal (p. 19).

8. This argument is supported by De Marchi and Van Miegroet, who argue that "invention" was only factored into prices from the seventeenth century onwards. Invention stands for the creation of an original work of art, which could subsequently be copied by the same or other artists. Its economic importance was indicated by "a fairly robust price difference between originals and copies that were the work of the same master, and dealers treating originals as a capital asset" (De Marchi and Miegroet 1996, p. 53).

9. Christine Temin, "Dealers and the Art of Pricing," *The Boston Globe,* 4.12.1989; Ann Landi, "Is The Price Right?" *ARTnews,* October 1998, p. 118.

10. Even contracts between French dealers and artists would specify the price per point at which the latter would sell their work (Gee 1981). In Japan, paintings are nowadays likewise priced by the "go," which is a unit of square measure, the size of a postcard (Havens 1982, p. 122). Abbing mentions the use of similar quantity-based rules, which are meant to circumvent the estimation of quality. Books, for instance, are partially priced according to their size (not to the time that the author spent writing the book); extra-long movies command higher prices at the box office, while movies with high production costs do not (Abbing 1989, pp. 168–69). Anthropologist Robert Prus encountered similar notions on "ordinary" retail markets. As one of his informants states: "you'll see where the physical size of the item makes people think that they are getting their money's worth" (Prus 1985, p. 81). A different manifestation of the size script is encountered when contemporary artists decide to swap works, either as a symbol of

mutual respect, or simply because they lack the money to buy artworks on the market; often they regard the market value of the works they exchange as of secondary importance. Disregarding price, they establish equivalents in terms of the size of the works (cf. Warchol 1992, p. 307). The American tax revenue service does treat such gift exchanges as commercial exchanges, however; the value of the works that artists exchange is taxable in the United States as far as it exceeds the material costs of production (Caplin 1989, p. 39).

11. See also Sandra Smallenburg, "Grote veranderingen in Nederlandse galeries," NRC Handelsblad, 9.9.2000.

12. See Carol Vogel, "The Art Market," The New York Times, 11.20.1992; Carol Vogel, "The Art Market," The New York Times, 5.14.1993.

13. Although this explanation was never mentioned during the interviews, another institutional influence may be the government arrangement to stimulate the market, from which my quantitative data were derived. The upper limit of the interest-free loan that can be obtained through this arrangement, 12,500 guilders, may have been absorbed in the mental models of dealers and collectors.

14. See also Nico Klous, "Helft beeldende kunstenaars legt erop toe," BBK Krant, no. 240, February 2000, pp. 12–13. Available data suggest that the present gallery commission is larger than it used to be. For instance, in the New York gallery scene which emerged after World War II, a gallery commission of 33.3 percent was considered standard (Robson 1995, p. 119).

15. For some of the galleries which are located in regular shopping areas of the city, the pricing decision boils down to setting a markup. They operate like "ordinary" consumer stores; since the works they have for sale are bought directly from wholesalers, they do not do direct business with artists. Often, as I was told, these galleries/framing shops simply "double the wholesale price."

CHAPTER 6. STORIES OF PRICES

1. Douglas Davis, "The Billion Dollar Picture?" Art in America, 76 (7), July 1988, p. 21; see also Peter C. T. Elsworth, "All About/Art Sales: The Market's Blue Period," The New York Times, 5.10.1992; Carol Zemel, "What Becomes a Legend Most," Art in America, 76 (7), July 1988, p. 90.

2. Following up on this assessment, some studies have focused on how extensive knowledge about the economy is among laymen (see Williamson and Wearing 1996).

3. Anthropologist Steven Gudeman has advocated studying these models as "local models of livelihood" (Gudeman 1986, 28), while James Carrier has studied different ways in which the nature of the market in general is understood in contemporary everyday discourse (Carrier 1997).

4. Although absent in the discourse of modern, academic economics, the notion of fairness has a long and deep-rooted academic history. In Aristotle's Ethics morality was indispensable when it came to setting prices. "The just price, then, derives from the demands of philia as expressed in the reciprocity which is of the essence of all human community," according to Karl Polanyi's interpreta-

tion of Aristotle (Polanyi 1957, p. 80). Scholastic thought, influential as it was at the end of the Middle Ages, dictated that prices correspond to what the producer needs to maintain himself. If he charged more, it would be tantamount to the sin of covetousness and avarice (Dilley 1992, pp. 4–5; cf. Carrier 1994).

5. Frey argues that by introducing monetary incentives into an economy, intrinsic motivation may be crowded out and replaced by extrinsic motivation (Frey 1997).

6. For instances of this rich, ornate discourse, see also Peter C. T. Elsworth, "All About/Art Sales: The Market's Blue Period," *The New York Times,* 5.10.1992; Carter Ratcliff, "Dealers Talk," *Art in America,* 76 (7), July 1988, p. 79; N. R. Kleinfield, "Bargaining at the Art Galleries: A Personal Odyssey," *The New York Times,* 5.7.1993. For other accounts of the use of evocative language in economic life, see, e.g., Morril 1991 and Burawoy 1979.

7. The procedure which guides to the art market encourage artists to follow in order to set prices is the following: an artist needs to make records of material costs, labor time devoted to a work (including mental labor), and overhead. The price that this procedure results in needs to be marked up in order to make a profit; in doing so, the artist needs to take into account that not all works will be sold. The value of the artist's labor time is extrapolated from jobs the artist has or had in the past (Cochrane 1978, p. 40). See Kessler-Harris 1990 for a comparable treatment of the living wage for women at the beginning of the twentieth century.

8. In Europe, auctions devoted to contemporary art were relatively common in early twentieth-century Paris, by then the center of the art world (see Gee 1981).

9. "People," *Time,* 10.29.73. The transaction and Rauschenberg's perception of it would frequently be referred to in debates over the introduction of resale royalties for artists. Resale royalties entitle artists to a fixed percentage of the price in case their work is sold on the secondary market. In the United States, California is the only state that has introduced resale royalties by law. In Europe, most countries have legal arrangements for resale royalties, although these arrangements are often not executed. In 2001, after fierce protests of the United Kingdom and the Netherlands, the European Commission decided to harmonize these national arrangements within the European Union and introduce them in member states that do not have resale royalties yet (see Velthuis 2000; Filer 1984).

10. Transcript of an interview with Leo Castelli, conducted by Andrew Decker for the Smithsonian Archives of American Art (1997); Anthony Haden-Guest, "The Art of Musical Chairs," *Vanity Fair,* September 1987, p. 64.

11. "People," *Time,* 10.29.73; Haden-Guest 1996, chapter 1; Eleanor Heartney, "Artists vs. the Market," *Art in America,* 76 (7), July 1988, pp. 27–33. Also see Katrine Ames, Maggie Malone, and Donna Foote, "Sold! The Art Auction Boom," *Newsweek,* 4.18.1988, p. 65.

12. The Tremaines had bought the painting in 1959 from Leo Castelli for a price of $900, plus a $15 delivery charge. The 1980 sale was, to the dismay of Castelli, orchestrated by the Pace Gallery. See Grace Glueck, "Painting by Jasper Johns Sold for a Million, a Record," *The New York Times,* 9.27.1980.

13. See Marianne Vermeijden, "Beroemd tussen Groningen en Maastricht," *NRC Handelsblad,* 3.15.1991.

14. See Grace Glueck, "Fresh Talent and New Buyers Brighten the Art World," *The New York Times*, 10.18.1981; Grace Glueck, "What One Artist's Career Tells Us of Today's World," *The New York Times*, 12.2.1984; Cathleen McGuigan, "Julian Schnabel: 'I Always Knew It Would Be Like This,'" *ARTnews*, 81 (6), Summer 1982, pp. 88–94; Jamie James, "Self-Portraits in a Changing Landscape," *ARTnews*, 87 (4), April 1988, pp. 110–13; "There's One Born Every Minute," *The Economist*, 5.27.1989; Eamonn Fingleton, "Portrait of the Artist as a Money Man," *Forbes*, 2.1.1982, pp. 58–62. Allan Schwartzman, "The Twilight of the Art Gods from the 80's," *The New York Times*, 6.4.1995; James Servin, "SoHo Stares at Hard Times," *The New York Times*, 1.20.1991.

15. See interview with Gagosian in Diamonstein 1994; Goldstein 2000; Jeffrey Hogrefe, "Gagosian Pays $5,75 Million for Largest Gallery in Chelsea," *New York Observer*, 8.23.1999; Brook Barnes, "Deals and Dealmakers: Tax Inquiry Places a Spotlight on Art Dealing, 'Go-Go' Dealer—Beginning as a Messenger, Gagosian Now Handles Multimillion-Dollar Works," *The Wall Street Journal*, 4.7.2003.

16. Servin, "SoHo Stares at Hard Times," *The New York Times*, 1.20.1991. An example that was frequently cited in the media was a work by Eric Fischl that had sold for $1.4 million at the height of the market and was resold after the collapse for $167,500.

17. Even superstar dealer of the 1980s Mary Boone remarked in the early 1990s that "[v]alue in everything is being questioned. The psychology in the 80's was excess; in the 90's, it's about conservation; it's about determining the value of everything." Nevertheless, when she and artists in her stable like Eric Fischl and David Salle were making a "comeback" in the late 1990s, this was interpreted as a sign that the art market would become overheated again. Peter C. T. Elsworth, "All about Art Sales: The Market's Blue Period," *The New York Times*, 5.10.1992; Nancy Hass, "Stirring Up the Art World Again," *The New York Times*, 3.5.2000.

18. Artists' guides and magazines for artists encourage them to set prices not only on the basis of a living wage, but also on the basis of their own aesthetic appraisal of their work. See Calvin J. Goodman, "How to Price Your Artworks: Some Introductory Guidelines," *American Artist*, June 1991, pp. 73–78.

19. One of the researchers responsible for the evaluation, G. Muskens, notes that these high prices may have had a stabilizing effect on the market, since they provided a living wage to artists; this allowed them to sell for lower prices on the free market (Muskens 1983, p. 90). The national government (Department of Social Affairs and Employment) spent €35 million on the arrangement in 1983. In the year to follow, this amount increased. Also, the municipal rather than the national government came to distribute the subsidy.

20. One dealer I interviewed was less self-assured about her prudent pricing practice, and wondered if her "conservative and democratic attitude" towards pricing simply meant that she was not ambitious enough (US7). In terms of marketing theory, the prudent pricing strategy resembles, but is not identical with, "market penetration" (Diamantopoulus and Mathews 1995, p. 102).

21. In a questionnaire of a Dutch artists association (Bond Beeldende Kunstenaars), 44% of the artists (n = 187) said that they concluded exhibitions at a loss; Nico Klous, "Helft beeldende kunstenaars legt erop toe," *BBK Krant*, no. 240, February 2000, pp. 12–13.

22. Judith H. Dobrzynski, "A Lull in Art Sales? Well, Not Anymore: New Collectors Are Changing the Market," *The New York Times*, 9.7.1999.

CHAPTER 7. SYMBOLIC MEANINGS OF PRICES

1. Moulin 1967 [1987], Plattner 1996, Klein 1994; for artist's guides to the market, see, e.g., Chamberlain 1983, p. 81; Katchen 1978, p. 80.

2. John Brooks, "Why Fight It? Profiles: Sidney Janis," *The New Yorker*, 11.12.1960.

3. See, e.g., Becker 1984; Zolberg 1990; Wolff 1983; Beckert and Rössel 2004.

4. Art dealer Andre Emmerich says that he never determines a price without examining the works in their own space: "Changing the context allows you to evaluate the quality, the scale, the beauty, the strengths." See Ann Landi, "Is the Price Right?" *ARTnews*, October 1998, p. 118.

5. Bourdieu 1993; Moulin argues that critics and museum curators, who stand at the junction of the aesthetic and the economic "universe," confer reputations of artists and thus influence the prices of their work at one and the same time. Of these two, the influence of the curator has become more prominent at the expense of the role of the critic (Moulin 1994, p. 10; Moulin 1992, p. 64).

6. Another phenomenon that, according to dealers, affects the collector's appraisal is a work that appears on the market, but fails to sell. The work is called "burned" in the dealer's jargon; this supposedly affects the collector's perception in a negative way.

7. Espeland and Stevens 1998, p. 316. R. Gollin and B. Witman, "Jung und Modern, das haben wir gern!," *de Volkskrant*, 11.4.1998.

8. In 1999, the Courtauld Galleries in London exhibited artworks in pairs which were made by the same artist, depicted a similar scene, or were comparable in some other respect. Visitors were requested to estimate which of the two was more valuable. After making their estimate, they could check the actual economic value, which was printed behind a shutter. Sarah Hyde, the curator of the exhibition, said that her purpose was "to investigate the ways in which our responses to works of art are affected by our expectations about their value." See Carol Vogel, "Inside Art: So, How Much for the Degas?" *The New York Times*, 7.9.1999.

9. This applies not only to actors in the field, but also to its academic observers. Marxist art historian Hauser, for instance, argued that the art trade "has a disastrous effect on production by the systematic whittling down of prices" (Hauser 1951, p 469). To illustrate his argument he quotes prices of works by, among others, the Dutch seventeenth-century painters Jan Steen and Jan van Goyen, which strike him as unjustifiably low; however, he categorically ignores the quantities which these artists sold of their work.

10. This property of art markets has been recognized in previous research on art markets. Plattner argued that "[i]n the absence of a well-defined set of rules for judging quality, price and how widely the work is distributed are taken as a signal of excellence" (Plattner 1996, p. 15). In her study of the French art market, Moulin noted similarly that "[g]iven the confusion of values that currently

prevails in the world of art, confused buyers who admit their incompetence to make up their minds see high prices as a guarantee of aesthetic quality" (Moulin 1967 [1987], p. 157).

11. Towse found likewise that a singer struggling to get employed at the bottom end of the market will indicate, by lowering his fees, that he has trouble being hired; as a result, potential demand will be put off rather than attracted (Towse 1992, pp. 213–14).

12. This strategy of "underpricing" has been discussed frequently in economic literature, in particular with respect to the pricing of equity at Initial Public Offerings (IPO's). Because of a company's underpricing strategy, investors can make an excess return by buying equity at an IPO and selling it as soon as the equity appears on the open market. One explanation for this excess return is that buyers need to be enticed with a lower price to buy the stock, since they are uncertain about its value (see, e.g., Levis 1990, p. 87); an alternative explanation is that companies are risk-averse, and therefore set the price low enough for investors to get interested. Nevertheless, what makes this situation different is that price decreases on stock markets are much more frequent and not as problematic as they are on the art market.

13. This signaling effect is not confined to uninformed parties who lack other sources of information to estimate the quality of goods. Michael Spence, who was one of the first economists to recognize the relevance of signaling in markets, argued that sellers correlate the quality of goods within a product line with the price on the basis of experience. As a result, price changes send quality signals to informed, frequent buyers of those goods (Spence 1974). For similar ideas in marketing studies, see, e.g., Dorward 1987 or Diamantopoulus and Mathews 1995.

14. Criticizing neoclassical economics, Austrian economists have paid attention to this interpretive dimension. My perspective differs from theirs, however, since meanings of prices are restricted to economic meanings within the Austrian approach (see Velthuis 2004).

15. John Brooks, 'Why Fight It? Profiles: Sidney Janis," *The New Yorker,* 11.12.1960; "A Portrait of Sidney Janis on the Occasion of His 25th Anniversary as an Art Dealer," *Arts Magazine,* November 1973; Rudie Kagie, "Interview met Frits Becht," *Vrij Nederland,* 49, 6.4.1988.

16. Optimistic as they are, artists' guides to the market therefore advise artists to choose galleries that offer "pricing *breadth,*" and to "think democratically in terms of the audience" when pricing work (Michels 1992, p. 128; cf. Grant 1991, p. 18).

17. In her research on the art market of the 1980s, Krystyna Warchol noted likewise that art students see prices as a status symbol: "High prices are read as messages sent by the student to the community which say—as one student put it—'I am pretty damned good, I am better than you are' " (Warchol 1992, p. 324).

18. See Richard B. Woodward, "Racing for Dollars, Photography Pulls Abreast of Painting," *The New York Times,* 3.25.2001; Alain Quemin, *Le Rôle des Pays Prescripteurs sur le Marché et dans le Monde de l'Art Contemporain,* report commissioned by the Ministry of Foreign Affairs, June 2000.

19. The late New York art dealer Leo Castelli argued that an important side-effect of high market prices is that they draw the attention of potential collectors

and get them involved with art: "Now the news about high prices has captured [the public's] attention. This has its unfavorable side, of course. Yet some who became interested in a superficial way have gotten truly involved with art"; Carter Ratcliff, "Dealers Talk," *Art in America*, 76 (7), July 1988, pp. 78–79.

20. For an overview of controversial acquisitions in the Netherlands, see Sven Lütticken, "Prijs en waarde. De moderne kunst onder vuur," *De Witte Raaf*, 78, March–April 1999, pp. 23–25; a famous historical instance of such a negative symbolic value of a price is the legal case involving John Ruskin and James Whistler in the late 19th century. In 1877, art critic and artist Ruskin wrote the following about Whistler's canvas *Nocturne in Black and Gold: The Falling Rocket:* "I have seen, and heard, much of cockney impudence before now; but never expected to hear a coxcomb ask two hundred guineas for flinging a pot of paint in the public's face." Whistler sued Ruskin for this remark and won, but since the damages he was granted were negligible and the costs of the trial were high, he eventually had to file for bankruptcy (see Erftemeijer 2000, p. 323).

21. These claims are illustrated by the contemporary artist Eric Fischl, who remarked that "[e]very price is too little." To a journalist of the American magazine *ARTnews* he said: "If you pay $5,000,000 for one of my paintings, it's not enough. (. . .) Artists make something they love, then they sell it to somebody else, who supposedly loves it. One person gets the love object, and the other one, the artist, gets a neutral exchange commodity, which he can use to buy things. But it's very hard to find something that you love as much as your work. That's why artists always feel like they're working at a deficit." Jamie James, "Selfportraits in a Changing Landscape," *ARTnews*, 87 (4), April 1988, pp. 110–13.

22. Steenbergen shows that these collectors actively need to restrain themselves by setting annual budgets, by predetermining a ratio of their income that can be devoted to art, or by allowing themselves to buy only a certain number of works per year (Steenbergen 2002, chapter 3). The upshot is that their passion can only be dealt with by actively regulating it with the help of mental accounting schemes.

23. Annemarie Sour, "Beleggen in kunst," *Safe: Beleggingsblad van Robeco*, 1999 pp. 49–54.

24. When art dealer Leo Castelli donated Robert Rauschenberg's iconic work *Bed*, with an estimated value of several million dollars, to the New York Museum of Modern Art, his ex-wife Ileana Sonnabend commented on the transaction in a similar vein: "I thought it was crazy. It certainly would not have been my choice (. . .). You know, I am not so enchanted with museums. Things change in museums, directors change. I would much rather sell to collectors, who appreciate what they've got." Calvin Tomkins, "An Eye for the New," *The New Yorker*, 1.17.2000, pp. 54–64.

25. For an analysis of the economic implications of rankings based on income level, for instance in academic settings, see Frank 1985.

26. Lilly Wei, "Making Art, Making Money: Artists Comments," *Art in America*, July 1990, p. 178.

27. Daniel Akst, "Let 70,000 Canvases Bloom in the Art World," *The New York Times* 1.7.2001; *The Art Newspaper*, no. 99, January 2000, p. 73; *The Art Newspaper*, no. 100, February 2000, p. 3.

CHAPTER 8. CONCLUSION

1. The work of the Italian artist Lucio Fontana fits the description of the painting.

2. "Critics and the Marketplace," *Art in America*, 76 (7), July 1988, p. 109.

3. Economic sociologist Frank Dobbin has argued, for instance, that recently, "choice within constraints" neoclassical economic theory is on its way to incorporating institutional aspects and even informal institutions like culture and norms. Dobbin remarks about this closure of the gap between economics and sociology: "If you expand the definition of institutions to include culture and norms, and you subscribe to a path-dependent view of institutions, you end up with a micro theory that is not compatible with the micro-economic view. You end up with a theory that is based in cognitive science, constructionist sociology or symbolic anthropology." Frank Dobbin, "How Institutional Economics Is Killing Micro-Economics," *ECONSOC*, Economic Sociology Electronic Discussion List, 5th guest editorial, 2001; earlier presented at a panel session on "The New Institutionalism," Annual Conference of the American Sociological Association, Washington, August 2000.

4. See, e.g., Dilley 1992; Davis 1992; Muldrew 1993; Thomas 1991; Geertz 1979.

APPENDIX B

1. Jeffrey Hogrefe, "Art Diary," *New York Observer*, 8.23.1999.

APPENDIX C

1. Stephanie Strom, "Art Bought during Boom Leaves Japan after Bust," *The New York Times*, 08.19.1999; Carol Vogel, "Inside Art: Museum Says No on Pollock," *The New York Times*, 11.28.03.

APPENDIX D

1. Many applications of multilevel models can be found in educational research, where pupils are nested within classes and within schools. The program used for the estimation of the model in chapter 4 is MLWIN (Multilevel for Windows).

2. Likewise, differences between galleries can explain observed relations at the level of works and artists. Since these differences are modeled in a similar way to the relation between works of art and artists, this relation is not depicted graphically. In a two-dimensional space, this picture would look identical to figures D1–3, with different labels on the axes. A "complete" graphical representation of the three levels (works of art, artists, and galleries) would be three-dimensional.

3. My data differ from the model depicted here in the sense that artists are not uniquely nested within galleries. Dutch artists are—on average—represented by 1.44 galleries. To check whether this violation of the assumptions influenced the results, I estimated the same model with a selection of the data in which artists were represented by only one gallery. This analysis gave similar results, and is therefore left aside.

Bibliography

Abbing, Hans. 1989. *Een economie van de kunsten: Beschouwingen over kunst en kunstbeleid.* Groningen: Historische Uitgeverij.
———. 1996. "The Artistic Conscience and the Production of Value." In *The Value of Culture: On the Relationship between Economics and Arts,* edited by Arjo Klamer, 138–48. Amsterdam: Amsterdam University Press.
———. 1998. "De symbiotische verhouding tussen overheid en beeldende-kunstmarkt." In *Visies op beleid en markt,* edited by Truus Gubbels and Gerben Voolstra, 25–39. Amsterdam: Boekmanstudies/Mondriaan Stichting.
———. 2002. *Why Are Artists Poor?* Amsterdam: Amsterdam University Press.
Abolafia, Mitchel Y. 1996. Making Markets: Opportunism and Restraint on Wall Street. Cambridge: Harvard University Press.
———. 1998. "Markets as Cultures: An Ethnographic Approach." In *The Laws of the Markets,* edited by Michel Callon, 69–85. Oxford: Blackwell Publishers.
Adler, Moshe. 1985. "Stardom and Talent." *American Economic Review* 75, no. 1: 208–12.
Adorno, Theodor W., and Max Horkheimer. 1944 [1972]. *Dialectics of Enlightenment.* New York: Seabury Press.
Agnello, Richard J., and Renée K. Pierce. 1996. "Financial Returns, Price Determinants, and Genre Effects in American Art Investment." *Journal of Cultural Economics* 20: 359–83.
Agnew, Jean-Christophe. 1986. *Worlds Apart: The Market and the Theater in Anglo-American Thought, 1550–1750.* Cambridge: Cambridge University Press.
Akerlof, George A. 1982. "Labor Contracts as Partial Gift Exchange." *Quarterly Journal of Economics* 97, no. 4: 543–69.
Alexander, Jennifer, and Paul Alexander. 1987. "Striking a Bargain in Javanese Markets." *Man* 22, no. 1: 42–68.
———. 1991. "What's a Fair Price? Price-Setting and Trading Partnerships in Javanese Markets." *Man* 26, no. 3: 493–512.
Alexander, Paul. 1992. "What's in a Price? Trading Practices in Peasant (and Other) Markets." In *Contesting Markets: Analyses of Ideology, Discourse and Practice,* edited by Roy Dilley, 79–96. Edinburgh: Edinburgh University Press.
Alper, Neil O., Gregory H. Wassall, Joan Jeffri, Robert Greenblatt, Ann O. Kay, Stephyn G. W. Butcher, and Harry Hillman Chartrand. 1996. *Artists in the Workforce: Employment and Earnings, 1970–1990.* NEA Research Report #37. Santa Ana, CA: Seven Locks Press.
Amariglio, Jack, and David F. Ruccio. 1999. "The Transgressive Knowledge of 'Ersatz' Economics." In *What Do Economists Know?,* edited by Robert F. Garnett, 19–36. London: Routledge.
Anderson, Elizabeth. 1993. *Value in Ethics and Economics.* Cambridge: Harvard University Press.

Anderson, Robert C. 1974. "Paintings as an Investment." *Economic Inquiry* 12, no. 1: 13–26.

Appadurai, Arjun. 1986. "Introduction: Commodities and the Politics of Value." In *The Social Life of Things: Commodities in Cultural Perspective*, edited by Arjun Appadurai, 3–63. Cambridge: Cambridge University Press.

Arber, Sara. 1993. "Designing Samples." In *Researching Social Life*, edited by Nigel Gilbert, 68–92. London: Sage.

Armstrong, Richard, Richard Marshall, and Lisa Philips. 1989. *Catalogue 1989 Biennial Exhibition: Whitney Museum of American Art*. New York: W.W. Norton.

Ashenfelter, Orley. 1989. "How Auctions Work for Wine and Art." *Journal of Economic Perspectives* 3, no. 3: 23–36.

Aspers, Patrik. 2001. *Markets in Fashion: A Phenomenological Approach*. Stockholm: City University Press.

Baaijens, J., J. H. Andriessen, and L. Kik. 1983. *BKR-onderzoek: uitvoering BKR*. Vol. 1: *Tekst*. Tilburg: IVA.

Baker, Wayne E. 1984. "The Social Structure of a National Securities Market." *American Journal of Sociology* 89, no. 4: 775–811.

Baudrillard, Jean. 1981. *For a Critique of the Political Economy of the Sign*. Translated by Charles Levin. Telos Press.

Baxandall, Michael. 1972 [1988]. *Painting and Experience in Fifteenth-Century Italy*. Oxford: Oxford University Press.

Becker, Gary S. 1976. *The Economic Approach to Human Behavior*. Chicago: University of Chicago Press.

———. 1991. "A Note on Restaurant Pricing and Other Examples of Social Influences on Price." *Journal of Political Economy* 99, no. 5: 1109–16.

Becker, Howard S. 1984. *Art Worlds*. Berkeley: University of California Press.

Beckert, Jens, and Jörg Rössel. 2004. "Kunst und Preise: Reputation als Mechanismus der Reduktion von Ungewissheit am Kunstmarkt." *Köllner Zeitschrift für Soziologie und Sozialpsychologie* 56, no. 1: 32–50.

Bell, Daniel. 1976 [1999]. *The Coming of Post-Industrial Society: A Venture in Social Forecasting*. New York: Basic Books.

Berger, Peter, and Thomas Luckmann. 1966 [1991]. *The Social Construction of Reality: A Treatise in the Sociology of Knowledge*. London: Penguin Books.

Bewley, Thomas F. 1999. *Why Wages Don't Fall during a Recession*. Cambridge: Harvard University Press.

Biggart, Nicole Woolsey. 1989. *Charismatic Capitalism: Direct Selling Organizations in America*. Chicago: University of Chicago Press.

Biggart, Nicole Woolsey, and Mauro F. Guillén. 1999. "Developing Difference: Social Organization and the Rise of the Auto Industries of South Korea, Taiwan, Spain, and Argentina." *American Sociological Review* 64: 722–47.

Blinder, Alan S. 1991. "Why Are Prices Sticky? Preliminary Results from an Interview Study." *American Economic Review* 81, no. 2: 89–96.

Blinder, Alan S., Elie R. D. Canetti, David E. Lebow, and Jeremy B. Rudd. 1998. *Asking about Prices: A New Approach to Understanding Price Stickiness*. New York: Russell Sage Foundation.

Boje, David. M. 1991. "The Storytelling Organization: A Study of Story Performance in an Office-Supply Firm." *Administrative Science Quarterly* 36: 102–26.

Bok, Marten Jan. 1998. "Pricing the Unpriced: How Dutch Seventeenth-Century Painters Determined the Selling Price of Their Work." In *Art Markets in Europe, 1400–1800,* edited by Michael North and David Ormrod, 103–11. Aldershot: Ashgate.

Boltanski, Luc, and Laurent Thévenot. 1999. "The Sociology of Critical Capacity." *European Journal of Social Theory* 2, no. 3: 359–77.

Bonus, Holger, and Dieter Ronte. 1997. "Credibility and Economic Value in the Visual Arts." *Journal of Cultural Economics* 21: 103–18.

Bourdieu, Pierre. 1979. "The Kabyle House or the World Reversed." In *Algeria 1960,* 133–53. Cambridge: Cambridge University Press.

———. 1983. "The Forms of Capital." In *The Handbook of Theory and Research for the Sociology of Education,* edited by J. G. Richardson, 241–58. New York: Greenwood.

———. 1992 [1996]. *The Rules of Art.* Standford: Stanford University Press.

———. 1993. *The Field of Cultural Production: Essays on Art and Literature.* Cambridge: Polity Press.

Bourdieu, Pierre, and Loïc J. D. Wacquant. 1992. *Argumenten: Voor een reflexieve maatschappijwetenschap.* Amsterdam: Sua.

Bowness, Alan. 1990. *The Conditions of Success: How the Modern Artist Rises to Fame.* London: Thames and Hudson.

Briesch, Richard A., Lakshman Krishnamurti, Tribid Mazumdar, and S. P. Raj. 1997. "A Comparative Analysis of Reference Price Models." *Journal of Consumer Research* 24: 202–14.

Brouwer, Natasja, and Heidi Meulenbeek. 2000. "De markt voor beeldende kunst: de markt en de financiële positie van de beeldende kunstenaars 1998." The Hague: Ministerie van Onderwijs, Cultuur en Wetenschappen.

Brown, Marily R. 1993. "An Entrepreneur in Spite of Himself: Edgar Degas and the Market." In *The Culture of the Market: Historical Essays,* edited by T. L. Haskell and R. F. Teichgraeber, 261–92. Cambridge: Cambridge University Press.

Burawoy, Michael. 1979. *Manufacturing Consent: Changes in the Labor Process under Monopoly Capitalism.* Chicago: University of Chicago Press.

Bürger, Peter. 1974 [1996]. *Theory of the Avant-Garde.* Translated by M. Shaw. Minneapolis: University of Minnesota Press.

Burn, Ian. 1975 [1996]. "The Art Market: Affluence and Degradation." In *Art in Theory 1900–1990: An Anthology of Changing Ideas,* edited by Charles Harrison and Paul Wood, 908–11. Oxford: Blackwell.

Bystryn, Marcia. 1978. "Art Galleries as Gatekeepers: The Case of the Abstract Expressionists." *Social Research* 45, no. 2: 390–408.

Calhoun, Craig, Edward LiPuma, and Moishe Postone, eds. 1993. *Bourdieu: Critical Perspectives.* Cambridge: Polity Press.

Callon, Michel. 1998. "Introduction: The Embeddedness of Economic Markets in Economics." In *The Laws of the Markets,* edited by Michel Callon, 1–58. Oxford: Blackwell.

Candela, Guido, and Antonello E. Scorcu. 2001. "In Search of Stylized Facts on Art Market Prices: Evidence from the Secondary Market for Prints and Drawings in Italy." *Journal of Cultural Economics* 25: 219–31.

Caplin, Lee. 1989. *The Business of Art.* 2nd ed. Englewood Cliffs: Prentice-Hall.

Carrier, James G. 1994. "Alienating Objects: The Emergence of Alienation in Retail Trade." *Man* 29, no. 2: 359–80.

———. *Gifts and Commodities.* 1995. London: Routledge.

———, ed. 1997. *Meanings of the Market: The Free Market in Western Culture.* Oxford: Berg.

Case, Bradford, Henry O. Pollakowski, and Susan M. Wachter. 1997. "Frequency of Transaction and House Price Modelling." *The Journal of Real Estate Finance and Economics* 14, no. 1/2: 173–87.

Castells, Manuel. 1996. *The Information Age: Economy, Society and Culture.* Vol. 1: *The Network Society.* Malden: Blackwell.

Caves, Richard. 2000. *The Creative Industries.* Harvard: Harvard University Press.

Chamberlain, Betty. 1983. *The Artist's Guide to the Art Market.* 4th ed. New York: Watson Guptill.

Cheal, David. 1988. *The Gift Economy.* London: Routledge.

Cochrane, Diane. 1978. *This Business of Art.* New York: Watson-Guptill.

Collins, Randall. 2000. "Situational Stratification: A Micro-Macro Theory of Inequality." *Sociological Theory* 18, no. 1: 17–43.

Coppet, Laura de, and Alan Jones. 2002. *The Art Dealers: The Powers behind the Scene Tell Me How the Art World Really Works.* 2nd ed. New York: Cooper Square Press.

Crane, Diana. 1976. "Reward Systems in Art, Science, and Religion." *American Behavioral Scientist* 19, no. 6: 719–34.

———. 1987. *The Transformation of the Avant-Garde.* Chicago: University of Chicago Press.

Cyert, Richard M., and James G. March. 1963. *A Behavioral Theory of the Firm.* Englewood Cliffs: Prentice-Hall.

Darr, Asaf. 2003. "Gifting Practices and Interorganizational Relations: Constructing Obligation Networks in the Electronics Sector." *Sociological Forum* 18, no. 1: 31–51.

Davis, John. 1992. *Exchange.* Minneapolis: University of Minnesota Press.

De Marchi, Neil. 1999. "Introduction." In *Economic Engagements with Art: History of Political Economy.* Annual supplement to volume 31, edited by Neil De Marchi and Craufurd D. W. Goodwin, 1–30. Durham: Duke University Press.

De Marchi, Neil, and Hans J. Van Miegroet. 1994. "Art, Value, and Market Practices in the Netherlands in the Seventeenth Century." *Art Bulletin* 76, no. 3: 451–64.

———. 1996. "Pricing Invention: 'Originals,' 'Copies,' and Their Relative Value in Seventeenth Century Netherlandish Art Markets." In *Economics of the Arts. Selected Essays,* edited by Victor A. Ginsburgh and P. M. Menger, 27–70. Amsterdam: Elsevier.

———. 1999. "Ingenuity, Preference, and the Pricing of Pictures: The Smith Reynolds Connection." In *Economic Engagements with Art: History of Politi-*

cal Economy. Annual supplement to volume 31, edited by Neil De Marchi and Craufurd D. W. Goodwin, 379–412. Durham: Duke University Press.

Dean, Joel. 1969. "Pricing Pioneering Products." *Journal of Industrial Economics* 17, no. 3: 165–79.

Diamantopoulos, Adamantios, and Brian Mathews. 1995. *Making Pricing Decisions: A Study of Managerial Practice.* London: Chapman & Hall.

Diamonstein, Barbaralee. 1994. *Inside the Art World.* New York: Rizzoli.

Dickie, Mark, Charles D. Delorme, and Jeffrey D. Humphreys. 1994. "Price Determination for a Collectible Good: The Case of Rare U.S. Coins." *Southern Economic Journal* 61: 40–51.

Dilley, Roy. 1992. "Contesting Markets: A General Introduction to Market Ideology, Imagery and Discourse." In *Contesting Markets: Analyses of Ideology, Discourse and Practice,* edited by Roy Dilley, 1–34. Edinburgh: Edinburgh University Press.

DiMaggio, Paul. 1994. "Economy and Culture." In *Handbook of Economic Sociology,* edited by Neil J. Smelser and Richard Swedberg, 27–57. Princeton: Princeton University Press.

————. 1997. "Culture and Cognition." *Annual Review of Sociology* 23: 263–87.

DiMaggio, Paul, and Hugh Louch. 1998. "Socially Embedded Consumer Transactions: For What Kinds of Purchases Do People Most Often Use Networks?" *American Sociological Review* 63, no. 5: 619–37.

DiMaggio, Paul, and Walter W. Powell. 1983. "The Iron Cage Revisited: Institutional Isomorphism and Collective Rationality in Organizational Fields." *American Sociological Review* 48: 147–60.

————. 1991. "Introduction." In *The New Institutionalism in Organizational Analysis,* edited by Paul J. DiMaggio and Walter W. Powell, 1–39. Chicago: University of Chicago Press.

Dobbin, Frank R. 1994. "Cultural Models of Organization: The Social Construction of Rational Organizing Principles." In *The Sociology of Culture,* edited by Diana Crane, 117–41. Cambridge: Blackwell.

Dorward, Neil. 1987. *The Pricing Decision: Economic Theory and Business Practice.* London: Harper & Row.

Dosi, Giovanni, and Massimo Egidi. 1991. "Substantive and Procedural Uncertainty." *Journal of Evolutionary Economics* 1, no. 2: 145–68.

Douglas, Mary, and Baron Isherwood. 1979. *The World of Goods.* New York: Basic Books.

Downward, Paul. 1999. *Pricing Theory in Post Keynesian Economics: A Realist Approach.* Cheltenham: Edward Elgar.

Duneier, Mitchell. 1999. *Sidewalk.* New York: Farrar, Straus & Giroux.

Durkheim, Emile. 1914 [1964]. "The Dualism of Human Nature and Its Social Conditions." In *Emile Durkheim: Essays on Sociology and Philosophy,* edited by Kurt H. Wolff, 325–40. New York: Harper & Row.

Duve, Thierry de. 1989. "Yves Klein, or the Dead Dealer." *October* 49, Summer: 72–90.

Eichner, Alfred S. 1987. "Prices and Pricing." *Journal of Economic Issues* 21, no. 4: 1555–84.

Erftemeijer, Antoon. 2000. *De aap van Rembrandt: Kunstenaarsanekdoten van de klassieke oudheid tot heden*. Haarlem: Becht.

Espeland, Wendy N., and Mitchell L. Stevens. 1998. "Commensuration as a Social Process." *Annual Review of Sociology* 24: 313–43.

Etzioni, Amitai. 1988. *The Moral Dimension: Towards a New Economics*. New York: Free Press.

Fanselow, Frank S. 1990. "The Bazaar Economy or How Bizarre Is the Bazaar Really?" *Man* 25, no. 2: 250–65.

Fase, Martin. 1996. "Purchase of Art: Consumption and Investment." *De Economist* 144, no. 4: 649–69.

Fengler, Matthias R., and Joachim K. Winter. 2001. "Psychological Pricing Points and Price Adjustments in German Retail Markets." Unpublished paper.

Filer, Randall K. 1984. "A Theoretical Analysis of the Economic Impact of Artists' Resale Royalties Legislation." *Journal of Cultural Economics* 8: 1–28.

Fitz Gibbon, Heather M. 1987. "From Prints to Posters: The Production of Artistic Value in a Popular World." *Symbolic Interaction* 10, no. 1: 111–28.

Fitzgerald, Michael C. 1995. *Making Modernism: Picasso and the Creation of the Market for Twentieth-Century Art*. New York: Farrar, Straus and Giroux.

Fligstein, Neil. 1996. "Markets as Politics: A Political-Cultural Approach to the Market Institutions." *American Sociological Review* 61: 656–73.

Foster, Hal. 1996. *The Return of the Real: The Avant-Garde at the End of the Century*. Cambridge, MA: MIT Press.

Frank, Robert H. 1985. *Choosing the Right Pond: Human Behavior and the Quest for Status*. Oxford: Oxford University Press.

———. 1988. *Passions within Reason: The Strategic Role of the Emotions*. New York: W. W. Norton & Company.

Frank, Robert H., and Philip J. Cook. 1995. *The Winner-Take-All Society*. New York: Free Press.

Frey, Bruno S. 1986. "Economists Favour the Price System—Who Else Does?" *Kyklos* 39: 537–63.

———. 1997. *Not Just for the Money: An Economic Theory of Personal Motivation*. Cheltenham: Edward Elgar.

———. 2000. *Art and Economics*. Heidelberg: Springer Verlag.

Frey, Bruno S., and Reiner Eichenberger. 1995. "On the Return of Art Investment Return Analyses." *Journal of Cultural Economics* 19: 207–20.

Frey, Bruno S., and Werner W. Pommerehne. 1989. *Muses and Markets: Explorations in the Economics of the Arts*. Oxford: Blackwell.

Fridén, Bertil. 1999. "The Problem of Unique Goods as Factors of Production: Rousseau on Art and the Economy." In *Economic Engagements with Art: History of Political Economy*. Annual supplement to volume 31, edited by Neil De Marchi and Craufurd D. W. Goodwin, 41–56. Durham: Duke University Press.

Friedland, Roger, and Robert R. Alford. 1991. "Bringing Society Back In: Symbols, Practices, and Institutional Contradictions." In *The New Institutionalism in Organizational Analysis*, edited by Paul J. DiMaggio and Walter W. Powell, 232–63. Chicago: University of Chicago Press.

Friedman, Milton. 1953 [1984]. "The Methodology of Positive Economics." In *Appraisal and Criticism in Economics: A Book of Readings,* edited by B. J. Caldwell, 3–43. Boston: Allen and Unwin.

———. 1962. *Price Theory.* Chicago: Aldine.

———. 1962 [1982]. *Capitalism and Freedom.* Chicago: University of Chicago Press.

Fukuyama, Francis. 1995. *Trust: The Social Virtues and the Creation of Prosperity.* London: Hamish Hamilton.

Galenson, David W. 1999. "Quantifying Artistic Success: Ranking French Painters—and Paintings—from Impressionism to Cubism." Cambridge: NBER.

———. 2000. "The Careers of Modern Artists." *Journal of Cultural Economics* 24: 87–112.

Gay, Paul du, and Michael Pryke, eds. 2002. *Cultural Economy. Cultural Analysis and Cultural Life.* London: Sage.

Gee, Malcolm. 1981. *Dealers, Critics, and Collectors of Modern Painting: Aspects of the Parisian Art Market between 1910 and 1930.* New York: Garland Publishing.

Geertz, Clifford. 1973 [1993]. *The Intrepretation of Cultures.* London: Fontana Press.

———. 1979. "Suq: The Bazaar Economy in Sefrou." In *Meaning and Order in Moroccan Society,* edited by Clifford Geertz, Hildred Geertz, and Lawrence Rosen, 123–225. Cambridge: Cambridge University Press.

Giuffre, Katherine. 1999. "Sandpiles of Opportunity: Success in the Art World." *Social Forces* 77, no. 3: 815–32.

Goffman, Erving. 1956 [1990]. *The Presentation of Self in Everyday Life.* London: Penguin Books.

Goldstein, Malcolm. 2000. *Landscape with Figures: A History of Art Dealing in the United States.* Oxford: Oxford University Press.

Graeber, David. 2001. *Toward an Anthropological Theory of Value: The False Coin of Our Own Dreams.* New York: Palgrave MacMillan.

Grampp, William D. 1989. *Pricing the Priceless: Art, Artists and Economics.* New York: Basic Books.

Grana, Cesar. 1964. *Bohemian Versus Bourgeois: French Society and the French Man of Letters in the Nineteenth Century.* New York: Basic Books.

Granovetter, Mark. 1985 [1992]. "Economic Action and Social Structure: The Problem of Embeddedness." In *The Sociology of Economic Life,* edited by Mark Granovetter and Richard Swedberg, 53–81. Boulder, CO: Westview Press.

Grant, Daniel. 1991. *The Business of Being an Artist.* New York: Allworth Press.

Green, Nicholas. 1987. "Dealing in Temperaments: Economic Transformation of the Artistic Field in France During the Second Half of the Nineteenth Century." *Art History* 10, no. 1: 59–78.

Greenfeld, Liah. 1989. *Different Worlds: A Sociological Study of Taste, Choice and Success in Art.* Cambridge: Cambridge University Press.

Gubbels, Truus. 1992. "Kwaliteit op krediet: De Rentesubsidieregeling Kunstaankopen 1984–1990." Amsterdam: Boekmanstichting.

———. 1995. "Korting en krediet voor beeldende kunst." *Boekmancahier* 7, no. 23, 24: 8–22, 193–204.

———. 1999. *Passie of professie: Galeries en kunsthandel in Nederland.* Abcoude: Uniepers.

Gubbels, Truus, and Ingrid Janssen, eds. 2001. *Kunst te koop! Artistieke innovatie en commercie in het Nederlandse galeriebestel.* Amsterdam: Boekmanstudies/Mondriaan Stichting.

Gubbels, Truus, and Gerben Voolstra, eds. 1998. *Visies op beleid en markt.* Amsterdam: Boekmanstudies/Mondriaan Stichting.

Gudeman, Steven. 1986. *Economics as Culture: Models and Metaphors of Livelihood.* London: Routledge & Kegan Paul.

Guilbaut, Serge. 1983. *How New York Stole the Idea of Modern Art: Abstract Expressionism, Freedom, and the Cold War.* Translated by Arthur Goldhammer. Chicago: University of Chicago Press.

Haden-Guest, Anthony. 1996. *True Colors. The Real Life of the Art World.* New York: Atlantic Monthly Press.

Hall, R. L., and C. J. Hitch. 1939. "Price Theory and Business Behaviour." *Oxford Economic Papers* 2, May: 12–45.

Halle, David. 1993. *Inside Culture: Art and Class in the American Home.* Chicago: University of Chicago Press.

Hannerz, Ulf. 1992. *Cultural Complexity: Studies in the Social Organization of Meaning.* New York: Columbia University Press.

Hauser, Arnold. 1951. *The Social History of Art.* Translated by Stanley Godman. 2 vols. London: Routledge & Kegan Paul.

Havens, Thomas R. H. 1982. *Artist and Patron in Postwar Japan.* Princeton: Princeton University Press.

Heath, Timothy B., Subimal Chatterjee, and Karen Russo France. 1995. "Mental Accounting and Changes in Price: The Frame Dependence of Reference Dependence." *Journal of Consumer Research* 22: 90–97.

Heijbroek, Jan Frederik, and Ester Wouthuysen. 1993. *Kunst, kennis en commercie: De kunsthandelaar J. H. de Bois.* Amsterdam: Contact.

Heilbroner, Robert L. 1988. *Behind the Veil of Economics.* New York: Norton.

Heilbrun, James, and Charles M. Gray. 1993. *The Economics of Art and Culture: An American Perspective.* Cambridge: Cambridge University Press.

Heimer, Carol A. 1999. "Competing Institutions: Law, Medicine, and Family in Neonatal Intensive Care." *Law and Society Review* 17: 17–66.

Heiner, Ronald A. 1983. "The Origin of Predictable Behavior." *American Economic Review* 73, no. 4: 560–95.

Herbert, Robert L. 1987. "Impressionism, Originality and Laissez-Faire." *Radical History Review* 38: 7–15.

Hirschman, Albert O. 1982 [1986]. "Rival Views of Market Society." In *Rival Views of Market Society and Other Recent Essays,* 105–41. Cambridge: Harvard University Press.

Hochschild, Arlie. 1983. *The Managed Heart.* Berkeley: University of California Press.

Hodgson, Geoffrey M. 1993. *Economics and Evolution. Bringing Life Back into Economics.* Cambridge: Polity Press.

———. 1998. "The Approach of Institutional Economics." *Journal of Economic Literature* 36, no. 1: 166–92.

Hoogenboom, Annemieke. 1993. *De stand des kunstenaars: de positie van kunsts-childers in Nederland in de eerste helft van de negentiende eeuw.* Leiden: Primavera Pers.

———. 1994. "Art for the Market: Contemporary Painting in the Netherlands in the First Half of the Nineteenth Century." *Simiolus* 22, no. 3: 129–44.

Hughes, Robert. 1990. *Nothing If Not Critical: Selected Essays on Art and Artists.* London: Collins Harvill, 1990.

Huston, John, and Nipoli Kamdar. 1996. "$9,99: Can 'Just-Below' Pricing Be Reconciled with Rationality?" *Eastern Economic Journal* 22, no. 2: 137–45.

Huyssen, Andreas. 1986 [1988]. *After the Great Divide: Modernism, Mass Culture and Postmodernism.* Basingstoke: MacMillan.

Hyde, Lewis. 1983. *The Gift: Imagination and the Erotic Life of Property.* New York: Random House.

Ingram, Paul, and Peter W. Roberts. 2000. "Friendships among Competitors in the Sydney Hotel Industry." *American Journal of Sociology* 106, no. 2: 387–423.

Jabbar, M. A. 1998. "Buyer Preferences for Sheep and Goats in Southern Nigeria: A Hedonic Price Analysis." *Agricultural Economics* 18, no. 1: 21–30.

Jameson, Frederic. 1984. "Postmodernism, or, the Cultural Logic of Late Capitalism." *New Left Review* 146: 59–92.

Jensen, Robert. 1994. *Marketing Modernism in Fin-de-Siècle Europe.* Princeton: Princeton University Press.

Jevons, W. Stanley. 1871 [1970]. *The Theory of Political Economy.* London: Penguin Books.

Kahneman, Daniel, Jack L. Knetsch, and Richard Thaler. 1986. "Fairness as a Constraint on Profit Seeking: Entitlements in the Market." *American Economic Review* 76, no. 4: 728–41.

Katchen, Carole. 1978. *Promoting and Selling Your Art.* New York: Watson Guptill.

Kempers, Bram. 1988. "De Macht Van De Markt." In *Kunst en beleid in Nederland 3,* 13–65. Amsterdam: Boekmanstichting/Van Gennep.

Kessler-Harris, Alice. 1990. *A Woman's Wage. Historical Meanings and Social Consequences.* Lexington: University of Kentucky Press.

Keynes, John Maynard. 1936. *The General Theory of Employment, Interest and Money.* New York: Harvest/Harcourt Brace Jovanovich.

Klamer, Arjo. 1996. "The Value of Culture." In *The Value of Culture,* edited by Arjo Klamer, 13–28. Amsterdam: Amsterdam University Press.

Klamer, Arjo, and Thomas C. Leonard. 1992. "Everyday versus Academic Rhetoric in Economics." Unpublished paper.

Klayman, Toby Judith, and Cobett Steinberg. 1984. *The Artist's Survival Manual. A Complete Guide to Marketing Your Work.* New York: Charles Scribner's Sons.

Klein, Ulrike. 1994. *The Business of Art Unveiled: New York Art Dealers Speak Up.* Frankfurt a. Main: Peter Lang.

Knorr Cetina, Karin, and Urs Bruegger. 2002. "Global Microstructures: The Virtual Societies of Financial Markets." *American Journal of Sociology* 107, no. 4: 905–50.

Koerner, J. L., and L. Koerner. 1996. "Value." In *Critical Terms for Art History,* edited by R. S. Nelson and R. Shiff, 292–306. Chicago: University of Chicago Press.

Koford, Kenneth, and Adrian E. Tschoegl. 1998. "The Market Value of Rarity." *Journal of Economic Behavior and Organization* 34: 445–57.

Kollock, Peter. 1994. "The Emergence of Exchange Structures: An Experimental Study of Uncertainty, Commitment, and Trust." *American Journal of Sociology* 100, no. 2: 313–45.

Komter, Aafke E. (ed.). 1996. *The Gift: An Interdisciplinary Perspective.* Amsterdam: Amsterdam University Press.

Kopytoff, Igor. 1986. "The Cultural Biography of Things: Commoditization as Process." In *The Social Life of Things: Commodities in Cultural Perspective,* edited by Arjun Appadurai, 64–91. Cambridge: Cambridge University Press.

Laermans, Rudi. 1991. "Het relatieve gelijk van Pierre Bourdieu: de legitimiteit van kunst en cultuur binnen de postmoderniteit." *Boekmancahier* 3, no. 8: 153–63.

———. 1993. "Splitting the difference: Over kunst, massacultuur en cultuurbeleid." In *Sociaal-democratie, kunst, politiek. Beschouwingen over een sociaal-democratisch Kunstbeleid,* edited by Hans van Dulken and Paul Kalma, 81–93. Amsterdam: Wiardi Beckmanstichting/Boekmanstichting.

Lamont, Michèle. 1992. *Money, Morals, and Manners: The Culture of the French and the American Upper-Middle Class.* Chicago: University of Chicago Press.

———. 2000. *The Dignity of Working Men.* Harvard: Harvard University Press.

Lamont, Michèle, and Annette Lareau. 1988. "Cultural Capital: Allusions, Gaps and Glissandos in Recent Theoretical Developments." *Sociological Theory* 6, no. 2: 153–68.

Lamont, Michèle, and Virag Molnar. 2002. "The Study of Boundaries across the Social Sciences." *Annual Review of Sociology* 28.

Lane, Robert E. 1991. *The Market Experience.* Cambridge: Cambridge University Press.

Lee, Frederic S. 1999. *Post Keynesian Price Theory.* Cambridge: Cambridge University Press.

Leibenstein, Harvey. 1950. "Bandwagon, Snob, and Veblen Effects in the Theory of Consumers' Demand." *Quarterly Journal of Economics* 64, no. 2: 183–207.

Lerner, Ralph E., and Judith Bresler. 1998. *Art Law.* 2nd ed. 2 vols. New York: Practicing Law Institute.

Levis, Mario. 1990. "The Winner's Curse Problem, Interest Costs and the Underpricing of Initial Public Offerings." *Economic Journal* 100, March: 76–89.

Lie, John. 1997. "Sociology of Markets." *American Review of Sociology* 23: 341–60.

Louargand, Marc A., and J. R. McDaniel. 1991. "Price Efficiency in the Art Auction Market." *Journal of Cultural Economics* 15, no. 2: 53–65.

Macaulay, Stewart. 1962 [1992]. "Non-Contractual Relations in Business: A Preliminary Study." In *The Sociology of Economic Life,* edited by Mark Granovetter and Richard Swedberg, 265–83. Boulder: Westview Press.

Marquis, Alice Goldfarb. 1991. *The Art Biz: The Covert World of Collectors, Dealers, Auction Houses, Museums and Critics.* Chicago: Contemporary Book.

Marshall, Alfred. 1890 [1982]. *Principles of Economics.* London: MacMillan.

Marx, Karl. 1844 [1978]. "Economic and Philosophical Manuscripts of 1844." In *The Marx-Engels Reader,* edited by Robert C. Tucker. New York: W. W. Norton.

McAfee, R. Preston, and John McMillan. 1987. "Auctions and Bidding." *Journal of Economic Literature* 25: 699–738.

McCloskey, Deirdre. 1990. *If You're So Smart: The Narrative of Economic Expertise.* Chicago: University of Chicago Press.

McLellan, Andrew. 1996. "Watteau's Dealer: Gersaint and the Marketing of Art in Eighteenth-Century Paris." *Art Bulletin* 78, no. 3: 439–53.

Meij, Helen van der. 2001. "Wat maakt een galerie succesvol? Vier voorbeelden uit de internationale kunstpraktijk." In *Kunst te koop! Artistieke innovatie en commercie in het Nederlandse galeriebestel,* edited by Truus Gubbels and Ingrid Janssen, 29–35. Amsterdam: Boekmanstudies/Mondriaan Stichting.

Mellon, Susan, and Tad Crawford. 1981. *The Artist-Gallery Partnership: A Practical Guide to Consignment.* New York: ACA Publications.

Merryman, John Henry, and Albert E. Elsen. 1979. *Law, Ethics, and the Visual Arts.* 2 vols. New York: Mathew Bender, 1979.

———. *Law, Ethics, and the Visual Arts.* 1998. 3rd ed. London: Kluwer Law.

Merton, Robert K. 1968. "The Matthew Effect in Science." *Science* 159, no. 3810: 56–63.

Meyer, Jörn-Axel, and Ralf Even. 1998. "Marketing and the Fine Arts—Inventory of a Controversial Relationship." *Journal of Cultural Economics* 22: 271–83.

Michels, Caroll. 1992. *How to Survive and Prosper as an Artist. Selling Yourself without Selling Your Soul.* 3rd ed. New York: Henry Holt.

Milgrom, Paul R. 1985. "The Economics of Competitive Bidding: A Selective Survey." In *Social Goals and Social Organization: Essays in Memory of Elisha Pazner,* edited by Leonid Hurwicz, David Schmeidler, and Hugo Sonnenschein, 261–89. Cambridge: Cambridge University Press.

Miller, Daniel. 1998. *A Theory of Shopping.* Ithaca: Cornell University Press.

———. 2002. "Turning Callon the Right Way Up." *Economy and Society* 31, no. 2: 218–33.

Montias, J. Michael. 1987. "Cost and Value in Seventeenth-Century Dutch Art." *Art History* 10, no. 4: 453–66.

———. 1990. "Socio-Economic Aspects of Netherlandish Art from the Fifteenth to the Seventeenth Century: A Survey." *Art Bulletin* 72, no. 3: 358–73.

Morril, Calvin. 1991. "Conflict Management, Honor, and Organizational Change." *American Journal of Sociology* 97, no. 3: 585–621.

Mossetto, Gianofranco. 1993. *Aesthetics and Economics.* Dordrecht: Kluwer.

Moulin, Raymonde. 1967 [1987]. *The French Art Market. A Sociological View.* New Brunswick: Rutgers University Press.

———. 1992. *L'Artiste, L'institution et le Marché.* Paris: Flammarion.

———. 1994. "The Construction of Art Values." *International Sociology* 9, no. 1: 5–12.

Muldrew, Craig. 1993. "Interpreting the Market: The Ethics of Credit and Community Relations in Early Modern England." *Social History* 18: 163–83.

Murray, Jonathan, and Nicholas Sarantis. 1999. "Quality, User Cost, Forward-Looking Behavior, and the Demand for Cars in the UK." *Journal of Economics and Business* 51, no. 3: 237–58.

Muskens, George. 1983. *BKR-onderzoek: beleidsanalyse BKR I. Beleidsdoel, beleidseffect, beleidscontext.* Vol. 1: *Tekst.* Tilburg: IVA.

Myers, Fred R. 2002. *Painting Culture.* Durham: Duke University Press.

Nerlove, Marc. 1995. "Hedonic Price Functions and the Measurement of Preferences: The Case of Swedish Wine Consumers." *European Economic Review* 39, no. 9: 1697–716.

North, Michael. 1992. *Art and Commerce in the Dutch Golden Age.* Translated by Catherine Hill. New Haven: Yale University Press.

O'Doherty, Brian. 1976 [1999]. *Inside the White Cube: The Ideology of the Gallery Space.* Berkeley: University of California Press.

Okun, Arthur M. 1981. *Prices and Quantities: A Macroeconomic Analysis.* Washington, DC: Brookings Institution.

O'Neill, John. 1998. *The Market.* London: Routledge.

Parsons, Talcott, and Neil J. Smelser. 1956. *Economy and Society: A Study in the Integration of Economic and Social Theory.* Glencoe: Free Press.

Pesando, James E. 1993. "Art as an Investment: The Market for Modern Prints." *American Economic Review* 83, no. 5: 1075–89.

Pesando, James E., and Pauline M. Shum. 1996. "Price Anomalies at Auction: Evidence from the Market for Modern Prints." In *Economics of the Arts. Selected Essays,* edited by Victor A. Ginsburgh and P. M. Menger, 113–34. Amsterdam: Elsevier.

Peterson, Karin. 1997. "The Distribution and Dynamics of Uncertainty in Art Galleries: A Case Study of New Dealership in the Parisian Art Market, 1985–1990." *Poetics* 25, no. 4: 241–63.

Phlips, Louis. 1988. *The Economics of Imperfect Information.* Cambridge: Cambridge University Press.

Plattner, Stuart. 1996. *High Art Down Home: An Economic Ethnography of a Local Art Market.* Chicago: University of Chicago Press.

Podolny, Joel M. 1993. "A Status-Based Model of Market Competition." *American Journal of Sociology* 98, no. 4: 829–72.

Polanyi, Karl. 1944 [1957]. *The Great Transformation.* Boston: Beacon Press.

———. 1957. "Aristotle Discovers the Economy." In *Trade and Market in the Early Empires,* edited by Karl Polanyi, C. M. Arensberg, and H. W. Pearson, 64–94. Glencoe: Free Press.

Polanyi, Michael. 1958 [1974]. *Personal Knowledge: Towards a Post-Critical Philosophy.* Chicago: University of Chicago Press.

Pommerehne, Werner W., and Lars P. Feld. 1997. "The Impact of Museum Purchase on the Auction Prices of Paintings." *Journal of Cultural Economics* 21, no. 3: 249–71.

Portes, Alejandro. 1995. "Economic Sociology and the Sociology of Immigration: A Conceptual Overview." In *The Economic Sociology of Immigration: Essays on Networks, Ethnicity, and Entrepreneurship,* edited by Alejandro Portes, 1–41. New York: Russell Sage Foundation.

———. 1998. "Social Capital: Its Origins and Applications in Modern Sociology." *Annual Review of Sociology* 24: 1–24.

Powell, Walter, and Paul DiMaggio, eds. 1991. *The New Institutionalism in Organizational Analysis.* Chicago: University of Chicago Press.

Prus, Robert C. 1985. "Price-Setting as a Social Activity: Defining Price, Value, and Profit in the Marketplace." *Urban Life* 14, no. 1: 59–93.

———. 1999. *Making Sales: Influence as Interpersonal Accomplishment.* Newbury Park: Sage.

Radin, Margaret Jane. 1996. *Contested Commodities.* Cambridge, MA: Harvard University Press.

Rengers, Merijn. 2000. "Kunstenmonitor 1998." Den Haag: HBO Raad.

Rengers, Merijn, and Christopher Madden. 2000. "Living Art: Artists between Making Art and Making a Living." *Australian Bulletin of Labour* 26, no. 4: 325–54.

Rengers, Merijn, and Erik Plug. 2001. "Private or Public." *Journal of Cultural Economics* 25, no. 1: 1–20.

Rengers, Merijn, and Olav Velthuis. 2002. "Determinants of Prices for Contemporary Art in Dutch Galleries, 1992–1998." *Journal of Cultural Economics* 26: 1–28.

Rewald, John. 1973 [1986]. "Theo Van Gogh as Art Dealer." In *Studies in Post-Impressionism,* 7–115. New York: Harry N. Abrams.

———. 1986. *Studies in Post-Impressionism.* New York: Harry N. Abrams.

Ricardo, David. 1817 [1925]. *Principles of Political Economy and Taxation.* London: G. Bell and Sons.

Rifkin, Jeremy. 2000. *The Age of Access.* London: Penguin.

Riley, John G. 2001. "Silver Signals: Twenty-Five Years of Screening and Signaling." *Journal of Economic Literature* 39, no. 2: 432–78.

Robbins, Lionel. 1932 [1984]. *An Essay on the Nature and Significance of Economic Science.* New York: New York University Press.

Robson, A. Deirdre. 1995. *Prestige, Profit, and Pleasure: The Market for Modern Art in New York in the 1940s and 1950s.* New York: Garland Publishing.

Rosen, Sherwin. 1974. "Hedonic Prices and Implicit Markets: Product Differentiation in Pure Competition." *Journal of Political Economy* 82, no. 1: 34–55.

———. 1981. "The Economics of Superstars." *American Economic Review* 71, no. 5: 845–58.

Rosler, Martha. 1984. "Lookers, Buyers, Dealers and Makers: Thoughts on Audience." In *Art after Modernism: Rethinking Representation,* edited by Brian Wallis, 311–40. New York: New Museum of Contemporary Art.

Rouget, Bernard, Dominique Sagot-Duvauroux, and Sylvie Pflieger. 1991. *Le Marché de l'Art Contemporain en France: Prix et Stratégies.* Paris: La Documentation Française.

Russell, John. 1999. *Matisse: Father and Son.* New York: Harry N. Abrams.

Sagot-Duvauroux, D., S. Pflieger, and B. Rouget. 1992. "Factors Affecting Price on the Contemporary Art Market." In *Cultural Economics,* edited by Ruth Towse and Abdul Khakee, 91–102. Berlin: Springer.

Sahlins, Marshall. 1976. *Culture and Practical Reason.* Chicago: University of Chicago Press.

Santagata, Walter. 1995. "Institutional Anomalies in the Contemporary Art Market." *Journal of Cultural Economics* 19: 187–97.

Schön, Donald. 1983. *The Reflective Practitioner. How Professionals Think in Action.* New York: Basic Books.

Scott, Richard W. 1987. "The Adolescence of Institutional Theory." *Administrative Science Quarterly* 32: 493–511.

Simmel, Georg. 1900 [1999]. *The Philosophy of Money.* Translated by Tom Bottomore and David Frisby. London: Routledge.

Simon, Herbert. 1957. *Administrative Behavior.* New York: MacMillan.

Simons, Riki. *De gijzeling van de beeldende kunst.* Amsterdam: Meulenhoff, 1997.

Simpson, Charles R. 1981. *Soho: The Artist in the City.* Chicago: University of Chicago Press.

Slater, Don. 2002. "Capturing Markets from the Economists." In *Cultural Economy: Cultural Analysis and Cultural Life,* edited by Paul du Gay and Michael Pryke, 59–77. London: Sage.

Smith, Adam. 1982. *Essays on Philosophical Subjects.* Vol. 3 of the Glasgow edition. Indianapolis: Liberty Press.

Smith, Charles W. 1989. *Auctions. The Social Construction of Value.* New York: Free Press.

———. 1993. "Auctions: From Walras to the Real World." In *Explorations in Economic Sociology,* edited by Richard Swedberg, 176–92. New York: Russell Sage Foundation.

———. 2003. "Markets as Definitional Mechanisms: A More Radical Sociological Critique." Paper presented at conference, Inside Financial Markets: Financial Knowledge and Interaction Patterns in Global Financial Markets, Constance, Germany.

Spence, A. Michael. 1974. *Market Signaling: Informational Transfer in Hiring and Related Screening Processes.* Cambridge, MA: Harvard University Press.

Star, Susan Leigh, and James R. Griesemer. 1989. "Institutional Ecology, 'Translations' and Boundary Objects: Amateurs and Professionals in Berkeley's Museum of Vertebrate Zoology, 1907–39." *Social Studies of Science* 19, no. 3: 387–420.

Stark, David, and Daniel Beunza. 2002. "Tools of the Trade: The Socio-Technology of Arbitrage in a Wall Street Trading Room." New York: Working Paper Series, Center of Organizational Innovation, Columbia University.

Staveren, Irene van. 2001. *The Values of Economics: An Aristotelian Perspective.* London: Routledge.

Steenbergen, Renee. 2002. *Iets wat zo veel kost, is alles waard: verzamelaars van moderne kunst in Nederland.* Amsterdam: Vassallucci.

Stein, John Picard. 1977. "The Monetary Appreciation of Paintings." *Journal of Political Economy* 85, no. 5: 1021–36.

Steiner, Christopher B. 1996. "Can the Canon Burst?" *Art Bulletin* 78, no. 2: 213–17.

Stigler, George. 1961 [1971]. "The Economics of Information." In *Economics of Information and Knowledge,* edited by D. M. Lamberton, 61–82. Harmondsworth: Penguin.

Stiglitz, Joseph E. 1987. "The Causes and Consequences of the Dependence of Quality on Price." *Journal of Economic Literature* 25, March: 1–48.

Stone, Deborah. 1999. "Care and Trembling." *The American Prospect* 43: 61–67.

Swedberg, Richard. 1994. "Markets as Social Structures." In *The Handbook of Economic Sociology*, edited by Neil Smelser and Richard Swedberg, 255–82. Princeton: Princeton University Press.

Swidler, Ann. 1986. "Culture in Action: Symbols and Strategies." *American Sociological Review* 51, April: 273–86.

———. 2001. *Talk of Love: How Culture Works*. Chicago: University of Chicago Press.

Szántó, András. 1996. "Gallery Transformations in the New York Art World in the 1980's." Unpublished dissertation, Columbia University.

———. 2003. "Hot and Cool. Some Contrasts between the Visual Art Worlds of New York and Los Angeles." In *New York and Los Angeles: Politics, Society, Culture*, edited by David Halle. Chicago: University of Chicago Press.

Thaler, Richard H. 1992. *The Winner's Curse: Paradoxes and Anomalies of Economic Life*. New York: Free Press.

———. 1999. "Mental Accounting Matters." *Journal of Behavioral Decision Making* 12: 183–206.

Theuns, Martina. 1994. "Een wankel evenwicht. De rol van de kunstenaar, de galerie en de koper bij de prijsvorming van een kunstwerk." Master's thesis, University of Utrecht.

Thomas, Nicholas. 1991. *Entangled Objects: Exchange, Material Culture and Colonialism in the Pacific*. Cambridge: Harvard University Press.

Thompson, Michael. 1979. *Rubbish Theory*. Oxford: Oxford University Press.

Throsby, David. 2001. *Economics and Culture*. Cambridge: Cambridge University Press.

Thurn, H. P. 1994. *Der Kunsthändler: Wandlungen eines Berufes*. Munich: Hirmer.

Tilly, Chris, and Charles Tilly. 1998. *Work under Capitalism*. Boulder, CO: Westview.

Titmuss, Richard M. 1971. *The Gift Relationship*. New York: Vintage.

Towse, Ruth. 1992. "The Earnings of Singers: An Economic Analysis." In *Cultural Economics*, edited by Ruth Towse and Abdul Khakee, 209–17. Berlin: Springer Verlag.

———. 1996. "Economics of Training Artists." In *Economics of the Arts: Selected Essays*, edited by Victor A. Ginsburgh and Pierre M. Menger, 303–29. Amsterdam: Elsevier.

———. 2001. "Partly for the Money: Rewards and Incentives to Artists." *Kyklos* 54, no. 2/3: 473–90.

Troy, Nancy J. 1996. "Domesticity, Decoration and Consumer Culture: Selling Art and Design in Pre–World War I France." In *Not at Home: The Suppression of Domesticity in Modern Art and Architecture*, edited by C. Reed, 113–29. London: Thames and Hudson.

Uzzi, Brian. 1997. "Social Structure and Competition in Interfirm Networks: The Paradox of Embeddedness." *Administrative Science Quarterly* 42: 35–67.

Van Gogh, Vincent. 1980. *Een leven in brieven*. Translated by Jan Hulsker. Amsterdam: Meulenhoff.

Veblen, Thorstein. 1899 [1994]. *The Theory of the Leisure Class*. New York: Dover.

Velthuis, Olav. 2000. "Europees volgrecht streeft zijn doel voorbij." *Economische en statistische berichten* 85, no. 4265: 597–99.

———. 2001. "Nieuwe inkomstenbronnen voor Nederlandse galeries." In *Kunst te koop! Artistieke innovatie en commercie in het Nederlandse galeriebestel*, edited by Truus Gubbels and Ingrid Janssen, 36–46. Amsterdam: Boekmanstudies/Mondriaan Stichting.

———. 2003. "Symbolic Meanings of Prices: Constructing the Value of Contemporary Art in Amsterdam and New York Galleries." *Theory and Society* 31: 181–215.

———. 2005. "Circuits of Commerce." In *International Encyclopedia of Economic Sociology*, edited by Jens Beckert and Milan Zafirovski. London: Routledge.

———. 2004. "An Interpretive Approach to Meanings of Prices." *Review of Austrian Economics* 17, no. 4: 371–386

Verger, Annie. 1995. "The Art of Evaluating Art: How to Assess the Incomparable?" *International Journal of Political Economy* 25, no. 2: 63–99.

Wacquant, Loïc. 1998. "A Fleshpeddler at Work: Power, Pain, and Profit in the Prizefighting Economy." *Theory and Society* 27: 1–42.

Waldfogel, Joel. 1993. "The Deadweight Loss of Christmas." *American Economic Review* 83, no. 5: 1328–36.

Wallis, Brian, ed. 1984 [1995]. *Art after Modernism: Rethinking Representation*. New York: New Museum of Contemporary Art.

Walzer, Michael. 1983. *Spheres of Justice*. Oxford: Basil Blackwell.

Warchol, Krystyna. 1992. "The Market System of the Art World and New Art: Prices, Roles and Careers in the 1980s." Dissertation, University of Pennsylvania.

Warnke, Martin. 1985 [1993]. *The Court Artist*. Cambridge: Cambridge University Press.

Watson, Peter. 1992. *From Manet to Manhattan*. New York: Random House.

Weber, Max. 1922 [1978]. *Economy and Society. An Outline of Interpretive Sociology*. 2 vols. Berkeley: University of California Press.

White, Harrison C. 1981. "Where Do Markets Come From?" *American Journal of Sociology* 87, no. 3: 517–47.

———. 2002. *Markets from Networks: Socioeconomic Models of Production*. Princeton: Princeton University Press.

White, Harrison C., and Cynthia A. White. 1965. *Canvases and Careers: Institutional Change in the French Painting World*. New York: John Wiley & Sons.

White, Harrison C., and Robert G. Eccles. 1987. "Producers' Markets." In *The New Palgrave Dictionary of Economic Theory and Doctrine*, edited by John Eatwell, Murray Milgate, and Peter Newman, 984–86. London: Macmillan.

White, Hayden. 1973. *Metahistory. The Historical Imagination in Nineteenth-Century Europe*. Baltimore: John Hopkins University Press.

White, Michael. 1999. "Obscure Objects of Desire? Nineteenth-Century British Economists and the Price(s) of 'Rare Art.'" In *Economic Engagements with Art: History of Political Economy*. Annual supplement to volume 31, edited by Neil De Marchi and Craufurd D. W. Goodwin, 57–84. Durham, NC: Duke University Press.

Williamson, Maureen R., and Alexander J. Wearing. 1996. "Lay People's Cognitive Models of the Economy." *Journal of Economic Psychology* 17, no. 3: 3–38.

Wolff, Janet. 1983. *Aesthetics and the Sociology of Art.* Boston: Allen & Unwin.

Wood, Paul. 1996. "Commodity." In *Critical Terms for Art History,* edited by Robert S. Nelson and Richard Shiff, 257–80. Chicago: University of Chicago Press.

Yakubovich, Valery, Mark Granovetter, and Patrick McGuire. 2001. "Electric Charges: The Social Construction of Rate Systems." Unpublished paper.

Zelizer, Viviana A. 1979. *Morals and Markets: The Development of Life Insurance in the United States.* New York: Columbia University Press.

———. 1985 [1994]. *Pricing the Priceless Child: The Changing Social Value of Children.* Princeton: Princeton University Press.

———. 1988. "Beyond the Polemics on the Market: Establishing a Theoretical and Empirical Agenda." *Sociological Forum* 3: 614–34.

———. 1994. "The Creation of Domestic Currencies." *American Economic Review* 84, no. 2: 138–42.

———. 1994 [1997]. *The Social Meaning of Money: Pin Money, Paychecks, Poor Relief, and Other Currencies.* Princeton: Princeton University Press.

———. 2000a. "The Purchase of Intimacy." *Law and Social Inquiry* 25, no. 3: 817–48.

———. 2000b. "How and Why Do We Care About Circuits?" *Accounts: Newsletter of the Economic Sociology Section of the American Sociological Association,* no. 1: 3–5.

———. 2002. "Enter Culture." In *The New Economic Sociology: Developments in an Emerging Field,* edited by Mauro F. Guillen, Randall Collins, Paula England, and Marshall Meyer, 121–28. New York: Russell Sage Foundation.

———. 2004. "Circuits of Commerce." In *Self, Social Structure, and Beliefs: Explorations in the Sociological Thought of Neil Smelser,* edited by Jeffrey Alexander, Gary T. Marx, and Christine Williams. Berkeley: University of California Press.

Zeruvabel, Eviatar. 1997. *Social Mindscapes: An Invitation to Cognitive Sociology.* Cambridge: Harvard University Press.

Zolberg, Vera L. 1990. *Constructing a Sociology of the Arts.* Cambridge: Cambridge University Press.

Zuckerman, Ezra W. 1999. "The Categorical Imperative: Securities Analysts and the Illegitimacy Discount." *American Journal of Sociology* 104, no. 5: 1398–438.

Index

Page references followed by *p* incicates a photograph; followed by *t* indicates a table; followed by *fig* indicates an illustrated figure.

PRINCETON STUDIES IN CULTURAL SOCIOLOGY